2010

Whitney Museum of American Art, New York

Distributed by Yale University Press, New Haven and London

This catalogue was produced on the occasion of the Whitney Biennial, *2010*, at the Whitney Museum of American Art, New York, February 25–May 30, 2010.

WHITNEY

Whitney Museum
of American Art
945 Madison Avenue
New York, NY 10021
whitney.org

Yale
Distributed by
Yale University Press
302 Temple Street
P.O. Box 209040
New Haven, CT 06520
yalebooks.com

Sponsored in part by

Deutsche Bank

Major support is provided by

Sotheby's

Fashion sponsor

TOMMY ☐ HILFIGER

Generous support is provided by the Wasserman Foundation, Donald R. Mullen Jr., the National Committee of the Whitney Museum of American Art in honor of Peter Dominick, and the Brown Foundation Inc.

Additional support is provided by the *2010* Friends, chaired by trustee Beth Rudin DeWoody: Jill and Darius Bikoff Foundation, Stefan Edlis and Gael Neeson, Rebecca and Marty Eisenberg, Liz and Jay Fensterstock, Marilyn and Larry Fields, Charlotte and Bill Ford, The Gage Fund, Barbara and Michael Gamson, Melanie Shorin and Greg S. Feldman, Amanda Steck and Glenn Fuhrman, and David Teiger.

Wine sponsor: Bear Flag

Funding for the Whitney Biennial is provided by endowments created by Melva Bucksbaum, Emily Fisher Landau, and Leonard A. Lauder.

Support for the catalogue is provided by Rosina Lee Yue and Bert A. Lies Jr., MD.

Library of Congress Cataloging-in-Publication Data

Whitney Biennial (2010)
 2010 : the Whitney Biennial / [curated by Francesco Bonami and Gary Carrion-Murayari].
 p. cm.
 Produced on the occasion of the Whitney Biennial, 2010, at the Whitney Museum of American Art, New York, Feb. 25–May 30, 2010.
 ISBN 978-0-300-16242-4
 1. Art, American—21st century—Exhibitions. I. Bonami, Francesco. II. Carrion-Murayari, Gary. III. Whitney Museum of American Art. IV. Title. V. Title: Whitney Biennial.
 N6512.7.A15 2010
 709.73'0747471—dc22
 2009053121

Printed and bound in the United States
10 9 8 7 6 5 4 3 2 1

Cover: An archival photograph shows the lobby of the Whitney's Marcel Breuer building on Madison Avenue; the inset photograph of Barack Obama is by Joshua Jow.

Contents

2010

Foreword

A viewer of recent Whitney Biennials would be hard-pressed to recognize many similarities to the Biennials that were organized during the founding of the Museum in the early 1930s. Today, biennials tend toward the spectacle, receive international press, and are the subject of speculation by collectors and the art market. At their best, biennials capture the zeitgeist of a period, introduce the work of new artists, and reacquaint us with familiar artists. It is generally understood that the Whitney Biennial is not intended to provide a survey of contemporary American art—a field that is now so complex and so diverse that to do so would be an impossibility. It is also understood that curators cannot be fully impartial; the selection of artists will be tempered by their curatorial background, exposure, tastes, and predilections. The curators of this Biennial, Francesco Bonami and Gary Carrion-Murayari, would be the first to admit the above. However, the way in which they have conceptualized and shaped the exhibition acknowledges the Biennial's founding tenets.

The Whitney's first Biennial was held in 1932. At the time, the field of American art was dominated by conservative and insular invitational and academic exhibitions, which catered to members of the host organizations and were dominated by juries whose purpose was to award prizes to outstanding works by their artists. In the spirit of democratic realism, the Whitney countered this tradition by founding an exhibition open to a cross-section of progressive American artists working in a wide range of figurative and abstract styles and practicing in different regions of the United States. The Museum's battle cry was "no juries, no prizes." This unique approach did not mean the Whitney was averse to recognizing artistic merit but rather that exhibitions should be more than "beauty contests." As Juliana Force, the Whitney's first director, said, they should provide "a depot where the public may see fine examples of American artistic production, in other words a forum for the presentation and examination of the diversity of American art." The first Biennial, for example, had works by 358 artists, an astonishing number considering the modest scale of the Museum's double townhouse facility on Eighth Street. Among the artists included were practitioners who bore a wide variety of artistic labels: Modernists like Arthur Dove, Impressionists like Childe Hassam, Social Realists like Ben Shahn, Realists like Edward Hopper, Expressionists like Ivan Le Lorraine Albright, Regionalists like Grant Wood, and Magic Realists like Peter Blume. In short, the curators—who appropriately remained in the shadows and whose names were not specified—cast a wide net as if to capture an objective record of American art at a moment in time. And in many ways, they did. While a large percentage of the artists' names are recognizable today, many others—such as Fiske Boyd, A. S. Baylinson, Ross Moffett, and Stanley Wood—are not, except to the specialist. The young Whitney, as a sign of faith in the artist, allowed each selected Biennial artist the opportunity to choose his or her own work to display. The early Museum's utopian commitment to the *breadth* of American art was so unshakable that a policy prohibiting one-person exhibitions by living artists was in place until 1986.

It would, of course, be impossible and undesirable to turn back the clock and attempt to organize a 1932-style Biennial in 2010. However, the thinking and approach of this year's curators reflects the roots of the Museum's seventy-four previous Biennials and Annuals. Recent Biennials have implicitly or explicitly acknowledged a thematic aspect. For example, the curators of the 2006 and 2008 Biennials were not searching for a theme or themes per se, but they emerged and were identified. This was tacitly recognized in 2006 by the title given to the exhibition, *Day for Night*, which caused some to question the difference between a thematic exhibition and a Biennial. The current Biennial is simply and unabashedly titled *2010*. To the curators' thinking, this title serves as a marker. The exhibition is a moment in time—no two years are the same. The Biennial is in effect an inexorable clock, providing a regular, systematic, arbitrary instrument to examine American art. The task of selecting has fallen to Bonami and Carrion-Murayari, but they are acting as agents in a particular time. As they write, "the year . . . defines the spirit of the show." The curators have called out the notion of the Biennial as a chapter in time by devoting a full floor of the Museum to art that addresses the history of the Biennial—works purchased from previous Biennials or created by artists included in them. The temporality of the Biennial is further emphasized in this catalogue, which lists every artist included in every Biennial and Annual

since the Museum's founding. The curators are well aware that *2010* is not an objective view but an acceptance of limitations—their own and those of the Biennial structure. Limitations are something every artist faces and often serve as parameters for potential success or failure. So, like the artists they have chosen, Bonami and Carrion-Murayari accept this risk. It is not only a risk well worth taking but a risk that is imposed by time—the two-year clock of the Biennial. Welcome to *2010*.

My profound thanks to Francesco Bonami and Gary Carrion-Murayari for taking on the risks and pleasures of the Biennial odyssey. Their enthusiasm and passion inspired the entire staff, and their thoughtfulness and intellect are evident in the exhibition.

The generosity of our funders offers Museum visitors the opportunity to see some of the most exciting, challenging, engaging, and innovative work being created in the United States today. My gratitude goes to Deutsche Bank for their sponsorship of the Biennial and for continually championing American art. The Whitney also owes a great debt of thanks to Sotheby's and fashion sponsor Tommy Hilfiger for their major support of the exhibition. The contributions of the Wasserman Foundation, Donald R. Mullen Jr., the National Committee of the Whitney Museum of American Art in honor of Peter Dominick, the Brown Foundation, and Bear Flag Wine were essential to the exhibition. My appreciation also goes to the *2010* Friends, chaired by Beth Rudin DeWoody and including: Jill and Darius Bikoff Foundation, Stefan Edlis and Gael Neeson, Rebecca and Marty Eisenberg, Liz and Jay Fensterstock, Marilyn and Larry Fields, Charlotte and Bill Ford, the Gage Fund, Barbara and Michael Gamson, Melanie Shorin and Greg S. Feldman, Amanda Steck and Glenn Fuhrman, and David Teiger for kindly acknowledging the importance of this year's Biennial. Rosina Lee Yue and Bert A. Lies Jr., MD, generously supported the catalogue, ensuring a lasting record of *2010*. In addition, I am deeply grateful to Melva Bucksbaum, Emily Fisher Landau, and Leonard A. Lauder for their longstanding devotion to the Whitney and their foresight in the creation of endowments for the Biennial. The steadfast commitment of these organizations and individuals has made the exhibition a reality.

Adam D. Weinberg
Alice Pratt Brown Director

Acknowledgments

2010 marks the seventy-fifth installment of the Biennials and Annuals at the Whitney Museum of American Art. Since the Museum's first Biennial in 1932, the exhibition has grown in scale and importance for the artists involved as well as the institution as a whole. Every Biennial is an enormous undertaking and requires the hard work of many people both inside and outside the Museum. Our foremost thanks go to the artists in the Biennial, and our appreciation extends to all the artists we visited during the research process. Every artist we saw gave us ideas to reflect upon while we were shaping the Biennial, and we are fortunate to have had the opportunity for a dialogue with so many individuals across the country. We are grateful to Adam D. Weinberg, Alice Pratt Brown Director, for inviting us to organize the Whitney's signature exhibition, and we benefitted from his ongoing support. We would also like to thank Donna De Salvo, chief curator and associate director for programs, for her invaluable input throughout the process.

The Biennial team deftly dealt with numerous aspects of making the exhibition a reality, but we also thank them for their exchange of ideas. Esme Watanabe, Biennial coordinator, managed all aspects of the installation process with patience and humor. Margot Norton, curatorial assistant, worked tirelessly from the beginning of the curatorial process, and her contributions can be felt in all aspects of the exhibition. Laura Phipps provided invaluable support, first as an intern and then as Biennial assistant. We would also like to thank Taylor Haunschild and the other Biennial interns.

Rachel de W. Wixom, head of publications, and Beth Huseman, editor, oversaw the creation of this volume. Beth, in particular, worked closely with us, the writers, and the designers to ensure a cutting-edge publication that reflects the spirit of the exhibition. Adam Michaels and Prem Krishnamurthy of Project Projects executed a visionary design, and we are grateful for their innovation and hard work. Writers Nicole Cosgrove, Hillary deMarchena, Diana Kamin, Tina Kukielski, Fionn Meade, Margot Norton, and William S. Smith contributed intelligent and thoughtful artist entries despite tight deadlines.

This exhibition inevitably involves the efforts of every department of the Museum, and we thank the entire Whitney staff, especially the following: Jay Abu-Hamda, projectionist; Marilou Aquino, director of prospects and stewardship; John Balestrieri, director of security; Jeffrey Bergstrom, audio visual coordinator; Caitlin Bermingham, assistant head preparator; Richard Bloes, senior technician; Melissa Cohen, associate registrar; Heather Cox, conservation coordinator; Anita Duquette, manager, rights and reproductions; Rich Flood, marketing and community affairs officer; Seth Fogelman, senior registrar; Carter E. Foster, curator of drawings; Larissa Gentile, new building project manager; Rebecca Gimenez, head of graphic design; Francesca Grassi, senior designer; Matt Heffernan, assistant registrar; Nick Holmes, general counsel; Tracy Hook, associate major gifts officer; Abigail Hoover, associate registrar; Brooke Horne, administrative coordinator; Chrissie Iles, Anne and Joel Ehrenkranz Curator; Anna Knoell, graphic designer; Emily Krell, coordinator of performing arts; Kristen Leipert, assistant archivist; Jeffrey Levine, chief marketing and communications officer; Kelley Loftus, paper preparator; Bill Maloney, new building project consultant; Carol Mancusi-Ungaro, associate director for conservation and research; Graham Miles, art handler, supervisor; Matt Moon, art handler, supervisor; Brianna O'Brien, membership and annual fund coordinator; Kathryn Potts, associate director, Helena Rubinstein Chair of Education; Christy Putnam, associate director for exhibitions and collections management; Brian Reese, publications intern; Gina Rogak, director of special events; Justin Romeo, executive assistant to the director; Joshua Rosenblatt, head preparator; Amy Roth, director of corporate partnerships; Carol Rusk, Irma and Benjamin Weiss Librarian; Emily Russell, acting curatorial manager; Lynn Schatz, exhibitions coordinator; Gretchen Scott, marketing manager; Matthew Skopek, assistant conservator; Stephen Soba, communications officer; Barbi Spieler, senior registrar; John S. Stanley, deputy director; Mark Steigelman, manager, design and construction; Emilie Sullivan, associate registrar; Elisabeth Sussman, Sondra Gilman Curator of Photography; Mary Anne Talotta, senior major gifts officer; Limor Tomer, adjunct curator of performing arts; Beth Turk, associate editor; Ray Vega, carpenter, supervisor; Alexandra Wheeler, associate director for development.

The following individuals generously offered advice and support throughout the process: Lina Bertucci; Staci Boris, senior museum curator, Spertus Institute of Jewish Studies, Chicago; Benjamin Buchloh, Andrew W. Mellon Professor of Modern Art, Harvard University, Massachusetts; Howie Chen; Apsara DiQuinzio, assistant curator, San Francisco Museum of Modern Art; Jarrett Gregory, curatorial assistant, New Museum, New York; Hou Hanru, director of exhibitions and public programs, San Francisco Art Institute; Jens Hoffman, director, Wattis Institute for Contemporary Arts, California College of the Arts, San Francisco; Anthony Huberman, chief curator, St. Louis Museum of Contemporary Art; Ruba Katrib, assistant curator, Museum of Contemporary Art, North Miami; Kristan Kennedy, visual arts program director, Portland Institute of Contemporary Art; Heather Pesanti, assistant curator of contemporary art, Carnegie Museum of Art, Pittsburgh; James Rondeau, curator and Frances and Thomas Dittmer Chair, department of contemporary art, Art Institute of Chicago; Jerry Saltz; Jay Sanders; Mark Shortliffe; Ali Subotnick, curator, Hammer Museum, Los Angeles; Tricia Van Eck, assistant curator, Museum of Contemporary Art, Chicago; Hamza Walker, associate curator and director of education, the Renaissance Society, the University of Chicago; Julie Rodrigues Widholm, Pamela Alper Associate Curator, Museum of Contemporary Art, Chicago.

We are delighted to acknowledge the support and kindness of the following galleries: 1301PE, Los Angeles; 303 Gallery, New York; ACME, Los Angeles; Miguel Abreu Gallery, New York; Nicelle Beauchene Gallery, New York; Bortolami Gallery, New York; Broadway 1602, New York; Gavin Brown's Enterprise, New York; Valerie Carberry Gallery, Chicago; Paula Cooper Gallery, New York; D'Amelio Terras Gallery, New York; Elizabeth Dee, New York; Deitch Projects, New York; Derek Eller Gallery, New York; Gagosian Gallery, New York; Gladstone Gallery, New York; Alexander Gray Associates, New York; greengrassi, London; Christopher Grimes Gallery, Santa Monica; Hauser and Wirth, London and Zurich; Herald Street, London; Rhona Hoffman Gallery, Chicago; Ibid Projects, London; Galleria Francesca Kaufmann, Milan; Sean Kelly Gallery, New York; David Kordansky Gallery, Los Angeles; Tanya Leighton Gallery, Berlin; Luhring Augustine, New York; Matthew Marks Gallery, New York; Mitchell-Innes and Nash, New York; PDX Contemporary Art, Portland; Pierogi, Brooklyn; The Project, New York; Ratio 3, San Francisco; Salon 94, New York; Small A Projects, New York; Tony Shafrazi Gallery, New York; Smith-Stewart Gallery, New York; Galerie Georges-Philippe and Nathalie Vallois, Paris; VG Bild-Kunst, Bonn; Michael Werner Gallery, New York; David Zwirner Gallery, New York.

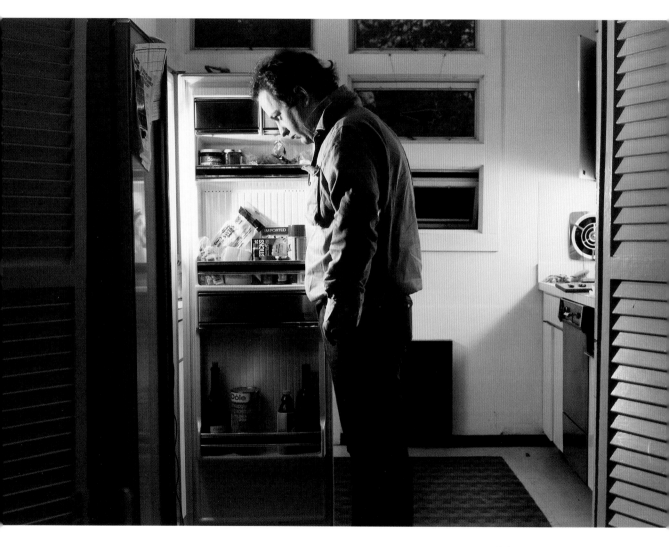

Philip-Lorca diCorcia
(b. 1951) / *Mario*, 1978 /
Chromogenic print, 20 × 24 in.
(50.8 × 61 cm) / Courtesy of
the artist and David Zwirner,
New York

The Fence and the Bridge, or Regeneration Through Art

Francesco Bonami / Gary Carrion-Murayari

Exhibitions, biennials more so than others, are defined by their time frame, which is why we gave this year's Whitney Biennial the simple and indisputable title *2010*. Time is what makes shows different from one another: the Whitney's 1993 Biennial differs from its 2006 Biennial not simply because different curators conceived it but because history changes our perspective on art. If the curators of the 1993 Biennial were called to curate the 2006 Biennial, they would have shaped a completely different exhibition than the one they curated thirteen years before. The year signals a given frame that defines the spirit of the show. It is inevitable that art produced since 2008 was affected—even if not visibly or directly—by the social, historical, and cultural mood of the past two years.

The Whitney Biennial is about art in America more than American art, so its identity heavily depends on the political, cultural, and social weather of the country. During the last two years the United States went through a huge atmospheric shift. After a period of political resistance came a kind of ecstasy. "Ecstatic resistance," a concept conceived by one of this year's Biennial artists, Emily Roysdon, is grounded in feminist theory and upends traditional forms of thinking and categorization in favor of innovative, plastic forms of communication and imaginative new relationships between the self and others. Not limited to one medium or discipline, ecstatic resistance shapes a form of personal protest that initially seems unintelligible or impossible. It is within this reimagination of the body politic that this exhibition falls.

With the election of Barack Obama, the clouds broke and the rain of renewal poured over the entire country. The presence of a reassuring and inspiring political figure allowed people to focus on their intimate concerns again. Traditional forms of protest and resistance were no longer needed as in the years before when it felt like the United States was losing its moral direction. The year 2010 marks a time when art seems to have gone back to certain basic aesthetic rules or what could be called a kind of self modernity or personal modernism— the need to rediscover the experimental nature of the artistic endeavor and politics within the self in order to understand our role in a larger social and cultural transformation.

A number of artists included in *2010* work within this kind of personal modernism by reconstructing the styles of earlier movements and bringing them into dialogue with traditions of craft and the handmade. These works, often paintings, are self-conscious about their relationship to history, interrogating its gaps and distortions while also reimagining personal images and memories. This strategy is both critical of Modernism and optimistic about the possibility of rejuvenating the social potential of abstraction. The abstract works produced by these artists are grounded in a careful consideration of process and a refined sense of skill, yet the finished works contain a sense of accident, ephemerality, or contingency. In addition, these works foreground the gesture of the artist even if it might seem arbitrary or mechanized. It is incorrect to view this type of abstraction—engaging the past while also relying on choreography

and chance—as an embrace of isolation or extreme individualism. Instead it suggests a primary reckoning with the body in relation to the world and an optimism in finding wonder in the most basic elements of the everyday. These improvised abstractions emerge out of the same political position as the open scores of John Cage, Merce Cunningham, and Robert Rauschenberg—an embrace of the void as a model for an open society in which all actions and individuals affect one another.

Regeneration through art. It feels as though artists all across the United States are reaffirming the importance of the individual gesture in order to produce a collective change. To a large degree the past eighteen months of artistic production have centered around a reconsideration of the distinction between collective and individual action. The grassroots activism and political organization that defined the Democrats' political triumph in November of 2008 contrasted sharply with the reckless individualism that defined Wall Street and the attendant financial ruin it precipitated. This binary opposition remains active in the postelection debates about the merits of govern-ment intervention versus the loss of individual freedom. At first glance, a lot of the work in *2010* appears intensely personal and concerned with simple gestures and everyday actions—depictions of individual bodies and stories, which might seem at odds with a sense of community and social responsibility. More accurately, however, these artists are constructing models that can serve as

the foundations of lasting communities and sustained critique.

These models can also be seen as another potential collection—a collection of bodies, gestures, and strategies representative of a collective coming into being. In this year's Biennial there are numerous images of individuals and groups of bodies in video, drawing, and sculpture. These works form an appropriate catalogue of characters for a time of burgeoning hope within a world of extreme violence, aptly illustrating theologian Paul Tillich's proclamation that "every period has its peculiar image of man." This statement was made in response to the 1959 Museum of Modern Art exhibition *New Images of Man*, and like that seminal show, the bodies of *2010* shift from vivid clarity and beauty toward grotesque distortion, and they almost disappear in the spaces they occupy, pass through, and move between. To a large extent, the image of the body that *2010* presents is one that is shaped by physical, spiritual, or social violence. The individuals depicted in much of this work, whether real or imagined, bear the scars of war, discrimination, and hatred; they are attacked, controlled, and disfigured. Visualizing this attack on the body, however, is not cynical or hopeless but rather a new form of regeneration and hope, providing an entreaty to individual dignity. The disembodied parts in Tristan Tzara's Dada play *The Gas Heart* (1920) convey this message well:

Nose: You over there, man with starred scars, where are you running?

Ear: I'm running toward happiness.

The focus on individuality suggested in much of the work included in *2010* is countered by the country coming back together and reflects a sense of politics as being built through personal encounters and dialogue. Any idea of public speech and public action is often a myth. In response, artists have created space for performances and potential encounters among themselves and individuals from different communities. Any new collectivity begins with the act of one individual meeting another. These artists attempt to build collectivity in a new historical moment. If the goal for artists in *2010* is to find these new communities, they start from the position of one artist standing alone.

"Yes we can" is now "Yes I can." The "Yes I can" artist, like many we encountered in our search for this year's Biennial, is curiously revealing a resurgent interest in Herman Melville's 1851 masterpiece *Moby Dick*. These artists view their practice as a kind of personal undertaking to battle or conquer something bigger than life. And yet few of the artists we visited had an attitude that could be read as heroic. Most of them revealed a meditative spirit—a deep need to observe reality rather than act upon it. Repetitive tasks, absurd gestures, and the observation of the everyday are treated as both subject and strategy. Every action is a form of ritual and performance. As Aki Sasamoto, who is included in *2010*, puts it, "the performer feeds energy into the objects every day, adding the boring and fascinating history between a person and her

environment." The domestic and the infinite can often be found in exactly the same place.

In a way *2010* is our Moby Dick. How do you bring home that ominous whale that every Biennial seems to be without going under? First we—an Ahab and an Ishmael—decided to look for the whale where it was supposed to be: the United States. But we were not simply looking for American artists; we were looking for artists whose practice was committed to a certain kind of American spirit. For us, the question of what it means to be American is obsolete. Instead we asked ourselves what a Biennial of American art means in an age of global understanding. We thought that geographic boundaries and limitations would help to build a more defined exhibition. We stopped at the Pacific Ocean, the Mexican border, the Atlantic coast, and the Canadian border. We looked to Hawaii, but without success; we did not feel too bad, though, since Hawaii is celebrated by having the coolest artist of all in the White House.

But the first step in the hunt did not start on the road but at home in the harbor. This exhibition began when the Museum's first Biennial was conceived seventy-eight years ago, and it presupposes that the history of the Whitney is based on a collection of Biennials and Annuals that exist today as a collection of images of dispersed objects and faded aesthetic propositions. What remains of these partial histories is imperfect, never accurately representing the historical moment from which they emerged. These regularly occurring exhibitions consistently fail to define a generation

of artists (and in spite of complaints from critics, its mission, stated or implied, has rarely been to do so). Instead the Biennial has historically gathered a shockingly disparate range of artistic positions, ones that often unexpectedly linger or reemerge in the contemporary consciousness years later.

Since 1966, the Whitney's Marcel Breuer–designed building has served as the site for innumerable potential encounters among artists, objects, and viewers. This year the Biennial extends to the Museum's fifth floor—a space typically devoted to works from the permanent collection—which contains an exhibition of artists and works specifically tied to the previous seventy-four Biennials and Annuals. Since the inception of these exhibitions in 1932, the Whitney has devoted funds to purchase work from them, acquiring pieces that sometimes become iconic and other times are rarely displayed again. Therefore, the creation of the collection has, in some ways, mirrored the process of evaluation and projection that is characteristic of the Biennials and Annuals themselves. We also considered the Museum's collection as another artist and a new territory to explore. Familiar and forgotten artists are brought together to demonstrate the influence of the past on 2010 and suggest other potential histories for the Whitney as both an institution and a collection.

We curated the collection as a Biennial and then applied this idea to the Biennial, curating it as a collection. Using the collection offers an opportunity to understand that this year's Biennial is both a fence and a bridge. A fence because a lot

of the art presented is challenging and, as a result, keeps the viewer at a distance; the fruition of the new is always more complex than the fruition of the established. A bridge because by looking at works drawn from the collection, the viewer will understand that some of the art now revered as classic probably faced some sort of resistance when it was shown in a Biennial or an Annual. Although this resistance brings us back to the time frame that defined the work, we see it without the fences of that moment. Now we can look at it closely, and time serves as another sort of bridge that leads to a better understanding—crossing the present and joining the past with the future.

The Whitney's collection was this bridge to the boat. Back in the harbor it became clear that the whale in the Museum, the Biennial, is only part of a bigger whale still out there. But knowing about the larger ocean of American art was extremely relevant for the building of the exhibition. People feel that the sole purpose of the Biennial is to include and exclude. The final list of artists is often perceived as the whole body of the show, but in reality it is just a big bone or one part. This bone also recalls the carcass that is emblematic of Santiago's intensely personal struggle with the marlin in Hemingway's The Old Man and the Sea (1952). Looking at artists across the United States made us understand that this exhibition is not the result of inclusion or exclusion but of a series of encounters. Most of these encounters did not end in an invitation, but the exchanges brought something to the exhibition. We met a great number

of artists who, although not selected, gave us ideas, inspiration, and even suggestions on how to proceed. We are grateful to them as much as we are to those invited to the Biennial. Many helped us figure out what 2010 is about even though they did not match what we where looking for. What we where looking for? In fact we still do not know. We will only know what 2010 is about when the dialogue among different artists plays out in the exhibition for the viewer who has not been with us for the entire research and selection process. We cannot show the work we did not choose but that still meant something in the Biennial structure. We cannot share all the impressions and experiences we had during the months of traveling to different studios, but we did come to realize that not all art, even if it is good, should be shown in the Biennial. There is some art that exists in isolation—inside a protected environment—and would not gain anything from being excavated and brought to Madison Avenue. Artists are sometimes on an intimate, spiritual journey and do not need exposure. Jokingly we called these kinds of artists Una-artists—people who see the world and interpret it, luckily through art and not explosive parcels, from their own cabin and on their own terms. Their art coincides with life and does not gain anything through achieving visibility, recognition, or conventional notions of "success." As curators we were slightly tempted to include the self-contained work of these types of artists as Biennial trophies. But we resisted the temptation, thinking it would have been unjust to break that kind of balance in an artist's life—an ecosystem that does not need the Biennial or any other

exhibition to exist and fulfill a creative necessity. This Biennial is dedicated to these Una-artists because they redefine artistic production.

Although visits to artists' studios ranged from inspiring to agonizing, the experience always produced a new question: Why? Many times after coming out from a studio, we asked ourselves, why is this person making art when it is obvious his or her art will not lead anywhere, when it is clear that success or even some remote form of recognition will always elude them? Why do so many people insist on defining themselves as artists? Because, as we came to realize, art can simply be a state of mind—a form of ecstatic resistance—that helps people to handle the complexities of society and even deal with the hardships of life. Art is not only what is shown in the Biennial or in any other exhibition in a museum or a gallery; for many it is also an effort to make sense of their own existence.

Any curatorial effort, especially something like the Biennial, has its shortcomings and failures. Failures and shortcomings disclosed in advance are a very convenient alibi. We hope that the shortcomings of *2010* are our best failures. We make no excuses for the artists we selected. We are attached to the big whale. They can survive floating on top of their own work even after the big white squall.

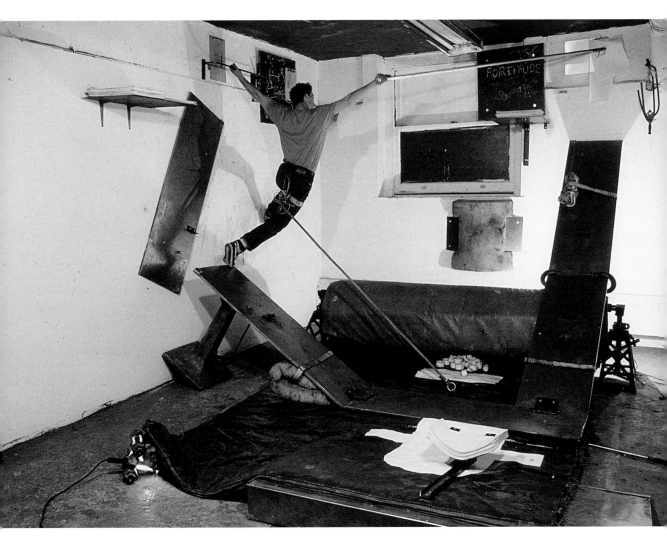

Matthew Barney (b. 1967) /
DRAWING RESTRAINT 2,
1988 / Documentation
photograph

15

David Adamo

Richard Aldrich

Michael Asher

Tauba Auerbach

Nina Berman

Huma Bhabha

Josh Brand

The Bruce High
 Quality Foundation

James Casebere

Edgar Cleijne and
 Ellen Gallagher

Dawn Clements

George Condo

Sarah Crowner

Verne Dawson

Julia Fish

Roland Flexner

Suzan Frecon

Maureen Gallace

Theaster Gates

Kate Gilmore

Hannah Greely

Jesse Aron Green

Robert Grosvenor

Sharon Hayes

Thomas Houseago

Alex Hubbard

Jessica Jackson Hutchins

Jeffrey Inaba

Martin Kersels

Jim Lutes

Babette Mangolte

Curtis Mann

Ari Marcopoulos

Daniel McDonald

Josephine Meckseper

Rashaad Newsome

Kelly Nipper

Lorraine O'Grady

R. H. Quaytman

Charles Ray

Emily Roysdon

Aki Sasamoto

Aurel Schmidt

Scott Short

Stephanie Sinclair

Ania Soliman

Storm Tharp

Tam Tran

Kerry Tribe

Piotr Uklański

Lesley Vance

Marianne Vitale

Erika Vogt

Pae White

Robert Williams

Often playing with the connotations of immediately recognizable proplike objects, David Adamo's installations hint at performative acts withheld and theatrical scenarios deferred. An ongoing untitled series features the blunt force and aggression of conventionally masculine tools and implements—sledgehammers, axes, and baseball bats—rendered fragile and useless by the artist as he hacks and whittles hefty items into mere spindles before delicately leaning his handi- work in taxonomical groupings along gallery walls. In a wry nod to the presentation of early Conceptual art, Adamo carefully pools wood chippings and shavings around each of these serially arranged and equally spaced out abused objects in self-conscious acknowledgment of his artistic process and the literally dematerialized art on display. In contrast to the austerity of a seminal work like Robert Morris's *Box with the Sound of Its Own Making* (1961), Adamo's gestural inversions rely upon comedic effect and a unique talent for spare configurations.

The installation *Untitled (Margret)* (2009) offers the proverbial "rotten tomatoes" that one might throw at a failing comedian or performer, cast in bronze and placed upon a soapbox like platform; *Untitled (Smashed Bronze Tomato No 2)*, for example, is one among a bushel of such fallen fruit littering the stage of an opaque mise-en-scène. As with *Untitled* (2008), where two feathered arrows are wrapped in a thick swath of Beuysian gray felt, many of Adamo's works function like the punch line of a joke wherein the set-up has been excised. *Untitled (The Rite of Spring)* (2008) creates a stage out of hundreds of Louisville Slugger baseball bats placed head to handle across the gallery floor, referencing Igor Stravinky and Vaslav Nijiksky's notorious ballet of 1913 and the riot it sparked at its Paris premiere in addition to the annual commencement of America's favorite pastime. Adamo's invitations to take the stage overturn participatory rhetoric with punning references and hapless gestures. FM

Untitled (Music for Strings), 2009 (installation view at N.O. Gallery, Milan) / Wood stage, harp strings, nylon string, copper and brass fittings, wood cane, and wood shavings, dimensions variable / Collection of the artist

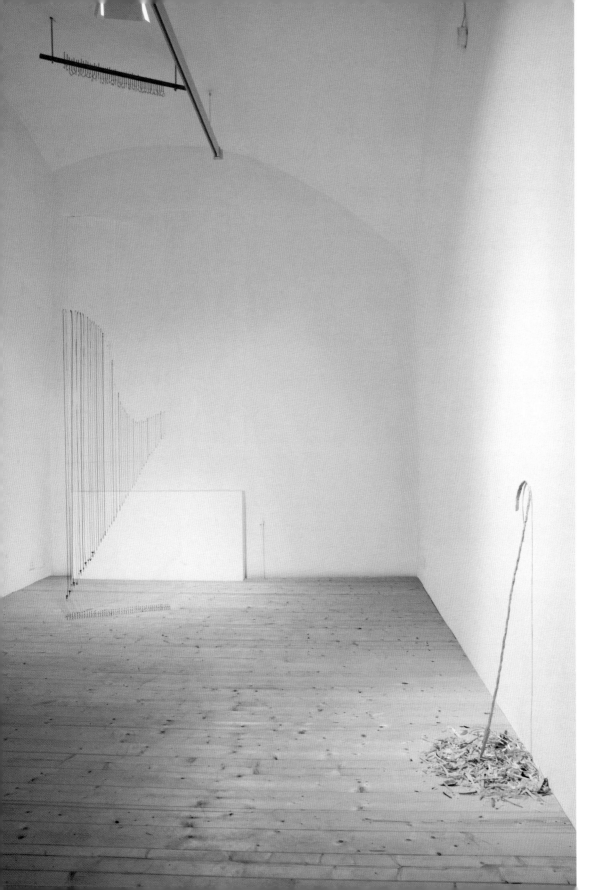

"One kind of sleight of hand turns into another, with effusive energy sa sa sa sa sa," exhorts Richard Aldrich in one of the bantam prose poems that form part of his multifaceted practice— he is a musician and recording artist in addition to being primarily a painter. Ranging from gestural abstraction to incipient portraiture, from dusty-hued patinas and faint washes to crudely collaged canvases and densely layered corners, from monochromatic stand-ins to cut paintings, Aldrich's image repertoire evinces a whimsical amusement and quizzical remove. Open to change and continually finding new ways of starting out, Aldrich's work insinuates its overall impression through stylistic detours, courting variation and even contradiction, while nevertheless positing his maneuvers as kindred and consonant. Neither parodic nor engaged with the pitfalls and pretensions of endgame dialogues regarding the oft-heralded demise of painting, Aldrich's gamesmanship seems joyful while harmonized with doubt.

As the artist has said regarding his penchant for tacking back and forth between mediums and fragmentary approaches, "often some sort of metamorphosis is necessary." Whether affixing the dark green linen fabric from a failed attempt at window curtains to a supine canvas lying about the studio, as with *Bed* (2008), or exhibiting a ruminative large-scale variation next to a diminutive original (or is it the other way around?) in *Treib Painting* (2007) and *Large Treib Painting* (2008), Aldrich constantly shifts scale and surface. Sharp bursts of clarity alternate with droughts of obscurity and languorous stretches of nothing, sometimes within the same composition. Such attentiveness to the differences that arise between an idea or intention and the resulting composition animates Aldrich's practice, welcoming second thoughts, pointing to nonappearances and colorful cameos alike, and thereby always making room for contingency. Working primarily with oil paint, wax, and found objects, an Aldrich installation manages to attain a serial yet disjunctive ambience in its stagecraft, releasing the everyday objects and hallucinatory moments it incorporates from the bracketed meanings of painterly discourse. Both protean and melancholy, Aldrich's paintings reveal a longing for meaning and rules alongside a ready acknowledgment of this very impossibility. FM

Past, Present and Future #2, 2009 / Oil and wax on linen with furniture, 84 × 58 × 36 in. (213.4 × 147.3 × 91.4 cm) / Collection of the artist

"I see myself as an author of situations, not of the elements involved in them," Michael Asher has said. Rather than producing discrete aesthetic objects, since the late 1960s Asher has enacted site-specific projects that critique the logic of institutions. By subtly manipulating the physical spaces of galleries and museums or exposing their bureaucratic processes, Asher draws attention to the ingrained codes that determine the circulation and display of art. The restrained economy of means that typify Asher's interventions belie expansive conceptual implications, and his influence marks subsequent generations of artists who define their work in terms of social contexts rather than physical media.

For a recent project at the Santa Monica Museum of Art in California, Asher rebuilt the metal supports for every temporary wall that the museum had constructed during its ten-year exhibition history. Shorn of the drywall they once supported, the web of metal beams outlined the precise configurations of previous gallery spaces. As in some of his earliest projects, Asher displaced the sleek white walls that have come to define the space of modern art. At the same time, Asher's work for the Santa Monica Museum of Art advanced the sustained interrogation of institutional memory that has defined his career. By raising the skeletons of past exhibitions, Asher rendered in spatial terms the museum's history of negotiating the needs of individual artists.

Asher's work frequently reveals awkward truths about the way museums and galleries operate as part of the art market and places them in a broader historical context. His 1999 project for the Museum of Modern Art in New York comprised a catalogue of works the museum had deaccessioned, a practice that may be routine, but sometimes suggests a lapse in the museum's mission to care for its entire collection and present it to the public. However challenging his work may be, Asher depends upon collaborating with host institutions; indeed, he participates in the very structures he questions. His works, therefore, neither launch polemics from a safe distance nor embrace the art world with an easy sense of irony, but model an institutional critique as a process of introspection. WS

Installation view of
Michael Asher at the Santa
Monica Museum of Art,
California, 2008

23

Tauba Auerbach uses a rigorous yet playful approach to investigate both the shortcomings and the possibilities of established systems of logic. In her paintings, drawings, photographs, and installations, Auerbach creates elegant patterns and juxtapositions that rework and deconstruct the conventional ways information is conveyed.

Working as a sign painter in San Francisco, Auerbach became fascinated with the formal qualities of individual letters and their role as visual signifiers. In her early explorations of this theme, *A, R, E, I, O, F, G,* and *V* (2005), large, calligraphic letters are methodically rendered in the tradition of the illuminated manuscript and embellished with ornate flourishes to the point of near abstraction. In *The Whole Alphabet, from the Center Out, Digital V* (2006), Auerbach takes these graphic meditations into the digital age, painting all twenty-six letters of the Latin alphabet from the center out as a mass of color-coded line-segments of LCDs (liquid crystal displays). By abstracting these symbols and isolating their line and shape, she guides us to rethink the connotations of familiar symbols.

In *50/50* (2006), a series that includes drawings and a large tile-floor installation, Auerbach creates a dizzying array of configurations, using arrangements of black and white shapes derived from binary code matrices. In this series, an equal mix of black and white wedges are presented in a variety of patterns, resulting in a wash of medium gray from a certain vantage point. Thus, a seemingly infinite number of possible paths (variations of black-and-white patterns) are shown to arrive at a single homogeneous outcome. Auerbach further questions the strength of the divide between order and chaos in her 2008 *Crumple* series. These works recall the 1960s Op art matrices of Bridget Riley, yet Auerbach's paintings have conceptual underpinnings. In the series, the "optical" pattern is derived from photographs of crumpled paper, which are meticulously reproduced with painted black dots. In her illusionistic two-dimensional representation of a three-dimensional quality, Auerbach challenges the limitations of dimensionality and presents the possibility that order and chaos are inextricably intertwined. In another recent series, *Static 1–5* (2008), she photographed television static and found that patterns emerged from a supposedly random display of colored points of light. With a mathematician's precision, Auerbach finds methods in madness and vice versa, challenging the validity of systems that are usually overlooked. MN

Untitled Fold III, 2009 /
Synthetic polymer on linen,
80 × 60 in. (203.2 × 152.4 cm) /
Collection of the artist

Nina Berman's poignant and hauntingly powerful color photographs document the rarely explored effects of contemporary warfare in the United States. With a keen formal and compositional intelligence, Berman shines a light on the harsh realities of post-9/11 America and the Iraq War that are as troubling to look at as they are essential.

Frustrated with the limited scope of conventional images of war, Berman strips away the contexts of typical "band of brothers" combat scenarios. In her series and first book, *Purple Hearts: Back from Iraq* (2003–04), and in subsequent works, Berman has sought to make the war "more intimately felt by a civilian audience." The portraits and interviews in *Purple Hearts* are of injured soldiers who have returned home. No longer in the hospital or embraced by military support networks, they are mostly shown alone and in domestic settings. Saturated in color and low-lit, these images evoke an overwhelming sense of fragility and isolation in their subjects, which is also mirrored in their accompanying interviews.

Marine Wedding (2006/2008), commissioned by the magazine *People* to accompany an article, focuses on the marriage of former Marine sergeant Ty Ziegel, then twenty-four, to his high-school sweetheart Renee Kline, twenty-one. Severely disfigured during a suicide bomber's attack, Ty underwent fifty operations, leaving his face almost completely reconstructed and unrecognizable, a plastic dome replacing his shattered skull, with holes where his ears and nose used to be. Without any staging or direction, Berman photographed Ty and Renee in the

weeks leading up to their wedding day and accompanied them as they got their wedding portrait taken. A disturbing and iconic image taken by Berman at the wedding portrait studio conveys an air of alienation and disconnection between the couple, who separated a few months after their wedding. Berman returned to photograph Ty in 2008 and describes the later images as suggestive of "a comfortable acceptance with military culture despite the cost."

Through her rigorous investigation, Berman sets out to locate a better understanding of the role of the military in American life. Applying her sharp observational powers to lives interrupted and off-kilter, Berman forces us to engage in a more intimate way with a disturbing subject that is not often covered in depth in the popular media. MN

Ty with gun, 2008, from *Marine Wedding*, 2006/2008 / Pigment print, 10 × 15 in. (25.4 × 38.1 cm) / Collection of the artist

Assembled from mundane materials, Huma Bhabha's sculptures engage the immense evocative range of the human form. Her figures and masklike heads project an ineffable psychological intensity as they take shape from scraps and detritus. While drawing upon deeply ingrained sculptural archetypes, Bhabha's works comprise fragments that coalesce uneasily, as if still in the process of being formed or already in a state of decay.

Bhabha often describes her sculptures as "characters" whose multivalent personalities unfold within webs of shifting associations. Fashioned from roughly worked clay, the ghostly face of *They Don't Speak* (2007) might belong to an archaic monument ravaged by time. Yet the chicken-wire structure and spray-painted Styrofoam base equally ground the work in an imagined dystopian future. Marked by heavy wear, each surface of the base conjures some obscure ritual use that surely exceeds the detached mode of contemplation invited by Western art. Through these traces of possible violence or fearful devotion, Bhabha's works appear to embody turbulent histories and enigmatic myths.

While Bhabha has compared her sculptures to ruins and bombed-out buildings, they also convey a paradoxical sense of renewal. By explicitly laying claim to a long tradition of figurative sculpture, her work instills new value into found objects that might otherwise be discarded. In their insistent materiality and raw emotional charge, Bhabha's figures most directly extend the radical reimaging of anthropomorphic forms undertaken in the wake of World War II by artists like Alberto Giacometti, Jean Dubuffet, and Eduardo Paolozzi. Yet the art historical foundation of Bhabha's practice also transcends the twentieth century, encapsulating the basic functions of sculpture that have persisted beyond particular cultures and civilizations. In addition to her totemic masks, recent works like *1,000* (2009) take the form of medieval funerary monuments whereas *The Orientalist* (2007) draws upon the vocabulary of monumental commemoration. As much as her pieces portray the violent ruptures of time, Bhabha's process of sculpting enacts the alchemy that might be inherent to all works of art, as she transmutes the stuff of everyday life into emotionally resonant objects. WS

1,000, 2009 (detail) / Wood, clay, Styrofoam, wire, plaster, steel, cast iron, synthetic polymer, and paper, 99 × 46 ¾ × 76 in. (251.5 × 118.7 × 193 cm) / Collection of the artist

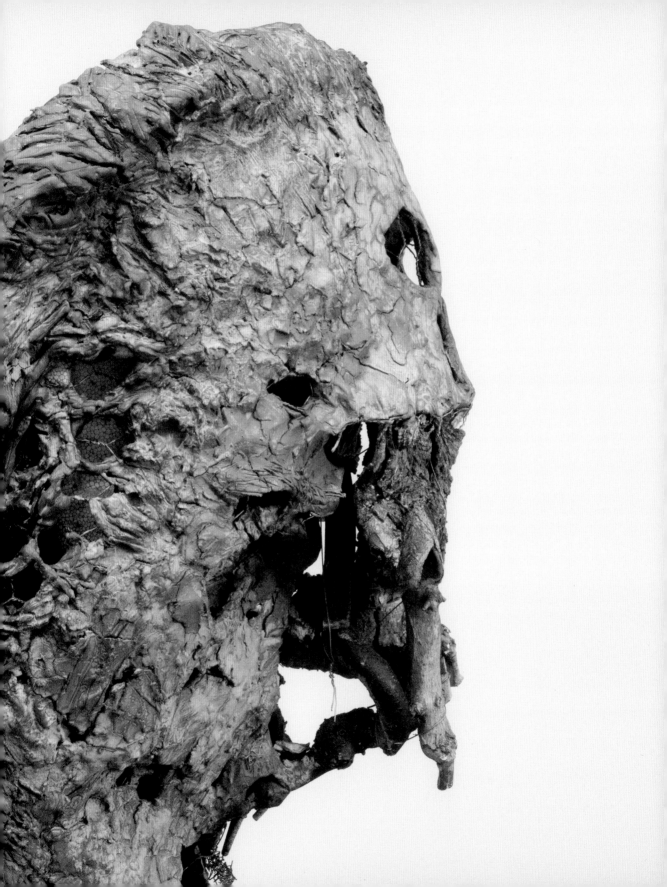

Josh Brand's photographic images often bear the characteristics of abstract painting—layering saturated colors and geometric patterns to amplify optical effects or paring back a composition until nothing but the fade of erasure and rudimentary mark-making remains. Frequently working in the darkroom without film, Brand employs everyday objects and semitransparent materials to partially occlude brief exposures of light onto sensitized paper in building up the depth, shape, and surface impression of his compositions. An expert understanding of color ratios and generational printing techniques further contributes to Brand's use of the photogram, as receding planes frequently alternate with incisive lines in evoking architectural and engineering motifs reminiscent of László Moholy-Nagy and El Lissitzky, while more organic forms and shapes recall the collages and canvases of Hans Arp, Lucio Fontana, and Ellsworth Kelly, among others.

Providing contrast to this improvised yet highly formal approach are fragmentary images culled from Brand's daily life, including photographs of an ongoing collection of artifacts and mementos that occasionally appear abstracted into the layers of his darkroom images. These negative-based images reflect Brand's commitment to photography as a way of perceiving and signifying the everyday alongside the ethereal. Extending to outtakes from ongoing relationships with people and objects in partially recognizable contexts, recent images include a portrait of a friend reclining with his arms covering his face, elbows pointed toward the camera in awkward acknowledgment. Another recent image, *Bed* (2009), shows the intimacy and close proximity between Brand's domestic life and studio practice, between living space and the space of composition; in the frame a diffuse fragment of amber light from the street outside his apartment reflects through a curtain along the wall of a dimly illuminated room, delineating the subtle yet shifting boundary that exists between the artist's own bedroom and makeshift studio, between the oneiric and the habitual, the subconscious and the act of making. Referring as it does to Robert Rauschenberg's Combine *Bed* (1955), Brand's abstracted image of the quotidian serves as an indirect self-portrait—occupying the narrow gap between art and life. FM

Black Monochrome (White and Black), 2008 / Chromogenic print with cuts, 12 × 10 in. (30.5 × 25.4 cm) / Unique / Private collection

2010

According to one of its numerous mission statements, the Bruce High Quality Foundation exists to preserve the legacy of the late "social sculptor" Bruce High Quality. Operating under the principle of permanent retrospection, the group has staged a series of prescient interventions that merge the cutting irony of a prank with a sincere regard for the critical potential of cultural production. The Foundation's conceits, however elaborate or absurd, consistently reveal the underlying logic—or illogic—that defines the art world.

Described by one critic as "walking bullshit detectors," the Foundation recognized in the giddy heights of the past decade's art market unlimited opportunities to excel in that capacity. Some of its early projects targeted the manic tone of commercial art fairs and the routine excesses of public sculpture. With a pitch-perfect balance of pop cultural references and knowing allusions to the history of art, the Foundation has emerged as one of the most cogent commentators on an art world still coming to terms with economic collapse. Its site-specific zombie movie *Isle of the Dead* (2009), produced for an abandoned cinema on a former Coast Guard base in New York Harbor, recasts the city's once-thriving arts community as legions of the undead.

More than simple laments about market fluctuations, the Foundation's projects openly grapple with the possibility of challenging institutions at a time when every art school teaches "institutional critique." Its most recent works engage that historical movement—and its attendant process of historicization—by questioning the role of pedagogy in the arts. A series of lectures on the professionalization of artists culminated in the founding of the Bruce High Quality Foundation University, an amateur enterprise that explores alternatives to the credentialed hierarchies of graduate school. The Foundation's "portable installations"—sculptures and environments that double as resource centers with texts, videos, and lectures— also attempt to initiate a process of informal learning and teaching. Recalling the work of Joseph Beuys, the other great "social sculptor" of the twentieth century, the Bruce High Quality Foundation aims to "enact art's potential to educate and education's potential to art." WS

Las Meninas, 2008 / Chromogenic print, 60 × 48 ½ in. (152 x 123.2 cm) / Collection of the artists

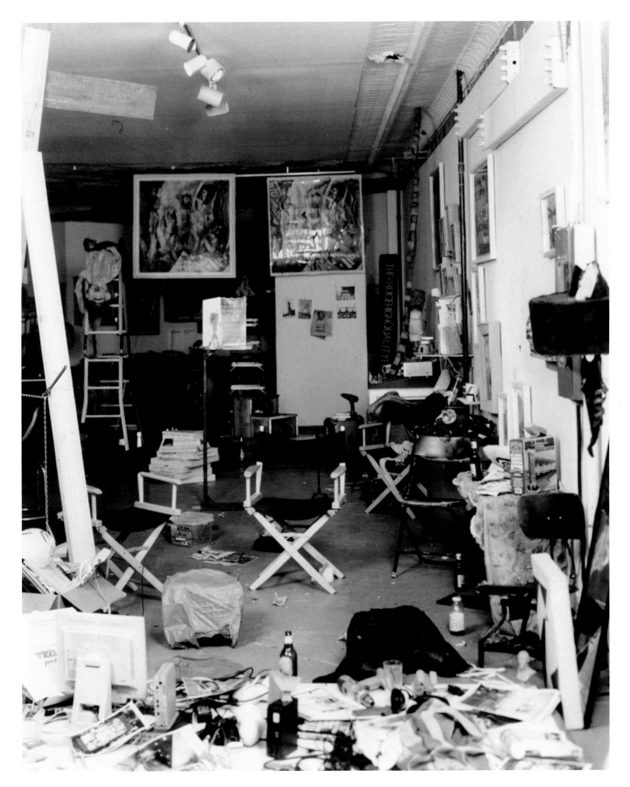

33

Since the 1980s, James Casebere's photographs have transported viewers into architectural environments at once ambiguous, evocative, and surreal. Informed by an interest in architecture, Conceptual art, painting, and film, Casebere shares sensibilities with other photographers of his generation, including Cindy Sherman and Laurie Simmons, who stage still images to suggest a narrative and explore the medium's capacity for sleight-of-hand.

To create his images, Casebere constructs tabletop models out of modest materials, including Styrofoam, plaster, and cardboard. He sources his subjects from diverse actual structures, ranging from the mundane to the iconic and encompassing schoolhouses, prisons, the Berlin sewage system, and Thomas Jefferson's Monticello. In his studio, the artist adds dramatic lighting to his models and carefully positions the camera to manipulate composition and mood. Devoid of human figures, the constructions invite the viewer to project into and inhabit the space.

His early works, executed in black and white, are of austere and simplified architectural forms. Throughout his career, Casebere's prints have become increasingly larger and his models more complex. For *Landscape with Houses (Dutchess County, NY)* (2009), Casebere has constructed his grandest, most detailed sculptural installation to date. Returning to the subject of residential areas he previously explored in *Subdivision with Spotlight* (1982) and *Tripoli* (2007), Casebere presents a model of an American suburb. This fabricated community is a hybridized pastiche, reflecting the patchwork sensibility of the developer-as-designer as realized in a multitude of communities across the United States, many of which have been hard-hit in the recent epidemic of foreclosures. *Landscape with Houses (Dutchess County, NY)* is printed large-scale and in wide format, mimicking the ratio of height to width that is used in standard 35mm motion-picture film. Expanding upon the exploration of his earlier work, Casebere probes the relationship between artifice and representation, illusion and fantasy, compelling the viewer to suspend judgment, engage the imagination, and perceive the drama inhabiting these seemingly deserted spaces. MN

View of studio, 2009

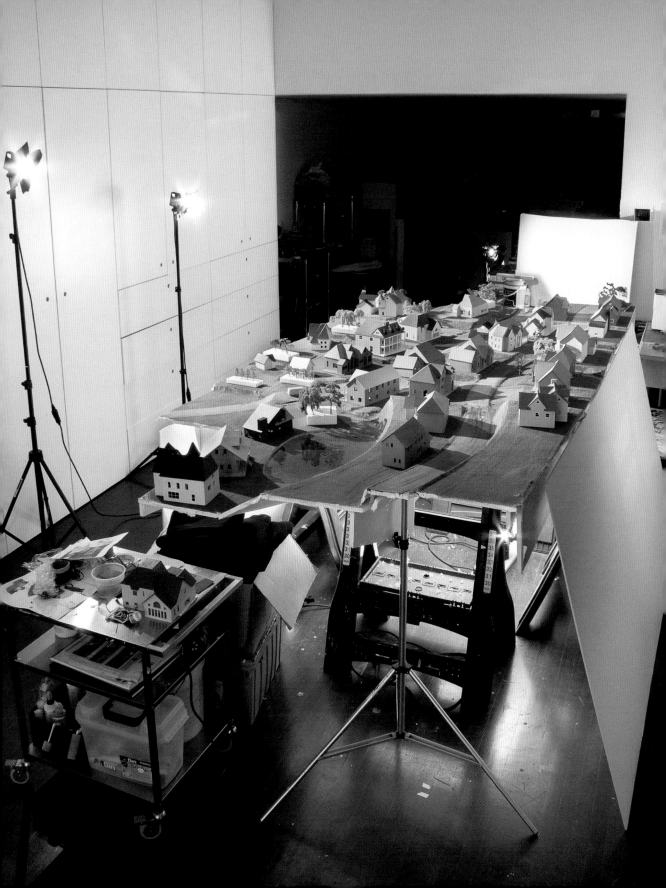

Edgar Cleijne and Ellen Gallagher

1963 Cleijne born in Eindhoven, The Netherlands
1965 Gallagher born in Providence, Rhode Island

Edgar Cleijne and Ellen Gallagher's immersive film environments present worlds of shifting signs and narratives. Their recent collaboration *Osedax* (2009) debuted in the exhibition *Moby Dick* (Wattis Institute for Contemporary Arts, California College of the Arts, San Francisco, 2009). Based on whale fall, the scientific term for dead whales that have fallen to the ocean floor and are consumed by scavengers, it includes a synced projection of painted glass slides and a 16mm film combining the artists' footage of Cameroon, Madagascar, and the New England coast. Using 3D animation, Cleijne and Gallagher wove their own drawings into these watery passages. The dark walls of the projection room are milled with abstract markings that recall Queequeg's engraved coffin, Polynesian reed mapping, and the scars that mar the whale's skin, foregrounding the fluidity and cryptic nature of symbolic systems that have become indecipherable through obsolescence or amnesia.

BETTER DIMENSION (2010), a totemlike film installation that is walled in on four sides by sliding panels, features graphic newsprint images. A projected central image—a head rotating over a vinyl LP and coral branches—floats above four synced projections of painted glass slides directed into the corners of the space. The reticulated lines and pools of ink caught within the glass slides hover between abstraction and specimen as the forms migrate across the planes of the room, magnified to cartoonish proportions. To enter the work, viewers interrupt the projections by sliding a panel out of place.

The texts and graphics on these panels are partly based on the polemical broadsheets and pamphlets of the American Illusionists Black Herman and Sun Ra. Famous in the 1920s and early 1930s for his "buried alive" act, Black Herman (who was influenced by Marcus Garvey) claimed he learned magic as a child in a Zulu tribe in Africa. Jazz musician Sun Ra, highly aware of the legacy of Black Herman, brought a theatrical magic to his concerts from the 1950s to the 1990s, enacting an interstellar origin myth that played out in "cosmic dramas" based on "cosmic newspapers." Like Sun Ra, whose music destabilized an origin myth to create the possibility of a new form, *BETTER DIMENSION* investigates the possibility of an abstract form approached through a composition of destabilized figurative elements, resulting in a visual poem, a graphic burial. DK

BETTER DIMENSION, 2010 (detail of ink and tape on glass slide) / Slide projections, 16mm film projection, and silkscreened panels, 106 × 252 × 268 in. (270 × 640 × 680 cm) / Collection of the artists

2010 Cleijne and Gallagher live in Rotterdam, The Netherlands, and New York, New York

37

Dawn Clements's painstakingly rendered large-scale drawings explore interior, often domestic, spaces—both her own and those imagined by Hollywood. Working largely from her surroundings and from time-based media, with a particular interest in the places that women occupy, Clements reconstructs spaces of melodrama as they unfold and are deployed in movies or soap operas. Her interest in these sites, Clements explains, lies in their contradictory nature: "They are the places, no matter how beautiful and wonderful they may appear, that incarcerate the characters. The doors may be unlocked, but somehow no one can walk out the door." Noticeably absent are the characters that inhabit these spaces. In omitting the figure, the artist has allowed the interiors to drive narrative—and to become active forces.

Clements draws directly from, and is conscientiously faithful to, the images on the screen or objects in her house or studio, never inventing elements to complete a picture. The drawings evolve as she works and reveal the process of their making: adding, subtracting, and folding. Notes that mark the time code of the corresponding scene or make reference to the sounds of the studio—for example, radio broadcasts and phone conversations—dot the margins, serving as a soundtrack to Clements's filmic spaces.

Clements's drawing *Mrs. Jessica Drummond's ("My Reputation," 1945)* (2010) depicts the bedroom of the main character in the film *My Reputation*, rendered in ballpoint pen. In a departure from her previous work of interiors, Clements includes the character in her environment, depicting Jessica Drummond (played by Barbara Stanwyck in the film) lying awake in bed, her face partially obscured by the dark, on what we learn is the day after her husband's funeral. The drawing (and the viewer's eye) follows the camera's pan across the room, shifting in scale as it moves from a sitting area to a close-up of Drummond's face. A composite of several scenes, the drawing reveals the room at different moments and from different camera angles in a flattening of space and time that appears seamless but uncannily distorted. The result is a work that allows the viewer to inhabit and explore the physical and psychic space of melodrama and is also a place where artist, viewer, and subject can meet in the middle. NC

Mrs. Jessica Drummond's ("My Reputation," 1945), 2010 (detail) / Pen with ink on paper, 87 ½ × 240 in. (222.3 × 609.6 cm) / Collection of the artist

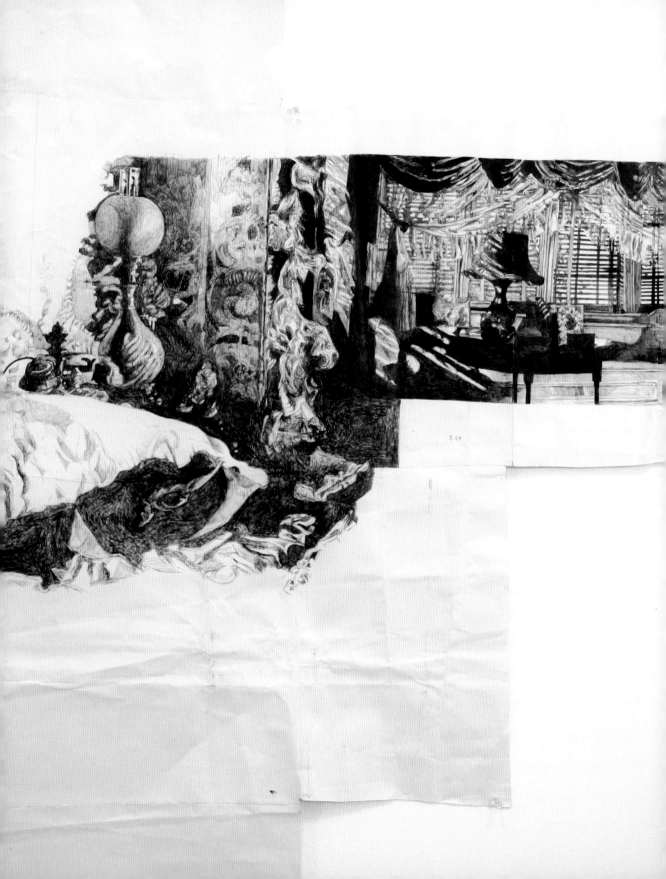

George Condo emerged on the New York art scene in the early 1980s with a style of art making he dubbed "Artificial Realism," defined as "the realistic representation of that which is artificial." Appropriating a variety of traditional techniques from his art historical forebearers, Condo fabricates fanciful beings and absurd juxtapositions that reveal the inner recesses of the imagination. His hauntingly bizarre, grotesque, and comical paintings and sculptures draw from a heterogeneous visual vocabulary, melding imagery from Old Masters and Modernists with cartoons and other icons of contemporary pop culture, in order to synthesize the divide between high and low, figurative and abstract, repulsion and seduction.

For *The Butcher and His Wife* (2008–09), Condo depicts one of his recurring characters, the "Butcher," here apparently surprised during an act of lovemaking. The bodies of the figures are abstracted into a tangle of limbs reminiscent of a Baroque sculpture and are crudely rendered in irregularly textured bronze, resembling the active surface of an Alberto Giacometti sculpture. Both figures look out in shock, returning the gaze of the viewer as if distressed by this interruption of their private moment. The face of the "Wife" is portrayed with her schizophrenic qualities revealed simultaneously, as one side projects an aggressive stare and primal scream, while the other side passively fades into the mass of mudlike bronze. The Butcher's head is pierced with a meat cleaver, alluding to his societal role. With this violent image, Condo also references the religious iconography of the cleaver or knife, attributes of the martyrdom of Saint Peter of Verona, and suggests the faith and transcendent love of the saintly, while at the same time evoking the carnality and vulnerability of the merely mortal.

As with his oil paintings, for which he is best known, Condo employs a traditional high-art context and medium for this work—a bronze sculpture atop a pedestal—to summon up an amalgam of often-contradictory themes. His prodigious visual lexicon, scrambled and rearranged as in this and other compositions, exposes the clash between the heroic and the mundane, the respectful and the voyeuristic, and the frenetic and the dispassionate, thus highlighting the ambiguity and absurdity within our contemporary environment. MN

The Butcher and His Wife, 2008–09 / Bronze, 43 × 48 × 85 in. (109.2 × 121.9 × 215.9 cm) / Collection of the artist

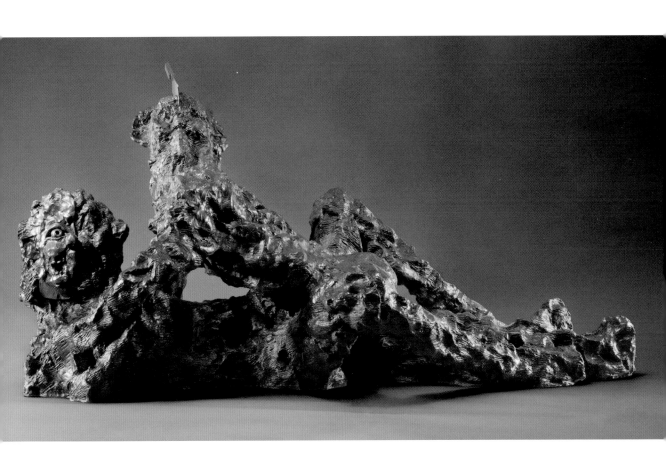

Sarah Crowner confronts the history of abstract painting and sculpture with the often-marginalized traditions of decorative and applied arts. Her sewn, painted canvases; rough-hewn ceramic vessels; and mosaic tiles not only question the privileged space of the fine arts, but also function as critical interventions within it.

In some of her recent work, Crowner assembles angular pieces of painted canvas and unpainted linen using a sewing machine. The geometric compositions and unmodulated passages of color evoke Hard-Edge paintings of the 1950s and 1960s, and in some cases Crowner appropriates specific compositions of that era as "templates." However, the visible seams that result from Crowner's process interrupt the slick surfaces of those works. "The 'hard edges' are now sewn," Crowner writes, "exposing the stitch of the thread." The act of sewing, with connotations of domestic labor, deflates high Modernism's rhetoric of transcendent opticality by evoking the tactility of a quilt.

By using new materials to reconstitute the artistic legacies she describes as the "ghosts of art history," Crowner foregrounds the aesthetic heterogeneity latent within abstract paintings of the 1950s. Her canvases engage the psychologically complex practice of Brazilian artist Lygia Clark, and the obliquely mystical "open form" works by the Swedish painter Olle Baertling, more than they do the macho aloofness of the American paintings that all too frequently serve as an emblem of that period.

Crowner's investigation into what she calls "the dialectic between Modernism and various practices of craft" extends to ceramics. Her unglazed vessels and mosaic tiles reference episodes in twentieth-century art when the experimental impulses of painting and sculpture could not be separated from concurrent developments in the decorative arts. Beatrice Wood, a key figure in the New York Dada scene and a pioneering ceramicist, looms large in Crowner's practice and was the inspiration for her series, *Handbuilt Vessels* (2008). Like Wood, Crowner balances a self-conscious negotiation of "fine" art with the rich tradition of the handmade. ws

Superficie Modulada 1956 [Part 1], 2009 / Gouache on sewn canvas, 58 × 36 in. (147.3 × 91.4 cm) / Private collection

2010

Verne Dawson is a student of human history, a prophet of strange and fantastic futures, and, perhaps above all else, a dedicated storyteller. The artist's paintings are marked by an unconventional, even unlikely, elegance that is both nostalgic and unnerving. Dawson is attempting to cast light on the continuity between ancient culture and contemporary life by uncovering the mythology, folklore, and traditions that have been lost, or disconnected from their origins and meanings. Or as he puts it, "I am simply passing down information."

Dawson takes a long view of history. Looking for an appropriate reference for the titular rhinoceros in *Boy and Wooly Rhinoceros* (1999), the artist chose to copy a Stone Age painting from roughly 10,000 BCE to gain "first-hand anatomical information about an extinct creature. I was getting very specific information from an artist—a colleague—across a chasm of 12,000 years." Such an insistent focus on prehistory is radical in its anachronism, but time in a Dawson painting is not only long, it is cyclical and multivalent, collapsing and conflating past, present, and future.

Concerned that we have lost our connection to nature's rhythms that governed our ancestors' lives, Dawson is interested in stories related to natural phenomena. A series of three paintings from 2009 depicting the biblical story of Jonah and the whale, which Dawson believes is a metaphorical description of the moon moving into the constellation Cetus (Latin for "whale") during a solar eclipse, demonstrates the intersections between nature, popular culture, religion, and astronomy. The artist portrays Jonah as a Christ-like figure and the interior of the whale as a gently glowing cathedral pierced by Cetus, and notes, "In both Christ's entombment and Jonah's three days in the whale's belly, or in hundreds of other folk tales and myths that refer to three days of darkness, all are alluding to the three days of a new moon, which is also the only time a far rarer solar eclipse can occur." In reinterpreting such stories, the artist highlights the need for a more balanced relationship with nature and technology in contemporary society. NC

Jonah and the Whale (in the Whale), 2009 / Oil on canvas, 108 × 100 in. (274.3 × 254 cm) / Collection of the artist

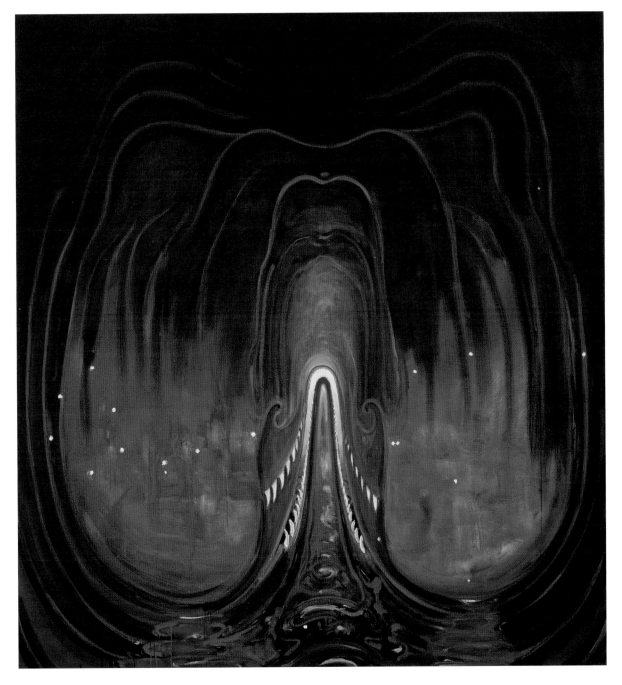

45

Although the layered, geometric forms of Julia Fish's paintings bear some resemblance to the mystifying plastic forms found in a De Stijl painting, Fish's work is representative, mostly specific to, or subjectively derived from, a given source in the artist's immediate surroundings. The subtle tension between the clearly defined shapes and the pale receding grounds of Fish's minimal and coloristically rigid compositions is analogous to the balance between ideas of abstraction and representation inherent in her work.

Fish has spent more than twenty years contemplating aspects of the private space of her home, garden, and studio. Operating under a reductive schema, her work examines interstitial moments that address patterns of human experience. Fish's work is reminiscent of Gordon Matta-Clark's archiving and photographing of the space—cracks, corners, and crevices—between the buildings and sidewalks of New York in his unrealized project of the early 1970s *Fake Estates*. Like Matta-Clark, yet on a more personal scale, Fish invites disorientation across her suites of architectural elevations, plans, and sections, as in her in-process set of six "threshold" paintings. In addition to representing the transitional crossover space between rooms in her home through layers of near-gray, Fish incorporates one of the three primary or the three secondary colors into each painting—this investigation informed by the image of light translated as spectrum is evident in her 2009 canvas *Lumine II, Northwest [Parhelion]*. Fish incorporates one of the three primary or the three secondary colors into each painting. Delineated white-gray areas result in a sort of topography— a map of a fragment of the threshold— which emerges from a foundation of color.

Obeying a symbolic language Fish has engineered, all of these works embody a mathematical precision: the measurements link to the specific dimensions of the rooms and spaces that they represent and from which they emerge. Yet despite the rigor of her pictorial vocabulary, ordinary subjects turn enigmatic. Fish writes, "I want the painted object to stretch the meaning of a given subject, to rearrange its visual syntax into another form of knowing, and to engage the larger history of images that have preceded it." Fish invites us to infiltrate the space between, to question its contours, and ultimately to fill its void with our own archetypes and allusions. TK

Lumine II, Northwest [Parhelion], 2009 / Oil on canvas, 38 × 43 in. (96.5 × 109.2 cm) / Collection of the artist

2010

Roland Flexner navigates between a Conceptualist's interrogation of medium and a traditionalist's devotion to artistry by expanding upon and distilling the fundamental characteristics of drawing. Although Flexner's drawings are often simply ink on paper, he uses an almost sculptural method to coax images out of air, space, and water, using his breath, chance, and gravity as tools. Flexner has been creating intricately detailed "bubble drawings" since the mid-1990s by blowing a mix of soapy water and ink through a hollow paintbrush. Using a breath or an utterance, he expands the bubble and lays it on paper at the moment a desired effect has been achieved. During a residency in Kyoto in 2004, he became proficient with another technique utilizing ink and water: the art of suminagashi (ink floating), in which a marbled effect is achieved by placing paper on ink floating on water or gelatin and blowing on it. Flexner manipulates the floating ink before laying paper on top of it. However, once the ink starts to get absorbed, the artist has only a moment to alter the composition with tilting, blowing, or blotting. With a meditative understanding of the media, he is able to affect pictorial spaces that oscillate between illusionistic landscapes and pure abstraction.

Both series reference Flexner's interest in two seventeenth-century European traditions. The bubble drawings relate to his investigation into vanitas paintings—Dutch still lifes in which a group of objects such as skulls, extinguished candles, timepieces, and bubbles convey the fleeting nature of life. By exploiting the ephemeral nature of the bubble, Flexner replaces the metaphor of the vanitas paintings with a physical process. His sumi drawings also recall the popular seventeenth-century practice of collecting and displaying geological samples selected for their resemblance to landscape or figurative images. The collections were inspired by similar practices in Asian cultures in which contemplating these stones was meant to inspire meditation on nature's transformations. In both cases, Flexner is more interested in creating a space for the viewer's shifting mental projections than in asserting any single fixed interpretation. DK

Untitled, 2009 / Sumi ink on paper, 5 ½ × 7 in. (14 × 17.8 cm) / Collection of the artist

For the past four decades Suzan Frecon has cultivated a practice, grounded in a reverence for the materials and methods of painting, that is both intuitive and rational, sensual and analytical. Frecon builds her paintings in a process that begins with the dimensions of the stretched canvas and the color and reflective or matte quality of oil paint. These physical elements serve as the mainspring for abstract compositions in which the interplay of a painting's tension resolves into a whole that is completed by the viewer's experience of the work.

Frecon often works out the precise imagery of her paintings in sketches, using mathematical formulas and visual intuition to create related forms in which dissonant and consonant features are held in balanced suspension. These sketches are often executed with colors already in mind; Frecon considers color the driving force behind the painting. Grinding and mixing oil paints to the desired hue and luminosity, she builds up layers of paint through brushing, rubbing, sanding, and reworking. Resulting differences in surface texture give complex dimensionality to flat planes of color and lead to subtle perceptual shifts depending on the light.

In recent years, Frecon has used large-scale, two-panel paintings for her compositions. In the nine-foot-high work *embodiment of red, version 1* (2007), the forms are delineated in hues of earth reds, colors Frecon favors. Differences in tones and luster define two heaving shapes that seem to dissolve into the background even as their materiality is asserted by strong contours. Each panel depicts a figure-ground relationship derived from the canvas size: in the top panel, the rounded form's width is identical to the panel's height, while the curved form of the bottom panel connects the corners of the panel.

Frecon's abstract forms may invite associative leaps to architectural or art historical references—she has cited her interest in varied art historical sources such as the Chartres Cathedral, Minoan labyrinths, Byzantine painting, and Pomo baskets—but ultimately, the works remain non-referential. For Frecon, the evocative quality of her work illustrates the transcendence of balanced form in the visual arts and natural world. DK

embodiment of red (soforouge), 2009 / Oil on linen, two panels: 54 × 87 ½ × 1 ½ in. (137.2 × 222.3 × 3.8 cm) each, 108 × 87 ½ × 1 ½ in. (274.3 × 222.3 × 3.8 cm) overall / Collection of the artist

2010

Maureen Gallace paints intimately sized, lyrical landscapes of serene, unpeopled houses and isolated beaches. Deceptively effortless in their appearance, Gallace's paintings take shape through careful observation, decisive omission, and rigorous attention to brushstroke, composition, and color. Her reductive meditations on the American countryside are at once peaceful and mysterious, desolate and lush, minimal and evocative.

For almost twenty years Gallace has found her muse in the modest edifices and rural environs of her native New England. For Gallace, "the architecture where you grow up is so much a part of your memory." She describes her process as "working backward" to come to her streamlined representations, adding that "most of it comes down to staring and breaking things down to what I consider to be essential." In *Cape Cod, Early September* (2008), a white, boxlike cottage rests at the center of the composition, surrounded by bright hues of thriving greenery and luminous pale sky. Light-infused areas of color are rendered in visible brushstrokes, which are achieved by using wet-on-wet layers of oil paint on panel. This technique flattens the perspective and creates an eerie illusion of the house floating atop the ocean's horizon line. With descriptive details such as windows and door absent from the scene, the viewer may attach his or her own associations to the image and grasp what Gallace refers to as the "essence of a place." The artist applies this strategy of nonspecific pictorial distillation to many of her paintings. Viewed together, her body of work conveys a genealogy of topography, season, and mood.

Gallace's oeuvre bears a strong relationship to early American Modernist painting, particularly the evocations of small-town isolation by Edward Hopper and the abstracted seascapes of Milton Avery, with their flat expanses of color. However, Gallace's work exists outside art historical time lines. Anomalous in the context of contemporary art-making trends, her technically sophisticated, poetic, and ethereal paintings exist in a quietly powerful category of their own. MN

Cape Cod, Early September, 2008 / Oil on panel, 12 × 12 in. (30.5 × 30.5 cm) / Collection of the artist

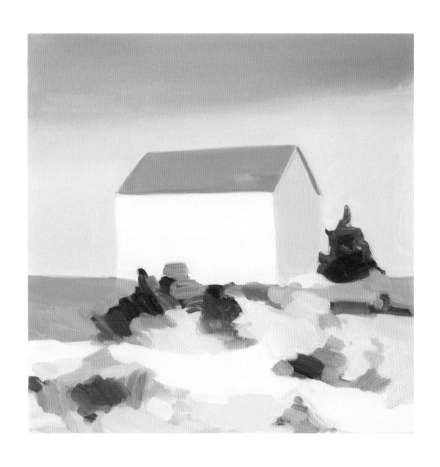

Theaster Gates's site-specific architectural installations function as spaces for convergence through community get-togethers and happenings. A sculptor, urban planner, and performer, Gates blurs vocational boundaries, using the resources at his disposal to create environments for diverse cultural practices to share the stage.

Raised in Chicago and rural Mississippi, Gates first traveled to Japan to study ceramic sculpture in 2001. His artistic practice is strongly informed by the junction of his culturally rich yet humble upbringing with his later immersion in Eastern philosophical and artistic traditions. *Plate Convergence* (2007) merges these disparate cultural influences with an artist-hosted dinner for a selection of people from a variety of backgrounds. The sushi and soul food fusion meal was presented on Japanese-inspired plank-shaped, wood-fired "plates" Gates fashioned specifically for the occasion. Treating the dinner table as a sacred space and as a platform for critical social engagement, the artist set the stage for discussion, focusing on urban tensions in areas like the South Side of Chicago, where race and class issues are prevalent.

For his latest and most ambitious project to date, *Temple Exercises* (2009), Gates, influenced by black storefront churches and Japanese Buddhist philosophy, created a templelike structure in a gallery at the Museum of Contemporary Art, Chicago. His edifice is constructed of modular ware boards sourced from the defunct Wrigley gum factory in inner-city Chicago and fastidiously cleaned by Gates to effect their transformation into the walls of his sacred space. Like the Rothko Chapel in Houston or Henri Matisse's Chapel of the Rosary in Vence, France, *Temple Exercises* explores the connection between art making and settings for spiritual practice. However, Gates went a step further by activating the space with performances by groups such as the Black Monks of Mississippi (a group he formed that combines African American spirituals and gospel with Asian monastic chants). A wide array of programming accompanied this exhibition in venues throughout Chicago's diverse neighborhoods, among them a dance club, an alternative arts center, and a shoeshine parlor.

Gates functions as orchestrator and alchemist by connecting arts institutions and the streets, offering bracing cultural juxtapositions, and elevating secular urban rituals to the sublime. MN

Tea Shack, 2009 / Found wood, 16 × 24 × 14 ft. (4.8 × 7.3 × 4.3 m) / Collection of the artist

Armed with her signature high heels, sheer muscle power, and desperate determination, Kate Gilmore is the sole protagonist in her performative videos, as she kicks, flails, strikes, hurls, and (sometimes) breaks through self-constructed obstacles. With metaphoric depth and formal sophistication, Gilmore's videos explore issues of displacement, struggle, and identity as a modern woman.

Straightforwardly shot in one take, Gilmore's videos are primarily concerned with the process of undertaking Sisyphean tasks rather than with the end results. Thus, goals are sometimes achieved, sometimes abandoned, and sometimes ultimately just beyond the artist's grasp. Designed for a night on the town, Gilmore's attire is at odds with the brute physical labor she performs. Wearing incongruous high-heeled pumps and cocktail dresses, she smashes through drywall in *Walk This Way* (2008), pounds on wood and cinder blocks with a sledgehammer in *Down the House* (2008), and heavy-lifts bails of hay in *Blue Ribbon* (2008). Working through these limitations, she grunts, perspires, and sighs, sometimes falls down or drops a shoe as in *Higher Horse* (2008), and then carries on intrepidly.

Careful attention is always paid in her videos to chromatic and textural harmony and symbolism. In *Down the House* (2008), she uses a bright pink plastic ribbon to tie together heaps of furniture and cinder blocks as well as her ponytail. The neon pink color provides a vibrant counterpoint to the neutral brown wood, stark white cinder blocks, and shiny yellow fabric of her dress. The pink ribbon, here used for the utilitarian purpose of binding things together, is also symbolic of femininity, a stereotype Gilmore exploits in this video and in the aptly titled *Every Girl Loves Pink* (2006). In the latter work, a narrow corridor tightly filled with pink packing paper provides the artist with her physical obstacle, from which Gilmore (in a pretty pink party dress) strives to break free.

Gilmore's work emerges from a history of body- and endurance-challenging video and performance art of the 1960s and 1970s, such as works by Marina Abramovic, Vito Acconci, Valie Export, and Bruce Nauman. With a decisively contemporary approach and aesthetic, Gilmore's tragicomic videos posit physical situations as metaphors for the inner conflicts and social obstacles we encounter today. MN

Walk This Way, 2008 / Inkjet print, dimensions variable / Collection of the artist

The shabby, low-lit interior of Hannah Greely's *Dual* (2005–09) underscores our recognition of it as a fragment of a bar, a place to drink and possibly carouse slouched in worn seats. As the title suggests, there are two sides to this work in which the halves are separated by a mirrored partition. Greely's earlier work focused on the singular object, including a dirt-encrusted empty beer bottle (*Doug*, 2004), a frail stepladder made of newsprint (*Assembly*, 2001), and an outdoor sculpture of a forlorn man serving as a birdfeeder (*Remainder*, 2002–06). Greely meticulously creates her work with an assortment of materials used for casting: bronze, plasticine, papier-mâché, resin, and cast urethane rubber. By incorporating the melancholy of a tableau by Edward Kienholz with the witty charm of a replica by Charles Ray—one of Greely's former teachers—the artist weds the influences of her West Coast sculptural predecessors.

In *Dual* Greely juxtaposes two sides of the same scene to draw attention to the idea of replication. The seeming resemblance of the two sides expounds on their differences: the chip in one of the wood-grain Formica tables and the stain on its surface, cracks in the vinyl seats, the fading of the lampshades. These distinctions raise additional questions about originals versus copies. Yet the different details—conceived and painstakingly crafted by Greely—also mark the passage of time. The near obsolescence of this typical American bar seat is further exhumed by the surreal rendition of a single payphone on the back of *Dual*, an obvious nod to a time before cell phones. "When an object is no longer useful in an obvious way, it becomes something closer to art," Greely has said about her work in general. Whether *Dual* embodies the triumph of progress or memorializes a hapless past, Greely, in the interest of offering timelessness to her chosen subjects, rebuffs any attempt at reconciling this divide. Instead, she elicits just enough banal absurdity in her allusions to question the very basis of this distinction. TK

Dual, 2005–09 / Mixed media, 68 × 91 × 50 in. (172.7 × 231.1 × 127 cm) / Collection of the artist

59

Jesse Aron Green's recent work investigates the historical dynamics of gender, sexuality, social authority, and violence, with reference to the forms and strategies of late twentieth-century art. As part of his research-based practice, Green produces video installations that enact anxieties about the regulation of embodied experience.

Ärtzliche Zimmergymnastik (Medicalized Indoor Gymnastics, 2008) takes its title from Green's object of study: an 1858 book by the German physician Daniel Gottlob Moritz Schreber. Over the course of the video, sixteen male performers execute forty-five gymnastic exercises precisely as Schreber codified them. A specially built camera system enabled Green to capture the performance in a single 360-degree tracking shot that coincides with the video's eighty-minute duration.

By activating Schreber's text as a "score," Green situates a seemingly innocuous series of movements within a social history of psychoanalysis and a narrative of family crisis. Reprinted multiple times until the 1920s, Schreber's directives for maintaining the "health and vigor of body and mind," which included sexual restrictions, proved influential amidst the cultural malaise of fin de siècle Germany. The bodily discipline that Schreber publicly prescribed, however, may have had consequences for his own son, Daniel Paul Schreber, whose autobiographical account of psychosis, *Denkwürdigkeiten eines Nervenkranken* (Memoirs of My Nervous Illness, 1903), became a central document in psychoanalytic literature on paranoia, sexuality, and paternal authority. Green's video

and a group of related sculptural and photographic works question the relationship between Schreber's physical regime and his son's trauma, which many scholars have understood to anticipate the psychological mechanisms characteristic of Modernism's most authoritarian tendencies, fascism and totalitarianism.

As much as it engages the fraught lineage of Schreber's *Ärtzliche Zimmergymnastik*, Green's work confronts the dominant history of contemporary art. Through the serial arrangement of performers on low wooden plinths and the extended duration of his shot, Green quotes from the vocabularies of Minimalism, Conceptual art, and Structural film. While the work inevitably suggests resonances between these aesthetic strategies and Schreber's system, the historical underpinnings and rigorous execution of Green's project also demonstrate how inherited artistic procedures can be reconfigured as sites for critical thought. ws

Still from *Ärztliche Zimmergymnastik*, 2008 / High-definition video projection, color, sound; 80 min. loop / Collection of the artist

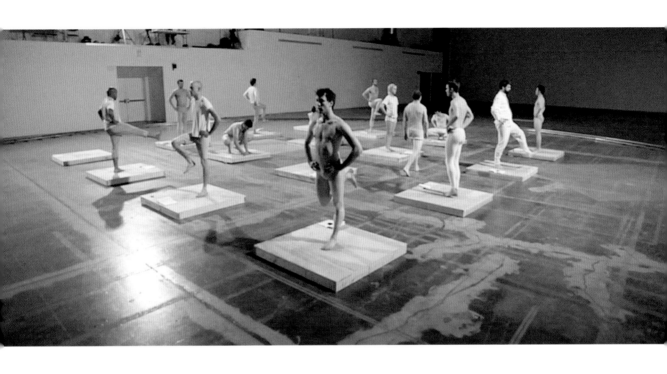

For more than five decades, Robert Grosvenor has produced a heterogeneous body of work that is united by his ability to create powerful compositions with simple and abstract sculptural gestures. When questioned about the disparate nature of the phases of his work, Grosvenor insists on its continuity: "the horizon reappears, the levels reappear, a distance reappears."

A carefully articulated sense of place runs through Grosvenor's work, from the architecturally scaled, cantilevered structures of the 1960s in which sizes were determined by the space between ceiling and floor; to the fractured wooden beams of the 1970s that were occasionally set in landscapes; the multielement works made out of industrial building materials he began creating in the 1980s. In each case the sculptures, tailored to their display site, relate formally and conceptually to architecture and landscape. It is this site-specificity, along with an emphasis on visual impact over critical theory, that set Grosvenor apart from his contemporaries in the 1966 exhibition *Primary Structures* (The Jewish Museum, New York), which identified him with Minimalism. His work since the 1980s has further distanced him from this association due to the invocation of postmodern stylistic pastiche defined by the architect Robert Venturi as generative of "messy vitality."

In the mid-1990s Grosvenor shifted from using materials evocative of urban detritus to those of a more suburban vernacular, incorporating lawn ornaments or flagstones into increasingly expansive arrangements.

These vaguely familiar forms are arranged in spare tableaux that maximize the disparity among the objects, pushing the viewer toward cascading associations that refuse to resolve into a single representational image.

Grosvenor's *Untitled* (2009) comprises a plane of hand-wrought aluminum and a bridgelike structure. As with all of Grosvenor's sculpture, the negative space within each element, as well as the space between the two, is unusually charged. The aluminum component does not function as a barrier but offers a visual permeability: it is an object that can be looked at or through. Grosvenor describes the sculpture as "two lines of poetry meeting, one in the foreground and one in the background." This tension between association and individuation of forms results in an abstract lyricism that is the crux of Grosvenor's work. DK

Untitled, 2009 / Two components: fiberglass and flocking component, 48 × 48 × 192 in. (121.9 × 121.9 × 487.7 cm); aluminum component, 48 × 312 × ½ in. (121.9 × 792.5 × 1.3 cm) / Collection of the artist

63

In performances, videos, and installations, Sharon Hayes interrogates the act of public speech. By appropriating the tools of public demonstrations, Hayes reconfigures the image of the protester in a manner that destabilizes the viewer's expectations and opens up the possibilities and challenges of reviving past models within a cynical present.

Hayes embraces the friction that results from what she terms "re-speaking" in her project *In the Near Future* (2005–09), a performance staged on the streets of London, New York, Vienna, Warsaw, Paris, and Brussels. Standing in sites historically associated with public protests, Hayes held up placards with texts either derived from past movements ("We condemn U.S. aggression in Vietnam," "I Am a Man") or invented ("Nothing will be as before"). The words acquire new resonances even as they are stripped of spatiotemporal specificity of meaning, but the image of a lone individual earnestly imploring the public to listen conveys an immediacy that transcends concrete politics.

In recent projects, Hayes weaves intimate speech into a public context as a means to further implicate the individual voice in the body politic. In *I March In The Parade Of Liberty, But As Long As I Love You I'm Not Free*, performed from December 2007 to January 2008 in New York, Hayes addresses an anonymous absent lover through a bullhorn, retelling the recent history of their love as it ebbed and flowed with the politics of the time in a plea for understanding and return. In *Revolutionary Love: I Am Your Worst Fear, I Am Your Best*

Fantasy (2008), performed at the Democratic National Convention in Denver and the Republican National Convention in Minneapolis and St. Paul, Hayes enlisted local volunteers from the LGBT community to create a chorus of voices reciting a similar appeal to a nameless lover. Punctuated with 1970s gay rights slogans, both texts describe an ambiguous longing that could apply to a government, the general public, a friend, or a lover. As with earlier projects, potency results not so much from the incongruity of dislocated modes of address but from the unexpected affinities that occur across history or between public and private discourse, which arise from pronouncements such as: "I refuse to give up the territory of my emotional expression. And I want you to love all of me." DK

Still from *Parole*, 2010 / High-definition video, color, sound / Collection of the artist

Thomas Houseago creates figurative sculptures that are at once physically imposing and emotively powerful in their scale and positioning yet purposefully disjointed and vulnerable in their construction. Houseago's roughly finished and fragmented creatures stand in pointed contrast to the macho and indestructible nature of traditional monumental sculpture.

To construct his figures, Houseago begins with a structure of iron rods and then adds materials ranging from California redwood to plaster, bronze, and hemp. Some of his works incorporate graphite or charcoal sketches of faces and anatomy on plaster and wood panels. Houseago's combination of three-dimensional plaster sculpting with two-dimensional wood panels and the addition of graphite drawing, as seen in *Half Wood Figure* (2008), challenges the conventionally imposed boundaries between three-dimensionality and flatness and between monumentality and spontaneity. The inner workings of his construction are also made apparent, as in *Untitled (Red Man)* (2008), a 13-foot-tall work consisting entirely of crudely executed bronze. This impressive figurative monolith is held together with no attempt to conceal its underpinnings—its fastening bolts are clearly visible, including one at the figure's left foot, which anchors the sculpture to the floor. The backside of *Untitled (Red Man)*, left hollow and seemingly unfinished, lays the inner workings of the artist's process bare, an attribute shared by many of Houseago's works.

For *Baby* (2009–10), a work similar to his 2009 *Big Baby*, Houseago has concocted a colossal quadruped, crafted with iron rebar, hemp, and drawings on nonporous boards, which are saturated liberally with fiber-strengthened plaster. This part-human, part-animal, ponderous yet buoyant, monstrous yet nonthreatening being is situated in a transitional pose between walking and crawling in a pounce-ready posture, weighted on flat expanses of plaster hands and feet. The figure is divided into three flat areas—legs, chest, and masklike head—that give the impression of depth. For Houseago, *Baby* represents a hopeful "beginning," with an affectionate nod toward the riddle the Sphinx posed to Oedipus: "What goes on four legs in the morning, on two legs at noon, and on three legs in the evening?" MN

Big Baby, 2009 / Tuf-Cal, hemp, iron rebar, wood, graphite, and charcoal, 58 × 84 × 40 in. (147.3 × 213.4 × 101.6 cm) / Collection of the artist

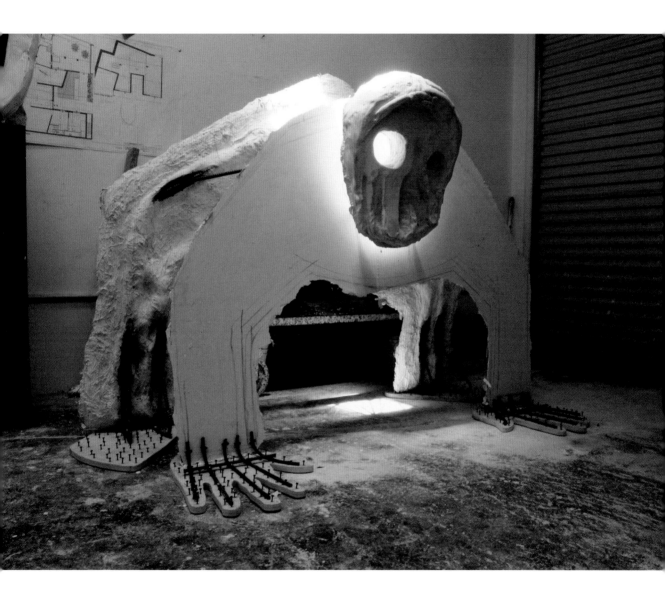

Alex Hubbard makes short videos that explore the complex pleasures of destruction. Operating just outside the of the camera frame, Hubbard spills, cuts, tears, drops, and burns a visually seductive litany of objects. Aleatory compositions, which he compares to paintings, continuously emerge from cluttered arrangements of flowers, paint, mylar, champagne, and other materials, before being swept aside as waste.

The Collapse of the Expanded Field (2007) establishes the terms of Hubbard's current practice. Shot from above, the flat, horizontal surface of a table collects detritus and functions as a kind of canvas, cleverly locating the piece in an aesthetic field that has been expanding the bounds of painting since the 1950s. Often exuberant, the video revels in the visual language of birthday parties, cooking shows, and vaudeville. Whether wrapping huge pink letters in cellophane or spray-painting the mutilated remains of a bouquet, Hubbard approaches each task with a purposefulness that shares much with Buster Keaton's brand of anarcho-comedy. The tightly edited video's restless progression of tableaux and its soundtrack of incongruous noises speak to an old-Hollywood reverence for well-timed sight gags and Foley sound effects. At the same time, Hubbard's myopic focus on making and unmaking recalls the process-based films of Richard Serra and Dennis Oppenheim.

In *Screens for Recalling the Blackout* (2009) Hubbard enlarges the scope of his activities to encompass the studio, which earlier works never fully reveal. Like the artist who continually dodges the camera, however, the space remains an elusive image of shifting walls and panels. Hubbard's videos seem to guard the traditional notion of the artists' studio as a sanctuary; the careless thrills of gutting pillows or misusing appliances may sour in the outside world. While deeply enmeshed in the historical claims of painting and sculpture, Hubbard also allows for proximity between the private world of artistic production and sites of more illicit doings, such as the methamphetamine laboratories he documented in 2005. Indeed, Hubbard's playful barrage of at-home vandalism always borders on becoming something more transgressive. WS

Still from *An Abbreviated Catalogue of Artistic Reference II*, 2009 / Video, color, sound; 9:45 min. / Collection of the artist

Jessica Jackson Hutchins explores the relationships between people and objects and the ability they have to form and inform each other. She transforms care-worn, everyday items (such as household furnishings and discarded toys) with ceramics, newspaper, papier-mâché, and fabric, rendering quotidian objects into sculptural works that probe the space between the banal and the sublime. As she investigates how self-awareness can be heightened through encounters with the items that are part of our daily surroundings, Hutchins gravitates toward objects and experiences from her own life to serve as the underpinnings for her work. The artist's recent sculptures have originated from pieces of furniture that have been readily available in her home. She says that this furniture-based sculpture comes out of an awareness of women's bodies: "bodies as food, bodies as domestic furniture, as support." Her use of ceramics contributes to this awareness by simultaneously invoking associations with everyday items as well as historical artifacts.

In *Couch For a Long Time* (2009) Hutchins completely covers a couch, inherited from her childhood living room, with every newspaper article she has encountered about Barack Obama. The couch seats five ceramic pieces: three are abstract and two are vessels. The vessels—a recurring form in Hutchins's work—relate to the artist's interest in regeneration through their metaphoric association with the female body and the transformative influence they enact as they are placed in a specific relationship to the couch and to each other. Although the three other ceramic pieces are not

necessarily emblematic of masculinity, as a collective whole, the five objects become anthropomorphized, imbued with a sense of humanity. The haphazard grouping of these ceramic objects on the couch makes them appear casually at home—like surrogates for the human presence that previously enjoyed its comforts. As a relic from Hutchins's past, the couch carries traces of its former life in the voids created by the indentations in the seat cushions, while the references to Obama's presidency firmly ground the work in a specific moment. *Couch For a Long Time* fuses public and private moments, creating a sense that monumentality can pervade everyday life. HDM

Couch For a Long Time, 2009 /
Couch, newspaper, and
ceramic, 76 × 29 × 35 ½ in.
(193 × 73.7 × 90.2 cm) /
Collection of the artist

2010

Martin Kersels makes sculpture, photography, sound, and performance in a tragicomic exploration of the physical realm from the perspective of a man who describes himself as someone who literally and figuratively does not quite fit. His use of physical, slapstick humor allows access to the awkward, the embarrassing, and the painful.

Kersels's work is deeply rooted in the performative. The artist's investigation of movement, size, and space began in the 1980s with his participation in the neo-Dada dance and performance collaborative SHRIMPS and continued in photographic projects such as *Falling* (1994), *Tripping* (1995), *Tossing a Friend* (1996), and *Friends Smacking Me* (1998), in which he is captured falling, tripping, playfully throwing friends into the air, and being smacked. The result is equal parts funny and sad, evoking the deadpan slapstick of Buster Keaton as well as the single-action performances of Trisha Brown, Joan Jonas, and Richard Serra.

Kersels's sculptures are similarly performative, placing him in the company of sculptors like Paul McCarthy, Chris Burden, and Charles Ray. Consisting largely of domestic objects, Kersels's contraptions are decidedly analog, enthusiastically revealing the method of their making and emphasizing process over execution. Sometimes objects serve as stand-ins for the artist's unwieldy body. *Piano Drag* (1995)— in which a baby grand piano is dragged across the floor by an electric winch, the creaks and groans of the interior amplified by a microphone, until the extension cord is pulled out of

the wall and the object falls silent— borders on self-portraiture.

Rickety (2007) marks a shift in which the object becomes a stage for the participation of others—a means through which the viewer can begin to access the artist's physical experience. A choreographed assemblage of wooden chairs, cabinets, and other domestic furniture supports a large wood and steel stage punctuated by plastic trees. Music, dance, lectures, and performances by Kersels and others take place both above and below the platform. In its simple and efficient compression of space and scale, *Rickety* creates a disorienting maze in which the viewer and performer experience the physical and emotional discomfort of largeness, while simultaneously creating a new space to be filled by the presence of potential future acts. NC

Study in Orange & White #4,
2009 / Colored pencil on paper,
14 × 11 in. (35.6 × 27.9 cm) /
Collection of the artist

STAGE #4
MIC & SPEAKER STAND
APPROX 7' TO 8' TALL

STUDY IN ORANGE & WHITE #4

73

Jim Lutes's paintings of figures, objects, and landscapes overlaid with painterly abstractions defy easy categorization. He has been compared to a 1930s Pablo Picasso and a 1970s Philip Guston, anointed an heir to the Chicago Imagist and "Bad Painting" traditions, and both dismissed and celebrated as a regionalist. In more than twenty-five years as a painter, most of them in Chicago, Lutes has created a highly personal body of work wholly his own, developing what he calls his "own private postmodernism."

Lutes's paintings have long inhabited the space between representation and abstraction. In the late 1980s he introduced to his decidedly figurative work the lyrical, looping abstract marks that have tangled with the representational to various degrees in his paintings since then. Initially he deployed the abstract elements to disrupt and obscure, reversing conventional readings of representation as symbolic and rational and of abstraction as intuitive and irrational. In the mid-1990s, Lutes began to consider his abstract mark an object, which freed him to use abstraction and figuration interchangeably and also allowed him to address more directly what he regards as the central problem in painting: "getting image and paint to talk to one another."

To that end, Lutes has experimented with various types of paint throughout his career: first oil, then synthetic polymer, and most recently egg tempera—a classical medium not often used in contemporary art. The use of egg tempera allows a greater level of fluidity, depth, and luminosity and connects him to a much older tradition of painting. His interest in the material life of paint and the history of painting is evident in *Zaagmolenstraat* (2006), in which he layers loose, ethereal squiggles over an empty street scene. The title, however, points to a more personal narrative: the painting depicts the Rotterdam street where Willem de Kooning—another artist strongly associated with a city other than his birthplace—was raised. In this constant blurring and collapsing of present and past, abstraction and representation, personal history and art history, Lutes claims a space for himself. NC

Tool, 2009 / Tempera and oil on linen, 78 × 56 in. (198.1 × 142.2 cm) / Collection of the artist

2010

Babette Mangolte's photographs and films constitute a vital record of more than three decades of dance and performance. Her iconic images of choreographers and artists like Trisha Brown, Yvonne Rainer, and Joan Jonas not only capture the ephemeral practices central to the art of the 1970s and 1980s but also shape the collective memory of them.

A skilled cinematographer trained in Paris, Mangolte was one of the first female directors of photography in French cinema. She has worked on dozens of films in that capacity and served as the de facto recorder of New York's downtown performance scene. In the mid-1970s, Mangolte began directing experimental films that evoke the atmospheric and luminous traditions of French cinema and the self-reflexive procedures of Structural film while proposing her own concept of cinema as an exchange between the filmmaker and spectator. As with her still photographs, Mangolte approaches the camera as both a documentary tool and an aesthetic medium grounded in subjective experience. Rather than simply concentrating on the objects in front of her camera lens, Mangolte explains that "looking is my subject."

When showing her work in a gallery, Mangolte emphasizes the interplay between viewer, photographer, and subject implied by the act of looking. Some of her recent exhibitions, *Looking and Touching* (2007) and *Collision* (2008), juxtapose multiple modes of display to explore the shifting valences of images in relation to space and context. *How to Look* (2009) reimagines Mangolte's earliest museum installation, which she realized in 1978. On a wall cordoned off from viewers by a low banister, Mangolte arranges portraits of friends and shots of buildings in a large grid. The enforced physical distance and rigid formal logic of the display serve as a counterpoint to a collection of similar photographs Mangolte prints on playing cards and scatters on a table. A film projected on a nearby screen depicts the cards on the table being handled and manipulated. Staging a complex interaction with photographs, architectural space, and film, *How to Look* does not so much direct a visual encounter as it suggests the multiple, nuanced ways that images can produce meaning. ws

Composite for "How to Look," 1978 (images) / 2009 (composite) / Gelatin silver print composite, 10 × 8 in. (25.4 × 20.3 cm) / Collection of the artist

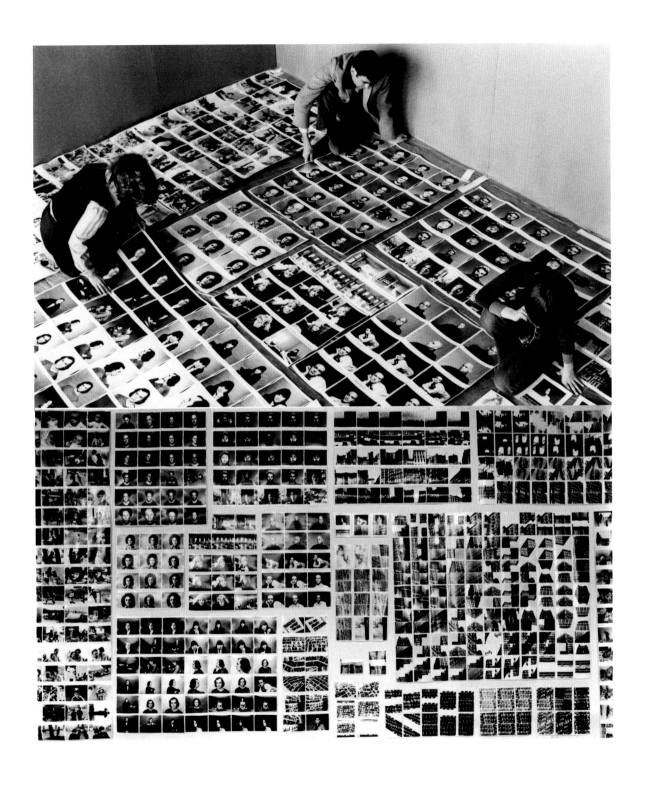

Curtis Mann's photographs contain partially hidden scenes erased and obscured by areas of blankness. Mann starts with images taken by others—journalists, tourists, or citizens—mostly culled from online sources and photosharing websites and ordered as printed photographs. He then applies batches of regular household bleach to the photographs, initiating a process of distortion and manipulation of his found imagery. When the artist first started to alter prints with bleach, he used images of family and friends, dealing with familiar, everyday subjects. However, he has recently turned to more foreign and unfamiliar subjects. For example, in Mann's *Modifications* series (2006–09), the archive of vernacular photography he selects is anything but ordinary. Fragments of the original photographs—piles of rubble; eroded buildings, lands, and cityscapes; the roofs of shanty towns; crowds of people; and playing children—peek through the white voids signaling the charged populated landscapes of war and violence in places like Israel, the Gaza Strip, Lebanon, Iraq, Afghanistan, and Kenya.

In the case of his most recent grid of photographs, *After the Dust, Second View (Beirut)* (2009), which is arranged like a large mural on the wall, Mann adapts candid and casual snapshots from a stranger's Flickr album documenting the thirty-three-day war between Israel and Hezbollah in the summer of 2006. He explains, "I question what I've learned about these places, and I realize I usually have to erase most of that knowledge and begin again—more open-minded, more curious, and more hopeful than before."

In this way, Mann raises questions about a photograph's role as a faithful reproduction. Through a process that is intentionally imperfect and destructive the artist challenges the trust we place in a photograph of an unknown place. Since the Surrealist photographers of the 1920s and 1930s, photography has been subject to manipulation through techniques like the photogram, solarization, and *brûlage* (a technique of heating a photographic negative that causes distortion on the surface of the emulsion). Mann says: "Paying attention to the photograph as an object exposes it as something impermanent, fallible and extremely malleable. Coming from a mechanical engineering background, I have always been curious about the paper, the chemicals and the inks used to produce photographic images. They are the birth of the image and their manipulation holds a lot of potential for disrupting the powers of the flat, conventional image." To look at Mann's altered photographs—especially those that constitute *After the Dust, Second View (Beirut)*—is to be disoriented by a blast or a cloud of smoke. Though bewildering, it just might be this effect that mimics the experience Mann hopes to create—that of looking without answers. ᴛᴋ

After the Dust, Second View (Beirut), 2009 / Synthetic polymer varnish on bleached chromogenic print, 65 ¾ × 153 ½ in. (167 × 390 cm) / Collection of the artist

Since arriving in New York from his native Holland in 1979, Ari Marcopoulos has documented the diverse subcultures of American youth. His photographs and videos depict the brash vitality of underground music and the rebellious athleticism of extreme sports. In a body of work that demonstrates a rare empathy for his subjects, who are almost always young men or boys, Marcopoulos neither patronizes tentative expressions of identity nor romanticizes youthful freedom. His straightforward portraits and lush snapshots capture everyday moments of beauty and anxiety, becoming, as he says, "something that just stands for life lived."

With little formal training, Marcopoulos started printing Andy Warhol's black-and-white photographs and photographing the artists and performers active in New York's downtown scene in the 1980s. Marcopoulos developed a pervasive sensitivity to the nuances of subcultural style that lends his studies of hip-hop artists and skateboarders from the 1990s an almost anthropological quality. Yet the intimacy of his photographs prevents Marcopoulos's subjects from seeming distant or exotic: "My anthropology has more to do with what's in my reach." This is especially true of his most recent photographs and videos, which focus on life with his two teenage sons at home in Sonoma, California.

Marcopoulos shot *Detroit* (2009) during a trip to that city, but the looped video captures the domestic energy and open-ended feel that characterize much of his latest work. In a cheerful adolescent bedroom, two middle-school-aged boys, the children of friends, improvise an incongruously aggressive electronic composition on an impressive collection of guitar pedals. Absorbed by their performance, the boys' intensity breaks only with the silencing of the last feedback loop, when their shy smiles return and they beam for the camera: "There you go…all right!" The array of high-end musical equipment crammed into the bedroom suggests an unusual degree of parental encouragement for noise rock. Indeed, familial collaboration has become a hallmark of Marcopoulos's practice. Whether studying with awe his own sons' skateboarding injuries or lip-synching with them along to a Tupac Shakur song, Marcopoulos has never more closely participated in the scene that he documents. ws

Still from *Detroit*, 2009 / DVD, color, sound; 7:32 min. loop / Collection of the artist

Daniel McDonald crafts dollhouse-scale narrative tableaux that metaphorically illustrate topical bohemian dilemmas and pop-cultural tragedies and traumas. To create his miniature mise-en-scènes, McDonald collects commercial toy figurines, which he surgically alters, transplanting body parts to create hybridized creatures and "weathering" them to a ghoulishly naturalistic effect. He activates and arranges these figures into theatrical montages, drawing from the trashy visuals of Hollywood horror films to produce three-dimensional political cartoons, which are both hilarious and dark.

An allegory of the present U.S. economic crisis is presented in *The Crossing: Passengers Must Pay Toll In Order to Disembark (Michael Jackson, Charon & Uncle Sam)* (2009). American pop-music icon and tragic hero Michael Jackson, clad in his zombie costume from *Thriller*, steps onto the boat of Charon, the ferryman in Greek mythology who transports the recently deceased to the underworld. As required by the situation at hand, Jackson offers a giant, shiny penny to the beckoning outstretched hand of Charon as payment for his voyage. In contrast, at the other end of the boat lies the dissolute figure of Uncle Sam, holding a bottle of champagne spilling over the side of the boat, pockets empty, with no money to give Charon. The figure of Uncle Sam, a stock character in many of McDonald's recent sculptures, displays reckless abandon analogous to the irresponsible behavior that contributed to the recent state of the U.S. economy. The drama of the scene is heightened with theatrical effects and a dreamlike scale that shifts throughout the composition.

McDonald was a founding member of Art Club 2000, an artists' collective formed by New York's Cooper Union School of Art students, who teamed up with art dealer Colin de Land of American Fine Arts Company, where McDonald also served as gallery codirector. The collective critically examined a range of emerging societal issues, including the rampant gentrification and corporate takeover practices that paralleled the migration of galleries from SoHo to Chelsea. A masterful social anthropologist, McDonald manipulates imagery in his recent sculptural work to capture the viewer's interest, as he deftly combines political satire, witty juxtaposition, and precise attention to detail. MN

The Crossing: Passengers Must Pay Toll In Order To Disembark (Michael Jackson, Charon & Uncle Sam), 2009 / Modified action figures and models, plastic, fabric, foil, plexiglass, copper, acrylic, glitter, wood, light-emitting diodes, water, and mist, 60 × 22 × 7 ½ in. (152.4 × 55.9 × 19.1 cm) / Collection of the artist

Josephine Meckseper has dedicated her career to creating a body of installations, photographs, and films that expose the social and political ramifications of the capitalist culture of consumption. As a means with which to engage the world, Meckseper's work is conceptually grounded in critical theory rather than in art history: "I'm less interested in the discourse of aesthetics than in factually exploring the contradictions and absurdities of the objects exhibited."

Perhaps it was only a matter of time before Meckseper turned her attention to Minnesota's Mall of America, bringing her work out of the gallery to engage with capitalism on its home turf. As one of the top tourist destinations in the United States, the mall brings forty million visitors a year to more than five hundred stores. Meckseper's video *Mall of America* (2009) inverts her curated, composed store displays of luxury and banal goods by using footage of actual store displays. The camera explores the sparsely populated mall, pausing to examine window displays, signs for 50 percent off, and dormant amusement park rides. Advertisements with bare bodies impart the desperate air of a rejected lover; one sign pleads, "Look at Me."

This footage is accompanied by an unnerving, vaguely sinister soundtrack and is overlaid with ironically patriotic red and blue filters inspired by Jean-Luc Godard; occasionally the footage is turned on its side, a strategy also employed by Meckseper in earlier work. The cumulative effect is that of abstraction and alienation, and a rending of

meaning from image. The filters lift momentarily as the camera turns its attention to colorful footage from a flight simulator attraction in the mall (advertised as the same simulator used to train military pilots) and from an IMAX fighter pilot movie on display for sale. In a moment of perfectly deadpan irony, the mannequin stationed at the entrance to the attraction and dressed in a pilot's flight suit and helmet looks menacingly across the mall to a store called Lake Wobegon, USA, which promises "Pretty Good Deals." Here, not only is the experience of war and violence sanitized, glamorized, and spectacularized, it is for sale. NC

Still from *Mall of America*, 2009 / Video transferred to DVD, color, sound; 12:48 min. / Collection of the artist

2010

Equal parts anthropologist and DJ, Rashaad Newsome samples from high and low culture to create compelling and often entertaining feats of collage. Newsome employs video, performance, sculpture, photography, and paper collage to create works that, as he puts it, "walk the tightrope between identity politics and abstraction, dismantling power structures one shiny block at a time." His work builds on a long history of artists employing collage for its political potential, beginning with the Russian Constructivists. Sampling heavily from hip-hop and popular culture, Newsome's work is culturally specific in its origins but universal in its aspirations.

In 2009, Newsome turned his attention to the highly stylized dance form known as vogue. Born of the gay ballroom scene of New York in the 1960s and 1970s, voguing enjoyed mainstream attention in the early 1990s but remains largely relegated to the gay community, marginalized particularly in comparison to other contemporary dance forms. For this project, Newsome invited vogue dancers into his studio to perform various styles of the dance on camera. He then edited the footage to choreograph a new dance and returned it to the dancers to study and finally to perform again for the camera. The resulting videos of these collaborations, *Untitled* and *Untitled (New Way)* (both 2009), are documents, alternately intimate and detached, of an underappreciated dance form that has long fascinated the artist. Says Newsome, "I really wanted to somehow translate the emotions I felt when I first saw someone voguing."

The dancers perform tirelessly for the camera, moving hypnotically to music we cannot hear, seducing the viewer in a private dance.

Through his strategy of reframing, remixing, and re-presenting, Newsome succeeds in divorcing these performances from their culturally and historically specific context, transforming them into a series of abstract movements. He explains, "I view these videos as drawings, with the dancers acting as my pen, creating lines, shapes, landscapes, and an array of narratives." In doing so, Newsome not only celebrates the origins, beauty, and legitimacy of vogue as a dance form but inserts this rogue language of movement into the contemporary art dialect. NC

Still from *Untitled (New Way)*, 2009 / Single-channel high-definition video, color, silent; 6:48 min. / Collection of the artist

Kelly Nipper's videos, installations, photographs, and live performances investigate the relationship between the moving human form and the shape of the space that surrounds deliberate, ritualized gestures. Having worked for ten years in special collections at the Getty Research Institute in Los Angeles processing post–World War II artist archives—including most notably those of Allan Kaprow, for whom Nipper worked as an archivist and studio manager from 1997 to 2006—Nipper has had an unusual intimacy with and direct access to a host of score-based approaches to performance. In *Floyd on the Floor*, a thirty-minute event first presented in 2007 as part of *Performa 07*, the audience activates Kaprow's notion of a "total environment." Executed by a troupe of eight masked performers, Nipper's collaborative score manipulates a parachute according to mapped interpretations of storm clouds and sudden shifts in barometric pressure, movements inspired by the severe weather and landscape of the Midwest, where the artist was raised. The performers' interactions with the parachute also recall educational exercises created to help children develop motor skills and teach teamwork. Although the performers are distanced from the audience by balaclava-like hoods and the calling out of a numbered sequence that indicates the duration of each gesture, the score nevertheless envelops the audience as the undulant form of the parachute brushes up and momentarily surrounds viewers.

The first part of a tripartite work yet to be presented in its entirety, *Floyd on the Floor* is also the overall title of a larger project that includes the video *Weather Center* (2009), shown here, as well as the "performance studies" *Sapphire* (2009) and *Circle Circle* (2007), which are composed of objects or sculptures, videos, photographs, notes, and collages. Based closely on German Expressionist choreographer Mary Wigman's gothically tinged *Witch Dance*, first performed in 1914, and influenced by the work of movement theorist Rudolph Laban (Wigman's teacher), *Weather Center* captures the highly stylized gestures and movements of a masked female performer who appears to be possessed by an animal-like spirit. Shoulders hunched and legs spread, the woman alternates between violent rocking motions, a birdlike cocking of the head, and repetitive tamping and clawing gestures. Shot in black-and-white against a neutral gray background and accompanied by a metronomic voice-over, the performance is isolated and heightened in a manner reminiscent of early ethnographic film studies but also indebted to the "trance films" of Maya Deren. Here Nipper elaborates a marriage of systematized notation and poetic choreography. FM

Still from *Weather Center*, 2009 / Single-channel video projection, black-and-white, sound; 5:11 min. / Dance performed by Taisha Paggett and costume by Leah Piehl / Collection of the artist

After successful careers as an intelligence analyst, translator, and rock critic, Lorraine O'Grady began making art in 1980 to address race, class, and gender inequalities. Her conceptually based practice, which encompasses photography, performance, collage, and video, is equally concerned with politics and aesthetics. Borrowing from Futurism, Dada, Surrealism, postmodern appropriation, and her own family history, O'Grady's unruly yet elegantly incisive work focuses on what she calls "that complex point where the personal intersects with the historic and cultural."

O'Grady is best known for performances in the early 1980s as her alter ego *Mlle Bourgeoise Noire*— a 1950s beauty queen wearing a gown of white gloves—in which she staged guerrilla invasions of art-world events to protest, as she states, both "timid black artists and thoughtless white institutions." Whipping herself and shouting poems, she declared, "Black art must take more risks!" In these performances, O'Grady reframes the image of the black female "not as an object of history, but as a questioning subject," interrogating structures of power with devastating humor.

O'Grady's ongoing project *Flowers of Evil and Good*, begun in 1995, demonstrates her facility in weaving together personal narrative and the history of Western art to "engage and comprehend the self through the study of cultural history." The work consists of diptychs of Charles Baudelaire and his (largely forgotten) black common-law wife, Jeanne Duval, laid over elements of Pablo Picasso's *Les Demoiselles*

d'Avignon (1907). Whereas excerpts from Baudelaire's writings are superimposed over his photograph, Duval's image is overlaid with texts invented by O'Grady to tell the story of her own mother's migration, one that loosely recalls Duval's. As curator Franklin Sirmans argues, "By splicing a modernist monument like *Les Demoiselles* with its African influences, and inserting Duval's point of view, O'Grady constructs an interwoven pattern of narratives that unravels the canon of modernism." Her new work for *2010, The First and the Last of the Modernists* (2010), with diptychs of Baudelaire and Michael Jackson, continues O'Grady's unraveling of hierarchies that has helped create an opportunity for black agency—in the art world and in larger feminist and cultural movements—the importance of which is perhaps only now beginning to be fully appreciated. NC

View of studio, 2009

your eyes the well
my boredom drinks

michael jackson

Her belly, her breasts, those grapes
than angels of evil, disturbed my soul from
the rock-crystal throne where, calm
breasts, those grapes on my vine
evil, disturbed my soul from
crystal throne where, calm it was seated
those grapes on my vine ward, caroling more
disturbed my soul from tumbling
throne where, calm seated. Her belly
grapes on my vine ing more than angels
my soul from its sle from the rock-crystal
where, calm and alone be rape
my vine, moved forwar
from its sleepin
and alone,
moved for distur
sleeping
alone
for

tumbling my soul
from the crystal throne

R.H. Quaytman's work stems from a self-professed desire "to maintain and simultaneously disrupt painting's absolute presence." She addresses this paradox by subsuming the context in which a painting is encountered—architecture, storage, documentation, and the viewer's mode of approach—into her subject matter. Aesthetically, Quaytman expands the visual language of the medium by incorporating alternate idioms sourced through media ranging from photography to book design.

Quaytman views her entire body of work, organized into chapters, as an ongoing archive in which each new painting or series is informed by what came before it. She sometimes inserts older paintings into new groupings, underscoring continuity across diverse motifs. As with pages in a book, the paintings are all of a similar format: silkscreened photographs or patterns are combined with oil paint on six distinct sizes of gessoed wood panel. The silkscreened optical patterning attunes viewers to the physical act of perceiving mediated images, while trompe l'oeil depictions of the panel's edges call attention to the temporality of the painting's current location, announcing its past and future location in a storage rack.

A single image or event acts as a starting point for each chapter of Quaytman's work. In her 2008 series *iamb: Chapter 12*, a lamp lighting a painting served as the catalyst for exploring the conditions of illumination and the blind spot across a series of paintings that are carefully choreographed throughout the exhibition space. In this grouping, Quaytman uses optical patterns to evoke the thin line between incandescence and obscurity; for example, white dots at the interstices of a scintillating grid illusion flicker in and out of existence depending on the focus of the viewer's gaze. The viewer's position in relation to the works alternately enhances or counteracts the optical effects, while the succession of similar but reconfigured images accumulates meanings in each new context.

In 2005–08 Quaytman was the director of the artist-run Lower East Side gallery Orchard, which had a program that advanced contemporary political conceptualist ideas while recontextualizing their historical influences. Attention to the conditions involved in exhibiting and viewing art was paramount. This concern plays out in Quaytman's individual practice as a generative principle: at the heart of her practice is the excavation of the myriad layers of contextuality involved in seeing and interpreting painting. DK

iamb: Chapter 12, 2008 / Oil, silkscreen, and gesso on wood, 32 ⅜ × 20 in. (82.2 × 51 cm) / Collection of Laura Belgray and Steven Eckler

In sharp contrast to Andy Warhol's well-known flower silk screens of the 1960s, wherein a photograph of a hibiscus blossom is abstracted and morphed into one highly saturated image to be repeated in two-tone variations against a tangle of articulated Photo-Realist undergrowth, Charles Ray's ink-on-paper drawings of flowers seem assembled in parts, brought repeatedly to the point of touching or gathering into a bountiful bunch only to be kept ever separate. Approaching a caricature of the anthropomorphic with their splayed postures of hesitancy and curiosity, Ray's floral studies reiterate a boundary that often recurs in his work as humans are positioned before but distanced from nature, awakened and attuned to the archaic cycles of life but tantalizingly incapable of wresting an idealized form or representative figuration. Disarticulated and reticent, each flower in Ray's bouquets stands as a fanciful specimen—isolated in distinctive gesture and coloration.

As with the artist's oft-mentioned early interest in Constructivist sculpture, the importance of juncture and the relationship of parts—one element next to or alongside another—remains a constant tension here and in much of Ray's work, extending in many cases to the viewer's role in a given scenario. This is the case, for example, with *Ink Box* (1986), *Rotating Circle* (1988), and *Ink Line* (1988), where the seemingly benign and finely crafted presence of a singular, uninterrupted object or form reveals itself to be an element set in constant motion or a precariously positioned volume ready to wreak havoc should the viewer inspect the illusion. Making use of the viewer's urge to grasp and apprehend an appearance of neutral perfection, Ray plays off the psychology of desire as provocation.

Recent works, however, evince a shift away from manufacturing ruptures in the present to looking back at moments of stilled transformation and metamorphosis. *Chicken* (2007), for example, depicts a baby bird on the precipice of being, held in between the pacific comfort of the embryo and the stark glare of the future—an impossible pause in the life cycle underscored by the finely detailed porcelain contour of the small-scale sculpture, its machined white surface, and the perfectly circular aperture through which the viewer glimpses the withheld life-form. Similarly drained of color, *The New Beetle* (2007), shown opposite the hatchling, configures a nostalgic life-size sculpture of a boy absorbed in pushing a toy car. The object of his affection appears conjoined with his body—blissfully contiguous—until one notices how the car is modeled on the New Beetle (the Volkswagen-branded car reintroduced to consumers in the late 1990s), severing the romantic illusion and presenting instead the gesture of oneness as a moment irrevocably past. Not like Ray's flowers, a seemingly idyllic form is unsettled and made strange. FM

Untitled, 2009 / Ink on paper, 47 × 31 ½ in. (119.4 × 80 cm) / Collection of the artist

2010

Emily Roysdon is an artist and writer who revels in language and all its transformative possibilities. Her video, photography, performances, and text use language as a malleable material that can be conceptualized, choreographed, and memorialized. The integrity of her ideas and the consistent investigation into the forms that speech takes in articulating history, politics, and memory allow for a seamless interchange between her visual arts projects and her work as a writer, editor, and organizer of exhibitions.

Roysdon's collaborative work includes her positions as cofounder of the queer feminist artist collective LTTR and as editor of the eponymous journal. Openly acknowledging historical precedents such as the feminist artist collective and journal *Heresies* (1977–92) and Gran Fury, a collective of AIDS activists responsible for public art projects from 1987 to 1994, the group organized performance series, events, and exhibitions as well as produced an annual journal.

Ecstatic Resistance (2009–), a project that includes group exhibitions and performances, was in some measure inspired by Roysdon's activity with LTTR. The term "ecstatic resistance" encompasses her articulation of a new vocabulary that links past and present strategies of protest with the explicit goal of providing "a stage for future actions." The artists Roysdon includes in the project display—through exhibitions and performances—images of resistance that center on the pleasure and power of imagining the impossible and enunciating the incommunicable.

Improvisation and public engagement are key strategies included in *Ecstatic Resistance*, and Roysdon foregrounded both in her recent performance *Work Why, Why not* (2008), presented at Weld in Stockholm. In this performance, large photographic screens on wheels served as stand-ins for language, the only spoken words provided by the audience. The screens, utilized in a dance by the performers, were also conceived as a stand-alone sculptural installation. Their semi-transparency signals language's status as a permeable barrier, and their mobility invites choreography. As Roysdon has written, "Talk is territorial and speaking is a dance."

For *2010*, Roysdon presents photographs of two future performance sites, manipulated to provide a visual score for the events. Roysdon selected these sites, both postindustrial urban landscapes, for their association with social transformation, and the performances create temporary monuments to this history. The work further explores the exchange between document, site, history, movement, and performance that is essential to Roysdon's practice. DK

Ecstatic Resistance (schema), 2009 / Silkscreen and chine collé on paper, 34 ½ × 25 in. (87.6 × 63.5 cm) / Designed in collaboration with Carl Williamson and printed by 10 Grand Press, Brooklyn, New York / Collection of the artist

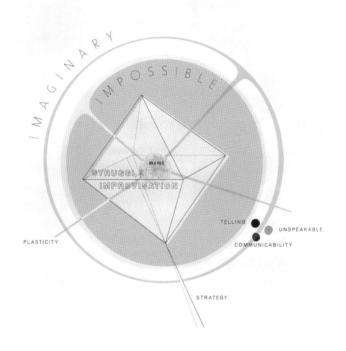

PLEASURE

IMAGINARY

IMPOSSIBLE

mvmt

STRUGGLE

IMPROVISATION

PLASTICITY

TELLING

UNSPEAKABLE

COMMUNICABILITY

STRATEGY

ECSTATIC RESISTANCE

2010

In her performance and installation works, Aki Sasamoto investigates the nuances and peculiarities of everyday gestures. She blends sculpture, movement, video, and sound to transform mundane, habitual actions into bizarre and compelling theatrical events. The daring and improvisatory nature of Sasamoto's work emerges from her layering of changeable and interchangeable vignettes over a core concept.

Sculptural assemblages of found furniture and invented mechanisms as well as manipulated audiovisual components are central to Sasamoto's performances. In her recent work, *Secrets of My Mother's Child* (2009), the artist situates herself inside an armoire decorated with string and clothespins to resemble a domestic cage. While hidden in this constrained environment, she relays a childhood memory about tears and manipulates an abacus. A public address system and microphone transport the action within the bureau to a television monitor on an adjacent table. The artist then exits through the drawers, and proceeds to tell a story while peeling grapefruits and stomping on them with kitchen knives embedded in a pair of wooden sandals. The performance concludes with Sasamoto's assertive discourse on a pseudo-mathematical equation, as she hangs unmatched socks along clotheslines set up to mimic a graph of the function $X \times Y = 1$. The exaggerated conviction of her performance belies its mundane environment and exposes the arbitrary nature of personally symbolic objects, actions, and systems of logic.

Sasamoto has been a part of numerous collaborations and has recently become the founder and codirector of Culture Push—a forum for a wide range of professionals to exchange ideas in symposia, performances, and workshops. In the spirit of the collaborative 1960s Fluxus happenings, including those initiated by Allan Kaprow, John Cage, and Yoko Ono, Sasamoto's compositions have embraced found objects and the banal, repetitive patterns of everyday experiences, infusing them with her own characteristic imagination and intensity. MN

Secrets of My Mother's Child, 2009 / Performance and mixed-media installation / Collection of the artist

Aurel Schmidt's beautifully detailed drawings contain decadent renderings of items such as cigarette butts, discarded foodstuffs, maggots, flies, worms, and rats—objects and creatures that imply decay and blight are lurking nearby. These individual elements form larger compositions, which often take the shape of living beings in varying states of dishevelment and dissipation. By using microimagery of scavengers and discarded objects as building blocks for her subjects, the artist's work becomes a sort of memento mori— a reminder of our own mortality. It is common to recoil with disgust from this sort of imagery since our destiny as decomposing organic matter, like any organism or organic material, is often an abstraction in modern society.

Through painstaking detail and exquisite draftsmanship, Schmidt questions our perceptions of beauty and aims to shift our prescribed associations with decay, rot, and refuse. Instead of experiencing the detritus of our lives as inherently gross and negative—a polarized way of thinking—Schmidt advocates for viewing the human condition as a cyclical process: "I feel like the mix of beauty and junk could function as a self-portrait for most people. Our entire lives are in a constant state of decay and renewal. Things we cherish and value rapidly become symbols of disgust and shame. The lovely dinner we have the night before gets shit out early the next day. Our healthy bodies fall apart."

Without conveying a sense of pathos, Schmidt injects her images with a dark humor, suggesting that their content simply reflects another facet (one that is neither inherently good nor bad) of what it means to be human. Because perfection has never been an apt description of humanity, Schmidt raises questions about the reasons for mourning something that was never there in the first place. As the artist explains: "I try and find beauty in ugly things, in ugly emotions...ugliness can make you laugh; it can be attractive. Things that are angry or disgusting can prompt you to care about life." HDM

The Fall, 2010 / Graphite, colored pencil, synthetic polymer, beer, dirt, and blood on paper, 48 × 84 in. (121.9 × 213.4 cm) / Collection of the artist

2010

Scott Short uses a specific, elaborately structured methodology to explore both the limitations and the possibilities of painting. The resulting painstakingly rendered, mesmerizing compositions bring us to reevaluate the relationships between abstraction and representation, between what is reproduction and what is original, and between the machine-made and the human-made.

Short's process begins with a piece of colored construction paper, which he copies on a black-and-white photocopying machine. He then takes that copy and copies it, repeating this process anywhere from a dozen to several hundred times, using the restricted parameters of the machine's vocabulary to produce a multilayered abstraction. Short selects a randomly produced result he finds compelling and photographs it to make a slide, which he projects onto a large primed canvas. Finally, the artist copies the image with black oil paint, taking care to remain as faithful as possible to the original. Through this process, Short and the photocopier undergo a role reversal whereby the copier creates the abstraction and the painter reproduces the copy. The titles of his pieces are the only remaining indications of the colors of the original pieces of paper.

The precision and specificity of this method yield a surprising variety of permutations in tone, texture, and patterning. In *Untitled (white)* (2008), three-quarters of the canvas is taken up by densely applied, rich black paint, forming a horizon line that fades into small black flecks against a gleaming white background. A black band seeps from the top of *Untitled (blue)* (2007), trickling into a looser static of black dots fading into white at the bottom.

A fanlike shape is formed in some of the paintings, exploding from the top of *Untitled (violet)* (2007) and lightly hovering in *Untitled (orange)* (2008). Stripped of the knowledge of his process, the viewer might liken Short's paintings to those of 1950s Abstract Expressionists such as Jackson Pollock or Robert Motherwell. However, by shunning the emotive quality of the autonomous artist and leaving the creation or generation to a machine, he reinvents traditional painterly practice. Through rigorous dedication to technique, Short's evocative renderings explore the futility of "faithful" reproduction and the ever-present existence of the creator within the copy. MN

Untitled (white), 2008 /
Oil on canvas, 93 × 120 in.
(236.2 × 304.8 cm) / Collection
of the artist

2010

As a photojournalist, Stephanie Sinclair has documented the defining conflicts of the past decade with a fearless persistence. Her widely published images of the occupation of Iraq and the war in Afghanistan refute characterizations of violence in anything but human terms. Although she has covered the dramatic events of war, many of Sinclair's most arresting works confront the everyday brutality faced by women and young girls around the world. Her studies of domestic life in developing countries and the United States bring into sharp relief the physical and emotional tolls that entrenched social conventions can take on those most vulnerable to abuse.

In her devastating series *Self-Immolation: A Cry for Help* (2003–05), Sinclair photographed women in Afghanistan who had set themselves on fire in acts of utter desperation. The rudimentary public hospital in western Afghanistan that Sinclair visited treats local women suffering from extensive, self-inflicted burns. Sinclair's images mark an exchange of trust and compassion. By consenting to be photographed at their most vulnerable, the women depicted in these images also demonstrate a rare bravery. In their suffering, they expose to the world a violence made more pernicious when it remains hidden. Indeed, in response to the widespread attention these images received, a new burn unit was created in Herat, Afghanistan.

Some of the survivors of self-immolation Sinclair photographed were child brides, girls who had been married to older men, often because of their family's debt or poverty. An ongoing series she began in 2005, *The Bride Price*, documents the effects of this widespread practice. In Nepal, Ethiopia, and Afghanistan, as well as the United States, Sinclair has met and photographed children struggling with their new roles as wives. Many of the women and girls Sinclair has spoken with have relayed personal narratives of the trauma of giving birth at a young age and the prolonged abuse they suffered at the hands of their husbands. The photograph Sinclair took of an eleven-year-old Afghan girl named Ghulam on the day she married a forty-year-old man encapsulates the sense of fear and stifled promise shared by an estimated fifty-one million child brides around the world. WS

Self-Immolation in Afghanistan: A Cry for Help, 2005 / Digital print, dimensions variable / Collection of the artist

In her digital montages, text pieces, and drawings, Ania Soliman explores the political implications of representation. Her hybridized methodology offers a view of global society that is both troubling and alluring, mining the resources of the internet and popular culture to engage the collective imagination.

Soliman's first major series, *Biohazards* (2000), examines the standard representation of epidemics in documentary film. Using stills from the Discovery Channel's *Killer Virus* as her point of departure, the artist has rendered the images as large-scale monochromatic drawings in cyan, magenta, yellow, and black— the four inks used in most color printing. Installed as a continuous eighty-inch-high band wrapped around the gallery walls, Soliman's images have been extracted from scenes in the documentary (e.g., an AIDS victim's funeral and the forest in Africa where the Ebola virus was discovered), and each panel has been expressed in a different hue. Loosely rendered and emotive, the drawings stand in sharp contrast to the direct and dispassionate quality of the television broadcast on which they are based.

For *NATURAL OBJECT RANT: The Pineapple* (2007–09), Soliman has created twenty-six digital montages corresponding to the different letters of the alphabet, along with twenty-six text panels. Like an alphabet, her fifty-two panels can be displayed in a variety of combinations. Soliman chose the pineapple as her subject matter in light of its loaded history as an exotic commodity tied up with colonialist geopolitics. For each of her digital montages, Soliman creates a hybrid construction out of two images taken from the internet. Reminiscent of Dadaist photomontages from the 1930s such as those by Hannah Höch, Soliman's work adds a conceptual element, as she confines the images to the shapes of individual letters. The letter-images are accompanied by panels of text, in which the artist has blended her own impressions with historical research. Thus a political and cultural context is provided for this tropical fruit— a prized object from distant lands that has historically exemplified luxury, conquest, and consumption. MN

NATURAL OBJECT RANT: The Pineapple ("R"), 2007–09 / Digital montage, dimensions variable / Collection of the artist

NET-
WORK OF
OBJECTS: SEED TO
SEED TO FLOWER TO
PLANT OPENING UP ITS
FLOWERS AT NIGHT, BAT
POLLINATED ONE,
EATEN BY WEEVILS.

THINGS SHOW UP, FLIT BY, AND
DISAPPEAR. AND I SIT MOTIONLESS FOR DAYS.
NOTHING MORE TO BE DONE. THEY TOOK IT OVER AND I
SIGNED THE BILL. IT'S STIFLING IN HERE, I CANT BREATHE IN
MY CORSET. LOOK AT MY FEET: THEY ARE SWOLLEN. I DON'T WANT
TO THINK ABOUT IT, I DID WHAT I COULD. WE ARE HERE AND WE
MEAN TO STAY THEY SAID, SHOVING PRESIDENT DOLE DOWN MY
THROAT. I SIGNED IT UNDER PROTEST, BOWING TO THE SUPERI-
OR MIGHT. TO THE SUPERIOR MIGHT I SAID. I UNDERLINED
THAT. BUT THERE YOU GO AND THERE IT WENT.

A broad cross-section of personality types exists in the grid of Storm Tharp's hanging portraits *Love Nothing More* (2009). However, unlike the formulaic class portraits that this work recalls, Tharp introduces a dense and diverse set of artistic techniques masterfully using blends of ink, gouache, and graphite to question aspects of representation. Each of his portraits is remarkably unique; some pop from the page with a blinding palette of yellows and pinks, while others emerge from dull tones of gray. The hairstyles and clothes of the personalities depicted by Tharp are sometimes meticulously reduced to individually rendered elements, such as strands of wavy hair or carefully painted folds of a striped dress shirt. A figure's upper torso might seem to vanish from the page or a halo might mark the void of a once full hairdo. Whatever the approach, one aspect of these portraits stands out above all the rest: the face. It is within the charged landscape of the face of his subject—whether entirely smudged out, layered with puddles of watery gouache, or sharply outlined with strong black strokes—that Tharp transfixes us. Like the desperate and lonely figures of a Francis Bacon composition, Tharp's portraits haunt the page. Although, at times, there is something subtly tragic about these washed out characters with dark, depressed, and furrowed eyes, they are not beyond beauty.

The ominously titled *Just Wait* (2008) contains a compelling bust of a young girl with golden hair. Yet alarming bleeds of ink and water on her face appear, in juxtaposition to the graphic quality of her hair, almost like the blurring of an extended-exposure black-and-white photograph. It might not be too far off to draw a connection between the image of the girl and the young female ghosts that haunt Japanese horror films like *The Ring* (1998). However, Tharp's graphic gestures, such as the almost automatic wavering line in the arms and shoulders of an intertwined couple in *Approaching Thunderhead* (2009), do not tread in a supernatural world. The artist imbues the work with an apparent humanity and, like the couple's awkward embrace, reminds us of our own fragility. TK

Jodie Jill, 2009 / Ink, gouache, and colored pencil on paper, 58 ½ × 42 ¼ in. (148.6 × 107.3 cm) / Collection of the artist

2010

Tam Tran

1986 Born in Hue, Vietnam

With her camera always at the ready, photographer Tam Tran trains her lens on, as she puts it, "everything and anything my eyes see and love." Tran's highly personal and intimate images of friends, family, and herself document and consecrate the performances of everyday life. Here, photography is employed as a tool through which identity is repeatedly discovered and constructed, relationships are defined, and every-thing and everyone is in a constant state of becoming.

Tran's self-portraits, in which she dresses up as various incarnations of herself (*Quiet Shiva* and *Retro Bitch*, both 2009), are offered as a meditation on "form and style, on self-definition through appearance." Working in the tradition of female chameleons such as Cindy Sherman and Nikki S. Lee, Tran shifts the focus from portraying others to asserting herself, physicalizing various aspects of her own personality. As Tran explains: "My outward appearance is putty which I shape at will. I see myself as taking on multiple sets of identities for my own amusement as well as for that of the viewer....I am all these women."

Self-definition takes another form in Tran's series *Raising Hell* (2008), starring her nephew Brian. What began as a simple record of childhood moments has over the years become a collaboration of sorts, in which Brian plays, choosing his costume, props, location, and sometimes pose, and the artist documents her nephew's fantastical one-man show. Through this series, Tran explores their relationship as nephew and aunt, play partners, and artist and subject, "with the camera a silent yet important partner in our dynamic." Dressed in Spiderman pajamas and a cape, and brandishing a broomstick, Brian demonstrates the various stages of vanquishing his backyard foe. He is alternately portrayed as monumental and diminutive—warrior and little boy. Through their collaboration, Tran gives her nephew a means of self-discovery and expression, and legitimizes the creativity and imagination romantically ascribed to childhood—a time when everyone is a performance artist. NC

Battle Cry, 2008 / Digital print, 24 × 16 in. (61 × 40.6 cm) / Collection of the artist

Kerry Tribe's conceptually robust and rigorously crafted film and video installations form an ongoing investigation into memory, subjectivity, and representation. Tribe often invites actors, crew members, and technical specialists to participate in her work, which frequently mimics conventions in television and documentary film. Through her mastery and manipulation of the medium, she exposes its artifice and influential power on collective consciousness.

Northern Lights (Cambridge) (2005) is the first in a trilogy of works that probe the malleable and elusive character of memory. Tribe employs an early 1980s low-tech light-art apparatus found in her parents' Cambridge, Massachusetts, home to simulate the appearance of the aurora borealis (a celestial event also known as the northern lights). Slowly moving, ghostly wisps of colored light are accompanied by an eerie soundtrack made on an obsolete synthesizer of the same vintage and from the same city to fabricate the sound sometimes said to be experienced during a northern lights display. Second in the trilogy, *Near Miss* (2005) presents three slightly different takes on a car accident that Tribe actually experienced in a blizzard ten years prior. Textual accounts of the accident written by members of her production team are displayed alongside the film, as well as a photograph of the vehicle and film equipment on set, in a haze of artificial snow and fog. The trilogy concludes with *Episode* (2006), a thirty-minute mock television talk show featuring a discussion with Tribe and two childhood friends as they recall their sighting of mysterious lights in

the night sky in 1991. Their unscripted speculations and impressions of the phenomenon underscore the range of memory permutations that can result as a function of the passage of time and the individuality of the observers.

Tribe's recent two-channel film installation, *H.M.* (2009), employs a documentary format to recount the case study of "H.M.," who underwent experimental surgery in the 1950s to cure his epilepsy by removing part of his brain. After his treatment, H.M. suffered from severe amnesia, with his short-term memory restricted to events of the prior twenty seconds. Tribe's film weaves touching interviews and reenactments with scientific animation, text, and archival images of iconic events from recent history that H.M. cannot remember. The single film is threaded through two adjacent projectors with an interval of twenty seconds between them, evoking H.M.'s condition and challenging the viewer to reflect on the provisional and fragile nature of human perception. MN

H.M., 2009 (installation view at 1301PE, Los Angeles) / Double projection of a single 16mm film, color, sound; 18:30 min. / Collection of the artist

Piotr Uklański often speaks of his prevailing interest in artifice: "I like to work with something that seems totally empty." Drawing from popular culture, art history, and the visual languages of nationalism, Uklański appropriates aesthetic strategies that he considers "bankrupt" and amplifies them to spectacular effect. Across a diverse body of work, which includes a feature film, sculptural installations, and meticulously crafted paintings, Uklański weighs the critical potential of cultural exhaustion.

Since 1996, when he produced a full-scale replica of the illuminated dance floor featured in *Saturday Night Fever*, Uklański's work has shown a cool affection for prosaic beauty. Referencing the codes of American cinema and the mass culture of his native Poland, Uklański blurs the line between art and entertainment while dismissing sentimental claims to originality and authenticity. His full-length film, *Summer Love* (2007), billed as "the first Polish western," renders a melodramatic vision of the American frontier in a Polish accent, undermining the genre's role in fabricating national myths.

Uklański's graffiti work *Untitled (Boltański, Polański, Uklański)* (2003) functions as a vehicle for both self-mythologizing and self-deprecation. By linking his surname with those of other "famous Poles," Uklański inserts himself within a genealogy of Polish visual culture while simultaneously subscribing to the ghettoized identity of the immigrant.

While his work resonates with a general post-Pop tendency in contemporary art, Uklański's practice also manifests a specifically historical orientation. He consistently refers to forms and images that evoke historical crisis but whose potency has been diminished by overuse or willful acts of forgetting. Uklański's most recent paintings and wall reliefs, although formally dissonant with earlier projects, nonetheless belong to his ongoing interrogation of cultural responses to the trauma of World War II. Composed of woven jute, *Untitled (Monster)* (2009) borrows from traditional Polish textile manufacturing techniques and the deliberately crude aesthetics of Art Brut. Coined by Jean Dubuffet in 1945, Art Brut characterizes a loose group of European artists who turned to the artwork of children, the self-taught, and the mentally ill to define a space outside bourgeois culture in which to register the fallout of the war. Overshadowed in many art historical narratives by the triumphalism of American painting, Art Brut's conflicted psychosexual imagery and rustic modes of production return in Uklański's work not as a site of subjective expression but as a marker of forgotten alternatives and lost possibilities. ws

View of Polski Western
headquarters, 2009

ROMAN POLAŃSKI

wygrał 55. festiwal w Cannes filmem Pianista

FOT. WITOLD KULIŃSKI / FORUM

FILM

Lesley Vance makes dark, luminous paintings that are as much about process as result. Her early work focused on fantastical, romantic landscapes and sparse still lifes, often blurring human and natural forms and referencing seventeenth-century Spanish painters like Francisco de Zurbarán and Sánchez Cotán in palette and mood. Vance's paintings now explore new territory while preserving these historical references. Representations of carefully lit natural forms anchored amidst backgrounds with visible brushwork have given way to measured abstractions glowing quietly from within.

Vance uses the creation of a still life as the point of entry for formal and spatial exploration. Initially, she photographs arranged and deliberately lit compositions of natural forms and works from these photographs to paint the still life. At a certain point, the work begins to evolve as Vance applies and scrapes paint, working wet on wet with palette knives and brushes to form fluid layers that are alternately lush and delicate, revealing patches of the canvas's linen weave in places. The earth and vegetal tones of earlier painting remain, as do forms that vaguely suggest leaves, blooms, and branches.

The still life endures, as Vance describes it, only as "the feeling of a memory—not a specific memory, but just that feeling a memory can produce." Working quickly and fluidly, the artist reveals a reverence for process, chance, and intuition. The paintings are completed in a day, finding resolution, she says, "where they part with their spatial and physical references and form a more malleable, even intuitive space, a tactile yet totally fictitious abstraction, that pushes and pulls, confuses spatial norms." While the artist's goal is an abstract space rendered in paint that retains the intimacy and refinement of a traditional still life, equally important is the painting's status as a physical record of marks, actions, accidents, negotiations, decisions, and ideas over time. The still life's traditional representation of time as strictly measured and fleeting is replaced by a more fluid, abstract, almost three-dimensional concept of time that Vance describes as "that quality of time unique to painting—everything folding and unfolding on the surface forward and backward." NC

Untitled (12), 2009 / Oil on linen, 18 × 15 in. (45.7 × 38.1 cm) / Collection of the artist

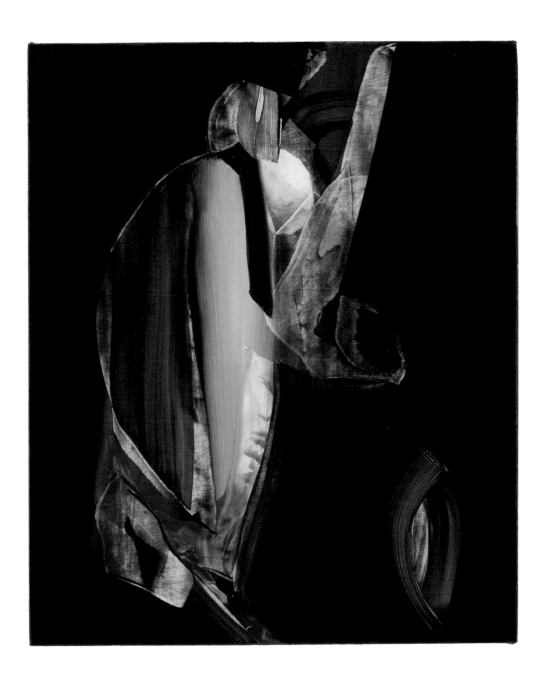

"Welcome to the future of Neutralism," Marianne Vitale announces at the beginning of her video *Patron* (2009). Positioned in front of a collaged paper background and staring directly into the camera, Vitale issues a litany of commands to members of an implied audience whom she addresses as "patron." Originally presented as part of *Performa 09*, a biennial of performance art organized around the theme of Futurism, the video mimics the movement's penchant for rhetorical aggression. Ranting in a pitched tone, Vitale orders her audience to stand up, open their mouths wide, recite tongue-twisting rhymes or "spit at the ceiling." While insisting on compliance with her videotaped instruction, Vitale also parodies authoritarian posturing, especially when her abusive demands border on the surreal ("imagine your feet soaking in gopher urine") and her monologue evolves into a poetic flight of mean-spirited aphorisms. The intensity of the speech recalls an earlier time when artists wrote breathless manifestos and held pretensions of shaping the masses. While Vitale aspires to "Neutralism," less grand than previous art historical "isms" and more grounded in a sense of irony, her direct address nonetheless retains something of the historical avant-garde's belief in the ability of artworks to jar viewers into action.

The aesthetic of carefully cultivated absurdity that Vitale develops in *Patron* characterizes her practice as a filmmaker and sculptor. With disjointed narratives reminiscent of Man Ray and René Clair films of the 1920s, Vitale's video works describe bizarre, often erotically charged, social interactions governed by opaque codes of behavior. In *Title Bound in Customs* (2007), a collaboration with Michael Portnoy, two dominatrices join the artists in a performance that hovers between a crude orgy and a sophisticated Surrealist theater piece. Vitale describes her sculptures as translations of her films' unsettling effect into permanent physical form. Her recent outdoor installation, *Landswab Over Berberis* (2009), aggregates found objects and bulky detritus into an object that appears simultaneously imposing and fragile. While Vitale sees her films as "expelling expression directly," enabling her to scream at an audience if necessary, her three-dimensional work can have a similar impact on the viewer, but in the more subtle way that "only sculptures can scream." ws

Patron, 2009 / Video, color, sound; 8:36 min. / Collection of the artist

2010

Erika Vogt creates images that instantiate ambiguous spaces and densely layered experiences of time. By videotaping film projections or rephotographing photographs, Vogt interlaces different modes of image production and multiple levels of mediation. Vogt's process of negotiating various media can be highly self-reflexive; she describes her practice as interrogating the codes and conventions latent within film, photography, and video. Yet through her nuanced depictions of cultural archetypes and symbolically charged objects, Vogt's work also makes broader reference to the meaning of ritual time and historical change.

I Arrive When I Am Foreign (Centennial Tin) (2006) embodies the complex dynamics characteristic of Vogt's work. The photograph depicts the artist standing on a nearly life-size image of herself while holding a recently opened one-hundred-year-old can of peas. Within the space of a single image Vogt manages to collapse multiple temporal frameworks. Just as the opening of the can marks an intrusion of the past into the present, Vogt's doubled figure—built from a well-scuffed visual artifact and a present-tense view of the artist— merges two discontinuous moments of image making.

Internally disjunctive and visually disorienting, Vogt's works lend themselves to expressions of enigmatic meaning. *Secret Traveler Navigator* (2009) sets a series of figures seen only in shadow against changing, undulating backgrounds. The silhouettes, which Vogt describes as filmic portraits, take on archetypal identities through repetitive, quasi-ritualistic interactions with emblematic objects. Vogt's idiosyncratic cast includes a marching man, a worker, a capitalist, and a mysterious image-traveler. These figures never share the same space, but their aggregate identities gesture toward a mythical narrative.

Like many of Vogt's projections that combine film and digital video, *Secret Traveler Navigator* can be compared to the work of Hollis Frampton and Morgan Fisher— experiential filmmakers who explored the gaps between different media, especially still and moving images. But the hieratic symbols and mystical allusions that animate Vogt's work also belong to a tradition of American avant-garde filmmaking that has proven resistant to assimilation into established theoretical discourses. In particular, Vogt's project recalls Harry Smith's intricate projections, which overlay and transform different media in a process that borders on alchemy. ws

Still from *Secret Traveler Navigator*, 2009 / 16mm film and digital video transferred to digital video, color, sound; 8 min. / Collection of the artist

2010

Pae White moves nimbly between a wide range of disciplines to create immersive aesthetic experiences. She has designed catalogues, perfume bottles, and stage curtains while simultaneously embracing conventional art-making processes to compose visually stunning sculptures and installations. For White, taking advantage of diverse strategies of production is a means to accommodate her voracious consumption, transformation, and distribution of images.

White's artistic vision is profoundly democratic; she is inspired by infinite details of everyday experience, with weight placed equally on Los Angeles street food and the fleeting sensation of sun piercing though clouds. Site-specificity is often integral to the inspiration for an object, though not to its interpretation. She has re-created the autumn leaves of Pasadena, California, in burned canvas and metal and made barbecues in the shape of Hudson Valley animals. Even without specific quotations, White's work often conjures a particular sense of place. Her layers of mirrored and colored plexiglass sheets evoke light reflecting off of suburban swimming pools. Mobiles composed of thousands of brightly colored paper cutouts appear as organic swarms frozen in place.

In 2006 White began creating tapestries with photographic images of crumpled aluminum foil and, later, plumes of smoke. White fuses image and material to stage what she envisions as the cotton's "dream of becoming something other than itself." In the large-scale tapestry *Smoke Knows* (2009), White isolates a close-up image of concentrated wisps of smoke, creating an all-over surface of illusory depth. The vision of an ephemeral moment suspended in space, embedded in fabric—something slight and fleeting monumentalized in the heroic tradition of tapestries— demonstrates White's ability to transform an everyday image into a seductive evocation of transience and longing.

It is possible to view White's work through the prism of a number of artistic precedents: Impressionist interpretation of nature, De Stijl stylistic abstraction, or Postminimalist relation to site and context, to name a few. The resistance of any of these movements to neatly encapsulating White's motivations is indicative of the work's ability to transcend distinctions and gesture toward universal experience. DK

Smoke Knows, 2009 (detail) / Cotton and polyester, 114 × 258 in. (289.6 × 655.3 cm) / Collection of the artist

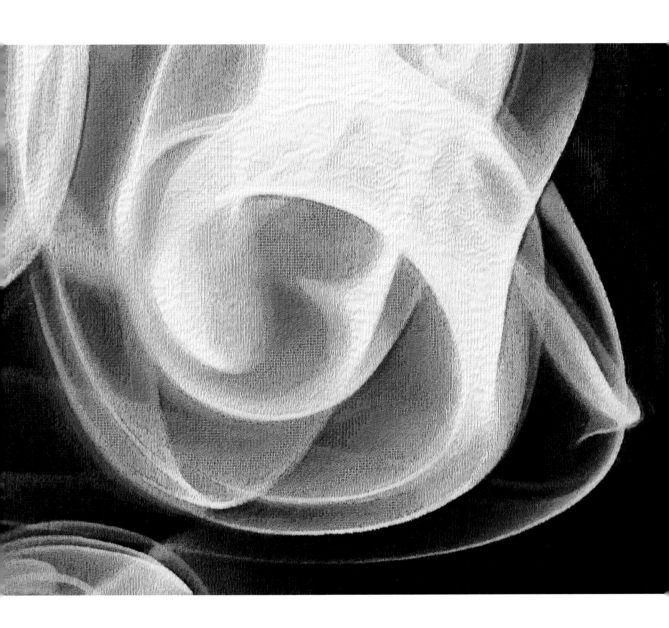

Robert Williams's watercolors provide a glimpse of a speculative world in which eccentric laws of physics can wreak havoc on suburban neighborhoods and in which the forests are home to spectral visions of tommy gun-wielding tomato-headed cowboys.

Williams's imagery is both idiosyncratic and deeply rooted in a range of interlocking subcultures. After leaving art school in Los Angeles in 1964, Williams rejected the burgeoning high-culture aspirations of the gallery scene and immersed himself in the vernacular aesthetics of California. He painted hot rod art at Ed "Big Daddy" Roth's legendary auto shop and contributed mind-expanded drawings to R. Crumb's *Zap Comix*. With an unpretentious brand of home-brewed Surrealism and a careful attention to craft, Williams gave visual expression to some of the most vital undercurrents of post–World War II American life.

In his oil paintings, sculptures, and watercolors, Williams invests the aesthetics of underground comix and custom cars with the historical weight of fine-art media and classical techniques. This conflation of "high" and "low" may recall the strategies of Pop art, but the popular culture that Williams evokes is not the same commercial world of the mass media that have fascinated artists from Andy Warhol to Jeff Koons. Rather than appropriating preexisting sources, Williams generates highly inventive material from a broadly shared (if often illicit) vocabulary of images. The pulp magazines, weirdo drawings, and pornographic illustrations that Williams's work evokes speak to a sphere of art production that has been equally difficult for both mainstream culture and the high arts to assimilate.

Williams's interest in creating crisp, realistic depictions, as much as the vulgar humor or sexualized violence that he often depicts, has set him apart from the dominant values in the art world of the past forty years. Yet in the cultural space between the museum and the comic-book convention, his work has fostered a public of its own. The lowbrow art movement that consolidated around *Juxtapoz* magazine, which Williams founded in 1994, evidences the wide demand for self-conscious, uncompromising art that is, at the same time, truly popular. ws

Astrophysically Modified Real Estate, 2009 / Gouache on paper, 14 ½ × 17 ½ in. (36.8 × 44.5 cm) / Collection of the artist

ASTROPHYSICALLY MODIFIED REAL ESTATE

Jeffrey Inaba (b. 1962) /
Sandwich, 2010

As part of *2010*, the Whitney
commissioned the architect Jeffrey
Inaba's architecture collective INABA
and C-Lab to design a temporary
restaurant space for the lower level
of the Museum's Marcel Breuer
building. The proposal is for an eatery
inspired by the form of a sandwich
with a variable element between two
similar ones. As Inaba explains,
"just like the conceptual middle
zone of a sandwich, the interceding
environment will host a variety of
contents: light fixtures, tables, chairs,
and seat cushions of different sizes
and shapes; various events; and
menu offerings—mainly sandwiches—
which change over time."

Jeffrey Inaba (b. 1962) /
820 Washington, 2010

Jeffrey Inaba and INABA designed a pavilion for 820 Washington Street, the Whitney's future downtown site. The 7,000-square-foot structure with more than 150 ceiling "lanterns" will house galas, receptions, talks, and other Museum events while also accommodating the High Line's maintenance and operation facilities.

2010

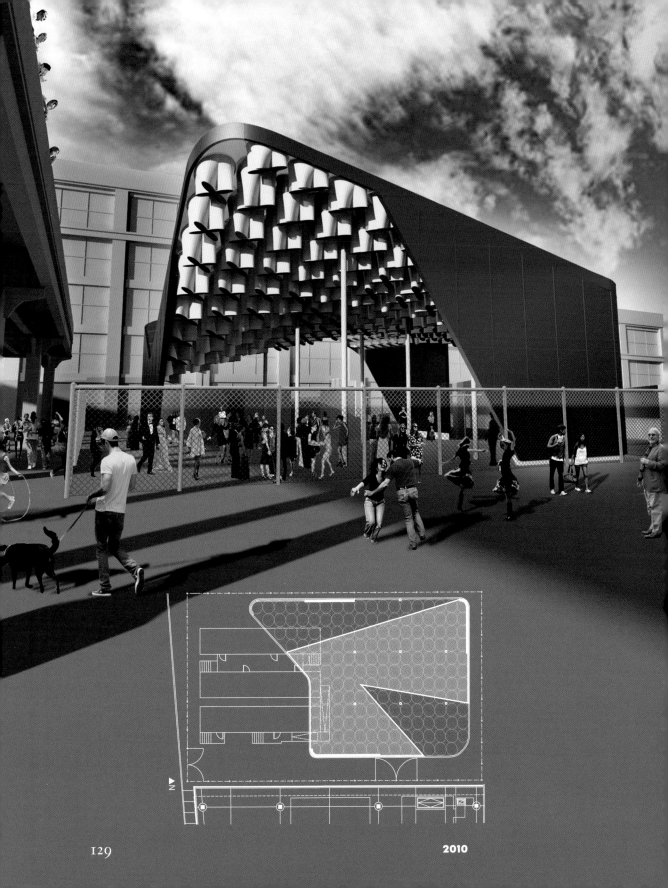

2010

Checklist of the Exhibition

David Adamo

Untitled (box with sound...), 2010 / Mixed media, dimensions variable / Collection of the artist; courtesy Ibid Projects, London, and Fruit and Flower Deli, New York

My Own Private Marathon, 2010 / Performance on all floors of the Whitney

Richard Aldrich

Untitled, 2008 / Wood on pedestal, 49 × 13 × 10 in. (124 × 33 × 25.4 cm) / Collection of the artist; courtesy Bortolami Gallery, New York

Gift, 2009 / Found object on pedestal, 52 × 18 × 13 in. (132 × 46 × 33 cm) / Collection of the artist; courtesy Bortolami Gallery, New York

Stranger in a Strange Land, 2009 / Enamel screenprint on linen, 84 × 58 in. (215.9 × 147.3 cm) / Collection of the artist; courtesy Bortolami Gallery, New York

Michael Asher

No Title, 2009–10 / This work temporarily reconfigures the hours the Whitney is open to the public. Rather than being closed most evenings, most mornings, and two full days, the Museum will be open to visitors twenty-four hours a day for one week.

Tauba Auerbach

Untitled Fold XII, 2009 / Synthetic polymer on canvas, 75 × 100 in. (190.5 × 254 cm) / Collection of the artist; courtesy Deitch Projects, New York, Jack Hanley Gallery, San Francisco and New York, and STANDARD (OSLO), Oslo

Untitled Fold XIII, 2009 / Synthetic polymer on canvas, 75 × 100 in. (190.5 × 254 cm) / Collection of the artist; courtesy Deitch Projects, New York, Jack Hanley Gallery, San Francisco and New York, and STANDARD (OSLO), Oslo

Untitled Fold XIV, 2009 / Synthetic polymer on canvas, 75 × 100 in. (190.5 × 254 cm) / Collection of the artist; courtesy Deitch Projects, New York, Jack Hanley Gallery, San Francisco and New York, and STANDARD (OSLO), Oslo

Nina Berman

Ty at the bar where Renee works, 2006, from *Marine Wedding*, 2006/2008 / Pigment print, 10 × 15 in. (25.4 × 38.1 cm) / Collection of the artist

Ty and Renee at Brooke Army, 2006, from *Marine Wedding*, 2006/2008 / Pigment print, 10 × 15 in. (25.4 × 38.1 cm) / Collection of the artist

Ty makes breakfast, 2006, from *Marine Wedding*, 2006/2008 / Pigment print, 10 × 15 in. (25.4 × 38.1 cm) / Collection of the artist

Ty and Renee plan their wedding, 2006, from *Marine Wedding*, 2006/2008 / Pigment print, 10 × 15 in. (25.4 × 38.1 cm) / Collection of the artist

Ty on a rainy day, 2006, from *Marine Wedding*, 2006/2008 / Pigment print, 10 × 15 in. (25.4 × 38.1 cm) / Collection of the artist

Ty at a candy store, 2006, from *Marine Wedding*, 2006/2008 / Pigment print, 10 × 15 in. (25.4 × 38.1 cm) / Collection of the artist

Ty and Renee, 2006, from *Marine Wedding*, 2006/2008 / Pigment print, 10 × 15 in. (25.4 × 38.1 cm) / Collection of the artist

Ty and flags, 2006, from *Marine Wedding*, 2006/2008 / Pigment print, 10 × 15 in. (25.4 × 38.1 cm) / Collection of the artist

Ty gets dressed for his wedding, 2006, from *Marine Wedding*, 2006/2008 / Pigment print, 10 × 15 in. (25.4 × 38.1 cm) / Collection of the artist

Ty carries his arm into his pick-up truck, 2006, from *Marine Wedding*, 2006/2008 / Pigment print, 10 × 15 in. (25.4 × 38.1 cm) / Collection of the artist

Untitled, 2006, from *Marine Wedding*, 2006/2008 / Pigment print, 10 × 15 in. (25.4 × 38.1 cm) / Collection of the artist

Marine Wedding, 2006, from *Marine Wedding*, 2006/2008 / Pigment print, 15 × 10 in. (38.1 × 25.4 cm) / Collection of the artist

Ty Ziegel, 2008, from *Marine Wedding*, 2006/2008 / Pigment print, 10 × 15 in. (25.4 × 38.1 cm) / Collection of the artist

Ty after Renee, 2008, from *Marine Wedding*, 2006/2008 / Pigment print, 10 × 15 in. (25.4 × 38.1 cm) / Collection of the artist

Ty with his dog, 2008, from *Marine Wedding*, 2006/2008 / Pigment print, 10 × 15 in. (25.4 × 38.1 cm) / Collection of the artist

2010

Ty with gun, 2008, from *Marine Wedding*, 2006/2008 / Pigment print, 10 × 15 in. (25.4 × 38.1 cm) / Collection of the artist

Ty with his mother Becky, 2008, from *Marine Wedding*, 2006/2008 / Pigment print, 10 × 15 in. (25.4 × 38.1 cm) / Collection of the artist

Ty on the land of his dreams, 2008, from *Marine Wedding*, 2006/2008 / Pigment print, 10 × 15 in. (25.4 × 38.1 cm) / Collection of the artist

Huma Bhabha

My Skull Is Too Small, 2009 / Clay, wood, wire, Styrofoam, aluminum, cast iron, synthetic polymer, paper, and charcoal, 93 × 28 × 92 in. (236.2 × 71.1 × 233.7 cm) / Collection of the artist; courtesy Salon 94, New York

Josh Brand

Vertical Red White Light, 2009 / Chromogenic print, 14 × 11 in. (35.6 × 27.9 cm) / Unique / Collection of the artist; courtesy Herald Street, London

Narrative Wall, 2008 / Gelatin silver print, 8 × 10 in. (20.3 × 25.4 cm) / Unique / Collection of the artist; courtesy Herald Street, London

Untitled (Corner), 2009 / Chromogenic print, 11 × 14 in. (27.9 × 35.6 cm) / Unique / Collection of the artist; courtesy Herald Street, London

Person with Drawing, 2007 / Chromogenic print, 8 × 10 in. (20.3 × 25.4 cm) / Unique / Collection of the artist; courtesy Herald Street, London

Untitled, 2007 / Chromogenic print, 14 × 11 in. (35.6 × 27.9 cm) / Unique / Collection of the artist; courtesy Herald Street, London

Untitled (Words and Mirror after Song and Painting), 2008 / Chromogenic print, 8 × 10 in. (20.3 × 25.4 cm) / Unique / Collection of the artist; courtesy Herald Street, London

The Bruce High Quality Foundation

We Like America and America Likes Us, 2010 / Hearse-ambulance and educational implements, dimensions variable / Collection of The Bruce High Quality Foundation

James Casebere

Landscape with Houses (Dutchess County, NY) #1, 2009 / Digital chromogenic print, 72 × 96 in. (182.9 × 243.9 cm) / Edition of 5 / Collection of the artist; courtesy Sean Kelly Gallery

Landscape with Houses (Dutchess County, NY) #2, 2009 / Digital chromogenic print, 72 × 96 in. (182.9 × 243.9 cm) / Edition of 5 / Collection of the artist; courtesy Sean Kelly Gallery

Edgar Cleijne and Ellen Gallagher

BETTER DIMENSION, 2010 / Screenprint on wood panels, four Hasselblad slide projectors, one 16mm Eiki projector, and glass and steel projection screen, 106 × 252 × 268 in. (270 × 640 × 680 cm) / Courtesy of the artists, Gagosian Gallery, New York, and Hauser and Wirth, London and Zurich

Dawn Clements

Mrs. Jessica Drummond's ("My Reputation," 1945), 2010 / Pen with ink on paper, 87 ½ × 240 in. (222.3 × 609.6 cm) / Collection of the artist; courtesy Pierogi, New York

George Condo

The Butcher and His Wife, 2008–09 / Bronze, 43 × 48 × 85 in. (109.2 × 121.9 × 215.9 cm) / Collection of the artist

Sarah Crowner

Untitled (Continuum 1963), 2009 / Gouache on sewn canvas, six panels: dimensions variable / Collection of the artist; courtesy Nicelle Beauchene Gallery, New York, and Nice and Fit Gallery, Berlin

Verne Dawson

Pagans, 2010 / Oil on canvas, 100 × 108 in. (254 × 274.3 cm) / Collection of the artist; courtesy Gavin Brown's Enterprise, New York

Julia Fish

Threshold, North [spectrum : blue], 2009–10 / Oil on canvas, 23 × 34 in. (58.4 × 86.4 cm) / Collection of the artist; courtesy Rhona Hoffman Gallery, Chicago

Threshold, SouthEast – One [spectrum : yellow], 2009–10 / Oil on canvas, 23 × 44 in. (58.4 × 111.8 cm) / Collection of the artist; courtesy Rhona Hoffman Gallery, Chicago

Threshold, SouthWest – Two [spectrum : green], 2009–10 / Oil on canvas, 25 × 42 in. (63.5 × 106.7 cm) / Collection of the artist; courtesy Rhona Hoffman Gallery, Chicago

Roland Flexner

Untitled, 2008–09 / Thirty sumi ink on paper drawings, 5 ½ × 7 in. (14 × 17.8 cm) each / Collection of the artist; courtesy D'Amelio Terras Gallery, New York

Suzan Frecon

cathedral series, variation 5 (closer), 2009 / Oil on linen, 108 × 87 ⅜ in. (274.3 × 222 cm) / Collection of the artist; courtesy David Zwirner Gallery, New York

embodiment of red (soforouge), 2009 / Oil on linen, two panels: 54 × 87 ½ × 1 ½ in. (137.2 × 222.3 × 3.8 cm) each, 108 × 87 ½ × 1 ½ in. (274.3 × 222.3 × 3.8 cm) overall / Collection of the artist; courtesy David Zwirner Gallery, New York

Maureen Gallace

Summer, 2009–10 / Oil on panel, dimensions variable / Collection of the artist; courtesy 303 Gallery, New York

Summer, 2009–10 / Oil on panel, dimensions variable / Collection of the artist; courtesy 303 Gallery, New York

Summer, 2009–10 / Oil on panel, dimensions variable / Collection of the artist; courtesy 303 Gallery, New York

Summer, 2009–10 / Oil on panel, dimensions variable / Collection of the artist; courtesy 303 Gallery, New York

Summer, 2009–10 / Oil on panel, dimensions variable / Collection of the artist; courtesy 303 Gallery, New York

Theaster Gates

Cosmology of Yard, 2009–10 / Conveyor pallets, found objects, and digital video, approximately 100 × 30 × 10 ft. (30.5 × 9.1 × 3 m) / Collection of the artist; courtesy Kavi Gupta Gallery, Chicago

Kate Gilmore

Standing Here, 2010 / Mixed-media sculpture with video, dimensions variable / Collection of the artist; courtesy Smith-Stewart Gallery, New York, Franco Soffiantino Arte Contemporanea, Turin, and Maisterravalbuena, Madrid

Hannah Greely

Dual, 2005–09 / Mixed media, 68 × 91 × 50 in. (172.7 × 231.1 × 127 cm) / Collection of the artist

Jesse Aron Green

Ärztliche Zimmergymnastik, 2008 / High-definition video projection, color, sound; 80 min. loop / Collection of the artist

Robert Grosvenor

Untitled, 2009 / Two components: fiberglass and flocking component, 48 × 48 × 192 in. (121.9 × 121.9 × 487.7 cm); aluminum component, 48 × 312 × ½ in. (121.9 × 792.5 × 1.3 cm) / Collection of the artist; courtesy Paula Cooper Gallery, New York

Sharon Hayes

Parole, 2010 / Multiple-channel audio and video installation, dimensions variable / Edition of 3 / Collection of the artist; courtesy Tanya Leighton Gallery, Berlin

Thomas Houseago

Baby, 2009–10 / Tuf-Cal, hemp, iron rebar, wood, graphite, and charcoal, 102 ½ × 90 × 81 in. (260.4 × 228.6 × 205.7 cm) / Collection of the artist; courtesy Michael Werner Gallery, New York

Alex Hubbard

Annotated Plans for an Evacuation, 2009 / Video, color, sound; 5:45 min. / Collection of the artist

Jessica Jackson Hutchins

Couch For a Long Time, 2009 / Couch, newspaper, and ceramic, 76 × 29 × 35 ½ in. (193 × 73.7 × 90.2 cm) / Collection of the artist; courtesy Laurel Gitlen (Small A Projects) and Derek Eller Gallery, New York

Jeffrey Inaba

Sandwich, 2010 / Mixed media, dimensions variable

820 Washington, 2010 / Steel, concrete, polycarbonate, and synthetic fabric, 70 × 100 ft. (21.3 × 30.5 m)

Martin Kersels

Family Song, 2009 / Wood and metal, 42 × 84 × 42 in. (106.7 × 213.4 × 106.7 cm) / Collection of the artist; courtesy Galerie Georges-Philippe and Nathalie Vallois, Paris, and Mitchell-Innes and Nash, New York

Ship Song, 2009 / Wood and steel, 84 × 54 × 30 in. (213.4 × 137.2 × 76.2 cm) / Collection of the artist; courtesy Galerie Georges-Philippe and Nathalie Vallois, Paris, and Mitchell-Innes and Nash, New York

Stuff Song, 2009 / Wood, plexiglass, rope, rock, and metal, 42 × 78 × 54 in. (106.7 × 198.1 × 137.2 cm) / Collection of the artist; courtesy Galerie Georges-Philippe and Nathalie Vallois, Paris, and Mitchell-Innes and Nash, New York

Loud Song, 2009 / Wood, speakers, beaded curtain, and aluminum / 108 × 48 × 48 in. (274.3 × 121.9 × 121.9 cm) / Collection of the artist; courtesy Galerie Georges-Philippe and Nathalie Vallois, Paris, and Mitchell-Innes and Nash, New York

Sing Song, 2009 / Wood, aluminum, microphones, metal, microphone cords, 102 × 66 × 48 in. (259.1 × 167.6 × 121.9 cm) / Collection of the artist; courtesy Galerie Georges-Philippe and Nathalie Vallois, Paris, and Mitchell-Innes and Nash, New York

Jim Lutes

Tool, 2009 / Tempera and oil on linen, 78 × 56 in. (198.1 × 142.2 cm) / Collection of the artist; courtesy Valerie Carberry Gallery, Chicago

Piece of Barbara, 2009 / Egg tempera on panel, 59 ¾ × 51 ⅛ in. (151.8 × 129.9 cm) / Collection of the artist; courtesy Valerie Carberry Gallery, Chicago

Babette Mangolte

How to Look, 2009 / 441 vintage photographs, 1977/1978, 8 × 10 (20.3 × 25.4 cm) each; two decks of fifty-two vintage photo playing cards, 1978, 3 ½ × 5 (8.9 × 12.7 cm) each; and 16mm film/Blu-ray projection, color, sound; 10 min. loop / Collection of the artist; courtesy Broadway 1602, New York

Curtis Mann

After the Dust, Second View (Beirut), 2009 / Synthetic polymer varnish on bleached chromogenic development print, 65 ¾ × 153 ½ in. (167 × 390 cm) / Collection of the artist

Ari Marcopoulos

Detroit, 2009 / DVD, color, sound; 7:32 min. loop / Collection of the artist; courtesy Ratio 3, San Francisco

Daniel McDonald

The Crossing: Passengers Must Pay Toll In Order To Disembark (Michael Jackson, Charon & Uncle Sam), 2009 / Modified action figures and models, plastic, fabric, foil, plexiglass, copper, acrylic, glitter, wood, light-emitting diodes, water, and mist, 60 × 22 × 7 ½ in. (152.4 × 55.9 × 19.1 cm) / Collection of the artist; courtesy Broadway 1602, New York

Josephine Meckseper

Mall of America, 2009 / Video transferred to DVD, color, sound; 12:48 min. / Collection of the artist; courtesy VG Bild-Kunst, Bonn

Rashaad Newsome

Untitled (New Way), 2009 / Single-channel high-definition video, color, silent; 6:48 min. / Collection of the artist

Untitled, 2009 / Single-channel high-definition video, color, silent; 8:07 min. / Collection of the artist

Kelly Nipper

Weather Center, 2009 Single-channel video projection, black-and-white, sound; 5:11 min. / Dance performed by Taisha Paggett and costume by Leah Piehl / Collection of the artist; courtesy Francesca Kaufmann, Milan

Lorraine O'Grady

The First and the Last of the Modernists (Diptych #1: Charles and Michael), 2010 / Two pigment prints, 46 ¾ × 37 ⅜ in. (118.7 × 94.9 cm) each / Edition of 8 / Collection of the artist; courtesy Alexander Gray Associates, New York

The First and the Last of the Modernists (Diptych #2: Charles and Michael), 2010 / Two pigment prints, 46 ¾ × 37 ⅜ in. (118.7 × 94.9 cm) each / Edition of 8 / Collection of the artist; courtesy Alexander Gray Associates, New York

The First and the Last of the Modernists (Diptych #3: Charles and Michael), 2010 / Two pigment prints, 46 ¾ × 37 ⅜ in. (118.7 × 94.9 cm) each / Edition of 8 / Collection of the artist; courtesy Alexander Gray Associates, New York

The First and the Last of the Modernists (Diptych #4: Charles and Michael), 2010 / Two pigment prints, 46 ¾ × 37 ⅜ in. (118.7 × 94.9 cm) each / Edition of 8 / Collection of the artist; courtesy Alexander Gray Associates, New York

R. H. Quaytman

Distracting Distance, Chapter 16, 2010 / Oil, silkscreen, and gesso on wood, dimensions variable / Collection of the artist; courtesy Miguel Abreu Gallery

Charles Ray

Flower drawings, 2003–09 / Ink on paper, dimensions variable / Collection of the artist and various private collections; courtesy Matthew Marks Gallery, New York

Emily Roysdon

No title, 2010 / Digital chromogenic print with silkscreen, dimensions variable / Collection of the artist

Aki Sasamoto

Strange Attractors, 2010 / Performance and mixed-media installation, dimensions variable / Collection of the artist

Aurel Schmidt

Master of the Universe/ FlexMaster 3000, 2010 / Graphite, colored pencil, synthetic polymer, beer, dirt, and blood on paper, 84 × 53 in. (213.4 × 134.6 cm) / Collection of the artist

Scott Short

Untitled (white), 2008 / Oil on canvas, 93 × 120 in. (236.2 × 304.8 cm) / Collection of the artist; courtesy Christopher Grimes Gallery, Santa Monica, and Cardi Black Box, Milan

Stephanie Sinclair

Self-Immolation in Afghanistan: A Cry for Help, 2005 / Nine digital prints, 17 × 22 in. (43.2 × 55.9 cm) each / Collection of the artist; courtesy VII, New York

Ania Soliman

NATURAL OBJECT RANT: The Pineapple, 2007–09 / Digital montage, dimensions variable / Collection of the artist

Storm Tharp

Jodie Jill, 2009 / Ink, gouache, and colored pencil on paper, 58 ½ × 42 ¼ in. (148.6 × 107.3 cm) / Collection of the artist; courtesy PDX Contemporary Art, Portland

Dolores, 2009 / Ink, gouache, colored pencil, and gold leaf on paper, 67 ¾ × 42 in. (172 × 106.7 cm) / Collection of the artist; courtesy PDX Contemporary Art, Portland

Pigeon (After Shunsen), 2009 / Ink, gouache, colored pencil, and graphite on paper, 58 × 42 in. (147.3 × 106.7 cm) / Collection of the artist; courtesy PDX Contemporary Art, Portland

Strangers Comin, 2009 / Ink, gouache, and colored pencil on paper, 58 × 42 ¼ in. (147.3 × 107.3 cm) / Collection of the artist; courtesy PDX Contemporary Art, Portland

Miss Cloud, 2009 / Ink, gouache, and colored pencil on paper, 58 × 42 ¼ in. (147.3 × 107.3 cm) / Collection of the artist; courtesy PDX Contemporary Art, Portland

Tam Tran

Rise of Your New Leader, 2008 / Digital print, 24 × 16 in. (60 × 40.6 cm) / Collection of the artist

Battle Cry, 2008 / Digital print, 24 × 16 in. (60 × 40.6 cm) / Collection of the artist

I Will Take Your Head Off Myself, 2008 / Digital print, 24 × 16 in. (60 × 40.6 cm) / Collection of the artist

The Battle Begins Now, 2008 / Digital print, 24 × 16 in. (60 × 40.6 cm) / Collection of the artist

On Your Feet Puny Human, 2008 / Digital print, 24 × 16 in. (60 × 40.6 cm) / Collection of the artist

A True Warrior is Balanced, 2008 / Digital print, 24 × 16 in. (60 × 40.6 cm) / Collection of the artist

Kerry Tribe

H.M., 2009 / Double projection of a single 16mm film, color, sound; 18:30 min., dimensions variable / Collection of the artist; courtesy 1301PE, Los Angeles

Piotr Uklański

No title, 2010 / Mixed-media installation, dimensions variable / Collection of the artist; courtesy Gagosian Gallery, New York, Galerie Emmanuel Perrotin, Paris, and Galleria Massimo de Carlo, Milan

Lesley Vance

Untitled (18), 2009 / Oil on linen, 18 × 15 in. (45.7 × 38.1 cm) / Collection of the artist; courtesy David Kordansky Gallery, Los Angeles

Untitled (12), 2009 / Oil on linen, 18 × 15 in. (45.7 × 38.1 cm) / Collection of the artist; courtesy David Kordansky Gallery, Los Angeles

Untitled (14), 2009 / Oil on linen, 16 × 12 in. (40.6 × 30.5 cm) / Collection of the artist; courtesy David Kordansky Gallery, Los Angeles

Untitled (21), 2009 / Oil on linen, 18 × 16 in. (45.7 × 40.6 cm) / Collection of the artist; courtesy David Kordansky Gallery, Los Angeles

Marianne Vitale

Patron, 2009 / Video, color, sound; 8:36 min. / Collection of the artist; courtesy Ibid Projects, London

Erika Vogt

Secret Traveler Navigator, 2009 / 16mm film and digital video transferred to digital video, color, sound; 8 min. with wood stand, enamel painted screen surface, and painted interior room / Collection of the artist

Pae White

Still, Untitled, 2010 / Cotton and polyester, 12 × 39 ft. (3.7 × 11.8 m) / Collection of the artist; courtesy greengrassi, London

Robert Williams

Astrophysically Modified Real Estate, 2009 / Gouache on paper, 14 ½ × 17 ½ in. (36.8 × 44.5 cm) / Collection of the artist; courtesy Tony Shafrazi Gallery, New York

Beyond Ferocious, 2009 / Gouache on paper, 14 ½ × 17 ½ in. (36.8 × 44.5 cm) / Collection of the artist; courtesy Tony Shafrazi Gallery, New York

Mr. Exponential Psychosis (Piss Pot Pete), 2009 / Gouache on paper, 14 ½ × 17 ½ in. (36.8 × 44.5 cm) / Collection of the artist; courtesy Tony Shafrazi Gallery, New York

The Green Kachina, 2009 / Gouache on paper, 14 ½ × 17 ½ in. (36.8 × 44.5 cm) / Collection of the artist; courtesy Tony Shafrazi Gallery, New York

The Inside Out House, 2009 / Gouache on paper, 14 ½ × 17 ½ in. (36.8 × 44.5 cm) / Collection of the artist; courtesy Tony Shafrazi Gallery, New York

Tommy Tomato Horse Knife (A Former Apparition), 2009 / Gouache on paper, 14 ½ × 17 ½ in. (36.8 × 44.5 cm) / Collection of the artist; courtesy Tony Shafrazi Gallery, New York

Whitney Biennial

Whitney Biennial

Whitney Biennial

Whitney Biennial

2000

Whitney Biennial

Whitney Biennial

Whitney Biennial

Whitney Biennial

1990

Whitney Biennial

Whitney Biennial

Whitney Biennial

Whitney Biennial

1990

Whitney Biennial

Whitney Biennial

Whitney Biennial

1980

Whitney Biennial

Whitney Biennial

Whitney Biennial

1970

Whitney Biennial

Whitney Biennial

Whitney Biennial

Whitney Biennial

Whitney Biennial

Whitney Biennial

1 1 1960)))

Whitney Biennial

Whitney Biennial

Whitney Biennial

1950

Whitney Biennial

Whitney Biennial

Whitney Biennial

1111940

Whitney Biennial

Whitney Biennial

Whitney Biennial

1111930

Whitney Biennial

Whitney Biennial

Whitney Biennial

1991

Appendix

Whitney Biennials and Annuals are exhibitions that invite constant reevaluation. While every Biennial or Annual is unassailably tied to the artists who participated in it, the meaning and reception of the exhibition shifts over time. Included in this appendix are a selection of installation photographs and *New York Times* reviews representing what we consider significant moments in the history of the Museum's Biennials and Annuals— the first Biennial in 1932, the inclusion of video art in 1973, and the initially controversial but now lauded 1993 Biennial, among others. Also included is a comprehensive list of all Biennial and Annual artists.

While checklists serve as records of works appearing in previous Biennials and Annuals, installation photographs provide a sense of these exhibitions and how the objects were brought together by the respective curators in various settings. The architecture of the Whitney's original home—a townhouse on West Eighth Street complete with furniture and curtains—stands in stark contrast to the open spaces and impersonal surfaces of the Museum's West Fifty-fourth Street location, which housed the Whitney from 1954 to 1966. Photographs documenting the 1966, 1973, and 1983 exhibitions in the Whitney's current Madison Avenue location reveal a surprising confluence of objects. These installation images underscore our thinking that it is only when the works come together in the Museum's galleries that we will begin to understand the meaning of *2010*.

The selected *New York Times* articles included here represent the long history of critical reaction to previous Biennials and Annuals. From a contemporary perspective, critical responses to the Biennials and Annuals or to individual artists have not necessarily coincided with contemporary estimations. But regardless of whether the previous reviews now seem perceptive or naive, they reveal that even critical reception to a Biennial is a product of the same moment in which a Biennial or Annual was created. For example, the *New York Times* review of the 1951 Annual reveals that, although abstraction was not a new or foreign idea at that time, the thought of completely nonobjective painting was something still being digested by the article's author, Howard Devreet: "Many of the pictures with numbers of merely abstract titles unquestionably reflect a highly disturbed emotional attitude on the part of artists toward life today." In 1977 Hilton Kramer had a somewhat similar reaction to the relatively new medium of video: "About the video art, incidentally, I cannot report. Much as I try to look at it, I find it has the effect upon me of a very strong sleeping potion."

The list of artists is an important and intriguing document of the Whitney's history and American art since 1932. Some artists who have gone on to great acclaim appear early in their careers (Matthew Barney, for example, was included in the 1993 Biennial at the age of twenty-five and again in 1995). Others, such as George Condo, resurface or appear consistently throughout their careers (Georgia O'Keeffe appears on the list an astonishing twenty-two times, while Charles Ray has been included in Biennials occurring in 1989, 1993, 1995, 1997, and 2010). But of special interest to us when thinking about *2010*, was that the Whitney builds its particular history of American art from the accumulative effect of all of the past Biennials and Annuals, and more importantly, the collection from the works acquired from them. As the perceived importance of individual artists changes over the years, the Museum continues to acquire works by previous Biennial artists, either going back to a work that failed to register at the time or acquiring new pieces by artists whose work has continued to mature and develop. Biennials, this year's included, are always imperfect mirrors of their time, reflecting a subjective interpretation of American art at any given moment, and the meaning and impressions of each Biennial and Annual are subsequently transformed by those that follow it.

Francesco Bonami and
Gary Carrion-Murayari

NB: The list of artists in this volume reflects changes in the structure of the Biennial and Annual exhibitions. From 1932 through 1936, separate Biennials were held for different media. Because these Biennials alternated between media, the Whitney hosted one Biennial each year during this period. Between 1937 and 1972, the Museum continued to hold yearly contemporary art exhibitions organized by media but began to call them Annuals. The current Biennial structure— a single exhibition of works in all media—began in 1973. There was no Biennial in 1999, effectively switching the Biennial from odd to even years. Artists' names were compiled from the original Biennial and Annual catalogues. Names that appear in multiple catalogues with slight variations of spellings or use of a middle initial have been standardized here. The exhibitions are listed in reverse chronological order, but the information is chronological within each year.

1932

ART IN REVIEW

Whitney Museum Plans a Series of Group Exhibitions of Paintings by Contemporary Americans.

By EDWARD ALDEN JEWELL.

The Whitney Museum of American Art announces for next November the first of a series of group exhibitions devoted to contemporary American painting, these exhibitions to be held thereafter biennially. It promises to represent a service to the public somewhat similar to that performed every two years at the Corcoran Gallery in Washington. The Whitney Museum, however, has in mind a show much smaller than the Washington biennial. A glance at the records shows that the 1930 exhibition at the Corcoran contained a few less than 400 canvases. The number of artists to be represented in the first event of the Whitney series has not yet been decided, but there will be, it is announced, 150 paintings.

Another difference betwene these two biennials lies in the method of procedure. For the Corcoran show, artists submit work, which is passed upon by a jury of selection. Representation in the Whitney Museum biennial will be by invitation. Consequently, no jury is required, and there will be no prizes. However, a purchasing fund of $20,000 has been established by Mrs. Gertrude Vanderbilt Whitney, founder of the museum, "for the purpose of acquiring works of outstanding merit from this exhibition for the museum's permanent collection." The first of the series of biennial showings has been scheduled for the middle of November, and the pictures will be on view for six weeks.

The Whitney Museum of American Art also announces another biennial series, to begin in 1933, which will devote itself exclusively to contemporary sculpture, water-colors, drawings and prints. These group exhibitions will thus take place in alternate years, beginning each new season with "a comprehensive showing of the latest work of representative artists"—the list being by no means, one learns, confined to artists already represented in the museum's permanent collection.

In the course of a typical New York season the galleries and museums place on view quantities of American art and one is always enabled to study the work of individual artists in considerable detail. But the value of comprehensive group displays hardly needs emphasizing. By such means scattered threads are woven into a single strand and a broad survey of the field becomes possible.

On an international scale this sort of service has for many years been rendered annually by the Carnegie Institute in Pittsburgh. It was announced some time ago that next season there will be no Carnegie International. The College Art Association has, however, stepped in and is now preparing a traveling international, which will make its first appearance at the Worcester Museum and later in the season will be brought to New York.

PAINTINGS SHOWN BY 153 AMERICANS

Strong National Tone Sounded at Biennial Exhibit of the Whitney Museum.

49 NEWCOMERS INCLUDED

Pictures Will Be on Public View Today—Choice of Entries by Artists Themselves.

By EDWARD ALDEN JEWELL.

The second biennial exhibition of contemporary American painting opened at the Whitney Museum with a private view yesterday afternoon. It opens to the public today and will be on until Jan. 10. The hours are 2 to 6 o'clock weekdays and Sundays with these exceptions: On Saturday the hours are from 10 A. M. to 6 P. M. and on Wednesday evening the museum will be open again from 8 to 10. It is always closed to the public on Monday and will be closed also on Thanksgiving Day.

Continuing the admirable policy that has obtained since the first of these biennial exhibitions was held, no prizes will be given. Instead an indefinite number of pictures will be purchased for the museum's permanent collection out of a fund of $20,000 provided for that purpose. These purchases are never announced until just before an exhibition reaches its conclusion. The series, which was begun in 1932, embraces two biennials—one (as at present) containing only oil paintings, the other consisting of sculpture, water-colors, drawings and prints.

Also still operative is the policy of inviting artists to participate, but leaving to them the choice of work by which they are to be represented. As Mrs. Juliana Force neatly phrases it: "We send out our invitations and each artist may wear what he pleases to our party."

It was the museum's desire to assemble an exhibition that should "represent in a broad way some of the most notable characteristics of American painting today." A catalogue note further explains: "It is almost inevitable that the limitations of space should compel the exclusion of many artists who are of equal importance to those invited. Realizing this, we have not felt strictly bound by the previous invitation lists, but have endeavored to include as many new names as possible. As a result, forty-nine artists are represented in the present exhibition who were not included in the first biennial."

All of the museum galleries—even the room ordinarily used for sculpture—are devoted to this big and enormously interesting show. Paintings by 153 American artists will be found on the walls, excellently hung. More than a quarter of the painters live and work outside of Greater New York. The area covered stretches from coast to coast and, specifically, includes the following States: Pennsylvania, Maryland, Massachusetts, Illinois, Iowa, Michigan, Ohio, Missouri, New Mexico, Texas, Colorado and California; also the District of Columbia.

The exhibition, which can be discussed in only the most general way at this time, is peculiarly vital; warmly alive and articulate. Leaving the matter of choice to the artist can often prove rather disastrous, but upon this occasion the artists seem quite as often to have been inspired, or at any rate to have used very good judgment. Naturally, every painter wants to look his best at a Whitney party. There isn't a dull room in the building. Each wall is an adventure. Taken as a whole, the exhibition can leave few visitors doubting that we have in this country an art that deserves to be called our own; an art full of courage in the face of handicap; an art that is in many respects robust and imaginatively progressive. There are no signs of the depression here!

Work by three painters who have died in recent months—Bryson Burroughs, John Kane and David Morrison—is included, since all of them had accepted the museum's invitation to exhibit.

WHITNEY MUSEUM TO HOLD EXHIBITION

Annual Show of Contemporary American Artists' Work Will Be Opened on Tuesday

117 TO BE REPRESENTED

Many Never or Not Recently Invited to Display Prints, Sculpture and Drawing

The Whitney Museum of American Art will open on Tuesday its 1939 annual exhibition of contemporary American sculpture, drawings and prints, including work by 117 living American artists from all parts of the United States.

As in previous exhibitions of the kind, the choice of work entered has been left to the artist. Further pursuing the museum's policy, a number of artists not previously or not recently represented in the Whitney annuals have been invited —a number which this year reaches twenty out of the fifty-three sculptors taking part.

The first floor galleries of the museum will be given over to sculpture and the second floor galleries to drawings and prints. The sculpture ranges from small to monumental, in marble, bronze, terra cotta, wood and plaster.

The exhibition will continue through Feb. 17 and will be followed by the annual exhibition of water-colors.

Artists represented in the exhibition are as follows:

Sculpture: Alexander Archipenko, Saul Baizerman, Ahron Ben-Shmuel, S. F. Bilotti, Betty Burroughs, A. Stirling Calder, Albino Cavallito, J. Claude Crow, Jo Davidson, Richard Davis, José De Creeft, José Ruiz de Rivera, Franc Epping, Mitchell Fields, John B. Flannagan, Eugenie Gershoy, Maurice Glickman, Aaron J. Goodelman, Dorothea Greenbaum, Waylande Gregory, Chaim Gross, Minna R. Harkavy and Alonzo Hauser.

Also Milton Hebald, John Hovannes, Paul Hyun, Sylvia Shaw Judson, Margaret Brassler Kane, Henry Kreis, Robert Laurent, Arthur Lee, Thomas L. Medico, Simon Moselsio, Isamu Noguchi, Hugo Robus, Charles Rudy, Sally Ryan, Antonio Salemme, Concetta Scaravaglione, Carl L. Schmitz, Henry Schonbauer, Louis Slobodkin, Dudley V. Talcott, Carl Walters, Marion Walton, Heinz Warneke, Jane Wasey, Nat Werner, Anita Weschler, Warren Wheelock, Gertrude V. Whitney and William Zorach.

Drawings and Prints: Peggy Bacon, Eugene Berman, Isabel Bishop, Peter Blume, Paul Cadmus, Federico Castellon, Adolf Dehn, Eugene C. Fitsch, Karl Free, Jared French, Emil Ganso, William Gropper, Chaim Gross, George Grosz, John Groth, Rosella Hartman, Yasuo Kuniyoshi, Edward Laning, Tom Lea, Rico Lebrun, Doris Lee, Charles Locke, Reginald Marsh, William C. Palmer, Hugo Robus, Umberto Romano, Georges Schreiber, Ivan Le Lorraine Albright, Andrew Butler, Nicolai Cikovsky and Minna Citron.

Also J. E. Costigan, Lewis C. Daniel, Hubert Davis, John De Martelly, Mabel Dwight, Roberta Everett, Philip Evergood, Don Freeman, Wanda Gag, Boris Gorelick, Albert Heckman, Irwin D. Hoffman, Earle Horter, Victoria Hutson Huntley, Armin Landeck, Martin Lewis, Russell T. Limbach, Charles Locke, Louis Lozowick, Kyra Markham, William C. McNulty, Helen Miller, Eugene Morley, Dudley Morris, Thomas W. Nason, Walter DuBois Richards, Robert Riggs, Louis Schanker, John Sloan, Raphael Soyer, Benton Spruance, Harry Sternberg, Prentiss Taylor, Byron Thomas, Stow Wengenroth and Harry Wickey.

WHITNEY MUSEUM GIVES EXHIBITION

Sculpture, Drawings, Prints and Water-Colors on View in the Annual Display

FEB. 19 IS SET FOR CLOSING

'Standing Woman' by Lachaise the Initial Note to Show of Plastic Works

By EDWARD ALDEN JEWELL

The Whitney Museum of American Art, 10 West Eighth Street, will open to the public at 1 o'clock this afternoon its annual exhibition of sculpture, water-colors, drawings and prints. This evening from 9 to 11 a private view and reception will be held in the galleries in which the work selected has been installed. The Whitney's painting annual was put on in November and remained current until a week ago.

The present exhibition, scheduled to continue through Feb. 19, occupies all of the museum galleries. The bulk of the sculpture will be found in the two largest rooms, Gallery IV, on the first floor, and Gallery VIII, on the second, but a few pieces have been placed also in some of the other rooms. An innovation, and it proves effective, leaves the entrance gallery quite bare save for the impressive big bronze "Standing Woman," by the late Gaston Lachaise. This, of course, does not belong to the exhibition proper, but comes from the museum's permanent collection. It strikes a significant initial note, and sets a standard that may well be considered helpful in judging the contemporary plastic work.

227 Artists Exhibit

Further statistics are pertinent. The total number of artists represented this year is 227; the number of States, twenty-one. There are in all fifty-five pieces of sculpture. The 126 water-colors, by ninety-eight artists, have been hung in Galleries I, III, V and VI. The print section occupies Galleries IX and X, on the second floor. Thirty drawings are to be seen in the small room adjacent to the large sculpture gallery on the first floor.

Our attention is called to the fact that forty of the present artists are newcomers—that is to say, they are making now their first appearance in a Whitney annual. Fourteen of these are sculptors, while twenty-six have contributed work in the other mediums. Except for a few pieces of sculpture, all of the contemporary work, it is announced, was selected by the invited artists themselves.

Sculpture in Varied Types

The assembled sculpture ranges, as usual, through certain distinct types of expression, beginning, at one extreme, with the naturalistic and winding up with near-abstraction or with the out-and-out "nonobjective." In between are encountered various phases of simplification and decorative stylization. The range also, with respect to scale, embraces figures of heroic dimensions (such as William Zorach's "Vita-Nova," Louis Slobodkin's "Shulamite," the "Garden Figure" by S. F. Bilotti and work as small as the little bronze "Salut au Monde" (a mother and child) by Harry Wickey, "The Cloud," in green stone, by José de Creeft, an amusing ceramic "Platypus" by Carl Walters, and the several portrait heads. In this realm of straight portraiture, particularly good examples are Betty Burroughs's "Negro Head" in mahogany and Marion Walton's "Head of a Young Man" in cast stone.

Among the sculptural pieces that stand out because, for one thing, of the novel plastic ideas they aim to express, are Hugo Robus's big bronze called "One Who Danced" and the plaster "Stevedores" by John Hovannes. Mr. Robus's powerful form, which apparently represents a hanging, is suspended against a wall and with it is incorporated no indication of the gallows. The "Stevedores" is constructed, as it were, in two "movements"—above, the men themselves; below, an attempted delineation of their reflections in water.

Much the same range of expression is found when we turn to the water-colors, and yet these, if considered collectively, seem to adhere to a basic scheme—that of stentorian pictorial vehemence. There are, to be sure, exceptions, among them Edward Hopper's quietly characteristic "House With a Vine," William C. Palmer's "August Noon, Hickory Park" and the richly, delicately imaginative "Dunes in Destroyed Light," a near-abstraction, by George Grosz.

Other papers of marked merit include those by Charles Burchfield (notably his "Roadside Stream,") Adolf Dahn's "Western Landscape," Ernest Fiene's "Lake George," David Fredenthal's "Chair Mountain," Henry G. Keller's "Fog and Mountain," the "Padua Pastures" by Millard Sheets, L. Jean Liberte's (albeit violent) "Beach at Rockport," Raymond Brainin's "Wanderers" and the excellent non-objective abstraction by John von Wicht entitled "Force."

There are some very interesting drawings, and in the print rooms Grant Wood, Vera Andrus, Lewis C. Daniel, John de Martelly, Wanda Gag, William Gropper, Yasuo Kuniyoshi, Mac Raboy, Georges Schreiber, Raphael Soyer, Benton Spruance and Stow Wengenroth are particularly well represented.

ART: THE WHITNEY

Stress on Fantasy in the Annual Show of Painting—Americans, Modigliani

By EDWARD ALDEN JEWELL

FIRST impressions, I think, are valid as far as they go. In writing about the painting annual at the Whitney Museum in our column of Tuesday last I expressed some amazement at finding the place overrun with various brands of fantasy. Whether we call it surrealism or apply some other comprehensive tag doesn't make a great deal of difference. It remains, as I look back at it now, an experience characterized by a pronounced element of strangeness far removed indeed from the "factual"—though strangeness itself, of course, is a "fact," and as such has its place in our panorama of daily living.

Something has happened to disrupt, for the time being, the "rounded policy" that has hitherto obtained down in Eighth Street. As previously noted, this can be accounted for in two ways. Either a definite idea along the lines just suggested prompted the museum's selections of work by artists invited to participate, or the artists themselves have suddenly found surrealism and abstraction—along with expression that veers toward these categories—of pressing significance. Perhaps both factors have applicability here. That a "rounded" exhibition, representing all "types" of contemporary painting, can be organized was amply proved by the American annual at Carnegie, discussed a few weeks ago.

Interest Seldom Lags

In any event, however compounded, the Whitney annual proves a stimulating affair throughout. That is because it contains so much painting that is truly excellent, without respect to theme. And nearly everything on view, unless my memory be at fault, is here shown for the first time, which creates, to begin with, an air of freshness.

Gallery I springs few surprises, since as usual it is devoted mostly to abstractions or work of a more or less "radical" nature. There are, for instance, abstractions by Walter Quirt, Walter Houmère, Ralston Crawford, Joseph Meert (but his "Color Movement" doesn't get him far), Arthur G. Dove, Karl Knaths, Hananiah Harari, I. Rice Pereira, Balcomb Green, Bradley Walker Tomlin (who maintains a high level of abstract lyricism),

George L. K. Morris and others.

Judson Smith—and this, for him, seems a very distinct departure—offers a "Sunday Morning on the Docks," which, in our black and white reproduction, is seen—by means of block-like simplification of design repeated as reflection in water—to create a definitely abstract effect. By painting in a hypernaturalistic vein, Tully Filmus assigns herself to at least the suburbs of surrealism, where Harold Sterner's severe architectural simplification, with its overtones of almost supernatural stillness, places himself also. Paul Burlin's title gives you a sufficient inkling: "Young Man Alone With His Face." Milton Avery continues his gratifying recent ascent with a striking "Fencers"—neither surrealism nor abstraction, but a long way removed from "naturalism." About the only piece of just plain painting in this room (and good painting, too) is Saul Schary's "Still Life."

The Trail Continues

So far we have encountered the expected. But moving now off from the left of the entrance to the right we are immersed in much the same atmosphere. Weird or openly surrealist stylization abounds, contributed to, in various guise, by Margaret Stark, Theodore Lux, Jan Matulka, Leon Kelly (his "Atlantic Pastorale" appears to be a dance engaged in by bit pieces of dried seaweed—unless it be a dance at the bottom of the sea); Everett Spruce and his strange, harsh "Gravel Pit," surely not of this world; John Atherton, whose house burns in a kind of stylized vacuum; Arthur Osver, Sylvia Fein, Morris Kantor, John E. Heliker. But this isn't all.

Jared French, in a large canvas called "Muscles," makes the anatomical serve his purpose: a disturbing tableau beside Georgia O'Keeffe's calm white "Pelvis With the Moon." Eugène Berman's "Proserpina" broods in a crepuscular murk. Ivan Le Lorraine Albright's "Smaller Than Tears Are the Little Blue Flowers" is typical and has been seen somewhere before.

Arnold Blanch is grotesque, O. Louis Guglielmi fantastic, Karl Priebe delicately and mysteriously charming. Then there are abstractions, among them Loren MacIver's not to my mind very suc-

cessful "Corner of Houston and Bedford," and Carl Holy's pleasant nonobjective "Composition" and Adolph. Gottlieb's "Persephone," which, as abstraction or what you will, holds no meaning for me.

Other Side of the Coin

I could go on an on. citing Harold Black's "Lightning," which seems in some way related to Bohrod; Breinin's "Self Portrait," Paul Cadmus' tiny "Survivor," Philip Evergood's shrieking "Production for Peace," Carl Hall's "Wood Pile," with its odd quality of light; Rico LeBrun's green "Bull Fight" (he ought to be designing for ballet); Mac Le Sueur's "Yellow Leaf," Jack Levine's incarnadined "Street Scene," Molly Luce's "Night Raider," Peppino Mangravite's "Shapes Arise," Anton Refregier's "Supermen," Felix Ruvolo's smart "Gertrude Abercrombie and Karl Priebe," Walter Stuempfig's fabulously romantic "Riverfront" (the ballet ought to get him signed up too); George Grosz's familiar "I'm Glad I Came Back," Max Weber's striking abstract-expressionist "Good News," and a deep-toned "Apparition of Flowers," suspended in space, by Stark Young.

But surely by this time I have conveyed the peculiar flavor of this year's Whitney annual. Is there not another side to the coin? Well, yes. Some names remain, the foreground figures: Eugene Speicher's brilliantly decorative "Bouquet in Yellow Pitcher"; the Paris scene by William Thoeny. who now is more coherent in the phrasing of a recondite decorative idiom; Niles Spencer's undeviating smooth simplification.

William Thon, in "Under the Brooklyn Bridge," keeps fully and splendidly abreast of his own past achievement, which, a few years ago, jolted the art world to admiring applause. Isabel Bishop remains typically pallid. Alexander Brook's deft full-length portrait of Bette Davis (lent by Life Magazine) seems mostly red cloak. The fingernails of James Chapin's "Stricken Clown" dig convulsively into the flesh. Guy Pène duBois' brush retains its cunning. Marion Greenwood's "In the Slaughter House" is a small, lusty canvas.

And, each in its own fashion, Thomas H. Donnelly's "Cape May," Philip Guston's "Holiday," Abraham Harriton's "Hurricane Tree," Mervin Jules' arresting "Carnival," Paul Ullman's quiet "North Stonington," Dorothy Varian's exuberant "Portrait of a Living Room" and Henry Lee McFee's "Still Life," sonorous in its rich color harmonies—these and other works are alive with vision and its confederate. artistry.

WHITNEY PRESENTS MODERN ART SHOW

Museum in Annual Exhibition Offers Display of Work by Contemporary Artists

By EDWARD ALDEN JEWELL

The Whitney Museum, at 10 West Eighth Street, opened with a preview yesterday afternoon its 1946 annual exhibition of contemporary American painting. And this morning's news concerns the fact that the museum has now virtually completed what it so courageously began last year. The swing to the left, too conspicuous to be mistaken in 1945, has at length become almost unanimous. The galleries present a startling panorama indeed; startling in the prevalence of this museum's sponsorship of modernism in its most advanced phases.

These annuals at the Whitney are not juried shows. The work is all invited by Juliana Force, the director, and Hermon More, curator. They alone are responsible for the inclusions. Thus if the exhibition is overwhelmingly modernist it would seem reasonable to suppose that they consider modernism of superlative importance in the American art world today.

Other Types of Art on View

Other types of art are of course produced today. In abundance, as they were in the past. The just-opened show is not representative in that it doesn't pretend to be a cross-section. The closest recent parallel would perhaps be the State Department show organized for travel in Europe and South America, which was deliberately planned as a report on "advanced" tendencies in American painting. So now you will find everywhere, throughout the galleries on both floors of the museum, examples of abstraction (both nonobjective and that based on objects in the natural world), surrealism, expressionism of about every sort conceivable, fantasy, representational painting that is nevertheless far removed from anything acceptable in the realm of right-wing academism, together with a very sparse sprinkling of work that could be called just "naturalistic."

Even those who abhor modernism in most of its manifestations will possibly be disposed to admit that the show does at least look alive. And the modernists themselves, with their ample following, are headed for a field day unprecedented in Eighth Street.

Artists Veer From Middle

Detailed analysis must wait. Meanwhile, it may be mentioned that several artists who had hitherto steered a more or less middle course are here seen to have swerved with the current, moving into stronger modern rhythms and experimenting with greater audacity. Not all of the painters are well represented. In certain instances the results are distinctly disappointing. But the exhibition as a whole reflects excellent judgment on the part of the organizers. And many of the selections are rousingly fine.

The roster is made up of 170 artists. While most of the names are familiar ones, newcomers are not absent from the list. There are also plenty of unexpected omissions, but that is to be expected in an exhibition that aspires to give fresh talents a chance and that must be kept within specified bounds. After all, 170 canvases do not make a show of gargantuan proportions, such as some of those that we get in the course of a season in New York.

Two of the artists whose work was invited—Arthur Dove and Laszlo Moholy-Nagy—died in November, so that their paintings stand as memorial tributes.

The exhibition will continue through Jan. 16. The Whitney is open daily, except Mondays, from 1 to 5. The museum charges no commission on sales.

WHITNEY MUSEUM OPENS ITS ANNUAL

Many Works in Contemporary Display Show Attitude of Artist to Troubled Times

By HOWARD DEVREE

The Whitney Museum opened its 1951 annual of Contemporary American Painting with a preview last evening. Beginning today the exhibition will be open daily except Mondays from 1 to 5 P. M. until Jan. 6.

In his foreword to the catalogue, Hermon More, director, points out that of the exhibitors this year sixty-four have not previously been represented in a Whitney annual and more than 100 of the 150 exhibitors from twenty states are not represented in last year's show. To accomplish this a considerable number of artists who have been regularly represented in a Whitney annual have been omitted this year.

Numerically the exhibitors this time are about equally divided between wholly nonobjectice, abstract, semi-abstract and realistic or expressionist artists. The esthetic left, however, by reason of size of pictures, violence of expression and stridency of color is likely at first glance to be regarded as dominating the show, whatever the numerical quotas. This group of work culminates, perhaps, in Rolph Scarlett's canvas, "Agitation," which is well named.

Beside the vigor of much of the work it is quickly noticeable that many of the pictures with numbers or merely abstract titles unquestionably reflect a highly disturbed emotional attitude on the part of artists toward life today. Much of the work is of molten intensity, far more emotional than emotive, with an outpouring of personal emotion obviously more important to the painter than communication.

Examples of the older geometrical abstraction and variations on it also appear. Much of the best work seems to me to lie in the sector which might be called semi-abstract — in which an abstract approach and organization or handling of forms and colors is evident while representational elements remain important. Except for an occasional ultra-realistic still-life, there is little in the show that does not reflect the changing tides of the art world of the last few years. Symbolism or a somber philosophic content is hinted at in quite a number of the paintings and the recurrence of crystal-like forms or mechanism is also to be noted.

The annual gives renewed evidence of the intensity of the contemporary artists' attitude toward our troubled times and indicates anew how much the horizon of content in painting has been enlarged in the last few years. The Whitney has again put forward a very provocative roundup of today's tendencies.

About Art and Artists

Abstract Paintings Dominate Annual Whitney Show of American Work

By HOWARD DEVREE

THE 1955 version of the Whitney Museum's annuals of contemporary American paintings opens to the public today with one painting by each of 165 artists.

The extremes are represented with a number of realistic canvases looking rather lonely and old fashioned in the midst of a preponderance of nonobjective and abstract-expressionist work. There are a few more or less geometrical abstractions, looking almost as dated as the realistic work, and a few examples of what has been called magic realism or sharp-focus painting.

•

The great majority of the paintings, however, are highly abstract or very, very expressionist, or both. Sheer manipulations of shapes and colors which stop right there are much in evidence, although here and there are examples in which something more or less in the manner opened up by de Kooning by his "Woman" series make their appearance. The chief dependence seems to be on sheer color statements, lurid or dark as the case may be, and the show as a whole is perhaps the most glamorous in effect that the Whitney has ever staged.

About forty artists are exhibiting in a Whitney annual for the first time, but most of them are hardly to be distinguished as introducing much innovation in the event. The cult of the very private statement is widely represented. And large pictures— much too large for any thing they may have to say—make up a considerable part of the show. Coming in the wake of the memorial exhibition of the work of the late Reginald Marsh, the change could hardly be more complete.

•

The exhibition will continue through Sunday, Jan. 8, and will be followed by a retrospective exhibition of paintings by Charles Burchfield. The museum is open daily (admission free) from 1 to 5 P. M. It will be closed Thanksgiving, Christmas and New Year's Day.

Art: A Whitney Annual

Drawings Overshadow Sculpture at Museum Exhibit of 200 Items

By John Canaday
Special to The New York Times.

NEW YORK.

The Whitney Museum of American Art opened its annual show to the public yesterday with a thumping selection of nearly 200 sculptures and drawings. Some years ago the Whitney began limiting its annuals to paintings on alternate years, and sculpture and drawing combined in others. So far, by the evidence of the Whitney annuals, American artists have shown themselves to be better sculptors than painters, and this year they also come through impressively as draftsmen.

American art at the moment is searching for a new balance, with abstraction looking a bit tentative. But abstract sculpture, liberally represented in the Whitney show, forges ahead with increased vigor year by year, and the American figure sculpture was never so nearly swamped by the abstract wave as was American painting.

The Whitney sculpture is executed in practically everything from neon lights, plastics and cardboard to the conventional stone, wood and bronze. The impression throughout is that the sculptors as craftsmen take delight in their materials, which are chosen not for their novelty, but because they expand the means of expression. There is hardly a dull work in the show, although there are two or three that, failing as experiments, could easily be entitled, "Here today and gone tomorrow."

The accompanying show of drawings, however, is the most significant part of the Whitney annual. Making minimum concessions to the drip-and-dribble school that has made the term "drawing" all but meaningless in so many contemporary exhibitions, the museum has selected a group of beautifully skilled and disciplined works, both figurative and abstract, ranging from big names to unknowns. Altogether, this year's annual is the most encouraging in several years as to the healthy state of American art. If next year's painting show is equally sound, we will have nothing to worry about.

1963 ANNUAL

1963

1964

The Whitney Annual, or, How About Next Year?

By JOHN CANADAY

THE Whitney Museum's 1965 Annual Exhibition of Contemporary American Painting opened last week, and turned out to be a rather jumbled affair. But as a cross-section, a jumble is appropriate enough just now, since so many things are going on at once that any cross-section has to be a kind of hash rather than a revelation of logical inner structure. In hanging the show, the museum has made no effort to distinguish between trend and trend, but has just managed to get the 138 paintings by 138 artists on the wall somehow according to size without regard for the strangeness of the bedfellows thus assigned.

Spotted through the exhibition there is a sizeable representation of the old guard who came into prominence during the 1930's, an area where the Whitney is perhaps excessively loyal to a standard list including several painters who are only marking time and one or two who have deplorably gone down hill. On through Pop and Op the expected names are included, and the stylistic conclusion, or temporary conclusion as of 1965, comes with Frank J. Malina's kinetic construction, "Away from the Earth," which combines oil painting with light projection in motion.

Hobbled

The 1965 Annual, all told, is only an adequate show, and "adequate" is not good enough for a museum that has so important a function to perform. But the Whitney has, at present, the best explanation in the world for any shortcomings. To present even an adequate exhibition in such inadequate quarters is a success of sorts, a tribute to human perseverance in the face of predetermined defeat. The cramped and dreary building has not only limited the museum's programs physically but has created, as well, a psychological image of the Whitney as an admirably intentioned but after all rather cramped and dreary institution. The dreadful rooms have reduced first-rate exhibitions to the second-rate by the sheer, inert wooliness of their architectural personality. It is wonderful to realize that the next Whitney Annual will be installed in the new building, can be planned on a more elastic basis, and presumably can be hung to show the selection at its best.

The Whitney Annuals are potentially the most vital exhibitions in this country, in their double character of current summaries and of explorations. The museum's recent statement of its proposed program in anticipation of the move to its new building shows where the potential lies. There will be greater emphasis, they say, on scouting for talent outside New York — meaning, let's hope, scouting not only among the few consequential dealers outside this city (the Whitney already explores the West Coast through dealers in Los Angeles and San Francisco) but scouting, too, in that vast stretch of country where artists who have never been able to find gallery representation anywhere are fighting it out alone and producing work at least as good as half of the paintings in this show.

Dealer's Choice

Few people realize that the New York dealers are the real tastemakers in American art today. As middlemen between the artists and their patrons, whether the patron is a museum or a private collector, the dealer does the scouting and the filtering that used to be the function of the big competitive exhibitions juried by artists and museum curators — exhibitions like the one-time Corcoran annual in Washington, D. C.

The Corcoran used to be a possible proving ground, a free-for-all where established artists might occupy the bulk of the space and carry off most of the prizes, but where a good painting by an unknown had a chance to get in and even to make a sen-coran gave in to the idea (and the arguments in favor of it are strong) that a museum's function is to keep the public abreast of things when things move so fast that you can't keep up with them very far away from Madison Avenue.

The last Corcoran was a group of invited one-man shows, with only a dozen or so paintings voted in from the several thousand that were offered on a competitive basis. For cohesiveness and effectiveness of display it was probably the most successful Corcoran ever, but it was ultimately a dealer-dictated show, since it only offered in museum format the work of artists who had been discovered and developed by dealers.

A good dealer is every bit as valid a judge of painting as a museum curator and probably a less prejudiced one than most artists. He has to have a good eye if he is to survive. But he is also a merchant, no matter how great an idealist he may be at the same time, and to survive he has to have a salable line of goods. With competition what it is, current art has to be merchandised in much the same way as clothes or furniture or anything else that can be sold in profitable volume only by the creation of an artificial market by means of arbitrarily induced changes in fashion. Surely the flaw in the dealer as tastemaker is too obvious to need further elaboration.

The forthcoming (Jan. 20) annual of the Pennsylvania Academy of the Fine Arts in Philadelphia promises a larger percentage of work beyond the main group of invited artists than the Corcoran allowed, but the method of selection is a questionable compromise. To ship pictures for jury consideration is so expensive (the artist has to bear the charges) and handling them literally by the thousands is such a cumbersome task that the preliminary selection is made by lantern slides, which reduce all paintings to the same size, although size is a vital factor in concept. And color slides may outrageously flatter some paintings while murderously deforming others. A few lucky exceptions will come through this pig-in-a-poke process, but the heart of the show will be the paintings chosen by the invitational jury in its series of treks from dealer to dealer along the standard New York route.

There must be a better way to organize a national exhibition than this. There must be a way to bring to the surface the good painters and sculptors (even if they are only dozens, submerged under thousands of mediocrities) who plug away locally and whose potential contribution is never made because their gift is never nourished by attention from the audience every artist needs. The best thing that the Whitney could do as a museum of American art would be to decentralize the annuals.

The selection of a properly national show would be expensive, and might require a full-time curator who would travel for a year. He would have to be a patient man, content to work hard for an occasional find. But how good it would be to have an annual that was not predictable and predigested. If it didn't work, then the whole idea could be abandoned and the entire affair could be turned over to the dealers with the acknowledgment that they are doing their work so effectively that we no longer need museums except as depositories for their decisions.

Art: The Whitney Museum Annual

Not Much New Talent Discovered in '67

By JOHN CANADAY

THE 1967 Whitney Museum of Painting, opening today to continue through Feb. 4, is the biggest yet, with 165 artists represented. It is probably also the most varied, since it attempts to cover the range of current manners in American painting, and these are more numerous than at any other time during the 3 years of the annual's history. However, with "biggest" and "most varied" the superlatives must end. The 1967 annual is neither the best (which one would that be?) nor the worst (numerous candidates here) of the list.

•

Any Whitney Annual is dependent on the merits of the paintings being turned out in the studios at the moment and the willingness of artists and dealers to let their best things go out of the sales rooms—a limitation not often recognized by the public but a cramping one for the people who select the show. Annuals, also, have always been, perforce, selected almost entirely in trips up and down Madison Avenue and to a few New York studios with, possibly, a kind of mail-order consideration of the West Coast. The Whitney has always limped along on inadequate funds, and it is expensive to go around the country in an effort to dig up undiscovered talents.

To dig these up is, as well, either impossible or beyond the capacities of the Whitney's curators and directors, by the evidence of this annual. During the past year they made trips around the country with funds supplied by the Ford Foundation, but the new talents are a disappointing lot. By "new talents" I mean those painters in the annual who have not yet been introduced to New York by dealers, and among this group I could find only naive provincial imitations of current New York sophistications or some more respectable but hardly original reflections of past excitements. But without touring the country himself, a critic cannot know whether this disappointment is the result of creative sterility in the area bounded by the Adirondacks and the Rockies, or an opportunity muffed.

The annual as a whole has changed character with the

Painters of 1950's Now Constitute Old Guard

recognition that American painting now has a new old guard. A number of the painters of the pre-World War II group whom the Whitney has loyally shown year after year have disappeared from the catalogue, although Jack Levine is there to represent them with another of his insistent pleas for attention to social consciousness as American painters understood it in the nineteen-thirties. The old guard is now the group of the fifties, with Helen Frankenthaler graduated from Den Mother to the dignity of Grand Matron of Honor, and her standard group of courtiers ranged around in attendance.

•

Among the younger painters, whether op, pop, hard-edge or art-nouveau-psychedelic, the insistent single quality shared by all is a tight, sometimes slick, impersonal rendering in opposition to the splash, flow and dash of Miss Frankenthaler and her companions. The most complete single contrast in the show is certainly between Miss Frankenthaler's huge and aptly-named "Flood" and Sidney Goodman's solid, powerful "Self-Portrait in Studio." It is a healthful contrast.

Depending on what you ask of painting, one or the other of these two might be the best in the show. To my way of thinking, there is no question which.

1966

The Whitney Annual, or, Take Back Your Muse

By JOHN CANADAY

THE Whitney Annual (full title, Whitney Museum Annual Exhibition of Contemporary American Art) has been held since 1932, which means there have been 38 of them, doesn't it, counting the one that opened last Tuesday. How many of the 38 I have seen I don't know, but it occurred to me, after a couple of days of deep depression following a viewing of this year's, that I must have seen ten in a row in line of duty for The New York Times.

Ten years also means that, averaging at least ten gallery shows a week during the season, I have taken in more than 3,500 of these, perhaps 4,000, most of them one man shows. Add to that the major museum shows, running to maybe a couple of hundred.

Some of these shows, major or minor, big or little, by famous names or by unknowns, have been delightful. As many have been infuriating. A gratifying number have afforded deeply rewarding experiences. Some have been appalling for any one of several reasons, and some have been dull, or at least as dull as is possible for anyone interested in a field where even the dullest painting must have a degree of interest just because it is part of an eternally fascinating matrix.

*

Some shows have been majestic, others ludicrous. But in all these ten years and thousands of shows, I have never before come upon one, until this year's Whitney Annual, that was truly and profoundly and altogether disheartening. So much of it is so bad that it breaks your heart for American painting. It breaks your heart, too, for the Whitney, and you hardly know which is more to blame, the condition of painting at the moment, or the Whitney's way of sizing it up.

John I. H. Baur, the Whitney's director, says that it is no longer possible even to "approximate a cross section of the creative trends of the moment" in a "fair" survey, and that the effort has been to concentrate on "those new directions which seem to be generating the most cre-

ative excitement." As an old-fashioned boy I had always thought that the job of a museum was to evaluate the worth or worthlessness of creative directions, old or new, rather than to serve as an excitement barometer. But this Annual flops by either measure. If you can find any excitement here, let know about it.

There is figurative painting, color field (all over the place, which accounts for a lot of the non-excitement), a couple of semi-porny male nudes just to show that the Whitney is right in there with 42nd Street (neither painting is good enough to justify its inclusion on any other score) and there are eleven black artists—although the Whitney has had the grace not to attach signs saying "black artist" to the frames. (I don't know which paintings these are.) More than half the artists are under the age of 35 (youth cult), which is dandy when the artists are any good but is a feeble standard for selection in itself, and I left the building with the impression that there was hardly a good painting on the two floors that the show fills.

This is not true, whether you are talking about good examples by Isabel Bishop and Raphael Soyer, who are tucked off in a corner as the Whitney's annual reminder that here today and gone tomorrow is not the universal rule in American art of this century, or some 20 or 30 good paintings of all types that can be winnowed from the 143 on view. But the good is obliterated by the exhibition's over-all lack of conviction, which haunts it.

*

Before reading Mr. Baur's disclaimer, quoted above, I had decided that he was trying to give a fair shake to all the contradictory elements in American painting that are, actually, its strength at the moment but which become, at the Whitney, symptoms of confusion and pretension. There is a sense of straining and getting nowhere that is shared by the big names (look at the Jasper Johns—and this is an artist usually filled with grace, if with nothing else) as well as

with nothing else) as well as by the newcomers. And there are too many newcomers who add nothing of their own. Barnett Newman and Kenneth Noland shine like beacons when thus surrounded by feebler lights. Hollow, hollow, hollow. An dstale, stale, stale.

*

But I do not believe, really, that American painting is as bad as all that—I know it isn't—in either its conservative or its so-called exciting manifestations. There is better painting, much better, than has found its way into the Annual. I have seen it. Trudging around your 300 or 400 shows a year you see a lot of trash and get discouraged, but when you look back over the season you realize that there was enough good to make it all worth while, some of it by new names, some by old.

What happened to the best en route to the Whitney? I don't think I was only out of sorts, nor do I think that the fact that some of the paintings were not hung, but leaning against the walls, when I saw the show, could have affected my reaction. (Actually, this is rather a pleasant way to see a show, and I see many that way.) The inescapable conclusion is that either Mr. Baur and his colleagues who selected this Annual don't know anything about painting, or else that I don't. Of course there is always the chance that we are both off base.

*

The 1969 Annual is typified for me by a billboard of a calamity called "Return of the Muse" by Paul Georges. Mr. Georges is a painter who can be very good, and I would certainly include him in any Annual I selected, but "Return of the Muse" is a dreadful picture — wretchedly drawn, sloppily painted, and ill designed. With flirtatious references to Courbet's "Burial at Ornans" and "The Artist's Studio" it is archly conceived as a Salon piece destined for the Whitney's contemporary equivalent. There are many large paintings in the show that echo the old Salon idea, come to think of

it. And I am told that "Return of the Muse" is supposed to reflect the return to painterly painting that is supposed to dominate this year's Annual. There's nothing I'd welcome with opener arms. But oh, this is an awful picture. And oh, it should never have fooled Mr. Baur or whoever. And oh, oh, oh—what's wrong at the Whitney?

All in All, Whitney Museum Annual Is Best in Years

By JOHN CANADAY

All in all, which means making the most of its virtues and the least of its shortcomings, the 1972 Annual, which opened at the Whitney Museum of American Art yesterday, is the best in years. It scores about 50-50 between paintings you're glad to see there and paintings you'd like to junk, which is fair enough, since no two people would junk the same half. So let's accept it—with relief, for the annuals lately have been sorely, and justly, belabored.

There is a lot of figurative painting here, some of it by now-classic masters such as Philip Pearlstein and Alfred Leslie, and a lot of it by a very accomplished cell of neophytes. But if the exhibition as a unit indicates a general trend in American painting, it is not so much a return to the figure as it is a general tightening up, a new respect for discipline even in the forms of abstraction that used to be the most free-wheeling. The perspiration-inspiration quotient is much better balanced than it used to be.

●

That the Whitney has managed to put on an acceptable annual this year, after 40 years of trying, is even more surprising than the recent series of sad annuals makes it. John I. H. Baur, the Whitney's director, points out that the variety of styles in which an increasing number of serious artists are working makes it impossible even to approximate a cross section of what American painters are up to today. But the real hurdle that stands in the way of a first-rate annual is not mentioned. This is that quality can no longer be the first consideration in the selection of more than a fraction of the show.

Unpublicized is the fact that the museum went out of its way to include a large number of black and women painters. Sticking my poor old white male neck out a mile, I suggest that while there are first-rate black painters and first-rate women painters, the only obligation of curators in selecting an exhibition should be to look at work unprejudiced by sex or color. All the yapping that goes on about the inclusion of militant groups is the introduction of prejudice rather than its elimination, and is implicitly a confession that the groups regard themselves as not up to scratch and hence eligible for a generous handicap.

●

Leave social injustice out of it. That is a different matter and there are great amends to be made. But the whole thing is vicious in art, where the best guarantee of equal - reward-for-equal-work is anonymous submission. Handicaps are all very well in amateur sports, but they should not be granted in esthetic evaluations. God knows, we have enough amateurs as it is.

These comments are made without checking on which paintings in the Whitney show are by artists of which sex or which color. "It's the principle of the thing," as the outmoded saying goes. Because after all, principles determine results.

To get back to where we started, it's not a bad annual, under the circumstances.

Whitney Biennial Replaces Annual

The Whitney Biennial, a massive survey of contemporary art, will open next month in three stages at the Whitney Museum of American Art, 945 Madison Avenue at 75th Street. The Biennial comprising both painting and sculpture, replaces the museum's Annual, which presented the two media in alternate years. The show will occupy all five floors of the Whitney.

On view will be the work of relative unknowns as well as that of established artists whose work has changed in ways that contribute to the development of modern art. Exhibitors are chosen by the museum's curatorial staff. In lieu of prizes, a number of works are customarily bought for the museum's permanent collection. Most of the works exhibited will be for sale.

The opening and closing dates for the Biennial, by floor, are: Garden and First Floor (Jan. 10-March 4); Second and Third Floors (Jan. 17-March 11), and Fourth Floor (Jan. 25-March 18).

1973

This Whitney Biennial Is As Boring As Ever

t will hardly be a surprise to anyone, I suppose, to hear that the 1977 Whitney Biennial Exhibition, now occupying the bulk of the gallery space at the Whitney Museum of American Art, is an unendurable bore. Most of us have learned—oh, how we have learned!—to expect little or nothing from these periodic attempts to summarize what is happening in contemporary American art. Recent experience gives us ample reason to know in advance that the specialty of these shows—the thing that gives them their special quality and flavor—is a surpassing esthetic boredom. They seem to be governed by a positive hostility toward— a really visceral distaste for—anything that might conceivably engage the eye in a significant or pleasurable visual experience.

The Whitney curators leave one with the impression that they approach their task with only one purpose in mind: to display their own bewilderment and confusion. These the public is invited to share, and the result is supposed to provide us with some sort of index of current artistic accomplishment. What a comedy!

The current installment of this Biennial farce has some special features of its own, to be sure. (When it comes to being boring, the Whitney staff is inexhaustibly inventive.) Someone on the staff has discovered—God help us!—photography. Naturally, it is the most boring of photographs that are favored. And to insure that these photographs will not engage our interest in even the most minimal way, they are installed at the Whitney in the most boring way, with no sense of scale, and no sense of how a photographic image addresses the eye. With friends like the Whitney curators, contemporary photography needs no enemies.

• • •

The accent elsewhere in the exhibition, too, is on art deliberately selected to have the most minimal effect on our sensibilities. The sculpture is, for the most part, confined to tiny bits of wood or metal scattered around very large gallery spaces. Barry Le Va is given an entire gallery for his boring bits of wood ("Wooden markings on the walls and floor . . . a purely intellectual system of geometry established by coordinates, in part physical and in part conceptual," as the catalogue text informs us), and Bruce Nauman is given another for his boring little stumps of solid

steel plate each a few inches high ("Fourteen rhombohedrons in three shapes," for those keen to keep score on such things).

Michael Heizer, however, gives us a kind of "garden" of large, polished granite elements that do engage the eye and that occupy their allotted space with a certain authority. But this work, entitled "Circle," is a kind of distant cousin to a great many larger and more ambitious works by a far greater artist, Isamu Noguchi, who is not represented in the exhibition. So the public is given no opportunity to see what Heizer's work looks like in the presence of a real master of his genre.

• • •

This appears to be the principle that operates throughout this Biennial. We are expected to suffer the same kind of amnesia that so conspicuously afflicts the curators who selected it. But even in this respect, there is no discernible consistency. On the one hand, we are told—by no less an authority than Tom Armstrong, the bemused director of the Whitney—that this Biennial is devoted "for the most part to work by artists who were first decisively influential in the 1970's, and also to comparably important work of a number of lesser-known artists." On the other hand, we are given three big paintings by Alfred Jensen (born 1903), whose work has been visible on the New York scene for many years, and three constructions by H. C. Westermann (born 1922), a familiar presence wherever contemporary art is shown in museums the country over.

There are other familiar names, of course, both among younger and older artists—Agnes Martin, Robert Ryman, Richard Serra, Dorothea Rockburne, Brice Marden, Duane Hanson, Chuck Close and Richard Estes. Minimal abstraction and Superrealism are the favored styles—these, I suppose, are taken to be the quintessential styles of the 70's—and very little that falls between these extremes is admitted. Perhaps the styles that fall between these extremes fail to meet the requisite criterion of extreme boredom.

There is also a sampling of what are called "relics," which are nothing but the physical remains of highly publicized events of the art world. Chris Burden is the reigning genius of this dismal genre, and we are given (among other inanities) two "Nails" from some idiotic episode in his idiotic career ("I lay on my back over the rear section of

the car, stretching my arms on to the roof. Nails were driven through my palms into the roof of the car," etc.) The nails are now in the collection of Jasper Johns.

Still, much as the Whitney staff resists the idea, there must occasionally be something to look at, even in a Whitney Biennial, and so we have a bit of mock theater and a tableau environment, and of course a good deal of video. The entire first-floor gallery is given over to Dennis Oppenheim's "Lecture," which consists of rows and rows of miniature chairs, each 18 inches high, with a tiny mechanical figure behind a lectern delivering a lecture by means of a tape. We observe the scene, we hear the lecture, but we cannot sit down to hear it. Terrific, eh? Then there is a high-spirited environment by Ree Morton, called "Signs of Love," all plastic roses and ribbons and ladders and bushel baskets, with even a few simple-minded paintings thrown in for good measure. It is said to be a great hit with the schoolchildren who are marched through the Whitney for the purposes of cultural enlightenment. Well, at least it is something to look at.

● ● ●

About the video art, incidentally, I cannot report. Much as I try to look at it, I find it has the effect upon me of a very strong sleeping potion. To explore this art would, in my case, require stronger doses of a drug to keep me awake than I am prepared to take.

As a measure of the real accomplishments of American art at the present moment, the show is a joke, of course. But the joke is not new. It is the kind of joke the Whitney has made familiar to us, again and again. Except on those occasions when the museum invites a guest curator (usually Jean Lipman) to organize a large exhibition on a historical subject, the Whitney nowadays gives the impression of being totally devoid of serious direction or taste. I am sure the curators believe in what they are doing, but what they are doing is, for the most part, a disaster, a libel and a misrepresentation of the art they are responsible for showing us. The responsibility for this muddled policy is, however, Mr. Armstrong's. He is no longer the new boy at the Whitney; he has been director long enough to be held accountable. Yet he gives no sign of being guided by any discernible standard of seriousness. Instead of upholding such a standard, the Whitney under his direction looks more and more like an institution against which the interests of art must be energetically defended.

For those who want to see the evidence, the Biennial remains on view through March 27, with parts of it remaining through April 3. The Sallek Chemical Company has bravely supported the show with a financial grant.

1983

1987

1989

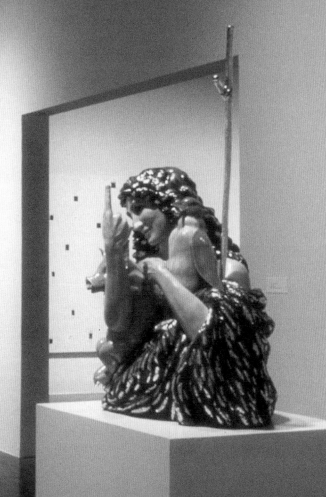

At the Whitney, Sound, Fury and Not Much Else

By MICHAEL KIMMELMAN

THE WHITNEY BIENNIAL HAS NOT SPONTA-neously brought about world peace and racial harmony, as it seems hellbent on proving it can do, but it has accomplished one minor diplomatic coup. It has brought various New York critics of usually discordant opinions into rare harmony: at the least, they dislike it.

I hate the show. I had hoped, after some weeks had passed and the smoke had cleared, to discover gems left in the rubble. But it turns out I became increasingly depressed by the exhibition, partly because the few good works in it — those of Cindy Sherman, Nan Goldin, Janine Antoni, Kiki Smith, Ida Applebroog, Gary Hill and some others — are so diminished by the grim circumstances in which they have been placed. There's virtually no sensitivity to art that demands a certain silence and space around it, art that aspires to something more than political sloganeering and self-indulgent self-expression.

One is supposed to credit the Whitney for doing with this Biennial what has been prescribed in the past: replacing the old selection-by-committee process with a single curator, in this case Elisabeth Sussman, who has veto power over the committee. The goal was to provide a more focused exhibition as well as one harder to identify with (read: blame on) the whole institution.

The show, which includes works by 82 artists, is certainly more focused — but focused in that it consists almost entirely of art that addresses political and social issues, not in the more important sense that it discriminates in its judgment. Ms. Sussman has apparently concluded that discrimination sounds suspiciously elitist.

In a preface to the catalogue, David Ross, the Whitney's director, pays lip service to the idea of a museum as a "sanctuary for a war-weary world." And the introductory wall text explains that "the strength of this art lies not only in its engagement with contemporary issues but also in its commitment to esthetic concerns." Neither statement is borne out by what is displayed.

The show is full of works that bring to mind gigantic gift boxes, filled with tissue paper and tied with ribbons, containing plastic Cracker Jack prizes. Typical is a towering translucent reproduction by Bruce Yonemoto, Norman Yonemoto and Timothy Martin of an Easter Island sculpture, onto which clips from television shows are projected to make a point about — you guessed it — ecology, colonialism and consumerism. I think this scam explains much of what angers people: the stark imbalance between the medium and the message. If the Whitney was so intent on mounting a show that confronted social and political issues, why didn't it present a survey of political cartoons? The work would have been more direct, lighter on its feet, more accessible, defter visually, and certainly more amusing.

Calling them gift boxes is not meant to imply works well or beautifully made. They are emphatically not well made, for the most part, relying on that tired excuse — that crudeness and tawdriness are deliberate expressions of raw emotion as well as of disdain for elitist values. When one thinks of effective political art from the past — by artists like Goya, Courbet, Daumier, Picasso, Rivera, and John Heartfield, whose marvelous photomontages are now on exhibit at the Museum of Modern Art, and even by contemporary

of Modern Art, and even by contemporary artists like Anselm Kiefer — one realizes how flimsy this excuse is. There is virtually nothing in the Biennial that encourages, much less rewards, close observation. There's certainly little of the satire and irony crucial to artists like Daumier and Heartfield, or to a contemporary artist like Christian Boltanski. Wit, as something that flatters a viewer's intelligence and acknowledges a work's own limitations, seems alien to most of the Biennial's participants.

It's hard not to identify this Biennial with the Whitney as a whole, since the museum has once again committed every floor in the building to the show (conspicuously leaving no room for the permanent collection, despite all the pious talk at the museum about how much it prizes its collection). There is pressure to have big biennials, no doubt. Bigness helps to attract people and media coverage, and the Whitney has boasted of the large crowds and widespread coverage that this Biennial has generated. I thought the departure of Tom Armstrong as director was supposed to signal the end of such showbiz standards at the Whitney. If the museum can't change its own way of thinking, how can it presume to lecture anyone else about changing theirs?

■

I imagine that many have left the Biennial, as I have, feeling battered by condescension. The show implies that anyone who disagrees with what is on view is morally suspect — as if the people who go to the Whitney are so witless and backward that they need to be told that sexual abuse and racism and violence are bad. The messages, even when larded with references to once-fashionable French philosophers, are rarely deeper. Or as if a Neanderthal would change his mind after being forced, like a penitent, to don one of the infamous admission badges that say "I can't ever imagine wanting to be white" and then being bullied and harangued by one sensationalistic image after another of wounded bodies, heaving buttocks, plastic vomit and genitalia. (I didn't actually count, but there seem to be more penises than female breasts on view, especially considering all the ones in Glenn Ligon's piece that appropriates photographs of male nudes by Robert Mapplethorpe. With the bean-counting mentality prevalent at the Whitney, one wonders whether this wasn't deliberate.)

The show also indulges in the absurd pretense, in its way deeply provincial, of novelty. Although many of the artists are not widely known (and there has been an effort, transparent in its by-the-numbers approach, to include lesser-knowns), much of this work is already familiar — even from the last Whitney Biennial. It is as if the fourth floor of that exhibition, featuring young artists, had been expanded to encompass the whole museum.

This show actually seems a bit out of date already, and I interpret the negative critical consensus as an indication that people's knees may finally be stiff from jerking at works of art that assume a high moral ground but provide zero visual pleasure. As if pleasure were a sin: the Biennial may be the best illustration yet that the Puritanism of

Many works suggest giant gift boxes, filled with tissue and tied with ribbons, containing plastic Cracker Jack prizes.

the left is not so far, after all, from the Puritanism of the right.

What is so daring about putting on view the kind of material that has been ubiquitous in galleries in New York and countless smaller exhibitions for several years? Why yet another crushingly pedantic Fred Wilson installation, for example, this one including reproductions of Egyptian art in mock-museum displays, all in order to rehash simplistic points like "art museums are built on the plunder of the rich and powerful"? Who needs a room-sized installation by Hillary Leone and Jennifer Macdonald consisting of 55 branding irons hung from the ceiling and muslin-covered bed frames hung on the walls and marked by what looks like brands (they are actually shorthand symbols) to be told that people are branded by their sexuality?

Following the Zeitgeist seems in no fundamental way a different procedure from the one that prevailed in previous biennials. It that is the function of the biennial, so be it. But don t act as though heroism were involved. It would be far riskier to put together an exhibition of contemporary painting — one that argued for art's power to change the world without depending on slogans and sermons — when the trendsters have declared painting dead yet again.

It's interesting to compare the artists in this show with the muralists of the 1930's, whose paintings were at once so visually rich and so accessible to a wide audience. It's also interesting to compare the "activism" of the Biennial participants with the actions of artists in the late 1960's and early 1970's who raised many of the same issues. There's nothing new about the debates over sexual and racial representation in museum collections or over the political role of artists and artistic institutions. But 20-odd years ago, the goals of artists, even though unrealized, involved setting up community centers in underprivileged neighborhoods to encourage the study of art. Now they involve making works that are indecipherable to most people and whose impact extends no further than the sanctified walls of the museum.

Context means a lot, as the Whitney knows well. To see this sort of work in a gallery is one thing; to see it in the Biennial touted as a kind of standardbearer of the era is more than most of the art can bear. It's certainly more than I could bear. □

A Remembrance of

Whitney Biennials Past

BY ROBERTA SMITH

I T MAY BE THE EXHIBITION THAT NEW YORK loves to hate, but the world would be a duller place without the Whitney Biennial to kick around every two years. This informative, if hardly infallible, barometer of contemporary art has been part of the scene since 1932; its latest incarnation, which will include 80 artists, will arrive on Thursday.

Over the years, the biennial has undergone major and minor adjustments. For the first decade, the artists invited selected their own works for the show, until it was noticed that instead of choosing their best efforts they sometimes sent pieces that were for sale. Beginning in 1937, the museum held two annuals a year — painting in the fall, and sculpture and other media in the spring. Not surprisingly, the exhibition became a regular event for many American artists: Georgia O'Keeffe was in 22, Charles Sheeler in 29 and Raphael Soyer, maybe the record-holder, was in 38.

In 1959, the museum slowed its pace a bit, alternating between painting and sculpture each year. Then, in 1973, the shows were consolidated into a single every-other-year exhibition, and the Whitney Biennial as we know it began to take shape.

Not that that shape has been constant. In a perpetual process of self-correction and revision, the show continues to be re-formed, re-thought and re-focused. In the 1970's it was fairly low-key, an exhibition by which the art world took stock of itself. But with the thriving art market and dueling megatrends of the 1980's, it became increasingly ambitious and, thanks to the growth of installation art, physically elaborate, if not overbearing. Needless to say, it also metamorphosed into a major media event,

Continued on Page 31

ART VIEW

Biennials Past: From Blue Chip to Subversive

Welcome to the 70's

The response to this biennial, which focuses on "artists who had their first decisive influence in the 1970's," is less unanimously negative. In The New York Times, Hilton Kramer's review carries the headline "This Whitney Biennial Is as Boring as Ever." But in New York magazine, Thomas B. Hess calls it "the best of its kind ... at least since 1946." (That was the year Jackson Pollock made his Whitney debut.) The show shrinks to 2 floors, 40 artists and 17 video artists. It is again a youngish show: 40 of the 57 artists are under 40.

In the catalogue, the curators proffer essays justifying their selections, while the show itself attempts a loose and partial map of burgeoning reputations and trends of the 70's. From the Minimal-Conceptual-installation Art nexus, there is Robert Ryman, Brice Marden, Mel Bochner, Dorothea Rockburne, Vito Acconci and Barry Le Va. In opposition is the more accessible, touchy-feely strains of semi-representation that will culminate in the museum's "New Image Painting" show in 1979 — exemplified by Nicholas Africano, Joe Zucker, Elizabeth Murray, Jennifer Bartlett, Ree Morton and Joel Shapiro. Photo Realism gets a nod (Richard Estes, Chuck Close), as does photography (Duane Michals, Lewis Baltz).

Correcting the sins of the 1975 biennial, the few artists from outside New York, among them John Baldessari, Vija Celmins, Chris Burden, Jim Nutt and Joan Brown, have sizable reputations. Lawrence Alloway complains that the majority of artists are represented by a handful of New York galleries.

1979:
The 70's, Only More So

The biennial gets big again, or at least bigger, expanding to 88 artists. It recapitulates many of the trends of the previous biennial, only with more and somewhat different names. The representation of women, 33 percent, is unusually high as biennials go. New Image is now a force, as is Pattern painting, represented by Kim MacConnel, Rodney Ripps and Joyce Kozloff. Martin Puryear and Susan Rothenberg are newcomers. Nobody ventures explanatory essays in the catalogue this time.

The 67-year-old painter Philip Guston, whose new figurative style is exerting a growing influence on younger artists, makes his first appearance since 1966. Also present are established artists like Lucas Samaras, Alex Katz, Ellsworth Kelly, Roy Lichtenstein and Philip Pearlstein. In some ways this show establishes a mixture of hip and blue chip that will inform many subsequent biennials.

The collectors Donald and Mira Rubell, dismayed that the museum tends to serve hot dogs and bad wine at biennial openings, hold the first of their postopening parties in their Upper East Side brownstone.

1981:
This Time They Really Mean It

Yet again the biennial reprises the basic styles of the 70's, using the entire museum to showcase 115 artists. The show emphasizes painting and, consequently, has an unusually spacious look. In an innovation that will never be repeated, outdoor installations

garnering admiration, indifference and outrage — especially outrage. Here is a rundown of the highlights of the last 20 years.

1973:
Together Again

The Whitney puts it all together, combining painting and sculpture annuals into one big ur-biennial that fills all five floors of its seven-year-old Marcel Breuer building on Madison Avenue at 75th Street. With 221 painters and sculptors, of which nearly 70 are biennial first-timers, the show is two to three times the size of future biennials.

A number of critics make a point of mentioning the show's pluralism, as if 221 artists could be anything but diverse. It is neither hated nor loved, although Lawrence Alloway observes in The Nation that "the mixture seems more than twice as bad as when the two media were shown apart." The selection ranges through several generations, embracing older, established artists like Jasper Johns, Robert Rauschenberg, Louise Nevelson, Joan Mitchell, Milton Resnick and Robert Motherwell, but also relative youngsters like Elizabeth Murray, Harriet Korman, Louise Fishman, Peter Campus, Terry Allen and Barbara Kruger (who at this point in her career practices a form of early Pattern painting).

A sign of the future is an installation piece that seems to lay siege to the museum. Rafael Ferrer's "Puegian House With Harpy Eagle," which is mentioned in nearly every review, consists of a teepee, piles of leaves and, when it's cold enough, cakes of ice. It commandeers the pedestrian bridge at the museum's front door. A sign of the past is the modest catalogue, which offers no essay, reproduces work by only 61 of the artists, and lists each artist's address for the convenience of collectors.

1975:
Are You Experienced?

In an attempt to make the show more independent of the New York art scene and market, the Whitney curators try something completely different: this biennial includes only artists who have never been in a Whitney biennial (or annual) or who have not had a solo show in New York in the past decade. In the kindest review, in Art in America, Amy Goldin dubs it "The Virgins' Show," but it is otherwise widely disliked.

Again the whole museum is filled, this time with the work of 147 artists, many from out of town. It includes 18 working in video, also a biennial first. The artists' average age is just under 30. The artists' addresses disappear from the catalogue, ending a 40-year tradition, but they all get photographs. Critic after critic points out that while the artists are unfamiliar, their work is not: much of it consists of weak imitations of more famous colleagues. (There are lots of Brice Marden look-alikes, for example.) Among the adjectives critics used to describe the show: "indulgent," "well-meaning," "muddleheaded," "frustrating," "uninspired," "disappointing," "dull." Emily Genauer's review in Newsday appeared under the scolding headline "Boring, Childish, Awful." Many "virgins" are never heard from

again; others become quite experienced, including Robin Winters, Ross Bleckner, Kim MacConnel, Scott Burton, Andrew Spence, Earle Staley, Charles Simonds, Alexis Smith, Judy Rifka, Allan McCollum, David Reed and Judy Pfaff.

by nine sculptors are shown on a slide projector, leading one critic to wonder if the entire exhibition might not be presented in slide form

Hilton Kramer finds the show "extremely boring" and "occasionally repulsive." In New York magazine, Kay Larson calls it "safely gold-plated." In fact, it is the first biennial to have a corporate sponsor, the American Can Company.

Although artists like Joel Shapiro, Jennifer Bartlett, Elizabeth Murray and Richard Serra are by now old biennial hands, some first-timers, like Julian Schnabel, Jedd Garet, Robert Mapplethorpe and Robert Wilson, hint of things to come.

1983:
O.K., the 70's Are Over

Basically, this is the end-of-pluralism, beginning-of-Neo-Expressionism biennial, the one that introduces the new, often figurative painting of the 80's It is also the first seriously multimedia biennial: its 36 painters, sculptors and photographers are balanced by 35 artists in film, video and installation. And it is unusually well liked, with Kay Larson calling it "the best I've ever seen."

It's a youthful show, with more than half the artists in their 20's or 30's and represented for the first time Among them are many soon-to-be-big names of the 80's: Jean Michel Basquiat, Eric Fischl, David Salle, Robert Longo, Keith Haring, Jenny Holzer, Mark Tansey and Cindy Sherman. Barbara Kruger is back, this time as a photographer. As a sign of the shift toward figurative images and politics, the painter Leon Golub is in his first biennial since 1955.

1985:
Where the Wild Things Are

The most widely disliked biennial since 1975, this show legitimizes the East Village art scene and is consistently regarded as a childish free-for-all, characterized by garish installations. That's not the whole story, but the only eminences in sight are Jasper Johns, Donald Judd and Bruce Nauman.

The show anoints Pictures Art, photo-fluent and socially critical, with Cindy Sherman and Barbara Kruger being joined by Richard Prince, Sherrie Levine, Jack Goldstein, James Casebere, Sarah Charlesworth and Laurie Simmons.

Other artists making their biennial debuts are East Village denizens like David Wojnarowicz, Kenny Scharf (whose relentlessly attacked installation turns the second-floor telephone booths and restrooms into a fluorescent jungle), Tom Otterness (whose frieze of small copulating figures also elicits wide comment), Todt and Rodney Alan Greenblat (who also contribute elaborate set pieces)

In Time magazine, Robert Hughes calls the show "the worst in living memory," while Kim Levin in The Village Voice labels it "a compendium of the safe, the predictable, the already seen."

1987:
Pop Goes the Simulacrum

This biennial anoints Neo-Geo, with Jeff Koons, Peter Halley, Philip Taaffe, Annette Lemieux and Nancy Dwyer among the artists making their debuts In so doing, it recognizes the new penchant for

operating in the gap between Pop, Minimalism and Conceptual Art Perhaps in honor of the interest in appropriation, the catalogue has an imitation plywood-print cover, it also has color reproductions for the first time The show has the dubious distinction of putting the Starn Twins on the map and the images of the fashion photographer Bruce Weber on the wall.

Many critics take retroactive potshots at the 1985 biennial and especially at poor Kenny Scharf, but they tend to like the show "The 1987 Whitney Biennial has learned a little discretion," writes Kay Larson, while Robert Hughes says that "the 1987 version is in some ways among the best." The Guerrilla Girls, an anonymous watchdog group of art-world women, take exception to the fact that only 24 percent of the show's artists are women. Their retort is "The Guerrilla Girls Review the Whitney," a show at a downtown alternative space called the Clocktower, that features big charts and graphs tracing the percentages of nonwhite artists and women in biennials since 1973

1989:
Almost Like a Virgin

The biennial's reputation takes another dip with this quiet show, in which the museum tries to stake out new territory and make up for past oversights. Nearly 40 percent of the 76 artists are women and approximately two-thirds are new to the biennial, including Donald Baechler, Martha Diamond, Meg Webster, Matt Mullican, Mark Innerst and Ashley Bickerton. But the show's chief distinction is to introduce the work of Robert Gober, Mike Kelley and Liz Larner, whose efforts eschew the hard machine-made look of much Neo-Geo and frequently evoke the body.

For the first time, the catalogue cover is designed by an artist, Christopher Wool, who specializes in stenciled lettering. Its stark black-on-white design signals an undernourished presentation, riddled with colorless art. "The patient is dangerously pale and thin," writes Kay Larson, while an unsigned review in The New Yorker states that "not-since the early 1970's has contemporary American art looked so pale."

1991:
Sobering Up for the 90's

At the start of the "we're sorry" decade, the Whitney returns to the size and breadth of biennials past, giving older artists their due while also embracing more completely the new political and esthetic subversiveness among younger ones The exhibition swells once again to more than 100 artists and fills the entire museum. All generations are welcomed Back once more are old hands like Robert Rauschenberg, Cy Twombly, Ellsworth Kelly, Roy Lichtenstein and Philip Pearlstein, who haven't seen the inside of a biennial in 10 years or more. Not only that, each generation — old hands, youngish hands and new hands — has a separate floor, a tactic that is not universally appreciated. The catalogue, with 392 pages and weighing three pounds, is the biggest ever

As if to distance itself from 1989, 1991 has the lowest rate of repeaters: only Mike Kelley and Robert Gober are asked back from the preceding biennial, and they function as presiding influences for the "kids' floor." Here the first-timers include Kiki Smith, Jessica Diamond, Rona Pondick, Cady Noland, Glenn Ligon and Nayland Blake. References to race, sexuality, AIDS and the body are prevalent, dispersed installation pieces known as scatter art are acknowledged; and the anti-esthetic of ugly art and pure thoughts begins.

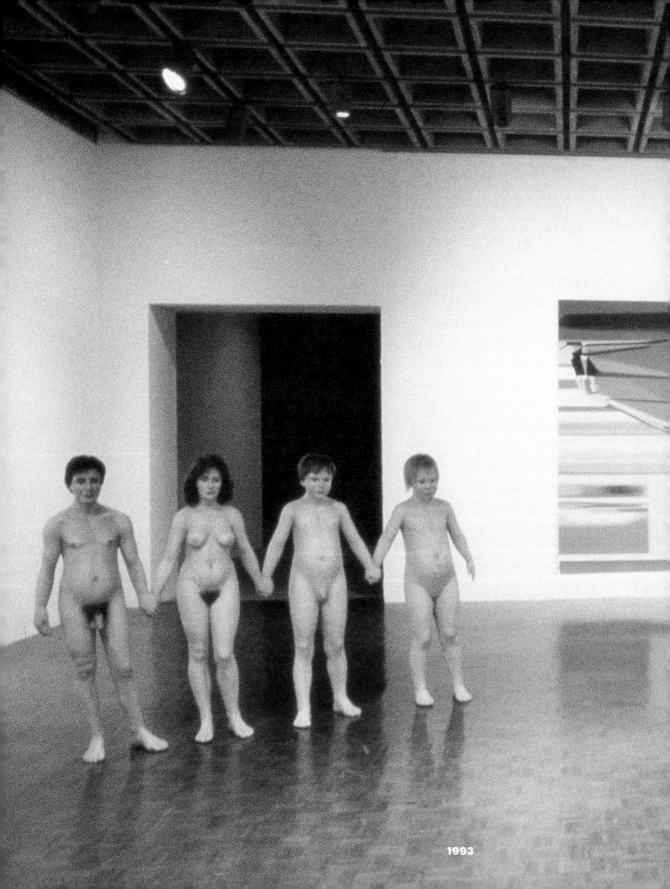

1993

2000

ART REVIEW

BIENNIAL 2006

Short on Pretty, Long on Collaboration

By MICHAEL KIMMELMAN

THERE are plenty of people rooting for this latest Whitney Biennial, hoping it recalibrates the image of the art world as something other than youth-besotted and money-obsessed. It's a start, just barely. I imagine it will provoke much head scratching by uninitiated visitors. This typically huge exhibition is very much an insider's affair, a hermetic take on what has been making waves. It will seem old hat to aficionados and inscrutable to many others

Maybe it's impossible, or impossible for the Whitney, to do a show today that doesn't seem beholden to fashion and, for art world types, familiar. Francesco Vezzoli's movie-star-studded version of a trailer for Gore Vidal's "Caligula" was a one-note gag when it was screened at the Venice Biennale; it's a tired joke the second time around.

A biennial can have many purposes. This one is partly about preaching to the converted. It is packaged — branded might be the better word — as a show long on collaboration and open-endedness: several shows under one roof. But it has other goals, too. You wouldn't say bliss is one of them. Not much in it leaps out as simply beautiful, with a few exceptions. Paul Chan's digital animation orchestrates images of shadowy objects like cellphones and bicycles, floating upward, Wizard of Oz-like, while bodies tumble down, the work cast as if it were light from a tall window slanting onto the floor of a dark room.

Day for Night
Whitney Biennial

And Pierre Huyghe's film, shot in Antarctica and Central Park, is really gorgeous: crosscut between day and night, fiction and reality, it encapsulates the show's operative — but ultimately airy — metaphor about the slippery state of art now. ("Day for Night" is the biennial's first-ever title, after the François Truffaut film.)

If the exhibition is short on easy pleasures, of course nobody said art had to be easy. The organizers are Chrissie Iles and Philippe Vergne. European-born,

they've brought in many foreigners (the traditional Americanness of the show long ago ceased to have meaning), and they recognize, which Americans are often reluctant to do, that the flow of influence has been going both ways across the Atlantic for a while. The impact of Europeans like Martin Kippenberger and Thomas Schütte on a young sculptor in the biennial like Matthew Monahan, from Los Angeles, is obvious. A bohemian favorite like the German-born Jutta Koether, who's also here, looms big for many art kids now, which is the reason she is included, although I must say it's hard to see why from her work in the show.

A contingent of other bohemians and gypsies (Kenneth Anger, Taylor Mead, Michael Snow, Sturtevant, Dorothy Iannone, Ira Cohen, the late Ed Paschke) receive their due. Mr. Anger, the occultist filmmaker and dishy "Hollywood Babylon" author, gets a virtual mini-retrospective with a screening of his hallucinatory Mickey Mouse short. A pair of Mr. Cohen's trippy light-box photographs, like several of Mr. Mead's cartoony drawings, are slight, but they should at least alert people to these visionary, underground personalities.

The last biennial was ingratiating, an upbeat truce brokered by a troika of curators, including Ms. Iles, which aimed at a broad public, as most biennials do. It was colorful, pleasing, not particularly taxing on the eye or brain, but clever and full of nifty, crafty objects, with enough oddball inclusions, crusty old-timers and resuscitated reputations to satisfy mild skeptics.

In retrospect that show dovetailed with a gathering tsunami of newly rich, clueless collectors infatuated with bright, neatly made, vision-free art, some of it groovily retro-chic (lots of outwardly snappy, vaguely melancholic 60's-style psychedelia with dystopian vibes; "collectives" became a buzzword again).

During the intervening months, virtuosic ditties by 20-somethings came to look more and more familiar and strategically inappropriate, including to savvy money types who run the art business and know the pitfalls of bad marketing. Among other things, the art world, or a conspicuous part of it, seemed tactlessly out of touch with a larger world going to hell. Then last year came "Greater New York," P.S. 1's nearly pedophilic riff on a biennial, to which the current Whitney effort seems an unspoken response.

Collectives are a big selling point to counter perceptions of rampant materialism and star-driven commerce. From the pseudonymous Reena Spaulings, the collective and downtown gallery which now has something of the celebrity and success it ostensibly critiques, there is a shop awning, the cheap kind slapped above all those fly-by-night phone stores and costume-jewelry shops along Canal Street, partly obliterating the letters of a Whitney donor's name emblazoned above the fourth-floor elevators.

The artists Mark di Suvero and Rirkrit Tiravanija have revived Mr. di Suvero's 1960's "Peace Tower": they've commissioned colleagues, who in turn invited friends, to devise two-foot-square panels, minimanifestos or whatever the artists

wanted, which hang on and around what resembles a giant Tinkertoy construction rising from the Whitney's courtyard beside the museum entrance.

"Down by Law," yet another group show within the biennial, with a stress on identity politics, is organized by the fashionable Wrong Gallery, whose principals include Maurizio Cattelan, Massimiliano Gioni and Ali Subotnick.

Conservatives — also citing Richard Serra's "Stop Bush" poster, antiwar programming from Deep Dish Television Network and three videos by the group Critical Art Ensemble, including one about the tribulations of its own Steven Kurtz, a Buffalo artist indicted by a federal grand jury for obtaining biological materials — will no doubt dismiss the whole exhibition as another political show like the 1993 biennial.

But this show's not like that one, which went out of its way to thumb its nose at many people. "Down by Law" is a disappointment because it's bland. And "The Peace Tower" is old-school civic protest, almost quaint — a genuine, albeit predictable response to what's going on in the world that makes no claims to being anything other than what it is. And why shouldn't artists get together to say something about war and peace, in the midst of war, if there is an opportunity like the biennial?

"The Peace Tower" is ad hoc. The whole ethos of the show is provisional, messy, half-baked, cantankerous, insular — radical qualities art used to have when it could still call itself radical and wasn't like a barnacle clinging to the cruise ship of pop culture.

That was back in the 1970's. Urs Fischer, taking off from what Gordon Matta-Clark did then, chops huge, irregular holes in a couple of the show's walls; like Mr. Serra in the old days, tossing hot lead, he also drips wax from candles perched on rotating tree branches (the effect is mildly meditative) to make rings on the floor. Lucas DeGiulio, from San Francisco, scavenges homely bits of twigs, bottle glass and old cans to make assemblages that summon up memories of Robert Smithson, Paul Thek and Bruce Conner.

The 1970's was the last time you might say there was a true downtown scene as opposed to an uptown scene, and money wasn't so prevalent. Today, when there are all sorts of constituencies and markets for all sorts of art, which all belong to the larger commercial world, art now is close to the fashion industry — at the cost of modernism's traditional outsider role. Artists don't have the luxury of placing themselves in opposition to a clear status quo. It is the crisis of new art.

In reaction, you get characters like Anthony Burdin, recouping 70's recording technologies and making himself into a West Coast vagabond version of the late Swiss shaman Dieter Roth: Mr. Burdin reputedly

lives in a beat-up 1973 Chevy Nova and shoots shaky videos of himself, singing and drumming over classic rock tracks, driving around, crawling through skanky drain pipes (shades of Matthew Barney). He is

like the wandering minstrel of slackerdom, a newfangled art star, declining to be seen (thereby enhancing his aura); and his installation here — an old wood shack, the springs of a mattress, a spindly drawing and a video of his exertions — is at once ridiculous and mesmerizing.

Gedi Sibony, another player on the scene, contrives a room-size environment out of carpet scraps, planks, masking tape and whispering bits of blue paint, positioned just so. He riffs on Richard Tuttle. Mr. Sibony hadn't clicked for me before, but the work here has a kind of grace.

I am also taken by Cameron Jamie, reared in Los Angeles, now living in Paris, whose subjects are mostly weird folk rituals. His film in the biennial (he shot it in 2002-3) documents a gang of marauders dressed in horned Wookiee-like outfits, donning bells made of soldered old Army helmets, flanked by St. Nick. Apparently it's a Christmas tradition in rural Austria. The shaggy creatures assault partygoers and menace children. With a pounding soundtrack by the Melvins, the film squares the expressionist legacy of senior troublemakers like Paul McCarthy and Mike Kelley with earlier avant-garde documentarians, from the late 60's and 70's, like Vito Acconci and Yoko Ono.

Much else here summons up thoughts of that same era. Seventies photography, for example, in Amy Blakemore's fuzzy pictures of suburbia, in Rodney Graham's experimental cinema, in Rodney Graham's hypnotic, rather sculptural room in which he shows a film of a spinning chandelier (shot in sumptuous 35-millimeter).

And 70's music. I can hardly count the artists who are musicians or whose works are collaborations with musicians Tony Conrad, Jim O'Rourke, Daniel Johnston, T. Kelly Mason, Spencer Sweeney, Steven Parrino. Parrino died last year. His enameled black-and-white paintings — like works by Malevich, if Malevich had come from the East Village — are uncompromising, and they were underrated when vacuous decoration came into vogue recently. I'm glad they have a spot here.

As for Mr. Johnston's cartoonish drawings, only a handful are on view, and they don't quite live up to their hype, but he's an original, and there's more to him than the biennial can show. It's also good that Paschke, who died in 2004, has his day. Extending the heritage of Chicago eccentrics, his funky paintings establish their own definition of beautiful.

The biennial, as I said, is otherwise not long on beauty. But a few more works deserve singling out. Florian Maier-Aichen's Technicolor vistas of Los Angeles, digitally cooked up to suggest romantic landscape

More to Explore

"Whitney Biennial 2006: Day for Night" runs through May 28 at the Whitney Museum of American Art, 945 Madison Avenue, at 75th Street. Events this weekend in conjunction with the biennial include a discussion tomorrow night at 6 with curators and artists represented in the display; fee: $8 (members, students and 62+, $6); registration, (212) 570-7715. In addition, the first in a series of film and video screenings begins tomorrow at 2 p.m. with "Meditation on Violence" (1948), directed by Maya Deren, and "Sufferers' Version" (2004), directed by Mathias Poledna. Film screenings are included in museum admission: $15, students and 62+, $10 The museum is open Wednesdays and Thursdays, 11 a.m. to 6 p.m.; Fridays, 1 to 9 p.m. (6 to 9 p.m. pay-what-you-wish); and Saturdays and Sundays, 11 a.m. to 6 p.m. Film schedule and other information: (800) 944-8639 or www.whitney.org.

paintings, were over the top in his recent show at 303 Gallery in Chelsea. But the ones here are not.

Angela Strassheim stages painstaking portraits of her evangelical family. She photographed her dead grandmother in her casket and her brother-in-law combing his son's hair before a mirror. They're surreal pictures, candy colored and strangely loving.

And I'm willing to give Hanna Liden's photographs of purported pagan rituals in Scandinavian forests the benefit of the doubt, although formally speaking they're not particularly novel.

Finally, nods to a few veterans: Dan Graham, Rodney Graham, Laurent P. Berger and Tony Oursler, working with the band Japanther, devised a live puppet opera, "Don't Trust Anyone Over 30." It went on tour. Here it is reconfigured (Mr. Oursler seems the major player, along with Dan Graham) as a blissed-out, abstract video.

Robert Gober's grainy black-and-white photographs from a trip to Jones Beach in the 1970's are sun-bleached and haunted. He has restaged a few of them, inserting odd bits and pieces, including a newspaper clipping about a man murdered because he was believed to be gay. The works are tender, but also like the evidence of some mysterious, horrible crime.

Lastly, Troy Brauntuch, a painter of the 80's, gets a fresh look. His Conté-crayon drawings of shirts stacked on store shelves and of his girlfriend's coat on a chair are dark, delicate and hard to read in black-blues and white-grays. The obvious connection is to Gerhard Richter's photo-based paintings, but Mr. Brauntuch's works come from his own memory bank. In the context of this biennial, they are exquisite and grave.

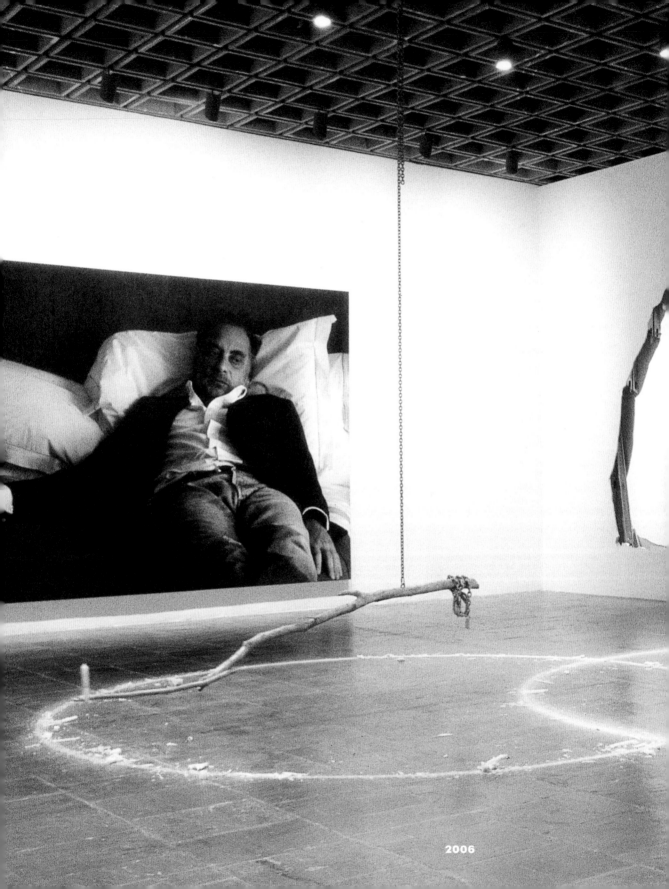

2006

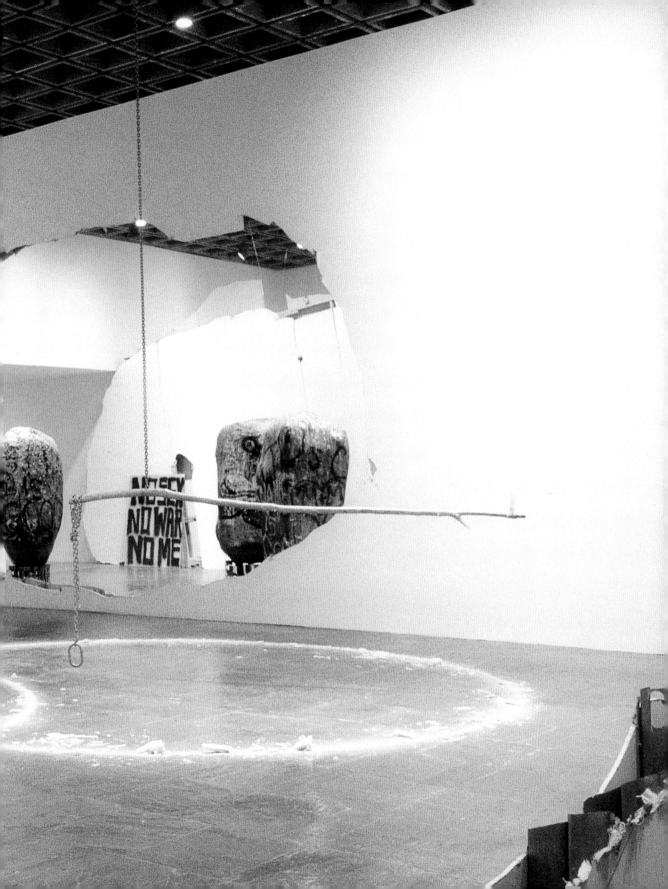

2008

WHITNEY BIENNIAL 2008

Artists
Rita Ackermann
Natalia Almada
Edgar Arceneaux
Fia Backström
John Baldessari
Robert Bechtle
Walead Beshty
Carol Bove
Joe Bradley
Matthew Brannon
Bozidar Brazda
Olaf Breuning
Jedediah Caesar
William Cordova
Dexter Sinister
Harry Dodge and
 Stanya Kahn
Shannon Ebner
Gardar Eide Einarsson
Roe Ethridge
Kevin Jerome Everson
Omer Fast
Robert Fenz
Coco Fusco
Gang Gang Dance
Amy Granat and
 Drew Heitzler
Rashawn Griffin
Adler Guerrier
M. K. Guth
Fritz Haeg
Rachel Harrison
Ellen Harvey
Mary Heilmann

Leslie Hewitt
Patrick Hill
William E. Jones
Karen Kilimnik
Alice Könitz
Louise Lawler
Spike Lee
Sherrie Levine
Charles Long
Lucky Dragons
Daniel Joseph Martinez
Corey McCorkle
Rodney McMillian
Julia Meltzer and
 David Thorne
Jennifer Montgomery
Olivier Mosset
Matt Mullican
Neighborhood Public
 Radio (NPR)
Ruben Ochoa
DJ Olive
Mitzi Pederson
Kembra Pfahler/
 The Voluptuous Horror
 of Karen Black
Seth Price
Stephen Prina
Adam Putnam
Michael Queenland
Jason Rhoades
Ry Rocklen
Bert Rodriguez
Marina Rosenfeld
Amanda Ross-Ho
Mika Rottenberg
Heather Rowe
Eduardo Sarabia
Melanie Schiff
Amie Siegel
Lisa Sigal
Gretchen Skogerson
Michael Smith
Agathe Snow
Frances Stark
Mika Tajima/New Humans
Javier Téllez
Cheyney Thompson
Mungo Thomson
Leslie Thornton
Phoebe Washburn

James Welling
Mario Ybarra Jr.

Curators
Henriette Huldisch
Shamim M. Momin

2006

WHITNEY BIENNIAL 2006 DAY FOR NIGHT

Artists
Jennifer Allora and
 Guillermo Calzadilla
Dawolu Jabari Anderson
Kenneth Anger
Dominic Angerame
Christina Battle
James Benning
Bernadette Corporation
Amy Blakemore
Louise Bourque
Mark Bradford
Troy Brauntuch
Anthony Burdin
George Butler
Carter
Carolina Caycedo
The Center for Land
 Use Interpretation
Paul Chan
Lori Cheatle and Daisy Wright
Ira Cohen
Martha Colburn
Dan Colen
Anne Collier
Tony Conrad
Critical Art Ensemble
Jamal Cyrus
Miles Davis

Deep Dish Television Network
Lucas DeGiulio
Mark Di Suvero and
 Rirkrit Tiravanija
Peter Doig
Trisha Donnelly
Jimmie Durham
Kenya Evans
Urs Fischer
David Gatten
Joe Gibbons
Robert Gober
Deva Graf
Dan Graham, Tony Oursler,
 Rodney Graham, Laurent
 P. Berger, and Japanther
Rodney Graham
Hannah Greely
Mark Grotjahn
Jay Heikes
Doug Henry
Pierre Huyghe
Dorothy Iannone
Matthew Day Jackson
Cameron Jamie
Natalie Jeremijenko/Bureau
 of Inverse Technology
Daniel Johnston
Lewis Klahr
Jutta Koether
Andrew Lampert
Lisa Lapinski
Liz Larner
Hanna Liden
Jeanne Liotta
Marie Losier
Florian Maier-Aichen
Monica Majoli
Yuri Masnyj
T. Kelly Mason and
 Diana Thater
Adam McEwen
Taylor Mead
Josephine Meckseper
Marilyn Minter
Momus
Matthew Monahan
JP Munro
Jesús "Bubu" Negrón
Kori Newkirk
Todd Norsten

Jim O'Rourke
Otabenga Jones
 and Associates
Steven Parrino
Ed Paschke
Mathias Poledna
Robert A. Pruitt
Jennifer Revves
Richard Serra
Gedi Sibony
Jennie Smith
Dash Snow
Michael Snow
Reena Spaulings
Rudolph Stingel
Angela Strassheim
Zoe Strauss
Studio Film Club
Sturtevant
Billy Sullivan
Spencer Sweeney
Ryan Trecartin
Chris Vasell
Francesco Vezzoli
Kelley Walker
Nari Ward
Christopher Williams
Jordan Wolfson
The Wrong Gallery
Aaron Young

Curators
Chrissie Iles
Philippe Vergne

2004

Artists
Marina Abramovic
Laylah Ali
David Altmejd

Cory Arcangel/BEIGE
assume vivid astro focus
Hernan Bas
Dike Blair
Jeremy Blake
Mel Bochner
Andrea Bowers
Slater Bradley
Stan Brakhage
Cecily Brown
Tom Burr
Ernesto Caivano
Maurizio Cattelan
Pip Chodorov
Liz Craft
Santiago Cucullu
Amy Cutler
Taylor Davis
Sue De Beer
Lecia Dole-Recio
Sam Durant
Bradley Eros
Spencer Finch
Rob Fischer
Kim Fisher
Morgan Fisher
Harrell Fletcher and
 Miranda July
James Fotopoulos
Barnaby Furnas
Sandra Gibson
Jack Goldstein
Katy Grannan
Sam Green and Bill Siegel
Katie Grinnan
Wade Guyton
Mark Handforth
Alex Hay
David Hockney
Jim Hodges
Christian Holstad
Roni Horn
Craigie Horsfield
Peter Hutton
Emily Jacir
Isaac Julien
Glenn Kaino
Mary Kelly
Terence Koh
Yayoi Kusama
Noémie Lafrance

Lee Mingwei
Golan Levin
Sharon Lockhart
Robert Longo
Los Super Elegantes
Robert Mangold
Virgil Marti
Cameron Martin
Anthony McCall
Paul McCarthy
Bruce McClure
Julie Mehretu
Jonas Mekas
Aleksandra Mir
Dave Muller
Julie Murray
Julie Atlas Muz
Andrew Noren
Robyn O'Neil
Catherine Opie
Jim O'Rourke
Laura Owens
Raymond Pettibon
Elizabeth Peyton
Chloe Piene
Jack Pierson
Richard Prince
Luis Recoder
Liisa Roberts
Dario Robleto
Matthew Ronay
Aïda Ruilova
Anne-Marie Schleiner,
 Brody Condon,
 and Joan Leandre
 (the "Velvet-Strike" team)
James Siena
Amy Sillman
SIMPARCH
Zak Smith
Yutaka Sone
Alec Soth
Deborah Stratman
Catherine Sullivan
Eve Sussman
Julianne Swartz
Erick Swenson
Fred Tomaselli
Tracy and the Plastics
 (Wynne Greenwood)
Jim Trainor

Tam Van Tran
Banks Violette
Eric Wesley
Olav Westhalen
T. J. Wilcox
Andrea Zittel

Curators
Chrissie Iles
Shamim M. Momin
Debra Singer

2002

Artists
Peggy Ahwesh
Bosmat Alon and Tirtza Even
José Alvarez
Maryanne Amacher
Archive: Chris Kubick and
 Ann Walsh
Irit Batsry
Robert Beavers
Zoe Beloff
Sanford Biggers and
 Jennifer Zackin
Susan Black
Jeremy Blake
AA Bronson
James Buckhouse
Javier Cambre
Jim Campbell
Peter Campus
Vija Celmins
Chan Chao
Richard Chartier
Tony Cokes
Stephen Dean

Destroy All Monsters
 Collective
Keith Edmier
Omer Fast
Vincent Fecteau
Ken Feingold
Robert Fenz
Mary Flanagan
Glen Fogel
Forcefield
Benjamin Fry
Brian Frye
David Gatten
Joe Gibbons
Luis Gispert
Gogol Bordello
Janine Gordon
Alfred Guzzetti
Trenton Doyle Hancock
Rachel Harrison
Tim Hawkinson
Arturo Herrera
Evan Holloway
Dennis Hopper
Peter Hutton
Ken Jacobs
Christian Jankowski
Lisa Jevbratt/C5
Yun-Fei Ji
Chris Johanson
Miranda July
Yael Kanarek
Margaret Kilgallen
Kim Sooja
Diane Kitchen
John Klima
Mark LaPore
Robert Lazzarini
John Leaños
Margot Lovejoy
Vera Lutter
Christian Marclay
Ari Marcopoulos
Bruce McClure
Conor McGrady
Meredith Monk
Julie Moos
Tracie Morris
Mark Napier
Robert Nideffer
Andrew Noren

DJ Olive
Josh On and Futurefarmers
Roxy Paine
Hirsch Perlman
Leighton Pierce
William Pope.L
Praxis: Delia Bajo and
 Brainard Carey
Seth Price
Walid Ra'ad/The Atlas Group
Luis Recoder
Erwin Redl
Marina Rosenfeld
The Rural Studio
Salon De Fleurus
Keith Sanborn
Peter Sarkisian
Judith Schaechter
Collier Schorr
Chemi Rosado Seijo
silt
Lorna Simpson
Kiki Smith
Gerry Snyder
Stom Sogo
Phil Solomon
Scott Stark
Steina
Brian Tolle
Rosie Lee Tompkins
Lauretta Vinciarelli
Stephen Vitiello
Chris Ware
Ouattara Watts
Peter Williams
Anne Wilson
Lebbeus Woods
Fred Worden
Zhang Huan
John Zurier

Curators
Lawrence R. Rinder
Chrissie Iles
Christiane Paul
Debra Singer

2000

Artists
Dennis Adams
Doug Aitken
Ghada Amer
Mark Amerika
Lutz Bacher
Craig Baldwin
Lew Baldwin
Rina Banerjee
Rebecca Baron
Vanessa Beecroft
Rolf Belgum
Ben Benjamin
Sadie Benning
Robin Bernat
Linda Besemer
Dawoud Bey
Jeremy Blake
Chakaia Booker
M. W. Burns
Cai Guo-Qiang
Ingrid Calame
Luis Camnitzer
Jem Cohen
John Coplans
Petah Coyne
John Currin
E. V. Day
William De Lottie
Roman De Salvo
Thornton Dial
Kim Dingle
Anthony Discenza
Tara Donovan
Nathaniel Dorsky
James Drake
Theresa Duncan

Leandro Erlich
Fakeshop
Vernon Fisher
Suzan Frecon
Brian Fridge
Dara Friedman
Joe Gibbons
Robert Gober
Jill Godmilow
Ken Goldberg
Kojo Griffin
Joseph Grigely
Hans Haacke
Trenton Doyle Hancock
Joseph Havel
Salomón Huerta
Arthur Jafa
Michael Joo
Kurt Kauper
Silvia Kolbowski
Harmony Korine
Louise Lawler
Ruth Leitman
Annette Lemieux
Les LeVeque
Sharon Lockhart
Anne Makepeace
Iñigo Manglano-Ovalle
Joseph Marioni
Josiah McElheny
Franco Mondini-Ruiz
Errol Morris
Mandy Morrison
Vik Muniz
Shirin Neshat
Nic Nicosia
Paul Pfeiffer
Carl Pope
Walid Ra'ad
Marcos Ramírez Erre
Jennifer Reeder
Laurie Reid
Kay Rosen
Michal Rovner
®™ark
Katherine Sherwood
John F. Simon Jr.
Al Souza
Darcy Steinke
Elisabeth Subrin
Chris Sullivan

Sarah Sze
Tran, T. Kim-Trang
Richard Tuttle
Ayanna U'Dongo
Chris Verene
Annette Weintraub
Yvonne Welbon
Krzysztof Wodiczko
Yukinori Yanagi
Lisa Yuskavage

Curators
Michael Auping
Valerie Cassel
Hugh M. Davies
Jane Farver
Andrea Miller-Keller
Lawrence R. Rinder

1997

Artists
Doug Aitken
Roman Anikushin and
 Bob Paris
Michael Ashkin
Robert Attanasio
Burt Barr
Zoe Beloff
Douglas Blau
Louise Bourgeois
Chris Burden
Bureau of Inverse Technology
Charles Burnett
Vija Celmins
Abigail Child
Francesco Clemente
Bruce Conner

Bryan Crockett
Philip-Lorca diCorcia
Cheryl Dunye
Sam Easterson
Wendy Ewald
William Forsythe
Leah Gilliam
Michael Gitlin
Felix Gonzalez-Torres
Dan Graham
David Hammons
Ken Jacobs
Ilya Kabakov
Martin Kersels
Annette Lawrence
Iara Lee
Zoe Leonard
Sharon Lockhart
Charles Long and Stereolab
Kristin Lucas
Kerry James Marshall
Antonio Martorell
Paul McCarthy
Christopher Münch
Bruce Nauman
Gabriel Orozco
Tony Oursler
Laura Parnes
Jennifer Pastor
Raymond Pettibon
Richard Prince
Charles Ray
Jason Rhoades
Matthew Ritchie
Aaron Rose
Edward Ruscha
John Schabel
Katy Schimert
Glen Seator
Paul Shambroom
David Sherman
Shahzia Sikander
Shashwati Talukdar
Diana Thater
Cecilia Vicuña
Kara Walker
T.J. Wilcox
Sue Williams
Robert Wilson
The Wooster Group

Curators
Lisa Phillips
Louise Neri

1995

1995 BIENNIAL EXHIBITION

Artists
Peggy Ahwesh
Karim Aïnouz
Lawrence Andrews
David Armstrong
Hima B.
Matthew Barney
James Bishop
Roddy Bogawa
Gregg Bordowitz
Stan Brakhage
Emily Breer
Peter Cain
Shu Lea Cheang
Cheryl Donegan
Stan Douglas
Carroll Dunham
Nicole Eisenman
Jeanne C. Finey and
 Gretchen Stoeltje
Jane Freilicher
Julio Galán
Ellen Gallagher
Harry Gamboa Jr.
Joe Gibbons
Nan Goldin
DeeDee Halleck
Thomas Allen Harris
Bessie Harvey
Todd Haynes
Peter Hutton
Ken Jacobs

Jim Jarmusch
Tom Kalin
Mike Kelley and
 Paul McCarthy
Toba Khedoori
Lewis Klahr
David Knudsvig
Harriet Korman
Greer Lankton
Elizabeth LeCompte /
 The Wooster Group
Barry Le Va
Siobhan Liddell
Judy Linn
Andrew Lord
Brice Marden
Agnes Martin
David McDermott and
 Peter McGough
Frank Moore
Stephen Mueller
Catherine Murphy
Frances Negrón-Muntaner
Andrew Noren
Catherine Opie
John O'Reilly
Gabriel Orozco
Raphael Montañez Ortiz
Jack Pierson
Lari Pittman
Scott Rankin
Charles Ray
Michael Rees
Milton Resnick
Sam Reveles
Jason Rhoades
Nancy Rubins
Robert Ryman
Peter Saul
Christian Schumann
Richard Serra
Cindy Sherman
Margie Strosser and
 Peggy Ahwesh
Philip Taaffe
Diana Thater
Leslie Thornton
Rirkrit Tiravanija
Alan Turner
Cy Twombly
Willie Varela

Jeff Wall
Nari Ward
Lawrence Weiner
Sue Williams
Terry Winters
Andrea Zittel
Joe Zucker

Curator
Klaus Kertess

1993

1993 Biennial Exhibition

Artists
Janine Antoni
Ida Applebroog
Charles Atlas
Matthew Barney
Sadie Benning
Camille Billops and
 James Hatch
Roddy Bogawa
Chris Burden
Peter Cain
Sophie Calle and
 Greg Shepherd
Peter Campus
Christine Chang
Shu Lea Cheang
Maureen Connor
DANCENOISE: Anne Iobst
 and Lucy Sexton
Julie Dash
Cheryl Dunye
Jimmie Durham
Jeanne C. Finley
Holly Fisher
Andrea Fraser

Kip Fulbeck
Miguel Gandert
Ernie Gehr
Robert Gober
Nan Goldin
Marga Gomez
Guillermo Gómez-Peña
 and Coco Fusco
Jean-Pierre Gorin
Renée Green
Michael Joaquin Grey
 and Randolph Huff
Gulf Crisis T.V. Project
Barbara Hammer
Gary Hill
George Holliday
William Jones
Mike Kelley
John Kelly
Karen Kilimnik
Byron Kim
Elizabeth LeCompte /
 The Wooster Group
Spike Lee
Zoe Leonard
Leone and Macdonald
Simon Leung
Glenn Ligon
James Luna
Daniel J. Martinez
Robbie McCauley
Suzanne McClelland
Trinh T. Minh-ha
Donald Moffett
Christopher Münch
Not Channel Zero
Pepón Osorio
Raymond Pettibon
Jack Pierson
Lari Pittman
Lourdes Portillo
Mark Rappaport
Charles Ray
Jonathan Robinson
Alison Saar
Allan Sekula
Peter Sellars
Cindy Sherman
Gary Simmons
Lorna Simpson
Kiki Smith

Nancy Spero
Janice Tanaka
Julie Taymor
Francesc Torres
Willie Varela
Bill Viola
Mac Wellman
Marco Williams
Pat Ward Williams
Sue Williams
Fred Wilson
Kevin Wolff
Bruce Yonemoto,
 Norman Yonemoto,
 and Timothy Martin

Curators
Thelma Golden
John G. Hanhardt
Lisa Phillips
Elisabeth Sussman

1991

BIENNIAL

Artists
Vito Acconci
Peggy Ahwesh and
 Keith Sanborn
Carlos Alfonzo
Lawrence Andrews
Ida Applebroog and Beth B.
Gregg Araki
Charles Atlas
Jennifer Bartlett
Ericka Beckman and
 Mike Kelley
Nayland Blake
Hans Breder

Chuck Close
Tony Cokes and
 Donald Trammel
John Coplans
Zeinabu Irene Davis
Jessica Diamond
Juan Downey
Carroll Dunham
Jeanne Dunning
Steve Fagin
Eric Fischl
Bill Fontana
Su Friedrich
Dawn Fryling
Adam Fuss
Joseph Glasco
Robert Gober
Felix Gonzalez-Torres
Vanalyne Green
Group Material
Peter Halley
Keith Haring
Gary Hill
Roni Horn
Peter Hutton
Wendy Jacob
Luis Jimenez
Jasper Johns
Larry Johnson
Joan Jonas
Tom Kalin
Alex Katz
Mike Kelley
Ellsworth Kelly
Mary Kelly
Lewis Klahr
Louise Lawler
Roy Lichtenstein
Glenn Ligon
Donald Lipski
Jennie Livingston
Sally Mann
Christian Marclay
Victor Masayesva Jr.
David McDermott and
 Peter McGough
John Miller
Richard Misrach
Joan Mitchell
Meredith Monk
Aimee (Rankin) Morgana

Ed Moses
Celia Alvarez Muñoz
Antonio Muntadas
Elizabeth Murray
Bruce Nauman
Cady Noland
Pat O'Neill
Philip Pearlstein
Ellen Phelan
Rona Pondick
Rebecca Purdum
Yvonne Rainer
Alan Rath
Robert Rauschenberg
Marlon Riggs
Tim Rollins and K.O.S.
Allen Ruppersberg
David Salle
Joseph Santore
Thomas Lanigan Schmidt
Julian Schnabel
Jim Shaw
Cindy Sherman
Laurie Simmons
Lorna Simpson
Kiki Smith
Philip Smith
Warren Sonbert
Pat Steir
Frank Stella
Jessica Stockholder
Philip Taaffe
Rea Tajiri
Janice Tanaka
Mark Tansey
Francesc Torres
Cy Twombly
Alex Webb
Carrie Mae Weems
David Wojnarowicz

Curators
Richard Armstrong
John G. Hanhardt
Richard Marshall
Lisa Phillips

1989

Artists
Jane Aaron
Eleanor Antin
John Arvanites
Donald Baechler
Cindy Bernard
Ashley Bickerton
Ross Bleckner
Hans Breder
Chris Burden
Michael Byron
Abigail Child
Christine Choy and
 Renee Tajima
Saint Clair Cemin
Constance De Jong
Martha Diamond
Nathaniel Dorsky
Daniel Eisenberg
Kate Ericson and
 Mel Ziegler
Ken Feingold
Su Friedrich
Robert Gober
April Gornik
Larry Gottheim
Sachiko Hamada and
 Scott Sinkler
Barbara Hammer
Mary Heilmann
Gary Hill
Mark Innerst
Jon Jost
Mike Kelley
Linda Klosky
Jeff Koons

Liz Larner
Erik Levine
Sherrie Levine
Chip Lord
Christopher MacDonald
Brice Marden
Victor Masayesva Jr.
Allan McCollum
Sherry Millner and
 Ernest Larsen
Sandy Moore
Matt Mullican
Joan Nelson
Andrew Noren
Deborah Oropallo
Tony Oursler
Nam June Paik
Hirsch Perlman
Martin Puryear
Charles Ray
David Reed
Martha Rosler
Julia Scher
Joel Shapiro
Jason Simon
Cary Smith
Ray Smith
Andrew Spence
Rea Tajiri
Leslie Thornton
Francesc Torres
Steina Vasulka
Woody Vasulka
Joan Wallace and
 Geralyn Donohue
Michael Wallin
Meg Webster
William Wegman
Christopher Wool
Tom Wudl
Michele Zalopany

Curators
Richard Armstrong
John G. Hanhardt
Richard Marshall
Lisa Phillips

1987

BIENNIAL
1987

WHITNEY MUSEUM OF AMERICAN ART

Artists
Richard Artschwager
Tina Barney
Judith Barry
David Bates
Ericka Beckman
James Benning
Alan Berliner
Stephanie Beroes
Ross Bleckner
Peer Bode
Louise Bourgeois
Joan Braderman
Hans Breder
John Chamberlain
Clegg and Guttmann
George Condo
Willem de Kooning
Juan Downey
Nancy Dwyer
Steve Fagin
R. M. Fischer
Louise Fishman
Ernie Gehr
Paul Glabicki
Shalom Gorewitz
Dan Graham
Robert Greene
Peter Halley
Barbara Hammer
Robert Helm
Gary Hill
Neil Jenney
Roberto Juarez
Leandro Katz
Jeff Koons

Joseph Kosuth
Ernest Marrero and
 Susan Kouguell
Barbara Kruger
Annette Lemieux
Sol LeWitt
Robert Lobe
Jim Lutes
David McDermott and
 Peter McGough
Nina Menkes
Sherry Millner
Trinh T. Minh-Ha
Stephen Mueller
Bruce Nauman
Nam June Paik
Izhar Patkin
Judy Pfaff
Lari Pittman
Richard Prince
Yvonne Rainer
Rachel Reichman
Martha Rosler
Edward Ruscha
Robert Ryman
Alan Saret
Matthew Schlanger
Julian Schnabel
Warren Sonbert
The Starn Twins
Donald Sultan
Skip Sweeney
Philip Taaffe
Richard Tuttle
Bill Viola
Bruce Weber
Grahame Weinbren and
 Roberta Friedman
Terry Winters
Bruce Yonemoto and
 Norman Yonemoto

Curators
Richard Armstrong
John G. Hanhardt
Richard Marshall
Lisa Phillips

1985

Artists
Jane Aaron
Gregory Amenoff
Doug Anderson
Robert Ashley
Charles Atlas
John Baldessari
Ericka Beckman
Dara Birnbaum
Lyn Blumenthal
Lizzie Borden
Robert Breer
Jo Anne Carson
James Casebere
Sarah Charlesworth
Douglas Davis
Juan Downey
John Duff
Carroll Dunham
Ed Emshwiller
Ken Feingold
Eric Fischl
Holly Fisher
Morgan Fisher
Charles Garabedian
Jedd Garet
Jill Giegerich
Nan Goldin
Jack Goldstein
Larry Gottheim
Rodney Alan Greenblat
Group Material
Doug Hall
Gary Hill
Perry Hoberman
Jenny Holzer
Robert Hudson

Bryan Hunt
Peter B. Hutton
Ken Jacobs
Jasper Johns
Joan Jonas
Donald Judd
Pooh Kaye
Mike Kelley
Mel Kendrick
Jon Kessler
Ken Kobland
Barbara Kruger
Robert Kushner
Sherrie Levine
Kim MacConnel
Frank Majore
Robert Mangold
Sheila McLaughlin
Sandy Moore
Elizabeth Murray
Bruce Nauman
John Newman
Tom Otterness
Ed Paschke
Liz Phillips
Richard Prince
Dan Reeves
Peter Rose
Elisabeth Ross
Susan Rothenberg
David Salle
Kenny Scharf
Cindy Sherman
Laurie Simmons
Ned Smyth
Warren Sonbert
James Surls
Robert Therrien
Lynne Tillman
TODT
Woody Vasulka
Bill Viola
Terry Winters
Joel-Peter Witkin
David Wojnarowicz
Robert Yarber
Bruce Yonemoto and
 Norman Yonemoto

Curators
Richard Armstrong
John G. Hanhardt
Barbara Haskell
Richard Marshall
Lisa Phillips
Patterson Sims

1983

Artists
Richard Artschwager
John Baldessari
Jean-Michel Basquiat
Ericka Beckman
James Benning
Jonathan Borofsky
Louise Bourgeois
Robert Breer
Ellen Brooks
Barbara Buckner
Bruce Charlesworth
Robert Colescott
Bruce Conner
John Coplans
Eileen Cowin
William Crozier
Vivienne Dick
Juan Downey
Ken Feingold
R. M. Fischer
Eric Fischl
Howard Fried
Ernie Gehr
Matthew Geller
Barry Gerson
Mike Glier
Leon Golub

Shalom Gorewitz
Nancy Graves
Doug Hall
Keith Haring
Martha Haslanger
David Haxton
James Herbert
Gary Hill
Jenny Holzer
Oliver Jackson
Jasper Johns
Lance Kiland
Ken Kobland
Barbara Kruger
Shigeko Kubota
Robert Longo
Mary Lucier
Bill Lundberg
Philip Maberry
Robert Mangold
Melissa Miller
Joan Mitchell
Sandy Moore
Max Neuhaus
Nic Nicosia
Nam June Paik
Judy Rifka
George Rodart
Martha Rosler
Susan Rothenberg
David Salle
Italo Scanga
Julian Schnabel
Cindy Sherman
Stuart Sherman
Kenneth Shorr
Bob Snyder
T.L. Solien
Warren Sonbert
Pat Steir
Frank Stella
Mark Tansey
Stan VanDerBeek
Edin Vélez
Bill Viola
Daniel Walworth
William T. Wiley
Jackie Winsor
Joe Zucker

Curators
John G. Hanhardt
Barbara Haskell
Richard Marshall
Patterson Sims

1981

1981 Biennial Exhibition

Artists
Vito Acconci
Robert Adams
Gregory Amenoff
William Anastasi
Kenneth Anger
Siah Armajani
Charles Arnoldi
Alice Aycock
William Bailey
Jennifer Bartlett
Lynda Benglis
James Benning
Jonathan Borofsky
Stan Brakhage
Robert Breer
Michael Brewster
Barbara Buckner
Scott Burton
Harry Callahan
Jo Ann Callis
Louisa Chase
Christo
Larry Clark
Robert Cumming
Peter D'Agostino
Willem de Kooning
Richard Diebenkorn
John Divola

Rackstraw Downes
Benni Efrat
Rafael Ferrer
Robert Fichter
Vernon Fisher
Kit Fitzgerald and
 John Sanborn
Richard Fleischner
Hollis Frampton
Richard Francisco
Robert Frank
Howard Fried
Benno Friedman
Jedd Garet
Ernie Gehr
Barry Gerson
Davidson Gigliotti
Frank Gillette
Bette Gordon
Shalom Gorewitz
Larry Gottheim
Jan Groover
Duane Hanson
Martha Haslanger
David Haxton
Al Held
Nancy Holt
Bryan Hunt
Taka Iimura
Ken Jacobs
Neil Jenney
Bill Jensen
Steve Keister
Ellsworth Kelly
Edward Kienholz
Robert Kushner
George Landow
William Larson
Peter Lodato
Kim MacConnel
Robert Mapplethorpe
Joel Meyerowitz
Duane Michals
Richard Misrach
Mary Miss
Owen Morrel
Robert Moskowitz
Grant Mudford
Elizabeth Murray
Andrew Noren
Arthur Ollman

Dennis Oppenheim
Nam June Paik
Ed Paschke
Judy Pfaff
Katherine Porter
Kenneth Price
Martin Puryear
Yvonne Rainer
Leland Rice
Bruce Robbins
James Rosenquist
Julian Schnabel
Victor Schrager
Buky Schwartz
Richard Serra
Joel Shapiro
Sally Shapiro
Paul Sharits
Richard Shaw
Judith Shea
Stuart Sherman
Hollis Sigler
Sandy Skoglund
Alexis Smith
Joan Snyder
Robert Snyder
Chick Strand
Wayne Thiebaud
Richard Thompson
Joan Thorne
Jack Tworkov
William Viola
Russ Warren
William Wegman
Robert Wilson
Robert Zakanitch

Curators
John G. Hanhardt
Barbara Haskell
Richard Marshall
Patterson Sims

1979

Artists

Robert Arneson
Alice Aycock
Bruce Baillie
John Baldessari
Jennifer Bartlett
William Beckley
Billy Al Bengston
James Benning
Mel Bochner
Jonathan Borofsky
Stan Brakhage
Robert Breer
Jane Brettschneider
Roger Brown
Barbara Buckner
Deborah Butterfield
Chuck Close
Bruce Conner
Manuel De Landa
Donna Dennis
Dennis Evans
Jackie Ferrara
Kit Fitzgerald and
 John Sanborn
Richard Foreman
Hollis Frampton
Mary Frank
Howard Fried
Gregory Gillespie
Brenda Goodman
Larry Gottheim
Robert Graham
Philip Guston
Walter Gutman
Martha Haslanger
David Haxton
Patrick Hogan
Nancy Holt

Ralph Humphrey
Bryan Hunt
Joan Jonas
Alex Katz
Craig Kauffman
Ellsworth Kelly
Joyce Kozloff
Lois Lane
Sol LeWitt
Roy Lichtenstein
Kim MacConnel
Christa Maiwald
Robert Mangold
Brice Marden
Jonas Mekas
Robert Moskowitz
Elizabeth Murray
Judith Murray
Rita Myers
Robert Nelson
Philip Pearlstein
Jody Pinto
Kenneth Price
Martin Puryear
Christina Ramberg
Anthony Ramos
Edda Renouf
Rodney Ripps
Dorothea Rockburne
Martha Rosler
Susan Rothenberg
Lucas Samaras
Barbara Schwartz
Richard Serra
Joel Shapiro
Paul Sharits
Stuart Sherman
Michael Singer
Alexis Smith
Warren Sonbert
Alan Sondheim
Frank Stella
Donald Sultan
James Surls
George Trakas
William Viola
H.C. Westermann
Christopher Wilmarth
Jackie Winsor
Joe Zucker

Curators

John G. Hanhardt
Barbara Haskell
Richard Marshall
Mark Segal
Patterson Sims

1977

Artists

Vito Acconci
Nicholas Africano
Terry Allen
John Baldessari
Lewis Baltz
Jennifer Bartlett
Lynda Benglis
Mel Bochner
Joan Brown
Chris Burden
Peter Campus
Vija Celmins
Chuck Close
Brian Connell
Robert Cumming
Stephen A. Davis
Richard Estes
Terry Fox
Howard Fried
Ron Gorchov
Duane Hanson
Michael Heizer
James Hill
Nancy Holt
Alfred J. Jensen
Joan Jonas
Allan Kaprow
Barry Le Va
Andy Mann
Brice Marden

Agnes Martin
Duane Michals
Ree Morton
Elizabeth Murray
Bruce Nauman
Jim Nutt
Dennis Oppenheim
Nam June Paik
Dorothea Rockburne
Robert Ryman
Alan Saret
Ilene Segalove
Richard Serra
Joel Shapiro
Charles Simonds
Alan Sondheim
Keith Sonnier
Pat Steir
David True
Richard Tuttle
Woody Vasulka
Willie Walker
William Wegman
H.C. Westermann
Jackie Winsor
Joe Zucker

Curators

John G. Hanhardt
Barbara Haskell
Mark Segal
Patterson Sims
Marcia Tucker

1975

Artists

Billy Adler and
 John Margolies
Martha Alf

David Anderson
James R. Anderson
John Arvanites
Dennis Ashbaugh
Domingo Barreres
W. B. Bearman
Tony Bechara
Gene Beery
Allan Edward Bertoldi
Gary Beydler
Ross Bleckner
George Bolling
Cheryl Bowers
Robin Bruch
Scott Burton
Barry Buxkamper
Jim Byrne
Sam Cady
Cristiano Camacho
Larry Ray Camp
Sarah Anne Canright
Mel Casas
Thomas Chimes
Joseph Clower
Maxine Cole
Christopher Darton
Phil Douglas Davis
John Dickson
Joe Di Giorgio
Paul Dillon
John E. Dowell Jr.
Juan Downey
Carol Eckman
William Fares
Frank Faulkner
Kathleen Ferguson
Carole Fisher
Kent Floeter
John Ford
Terry Fox
Hermine Freed
Charles F. Gaines
Charles Garabedian
Richard George
Abigail Gerd
Frank Gillette
Roland Ginzel
Joel Glassman
Ron Gorchov
John S. Gordon
George Green

Tom Green
Dominick Guida
Fred N. Guyot
Don Hazlitt
Leonard L. Huner III
Miyoko Ito
Jack Jefferson
Pamela Jenrette
Virginia Johnson
David Jones
Jerry Jones
Elizabeth Ann Knox
Beryl Korot
Paul Kos
Robert Kushner
Salvatore J. La Rosa
Patricia Lay
Marilyn Lenkowsky
Alvin Light
Carol Lindsley
Kim Robert MacConnel
David Mackenzie
William E. Mahan
Andy Mann
Allan McCollum
Jan Lee McComas
Todd McKie
George Miller
Judith Suzanne Miller
Scott Miller
Rudolph Montanez
Philip Mullen
Hiroshi Murata
Hass Murphy
Paula Nees
Stuart Nielson
Rob Roy Norton Jr.
Mary McLean Obering
Carl Palazzolo
Lan Payne
James Perry
Judy Pfaff
Tomaso Puliafito
Cherie Raciti
Kaare Rafoss
Anthony Ramos
David Reed
Roland Reiss
Gregg Renfrow
Philip Renteria
Bill Richards

Judy Rifka
Frank Rivera
George Rodart
John Scott Roloff
Edward Ross
Barbara Rossi
Barbara Quinn Roth
Edwin Rothfarb
Paul Rotterdam
Allen Ruppersberg
Ursula Schneider
John Schnell
Barbara Schwartz
Samuel Scott
Ilene Segalove
Rudy Serra
Charles Simonds
Alexis Smith
Andrew Spence
Earl Staley
Barbara Strasen
John Sturgeon
Gene Sturman
Susanna Tanger
Robert Thiele
Richard Thompson
Ken Tisa
Alan Turner
Alan Uglow
Carolynn Umlauf
Thomas M. Uttech
Bill Viola
Mary Warner
Robert J. Warrens
Sibyl L. Weil
John Wenger
Wanda Westcoast
Mark Christian Wethli
Edward R. Whiteman
Andrew Wilf
Donald Roller Wilson
Connie Zehr
Elyn Zimmerman

1973

1973
Biennial
Exhibition

Contemporary
American
Art

Artists
Alice Adams
William Allan
Terry Allen
Carl Andre
Jo Baer
Malcolm Bailey
John Baldessari
Thomas Bang
Paula Barr
Frances Barth
Joel Bass
Robert Bechtle
Lynda Benglis
Fletcher Benton
Tony Berlant
Jake Berthot
Natalie Bieser
Ronald Bladen
William Bollinger
Louise Bourgeois
Frank Bowling
James Boynton
Peter Bradley
Roger Brown
Howard Buchwald
Peter Campus
Cynthia Carlson
John Chamberlain
Dan Christensen
Edward Clark
John Clem Clarke
Arthur Cohen
Joyce Cole
Jaime Davidovitch
Gene Davis
S. A. Davis
Roy DeForest
Stuart Diamond

David Diao
Guy Dill
Jim Dine
John Duff
Loretta Dunkelman
Robert Duran
Jimmy Ernst
Fred Eversley
Charles Fahlen
Jackie Ferrara
Rafael Ferrer
Louise Fishman
Sherron Francis
Mary Frank
Helen Frankenthaler
Ernest Frazier
Richard Friedberg
William Geis
Gregory Gillespie
Carl Gliko
Michael Goldberg
Sidney Goodman
Robert Gordy
Adolph Gottlieb
Jaqueline Gourevitch
Nancy Stevenson Graves
Stephen Greene
Ken Greenleaf
Mary Grigoriadis
Nancy Grossman
Robert Grosvenor
Peter Gutkin
Ira Joel Haber
Michael D. Hall
Duane Hanson
Randy Hardy
Robert Hartman
Joe Haske
Al Held
Gilah Hirsch
Will Horwitt
Gary Hudson
Joel Janowitz
Neil Jenney
Alfred Jenson
Luis Jiminez
Jasper Johns
Buffie Johnson
Lester Johnson
Joan Jonas
Donald Judd

Alex Katz
Lila Katzen
Jane Kaufman
Ellsworth Kelly
Lyman Kipp
Harriet Korman
Lee Krasner
Barbara Kruger
Nicholas Krushenick
Frances Kuehn
Kay Kurt
Ronnie Landfield
Richard Landry
Alfred Leslie
Mon Levinson
Alexander Liberman
Roy Lichtenstein
Robert J. Lobe
Alvin Loving
Brice Marden
John Mason
Louisa Matthiasdottir
Dennis McCarthy
Ann McCoy
David McManaway
Clement Meadmore
Brenda Miller
Richard McDermott Miller
Mary Miss
Joan Mitchell
Richard Mock
Joan Moment
Robert Morris
Ree Morton
Robert Moskowitz
Robert Motherwell
Catherine Murphy
Elizabeth Murray
Robert Murray
Forrest Myers
Louise Nevelson
Kenneth Noland
Richard Nonas
David Novros
Jim Nutt
Kenzo Okada
Jules Olitski
William Omwake
George Ortman
Ray Parker
Ed Paschke

Philip Pearlstein
Joel Perlman
Irving Petlin
William Pettet
Larry Poons
Katherine Porter
Joanna Pousette-Dart
Richard Pousette-Dart
Robert Povlich
Harvey Quaytman
Joseph Raffael
Christina Ramberg
Robert Rauschenberg
Peter Reginato
James Reineking
Milton Resnick
Tony Robbin
Dorothea Rockburne
Robert Rohm
Bernard Rosenthal
Ed Ruda
Ludwig Sander
Ray Saunders
Charles Schucker
William Schwedler
Arden Scott
John Seery
Richard Serra
Alan Shields
Nate Shiner
Ed Shostak
Alex Siburney
Alan Siegel
Louis Siegriest
Site, Inc.
Arlene Slavin
Susan Smith
Tony Smith
Robert Smithson
Kenneth Snelson
Joan Snyder
Jack Sonenberg
Keith Sonnier
Raphael Soyer
Christopher Sproat
Bob Stanley
Jim Starrett
Michael Steiner
Pat Steir
Frank Stella
Gary Stephan

Sylvia Stone
George Sugarman
Andy Tavarelli
Gary Tenenbaum
Edgar Tolson
George Trakas
Anne Truitt
Susan Tunick
Cy Twombly
Jack Tworkov
Nancy Van Deren
Lester Van Winkle
Robert Wade
Jeffrey Way
William Wegman
Neil Welliver
Lynton Wells
Salle Werner
Tom Wesselmann
H.C. Westermann
Jay Wholley
William T. Wiley
Hannah Wilke
Neil Williams
Chris Wilmarth
Jackie Winsor
Philip Wofford
Nina Yankowitz
Adja Yunkers
Robert Zakanych
Larry Zox

1972
Painting

Artists
William Allan
Richard Anuszkiewicz
Richard Artschwager
Malcolm Bailey

Darby Bannard
Peter Bardazzi
Victoria Barr
Frances Barth
Jennifer Bartlett
Romare Bearden
Tom Blackwell
Norman Bluhm
Ilya Bolotowsky
Blythe Bohnen
Sharon Brandt
James Brooks
Joan Brown
Marvin Brown
David Budd
Catti
John E. Chandler
Sue Ann Childress
Dan Christensen
John Clem Clarke
Chuck Close
William Conlon
Alan Cote
Susan Crile
Brad Davis
Willem de Kooning
Richard Diebenkorn
Don Dudley
Jimmy Ernst
Richard Estes
Perle Fine
Audrey Flack
Helen Frankenthaler
Ernest Frazier
LeRoy Frazier
Jane Freilicher
Andrew Gaylard
J. Nebraska Gifford
Gregory Gillespie
Carl Gliko
Juan Gonzalez
Guy Goodwin
Adolph Gottlieb
Nancy Stevenson Graves
Stephen Greene
Carol Haerer
Joe Haske
Mary Heilmann
Al Held
Budd Hopkins
Virginia Jaramillo

Yvonne Jacquette
Jasper Johns
Lester Johnson
Howard Kanovitz
Alex Katz
Harriet Korman
Joyce Kozloff
Frances Kuehn
Kunié
Jacob Lawrence
Alfred Leslie
Roy Lichtenstein
Frank Lobdell
Vincent Longo
Alvin Loving
Noel Mahaffey
Jim Malone
John Mandel
Sylvia Mangold
Bill Martin
Knox Martin
Richard Merkin
Malcolm Morley
Catherine Murphy
Elizabeth Murray
Alice Neel
Kenneth Noland
Kenzo Okada
Georgia O'Keeffe
Jules Olitski
William Omwake
Tommy Dale Palmore
James Parker
Ray Parker
Philip Pearlstein
Howardena Pindell
Peter Plagens
Larry Poons
Stephen Posen
Richard Pousette-Dart
Robert Povlich
Harvey Quaytman
Christina Ramberg
Robert Reed
Murray Reich
Deborah Remington
Tony Robbin
Raymond Saunders
Edward Scher
William Schwedler
Alan Shields

Nate Shiner
Thomas Sills
Jenny Snider
Joan Snyder
Raphael Soyer
Bob Stanley
Jim Starrett
Pat Steir
Frank Stella
Gary Stephan
Jim Sullivan
Joan Thorne
Sidney Tillim
Cy Twombly
Jack Tworkov
Nancy Van Deren
Carlos Villa
F. J. Wardy
Neil Welliver
Tom Wesselmann
Joseph P. White
Jack Whitten
Guy Williams
William T. Williams
Philip Wofford
Larry Zox

1970
Sculpture

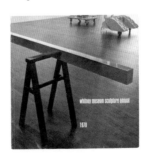

Artists
Alice Adams
Peter Agostini
Carl Andre
Stephen Antonakos
Robert Arneson
Richard Artschwager
Mel Bochner
Bill Bollinger
Louise Bourgeois

Marvin Brown
Alexander Calder
Vija Celmins
John Chamberlain
Barbara Chase-Riboud
Chryssa
Mary Corse
John De Andrea
José De Rivera
Mark Di Suvero
John Duff
Melvin Edwards
Frederick John Eversley
Jackie Ferrara
Rafael Ferrer
Dan Flavin
Mary Frank
Richard Friedberg
David Gilhooley
Robert Graham
Nancy Graves
Scott Grieger
Ira Joel Haber
Duane Hanson
Robert Hubbard
Robert Hudson
Richard Hunt
Laurace James
Daniel La Rue Johnson
Donald Judd
Lyman Kipp
Gabriel Kohn
Haydn Larson
Marilyn Lerner
Barry Le Va
Mon Leinson
Jean Linder
Seymour Lipton
Robert Lobe
John McCracken
James Melchert
Mary Miss
G. E. Moore
Robert Morris
Ree Morton
Robert Murray
Forrest Myers
Bruce Nauman
Manuel Neri
Isamu Noguchi
Kenneth Noland

207

Claes Oldenburg
Dennis Oppenheim
Alfonso Ossorio
Kenneth Price
Peter Reginato
George Rickey
Jim Roche
Dorothea Rockburne
Robert Rohm
Allen Ruppersberg
Bettye Saar
Lucas Samaras
Italo Scanga
George Segal
Richard Serra
Joel Shapiro
Richard Shaw
Ed Shostak
George Smith
Tony Smith
Robert Smithson
Kenneth Snelson
Keith Sonnier
Michael Steiner
Sylvia Stone
Marjorie Strider
George Sugarman
Michael Tetherow
Mike Todd
Anne Truitt
DeWain Valentine
Richard Van Buren
Ellen Van Fleet
Peter Voulkos
H. C. Westermann
William T. Wiley
Christopher Wilmarth
May Wilson
Jacqueline Winsor

1969
Painting

Whitney Museum of American Art
1969 Annual Exhibition Painting

Artists
Thomas Akawie
William Allan
Neil R. Anderson
Richard Anuszkiewicz
Edward Avedisian
Jo Baer
Malcolm Bailey
John Baldessari
Darby Bannard
Jack Beal
Romare Bearden
Robert Beauchamp
Lynda Benglis
Billy Al Bengston
Jake Berthot
Natvar Bhavsar
Isabel Bishop
Gary Bower
Lynn Bowers
Frank Bowling
Marvin Brown
David Budd
Walter Cade III
Lawrence Calcagno
Dan Christensen
John Clem Clarke
Chuck Close
Ron Cooper
Alan Cote
Nassos Daphnis
Alan D'Arcangelo
Gene Davis
Ron Davis
Peter Dechar
Roy De Forest
Willem de Kooning
David Diao

Richard Diebenkorn
Robert Duran
Jimmy Ernst
Manny Farber
Llynn Foulkes
Sam Francis
Helen Frankenthaler
Paul Georges
Sam Gilliam
Joe Goode
Sidney Goodman
Adolph Gottlieb
José Guerrero
Allan Hacklin
Carol Haerer
Mike Heizer
Al Held
Charles Hinman
Tom Holland
Gary Hudson
Ralph Humphrey
Robert Huot
Neil Jenney
Jasper Johns
Donald Kaufman
Ellsworth Kelly
Joseph Kosuth
Nicholas Krushenick
Ronnie Landfield
Jacob Lawrence
Roy Lichtenstein
Sven Lukin
Alan D. Lynch
John Mandel
Robert Mangold
Conrad Marca-Relli
Brice Marden
Fred Martin
Richard Mayhew
Denis McCarthy
James McGarrell
Richard Merkin
Ralph Moseley
Robert Moskowitz
Robert Motherwell
Robert Natkin
Barnett Newman
Kenneth Noland
David Novros
Doug Ohlson
Kenzo Okada

Jules Olitski
Arthur L. Orr
Ray Parker
David Paul
Philip Pearlstein
William Pettet
Larry Poons
Katherine Porter
Richard Pousette-Dart
David Prentice
Harvey Quaytman
Leo Rabkin
Robert Rauschenberg
Murray Reich
Garry Rich
James Rosenquist
Richard Roth
Edwin Ruda
Edward Ruscha
Paul Sarkisian
Roy Schnackenberg
Jon Schueler
William Schwedler
Alan Shields
Kenneth Showell
Alan Siegel
Theodore Singer
Raphael Soyer
Lawrence Stafford
Robert Stanley
Thomas Steigerwald
Lewis Stein
Frank Stella
Gary Stephan
James Sullivan
Sam Tchakalian
Wayne Thiebaud
George Tooker
John Torreano
Cy Twombly
Robert Wade
Andy Warhol
John Wesley
Tom Wesselmann
Jack Whitten
William T. Wiley
William T. Williams
Philip Wofford
Peter Young
Jack Youngerman
Mario Yrisarry

Robert Zakanych
Duane Zaloudek
Kestutis Zapkus
Larry Zox

1968
Sculpture

Artists
Peter Agostini
Calvin Albert
Peter Alexander
John Anderson
Stephen Antonakos
Richard Artschwager
Jerry Bellaine
Robert Bart
Leonard Baskin
Mary Bauermeister
Bennett Bean
John Bennett
Fletcher Benton
Tony Berlant
Ben Berns
Michael Bigger
Ronald Bladen
Varujan Boghosian
Lee Bontecou
Louise Bourgeois
Alexander Calder
Kenneth Campbell
John Chamberlain
Chryssa
Mike Cooper
Tony Delap
Walter De Maria
Deborah De Moulpied
José De Rivera
Mark Di Suvero
Tom Doyle

Robert Engman
Peter Erskine
Herbert Ferber
Frank Gallo
William Geis III
Cristos Gianakos
John Goodyear
Robert Graham
Nancy Grossman
Robert Grosvenor
Roy Gussow
Peter Gutkin
Michael Hall
Duayne Hatchett
Alex Hay
Michael Heizer
Eva Hesse
Will Horwitt
Robert Howard
Robert Hudson
Richard Hunt
James Huntington
Daniel Larue Johnson
Donald Judd
Craig Kauffman
Ellsworth Kelly
William King
Robert Kinmont
Lyman Kipp
Gabriel Kohn
Joseph Konzal
Rockne Krebs
Gary Kuehn
Gerald Laing
Leroy Lamis
Stanley Landsman
Michael Lekakis
Joseph Levi
Les Levine
Alexander Liberman
Roy Lichtenstein
Seymour Lipton
Jim Love
Bix Lye
Sheldon Machlin
Robert Mallary
John McCracken
Ed McGowin
Walter McNamara
Clement Meadmore
James Melchert

Robert Morris
Robert Murray
Louise Nevelson
Barnett Newman
Minoru Niizuma
Claes Oldenburg
Dennis Oppenheim
Alfonso Ossorio
Harold Paris
Kenneth Price
Leo Rabkin
Carlos Ramos
James Reineking
Sam Richardson
Robert Richenburg
George Rickey
Larry Rivers
Henry Rollins
James Rosati
Bernard Rosenthal
Charles Ross
Theodore Roszak
Lucas Samaras
Fred Sandback
Alan Saret
Julius Schmidt
Roy Schnackenberg
George Segal
Jason Seley
William Sellers
Richard Serra
Robert Smithson
Kenneth Snelson
Sylvia Stone
Edvins Strautmanis
George Sugarman
Wayne Taylor
Julius Tobias
Michael Todd
Ernest Trova
Anne Truitt
William Tunberg
DeWain Valentine
Richard Van Buren
Frank Lincoln Viner
Ruth Vollmer
David Von Schlegell
David Weinrib
Tom Wesselmann
H. C. Westermann
John Willenbecher

Franklin Williams
Christopher Wilmarth
James Wines
Gary Wojcik

1967
Painting

WHITNEY MUSEUM OF AMERICAN ART
1967 ANNUAL EXHIBITION
OF CONTEMPORARY AMERICAN PAINTING

Artists
Josef Albers
John Altoon
Lennart Anderson
Richard Anuskiewicz
Edward Avedisian
Jo Baer
Thomas Bang
Darby Bannard
Ross Barron
Jack Beal
Robert Beauchamp
Robert Bechtle
Billy Al Bengston
James Bishop
Ilya Bolotowsky
James Bolton
James Boynton
James Brooks
Lawrence Calcagno
Francis Celentano
Dan Christensen
John Clem Clarke
Calvert Coggeshall
Ron Cooper
Ralston Crawford
Nassos Daphnis
Allan D'Arcangelo
Gene Davis
Ron Davis
Peter Dechar
Willem de Kooning

Richard Diebenkorn
Dominick Di Meo
Jim Dine
Thomas Downing
Philip Evergood
Lorser Feitelson
John Ferren
Llyn Foulkes
Helen Frankenthaler
Paul Georges
James Gill
Gregory Gillespie
Michael Goldberg
Joe Goode
Sidney Goodman
Robert Goodnough
Robert Gordy
Adolph Gottlieb
Peter Gourfain
Stephen Greene
Robert Gwathmey
Howard Hack
Al Held
John Heliker
Charles Hinman
Valerie Hollister
Budd Hopkins
Jim Huntington
Robert Huot
Robert Indiana
Will Insley
Norman Ives
Alfred Jensen
Jasper Johns
Lester Johnson
Howard Kanovitz
Alex Katz
Donald Kaufman
Ellsworth Kelly
Leslie Kerr
R.B. Kitaj
Karl Knaths
Bill Komodore
Nicholas Krushenick
Ronnie Landfield
Alfred Leslie
Jack Levine
Alexander Liberman
Roy Lichtenstein
Richard Lindner
Elliott Lloyd

Sven Lukin
Helen Lundeberg
Loren MacIver
Robert Mangold
Conrad Marca-Relli
Agnes Martin
Knox Martin
James McGarrell
Howard Mehring
Richard Merkin
Joan Mitchell
Tad Miyashita
Robert Motherwell
Walter Murch
Robert Natkin
Lowell Nesbitt
Barnett Newman
Gladys Nilsson
Kenneth Noland
David Novros
Kenzo Okada
Georgia O'Keeffe
Jules Olitski
Nathan Oliveira
George Ortman
Raymond Parker
Philip Pearlstein
Henry Pearson
I. Rice Pereira
Gabor Peterdi
William Pettet
Frank J. Piatek
Larry Poons
Fairfield Porter
Richard Pousette-Dart
Deborah Remington
Larry Rivers
James Rosenquist
Irving Rosenzweig
Edward Ruscha
Katherine Schmidt
Roy Schnackenberg
Ben Shahn
Kenneth L. Showell
Oli Sihvonen
Richard Smith
Jack Sonenberg
Raphael Soyer
Albert Stadler
Theodoros Stamos
Julian Stanczak

Bob Stanley
Frank Stella
Hedda Sterne
Norman Stiegelmeyer
James Sullivan
Peter Tangen
Wayne Thiebaud
John Haven Thornton
Mark Tobey
George Tooker
Cy Twombly
Jack Tworkov
Esteban Vicente
John Von Wicht
Paul Waldman
Andy Warhol
John Wesley
Tom Wesselman
Joseph P. White
William Wiley
Franklin Williams
Neil Williams
Jane Wilson
Karl Wirsum
Paul Wonner
Andrew Wyeth
Alfred Young
Peter Young
Jack Youngerman
Adja Yunkers
Robert S. Zakanych
Larry Zox

1966
Sculpture and Prints

Artists
Peter Agostini
Calvin Albert
John Anderson

Stephen Antonakos
Richard Artschwager
George Baker
Robert Bart
Leonard Baskin
Mary Bauermeister
Larry Bell
John Bennett
Fletcher Benton
Tony Berlant
Harry Bertoia
Charles Biederman
Ronald Bladen
Varujan Boghosian
Roger Bolomey
Ilya Bolotowsky
Lee Bontecou
Alexander Calder
William H. Calfee
Kenneth Campbell
John Chamberlain
Chryssa
Joseph Cornell
José De Creeft
Tony De Lap
Walter De Maria
José De Rivera
Jim Dine
Mark Di Suvero
Enrico Donati
Tom Doyle
Robert Engman
Peter Erskine
Herbert Ferber
Paul Frazier
Frank Gallo
Herbert George
Joe Goode
John Goodyear
Robert Graham
Philip Grausman
David Gray
Roy Gussow
Raoul Hague
Lloyd Hamrol
David Hare
Duayne Hatchett
George Herms
Edward Higgins
Keith Hollingworth
Will Horwitt

Robert Howard
Robert Hubbard
Robert Hudson
Douglas Huebler
Richard Hunt
Robert Indiana
Donald Judd
Luise Kaish
Ellsworth Kelly
Edward Kienholz
William King
Lyman Kipp
Gabriel Kohn
Joseph Konzal
Rockne Krebs
Gary Kuehn
Gerald Laing
Leroy Lamis
Ibram Lassaw
Michael Lekakis
Sol LeWitt
Alexander Liberman
Roy Lichtenstein
Jean Linder
Jacques Lipchitz
Seymour Lipton
Sven Lukin
Sheldon Machlin
Anthony Magar
Phillip Makanna
Robert Mallary
Ronald Mallory
Conrad Marca-Relli
John Marshall
Ezio Martinelli
John McCracken
Ed McGowin
James Melchert
Robert Morris
Robert Murray
Forrest Myers
Reuben Nakian
Louise Nevelson
Barnett Newman
Minoru Niizuma
Constantino Nivola
Isamu Noguchi
Giora Novak
Toshio Odate
Claes Oldenburg
George Ortman

Alfonso Ossorio
Anthony Padovano
Harold Paris
Phillip Pavia
Charles Perry
Kenneth Price
Leo Rabkin
William Reimann
Daniel Rhodes
George Rickey
Larry Rivers
James Rosati
Bernard Rosenthal
Theodore Roszak
Lucas Samaras
Julius Schmidt
Day Schnabel
James Seawright
George Segal
Jason Seley
William F. Sellers
Tony Smith
Robert Smithson
Kenneth Snelson
Sasson Soffer
George Spaventa
Jack Squier
Richard Stankiewicz
George Sugarman
William Tarr
Mike Todd
Harold Tovish
Ernest Trova
DeWain Valentine
Al Vanderburg
David Von Schlegell
Elbert Weinberg
David Weinrib
John Willenbecher
William T. Wiley
Christopher Wilmarth
James Wines
William Zorach

1965
Painting

WHITNEY MUSEUM OF AMERICAN ART
1965 ANNUAL EXHIBITION
OF CONTEMPORARY AMERICAN PAINTING

Artists

Josef Albers
Milet Andrejevic
Richard Anuszkiewicz
Joel Barletta
Will Barnet
Robert Beauchamp
Elmer Bischoff
Isabel Bishop
Ilya Bolotowsky
James Brooks
Charles Burchfield
Paul Burlin
Jacqueline Byrne
Paul Cadmus
Lawrence Calcagno
Victor Candell
Giorgio Cavallon
Francis Celentano
Carmen Cicero
Edward Corbett
Ralston Crawford
Ben Cunningham
Nassos Daphnis
John Day
Willem de Kooning
Angelo Di Benedetto
Richard Diebenkorn
Jim Dine
Enrico Donati
Jimmy Ernst
Philip Evergood
Paul Feeley
Lorser Feitelson
John Ferren
Helen Frankenthaler
Lee Gatch
Thomas George

James Gill
Gregory Gillespie
Edward Giobbi
Fritz Glarner
Michael Goldberg
Robert Goodnough
Adolph Gottlieb
Cleve Gray
Balcomb Greene
Robert Gwathmey
Howard Hack
Mary Heisig
Al Held
John Heliker
Joseph Hirsch
Hans Hofmann
Carl Holty
Budd Hopkins
Edward Hopper
Robert Indiana
Will Insley
Paul Jenkins
Alfred Jensen
Jasper Johns
Ben Johnson
Lester Johnson
Morton Kaish
Howard Kanovitz
Ellsworth Kelly
William Kienbusch
R. B. Kitaj
Karl Knaths
Nicholas Krushenick
Jannett Lam
Jacob Lawrence
Alfred Leslie
John Levee
Jack Levine
Alexander Liberman
Roy Lichtenstein
Richard Lindner
Helen Lundeberg
Loren MacIver
Frank J. Malina
Leo Manso
Conrad Marca-Relli
Marcia Marcus
Agnes Martin
George McNeil
Joan Mitchell
Tad Miyashita

Hans Moller
George L. K. Morris
Kyle Morris
Robert Motherwell
George Mueller
Walter Murch
Robert Natkin
Barnett Newman
Kenneth Noland
Kenzo Okada
Georgia O'Keeffe
George Ortman
Raymond Parker
Henry Pearson
I. Rice Pereira
Gabor Peterdi
Larry Poons
Farfield Porter
Richard Pousette-Dart
Gregorio Prestopino
Leo Rabkin
Abraham Rattner
Robert Rauschenberg
Ad Reinhardt
Deborah Remington
Larry Rivers
Karl Schrag
John Schueler
Ben Shahn
Honoré Sharrer
Oli Sihoven
Hyde Solomon
Raphael Soyer
Theodoros Stamos
Frank Stella
Jack Stuck
James Sullivan
Reuben Tam
Wayne Thiebaud
Mark Tobey
George Tooker
Jack Tworkov
Gene Vass
Esteban Vicente
John Von Wicht
Tom Wesselmann
Hiram Williams
Jane Wilson
Jean Xceron
Larry Zox

1964

Sculpture

Artists
Peter Agostini
Calvin Albert
Jeremy Anderson
John Anderson
David Aronson
Leonard Baskin
Mary Bauermeister
Sondra Beal
Harry Bertoia
Charles Biederman
Varujan Boghosian
Roger Bolomey
Alexander Calder
Kenneth Campbell
John Chamberlain
Peter Chinni
Chryssa
John Clague
Bruce Conner
Joseph Cornell
Robert Cremean
Lindsey Decker
Tony De Lap
Koren Der Harootian
José De Rivera
Burgoyne Diller
Ludvik Durchanek
Robert Engman
Claire Falkenstein
Herbert Ferber
Charles Frazier
Paul Frazier
Elias Fridensohn
Frank Gallo
Philip Grausman
David Gray
Roy Gussow

Raoul Hague
David Hare
Milton Hebald
Edward Higgins
Will Horwitt
Robert A. Howard
Robert Hudson
Richard Hunt
Luise Kaish
Herbert Kallem
Fredric Karoly
Tauno Kauppi
Edward Kienholz
William King
Lyman Kipp
Gabriel Kohn
Joseph Konzal
Joseph Kurhajec
Leroy Lamis
Ibram Lassaw
Michael Lekakis
Jacques Lipchitz
Peter Lipman-Wulf
Seymour Lipton
Bruno Lucchesi
Bix Lye
Len Lye
Sheldon Machlin
Robert Mallary
John Manno
Conrad Marca-Relli
Marisol
John Mason
Barrie C. McDowell
James Metcalf
Richard A. Miller
Robert Murray
Richard Navin
Louise Nevelson
Mike Nevelson
Constantino Nivola
Isamu Noguchi
Toshio Odate
Claes Oldenburg
Anthony Padovano
Harold Persico Paris
Charles O. Perry
Leo Rabkin
William Reiman
Edward Renouf
George Rickey

Robert Rohm
James Rosati
Bernard Rosenthal
Theodore Roszak
Lucas Samaras
Abe Satoru
Julius Schmidt
Stephanie Scuris
George Segal
Jason Seley
David Smith
Leon Polk Smith
Jack Squire
Richard Stankiewicz
Tal Streeter
George Sugarman
Sahl Swarz
Tania
William Tarr
Mike Todd
Harold Tovish
Ruth Vollmer
Paul Von Ringelheim
David Von Schlegell
Peter Voulkos
Jane Wasey
Robert Watts
Elbert Weinberg
David Weinrib
H. C. Westermann
John Willenbecher
Charles Wilson
James Wines
Wilfrid Zogbaum
William Zorach

1963

Painting

Artists

Josef Albers
Lennart Anderson
Milet Andrejevic
Richard Anuszkiewicz
Edward Avedisian
Mitlon Avery
Robert Beauchamp
Elmer Bischoff
Isabel Bishop
Ilya Bolotowsky
William Brice
Morris Broderson
James Brooks
Colleen Browning
Charles Burchfield
Paul Burlin
Paul Cadmus
Lawrence Calcagno
Chen Chi
Carmen Cicero
William C. Collins
Edward Corbett
Ralston Crawford
Nassos Daphnis
Stuart Davis
Willem de Kooning
Richard Diebenkorn
Enrico Donati
Friedel Dzubas
Ronnie Elliott
Jimmy Ernst
Philip Evergood
Yonia Fain
Sam Francis
Helen Frankenthaler
Jared French
Lee Gatch

Paul Georges
Ruth Gikow
Fritz Glarner
Joseph Glasco
Sidney Goodman
Robert Goodnough
Adolph Gottlieb
Cleve Gray
Balcomb Greene
Stephen Greene
Joe Guerrero
Philip Guston
Robert Gwathmey
Robert Hansen
Grace Hartigan
Burt Hasen
Gene Hedge
Al Held
John Heliker
Hans Hofmann
Budd Hopkins
Edward Hopper
John Hultberg
Robert Indiana
Paul Jenkins
Alfred Jensen
Jasper Johns
Ben Johnson
Frederic Karoly
Ellsworth Kelly
William Kienbusch
Karl Knaths
George Kokines
Nicholas Krushenick
Lawrence Kupferman
Jacob Lawrence
Rico Lebrun
Julian Levi
Jack Levine
Richard Lidner
Richard Lytle
Loren MacIver
Leo Manso
Conrad Marca-Relli
Marcia Marcus
Agnes Martin
James McGarrell
Carl Morris
Kyle Morris
Robert Motherwell
George Mueller

Walter Murch
Barnett Newman
Kenneth Noland
Kenzo Okada
Arthur Okamura
Georgia O'Keeffe
Jules Olitski
Gordon Onslow-Ford
George Ortman
Arthur Osver
William Palmer
Raymond Parker
Robert Andrew Parker
David Pease
I. Rice Pereira
Gabor Peterdi
Reginald Pollack
Charles Pollock
Fairfield Porter
Richard Pousette-Dart
Abraham Rattner
Robert Rauschenberg
Milton Resnik
Robert B. Richenburg
Larry Rivers
Kurt Roesch
James Rosenquist
Richards Ruben
Katherine Schmidt
Karl Schrag
Charles Schucker
Jon Schueler
Ethel Schwabacher
Manfred Schwartz
Ben Shahn
Honoré Sharrer
Charles Shaw
Sarai Sherman
Hyde Solomon
Moses Soyer
Raphael Soyer
Theodoros Stamos
Frank Stella
Harold Stevenson
Reuben Tam
George Tooker
Stanley Twardowicz
Ernst Van Leyden
Esteban Vicente
Robert Vickrey
John Von Wicht

Neil Welliver
Walter Williams
Andrew Wyeth
Jean Xceron
Adja Yunkers
Karl Zerbe

1962

Sculpture and Drawings

Artists

George Abend
Josef Albers
Calvin Albert
Albert Alcalay
Harold Altman
Leo Amino
David Aronson
Leonard Baskin
Harry Bertoia
Robert Birmelin
Isabel Bishop
Arnold Bittleman
Peter Blume
Lee Bontecou
Louise Bourgeois
Richard Boyce
Robert Broderson
Paul Cadmus
Doris Caesar
Charles Cajori
Alexander Calder
Kenneth Callahan
Kenneth Campbell
Cosmo Campoli
Martin Carey
Norman Carlberg
John Chamberlain
Peter Chinni
Chryssa

Carmen Cicero
Joseph Cornell
Douglas D. Craft
Stefano Cusumano
Nassos Daphnis
Lindsey Decker
José De Creeft
Adolf Dehn
Dorothy Dehner
José De Rivera
Arthur Deshaies
Edwin Dickinson
Burgoyne Diller
Harvey Dinnerstein
Ethel Edwards
Robert Engman
Jimmy Ernst
Phlip Evergood
Gray Foy
Paul Frazier
Jared French
Elias Friedensohn
Harold Gebhardt
Thomas George
Joseph Glasco
Sidney Goodman
Sidney Gordin
Philip Grausman
Dorothea Greenbaum
Peter Grippe
Chaim Gross
José Guerrero
Roy Gussow
Philip Guston
Robert Gwathmey
Dimitri Hadzi
David Hare
Janet Harwood
David Hayes
Milton Hebald
John Heliker
Edward Higgins
Richard Hunt
Francis Jennings
Jasper Johns
Luise Kaish
Herbert Kallem
Matsumi Kanemitsu
Stanley Brandon Kearl
Ellsworth Kelly
León Kelly

Evelyn Keyser
William King
Lyman Kipp
Gabriel Kohn
Joseph Konzal
Chaim Koppelman
Harold Krisel
Bernard Langlais
Ibram Lassaw
Robert Laurent
Rico Lebrun
Michael Lekakis
David Levine
Jack Levine
Alexander Liberman
Richard Lindner
Seymour Lipton
Sven Lukin
Len Lye
Loren MacIver
Oronzio Maldarelli
Robert Mallary
Marisol
Nicholas Marsicano
Ezio Martinelli
Norman Narotzky
Richard Navin
Louise Nevelson
Mike Nevelson
Knud Nielsen
Isamu Noguchi
Anthony Padovano
Robert Andrew Parker
Robert Partin
Philip Pearlstein
Henry Pearson
Gabor Peterdi
Reginald Pollack
Thomas Prentiss
Andre Racz
Albert Radoczy
Robert Rauschenberg
William Reimann
Larry Rivers
Hugo Robus
Raymond Rocklin
Robert Rohm
James Rosati
Bernard Rosenthal
Theodore Roszak
Kay Sage

Julius Schmidt
Karl Schrag
Jason Seley
Ben Shahn
Sarai Sherman
Oli Sihvonen
Sidney Simon
David Smith
Lawrence Beall Smith
Leon Polk Smith
Raphael Soyer
George Spaventa
Richard Stankiewicz
Leo Steppat
Sahl Swarz
Peter Takal
William Talbot
William Tarr
Jane Teller
Mark Tobey
David Tolerton
Hugh Townley
Jack Tworkov
Polygnotos Vagis
Gene Vass
Esteban Vicente
John Von Wicht
Elbert Weinberg
David Weinrib
John Wilde
James Wines
Andrew Wyeth
Wilfred Zogbaum
Zorach William

1961
Painting

Artists
Pat Adams
Josef Albers
Ivan Albright
Milton Avery
Rudolf Baranik
Robert Barnes
Will Barnet
William Baziotes
Janice Biala
Elmer Bischoff
Isabel Bishop
Peter Blume
Seymour Boardman
Ilya Bolotowsky
Ernest Briggs
Robert Broderson
James Brooks
Charles Burchfield
Paul Cadmus
Lawrence Calcagno
Nicolas Carone
Edmund Casarella
Giorgio Cavallon
Carmen Cicero
Carroll Cloar
Edward Corbett
Ralston Crawford
Nassos Daphnis
Stuart Davis
Elaine de Kooning
Richard Diebenkorn
Enrico Donati
Jimmy Ernst
Philip Evergood
Perle Fine
Seymour Fogel
Sam Francis

Helen Frankenthaler
Jared French
Elaine Galen
Lee Gatch
Thomas George
Paul Georges
Edward Giobbi
Joseph Glasco
Michael Goldberg
Sidney Goodman
Robert Goodnough
Adolph Gottlieb
Morris Graves
Cleve Gray
Balcomb Greene
Stephen Greene
Philip Guston
Grace Hartigan
John Heliker
Margo Hoff
Hans Hofmann
Carl Holty
Edward Hopper
Angelo Ippolito
Paul Jenkins
Jasper Johns
Wolf Kahn
Ellsworth Kelly
William Kienbusch
Franz Kline
Karl Knaths
Yayoi Kusama
Jacob Lawrence
Alfred Leslie
Jack Levine
Denver Lindley
Michael Loew
David Lund
Loren MacIver
Leo Manso
Conrad Marca-Relli
Nicholas Marsicano
Richard Mayhew
Gerald McLaughlin
George McNeil
Samuel M. Middleton
Joan Mitchell
Randall Morgan
Kyle Morris
Robert Motherwell
George Mueller

Walter Murch
Kenneth Noland
Kenzo Okada
Arthur Okamura
Georgia O'Keeffe
Nathan Oliveira
Stephen Pace
William Pachner
Robert Andrew Parker
I. Rice Pereira
Gabor Peterdi
Fairfield Porter
Richard Pousette-Dart
Gregorio Prestopino
Leo Rabkin
Abraham Rattner
Robert Rauschenberg
Ad Reinhardt
Milton Resnik
Robert Richenburg
Larry Rivers
Tadashi Sato
Karl Schrag
Charles Schucker
Jon Schueler
Ethel Schwabacher
Kurt Seligmann
Ben Shahn
Honoré Sharrer
Sasson Soffer
Hyde Solomon
Raphael Soyer
Theodoros Stamos
Joseph Stefanelli
Ann Steinbrocker
James Strombotne
Teiji Takai
Reuben Tam
Mark Tobey
George Tooker
Joyce Treiman
Jack Tworkov
Esteban Vicente
John Von Wicht
Hiram Williams
Jane Wilson
Andrew Wyeth
Adja Yunkers

1960
Sculpture and Drawings

Artists
Calvin Albert
Albert Alcalay
Harold Altman
Leonard Baskin
Margit Beck
Harry Bertoia
Robert Birmelin
Isabel Bishop
Arnold Bittleman
Varujan Boghosian
Lee Bontecou
Louise Bourgeois
James Boynton
William Brice
Morris Brose
David Budd
Charles Burchfield
Paul Cadmus
Doris Caesar
Alexander Calder
Kenneth Callahan
Kenneth Campbell
Cosmo Campoli
Rhys Caparn
Peter Chinni
Chryssa
Carmen Cicero
Robert Cook
Joseph Cornell
Robert Cremean
Lindsey Decker
José De Creeft
Dorothy Dehner
Koren Der Harootian
José De Rivera
Arthur Deshaies
Harvey Dinnerstein

John Dobbs
Seymour Drumlevitch
Ludvik Durchanek
Ethel Edwards
Walter Erlebacher
Jimmy Ernst
Philip Evergood
Claire Falkenstein
Herbert Ferber
Jean F. Follett
Gray Foy
Elias Friedensohn
Naum Gabo
Thomas George
Kahlil Gibran
Maurice Glickman
Robert Goodnough
Sidney Gordin
Joseph Goto
John D. Graham
Cleve Gray
Dorothea Greenbaum
Peter Grippe
Chaim Gross
Robert Gwathmey
Dimitri Hadzi
David Hare
Minna Harkavy
Stanley W. Hayter
Milton Hebald
John Heliker
Edward Higgins
Albert Hirschfeld
Jasper Johns
Richard Kamm
Nathaniel Kaz
James Kearns
Ellsworth Kelly
León Kelly
William King
Lyman Kipp
Franz Kline
Gabriel Kohn
Joseph Konzal
Chaim Koppelman
Louise Kruger
Lily Landis
Bernard Langlais
Ibram Lassaw
Rico Lebrun
Michael Lekakis

215

David Levine
Jack Levine
Jacques Lipchitz
Peter Lipman-Wulf
Seymour Lipton
Oronzio Maldarelli
Robert Mallary
Leo Manso
Ronald Markman
Nicholas Marsicano
Ezio Martinelli
Tom Morin
Roy Moyer
Louise Nevelson
Isamu Noguchi
Richard O'Hanlon
Gordon Onslow-Ford
Robert Osborn
Robert Andrew Parker
Henry Pearson
Bernard Perlin
Gabor Peterdi
Reginald Pollack
Richard Gorman Powers
Gregorio Prestopino
Roger Prince
Albert Radoczy
Abraham Rattner
Bernard Reder
Edward Renouf
Larry Rivers
Hugo Robus
Raymond Rocklin
James Rosati
Bernard Rosenthal
Theodore Roszak
Tadashi Sato
Abe Satoru
Julius Schmidt
Karl Schrag
Charles Seliger
Kurt Seligmann
Ben Shahn
Mitchell Siporin
David Smith
Raphael Soyer
Jack Squier
Richard Stankiewicz
Joseph Stephanelli
Walter Stein
George Sugarman

Richard Sussman
Sahl Swarz
Peter Takal
Marie Taylor
Jane Teller
Anthony Toney
Harold Tovish
Polygnotos Vagis
John Von Wicht
Elbert Weinberg
John Wilde
Jack Zajac
Wilfrid Zogbaum
William Zorach

1959

Painting

Artists
Sam Amato
Harold Baumbach
William Baziotes
Margit Beck
Fred Berman
Janice Biala
George Biddle
Elmer Bischoff
Isabel Bishop
Frederick Black
Donald S. Bloom
Norman Bluhm
Ilya Bolotowsky
Cameron Booth
Gandy Brodie
James Brooks
Louis Bunce
Charles Burchfield
Paul Burlin
Peter Busa
Paul Cadmus

Gretna Campbell
Victor Candell
Giorgio Cavallon
Chen Chi
Carmen Cicero
Robert Conover
Rollin Crampton
Nassos Daphnis
Robert D'Arista
Adolf Dehn
Willem de Kooning
Enrico Donati
Charles Steven Duback
Edward Dugmore
Yonia Fain
Herbert Ferber
John Ferren
Louis Finkelstein
Joseph Fiore
Seymour Fogel
Sam Francis
Jared French
Elias Friedensohn
Shirl Goedike
Augustus Goertz
Robert Goodnough
Adolph Gottlieb
Stephen Greene
John Grillo
Salvatore Grippi
Sally Hazelet
John Heliker
Joseph Hirsch
Hans Hofmann
Carl Holty
Edward Hopper
Jo N. Hopper
William Ivey
Jasper Johns
James Kearns
Ellsworth Kelly
León Kelly
Robert Keyser
William Kienbusch
Jonah Kingstein
Franz Kline
Karl Knaths
Edward Laning
Alfred Leslie
John Levee
Si Lewen

Julian Levi
Richard Lidner
Loren MacIver
Peppino Mangravite
Conrad Marca-Relli
Boris Margo
Keith M. Martin
James McGarrell
Hugh Mesibov
Edward Millman
Joan Mitchell
Paul Mommer
William Morehouse
Carl Morris
Robert Motherwell
George Mueller
Walter Murch
Barnett Newman
Tetsuo Ochikubo
Kenzo Okada
Georgia O'Keeffe
Cyril Osborne
Charles Oscar
Arthur Osver
William Pachner
Anthony Palumbo
David Park
James Penney
I. Rice Pereira
George Picken
Anne Poor
Fairfield Porter
Richard Pousette-Dart
Gregorio Prestopino
Leo Quanchi
Leo Rabkin
Abraham Rattner
Ruth Ray
Ad Reinhardt
Milton Resnick
Dean Richardson
Kurt Roesch
William Ronald
Lucia Autorino Salemme
Charles Schucker
Jon Schueler
George Segal
Ben Shahn
Charles Sheeler
Sarai Sherman
Semyon Shimin

Lundy Siegriest
Thomas Sills
Sidney Simon
Mitchell Siporin
Kimber Smith
Syd Solomon
Everett Spruce
Theodoros Stamos
Hedda Sterne
James Strombotne
Teiji Takai
Reuben Tam
Brie Taylor
John Taylor
Mark Tobey
Jack Tworkov
John Von Wicht
Max Weber
Paul Wonner
Andrew Wyeth
Adja Yunkers
Jack Zajac

1958

Sculpture, Paintings,
Watercolors, and Drawings

Artists
Josef Albers
Ivan Albright
Albert Alcalay
Leo Amino
Ruth Asawa
Milton Avery
Rudolf Baranik
Leonard Baskin
William Baziotes
Robert Benham Becker
Harry Bertoia
Edward Betts

Isabel Bishop
Arnold Blanch
Aaron Bohrod
Bill Bomar
Louis Bouché
James Boynton
Theodore Brenson
William Brice
James Brooks
Charles Burchfield
Hans Burkhardt
Paul Cadmus
Alexander Calder
Herman Cherry
Carroll Cloar
John Colt
Edward Corbett
Joseph Cornell
Ralston Crawford
Robert Cronbach
Stuart Davis
José De Creeft
José De Rivera
Richard Diebenkorn
Seymour Drumlevitch
Lu Duble
Friedel Dzubas
Leonard Edmondson
Ethel Edwards
Jimmy Ernst
Philip Evergood
Herbert Ferber
Perle Fine
Don Fink
Gray Foy
Frederick Franck
Helen Frankenthaler
Thomas Fransioli
Antonio Frasconi
Naum Gabo
Lee Gatch
Sonia Gechtoff
Fritz Glarner
Joseph Glasco
Xavier Gonzalez
Sidney Gordin
Adolph Gottlieb
Cleve Gray
Balcomb Greene
José Guerrero
Philip Guston

Robert Gwathmey
David Hare
Grace Hartigan
Julius Hatofsky
John Heliker
Hans Hofmann
Budd Hopkins
Edward Hopper
John Hultberg
Richard Hunt
Angelo Ippolito
Ralph Iwamoto
Hazel Janicki
Lester Johnson
Robert Kabak
Max Kahn
Ben Kamihira
Nathaniel Kaz
James Kearns
León Kelly
Franz Kline
Gabriel Kohn
Joe Lasker
Ibram Lassaw
Robert Laurent
Jacob Lawrence
Rico Lebrun
Doris Lee
Michael Lekakis
Jacques Lipchitz
Peter Lipman-Wulf
Bruno Lucchesi
Loren MacIver
Barnett Mather
Elizabeth McFadden
Gerald McLaughlin
Walter Meigs
Sigmund Menkes
Felicia Meyer
Sam Middleton
Raymond Mintz
Hans Moller
George L. K. Morris
Kyle Morris
Robert Motherwell
Seong Moy
Katherine Nash
Isamu Noguchi
Georgia O'Keeffe
Earle Olsen
Stephen Pace

William Palmer
Ray Parker
Robert Andrew Parker
Jarvin L. Parks
Abbott Pattison
Philip Pearlstein
I. Rice Pereira
Gabor Peterdi
Mariana Pineda
Walter Plate
Reginald Pollack
Richard Pousette-Dart
Walter Quirt
George Ratkai
Bernard Reder
Ad Reinhardt
Larry Rivers
Hugo Robus
Bernard Rosenthal
Robert Rosenwald
Theodore Roszak
Frank Roth
Andrée Ruellan
Kay Sage
Tadashi Sato
Concetta Scaravaglione
Louis Schanker
Miriam Schapiro
Katherine Schmidt
Ethel Schwabacher
Joseph Schwarz
William E. Sebring
Kurt Seligman
Sueo Serisawa
Ben Shahn
Honoré Sharrer
Charles Sheeler
Esphyr Slobodkina
Raphael Soyer
Jack Squier
David Smith
Theodoros Stamos
Joe Stefanelli
Leo Steppat
Myron Stout
James Suzuki
Peter Takal
Howard Takal
Howard Thomas
John Thomas
William Thon

Mark Tobey
George Tooker
Anthony Toney
Joyce Treiman
Esteban Vicente
Charles Virga
Howard Warshaw
Max Weber
Elbert Weinberg
Nat Werner
James Wines
Joseph Winter
Emerson Woelffer
Jack Wolfe
Robert Jay Wolff
Thomas Yerxa
Adja Yunkers
Karl Zerbe
William Zorach

1957
*Sculpture, Paintings,
and Watercolors*

Artists
Josef Albers
Calvin Albert
Ivan Albright
Alexander Archipenko
David Aronson
Milton Avery
Peggy Bacon
Will Barnet
Leonard Baskin
William Baziotes
Rosemarie Beck
Isabel Bishop
Alfred Blaustein
Ilya Bolotowsky
Louise Bourgeois

Gandy Brodie
James Brooks
Carlyle Brown
Charles Burchfield
Paul Burlin
Doris Caesar
Charles Cajori
Lawrence Calcagno
Alexander Calder
Kenneth Callahan
Mary Callery
Victor Candell
Nicholas Carone
William Chaiken
Edward Chavez
William Congdon
Joseph Cornell
Richard Crist
Bruce Currie
Lily Cushing
Stuart Davis
José De Creeft
Adolf Dehn
Koren Der Harootian
José De Rivera
Enrico Donati
Jimmy Ernst
Philip Evergood
Yonia Fain
Herbert Ferber
Keith Finch
Sam Francis
Jack Frankfurter
Jared French
Lee Gatch
Edward Giobbi
Fritz Glarner
Michael Goldberg
Milton Goldring
Robert Goodnough
Sidney Gordin
Adolph Gottlieb
Morris Graves
Dorothea Greenbaum
Balcomb Greene
Stephen Greene
Peter Grippe
Chaim Gross
Philip Guston
Robert Gwathmey
Raoul Hague

David Hare
Minna Harkavy
Grace Hartigan
Milton Hebald
John Heliker
Hans Hofmann
Carl Holty
John Hultberg
Robert Irwin
Wolf Kahn
Herbert Kallem
Herbert Katzman
William Kienbusch
William King
Dong Kingman
Jonah Kinigstein
Jules Kirschenbaum
Franz Kline
Karl Knaths
Lee Krasner
Lawrence Kupferman
Edward Laning
Ibram Lassaw
Jacob Lawrence
Pietro Lazzari
Rico Lebrun
Barbara Lekberg
Alfred Leslie
John Levee
Julian Levi
Jack Levine
Si Lewen
Jacques Lipchitz
Seymour Lipton
Eugene Ludins
Loren MacIver
Ethel Magafan
Oronzio Maldarelli
Conrad Marca-Relli
Fletcher Martin
Gerald McLaughlin
George McNeil
Zygmunt Menkes
Edward Millman
Joan Mitchell
Randall Morgan
Carl Morris
George L. K. Morris
Kyle Morris
Robert Motherwell
Jan Muller

Walter Murch
Louise Nevelson
Juan Nickford
Henry Niese
Kenzo Okada
Georgia O'Keeffe
Charles Oscar
Alfonso Ossorio
Arthur Osver
Stephen Pace
William Pachner
William Palmer
Betty Parsons
I. Rice Pereira
Bernard Perlin
Blanche Phillips
Marianna Pineda
Walter Plate
Anne Poor
Richard Pousette-Dart
Gregorio Prestopino
Abraham Rattner
Anton Refregier
Ad Reinhardt
Milton Resnick
Jeanne Reynal
Larry Rivers
Hugo Robus
Umberto Romano
Theodore Roszak
Kay Sage
Day Schnabel
Henry Schnakenberg
Karl Schrag
Charles Schucker
Jon Schueler
Ethel Schwabacher
Manfred Shwartz
Charles Seliger
Kurt Seligmann
Ben Shahn
Charles Sheeler
Mitchell Siporin
Raphael Soyer
Theodoros Stamos
Richard Stankiewicz
Joseph Stefanelli
Hedda Sterne
Sahl Swarz
William Thon
Mark Tobey

Margaret Tomkins
George Tooker
Harold Tovish
Stanley Twardowicz
Jack Tworkov
Polygnotos Vagis
Alfred Van Loen
Robert Vickrey
David Von Schlegell
Charmion Von Wiegand
Max Weber
Elbert Weinberg
John Wilde
Walter Williams
Jack Wolfe
Andrew Wyeth
Karl Zerbe
William Zorach

1956
*Sculpture, Watercolors,
and Drawings*

Artists
Aach
Calvin Albert
Ivan Albright
Leo Amino
Jeremy Anderson
Malcolm Gordon Anderson
Oliver Andrews
Ruth Armer
Ruth Asawa
Milton Avery
Peggy Bacon
Virginia Banks
Leonard Baskin

William Baziotes
Margit Beck
Ben-Zion
George Biddle
Isabel Bishop
Dusti Bonge
Louise Bourgeois
William Brice
James Brooks
Carlyle Brown
Byron Browne
Charles Burchfield
Paul Burlin
Paul Cadmus
Doris Caesar
Lawrence Calcagno
Alexander Calder
Kenneth Callahan
Mary Callery
Victor Candell
Rhys Caparn
Clarence H. Carter
Chen-Chi
Warrington Colescott
Robert Cook
Edward Corbett
Joseph Cornell
Robert Cronbach
Roger L. Crossgrove
Noel Davis
Stuart Davis
Lindsey Decker
José De Creeft
Adolf Dehn
Willem de Kooning
Koren Der Harootian
José De Rivera
Henry Di Spirito
Enrico Donati
Lu Duble
Leonard Edmondson
Ethel Edwards
Jimmy Ernst
Philip Evergood
Fred Farr
Berenice Feinstein
Josh Fendell
Herbert Ferber
John Ferren
Keith Finch
Seymour Fogel

Gray Foy
Antonio Frasconi
Paul Frazier
David Fredenthal
Jared French
Sue Fuller
Adomas Galdikas
Jan Gelb
Joseph Glasco
Xavier Gonzalez
Sidney Gordin
Adolph Gottlieb
John D. Graham
Morris Graves
Dorothea Greenbaum
Balcomb Greene
Stephen Greene
Peter Grippe
Chaim Gross
George Grosz
Roy Gussow
Philip Guston
Carl Hall
David Hare
Minna Harkavy
John Hartell
Stuart Harwood
Milton Hebald
Albert Heckman
Charles Heidenreich
John Heliker
Hans Hofmann
Robert B. Howard
John Hultberg
Angelo Ippolito
Ynez Johnston
Robert Kabak
Herbert Kallem
Nathaniel Kaz
León Kelly
Adaline Kent
William Kienbusch
Frederick J. Kiesler
Dong Kingman
Jonah Kinigstein
Lyman Kipp
Jules Kirschenbaum
Henry Koerner
Richard Koppe
Louise Kruger
Lawrence Kupferman

Edward Laning
Maurice A. Lapp
Ibram Lassaw
Robert Laurent
Pietro Lazzari
James Lechay
Charles LeClair
Leonid
Jack Levine
Simon Levine
Richard Lidner
Jacques Lipchitz
Peter Lipman-Wulf
Seymour Lipton
Vincent Longo
Eugene Ludins
Oronzio Maldarelli
Beatrice Mandelman
Peppino Mangravite
Boris Margo
De Hirsh Margules
Harry Marinsky
Helen Marshal
Ezio Martinelli
John W. McCoy
J. Jay McVicker
Hugh Mesibov
Edward Millman
Robert Moir
Carl Morris
George Morrison
Lee Mullican
Reuben Nakian
Louise Nevelson
Juan Nickford
Constantino Nivola
Isamu Noguchi
Elizabeth Olds
Charles Oscar
Alfonso Ossorio
Stephen Pace
Robert Andrew Parker
Betty Parsons
Abbott Pattison
I. Rice Pereira
Bernard Perlin
Gabor Peterdi
Ogden Pleissner
Richard Pousette-Dart
Rudy Pozzatti
Gregorio Prestopino

George Ratkai
Abraham Rattner
Jeanne Reynal
Daniel Rhodes
Larry Rivers
Hugo Robus
Theodore Roszak
Henry Rox
Andrée Ruellan
Robert I. Russin
Hélène Sardeau
Concetta Scaravaglione
Karl Schrag
Georges Schreiber
Charles Schucker
Sonia Sekula
Charles Seliger
Kurt Seligman
John Sennhauser
Rene Shapshak
Sarai Sherman
Helena Simkhovitch
Sidney Simon
Mitchell Siporin
David Smith
Edwin E. Sponsler
Theodoros Stamos
Richard Stankiewicz
Saul Steinberg
Edward John Stevens
Dorothy Sturm
Peter Takal
John Taylor
William Thon
Mark Tobey
Trajan
Charles Umlauf
Polygnotos Vagis
Robert Vickrey
John Von Wicht
Jane Wasey
Max Weber
Nat Werner
Anita Weschler
Charles White
John Wilde
Andrew Wyeth
Karl Zerbe
William Zorach
Jack Zuckerman

ANNUAL EXHIBITION
SCULPTURE PAINTINGS
WATERCOLORS
DRAWINGS
November 14, 1956 to January 6, 1957
WHITNEY MUSEUM OF AMERICAN ART

Artists
Pat Adams
Samuel Adler
Josef Albers
Calvin Albert
Leo Amino
Alexander Archipenko
Milton Avery
Gertrude Barrer
William Baziotes
Janice Biala
Isabel Bishop
Nell Blaine
Lucile Blanch
Hyman Bloom
Peter Blume
Louis Bouché
Louise Bourgeois
William Brice
Ernest Briggs
James Brooks
Carlyle Brown
Colleen Browning
Charles Burchfield
Paul Burlin
Paul Cadmus
Doris Caesar
Lawrence Calcagno
Alexander Calder
Kenneth Callahan
Victor Candell
Cecil Lang Casebier
William Chaiken
Edward Chavez
Herman Cherry

William Congdon
Robert Cook
Edward Corbett
Joseph Cornell
Richard Crist
Robert Chronbach
Adolf Dehn
Willem de Kooning
Koren Der Harootian
José De Rivera
Lamar Dodd
Enrico Donati
Seymour Drumlevitch
Lu Duble
Hazard Durfee
Jimmy Ernst
Philip Evergood
Herbert Ferber
John Ferren
Seymour Fogel
Gray Foy
Sam Francis
Jared French
Joseph Friebert
Sue Fuller
William Gambini
Lee Gatch
Jan Gelb
Fritz Glarner
Joseph Glasco
Xavier Gonzalez
Robert Goodnough
Sidney Gordin
Joseph Gotto
Adolph Gottlieb
Morris Graves
Dorothea Greenbaum
Balcomb Greene
Stephen Greene
Peter Grippe
Chaim Gross
John Guerin
Philip Guston
Ernest Guteman
Robert Gwathmey
Raoul Hague
David Hare
Minna Harkavy
Grace Hartigan
Kaname Hayashi
John Heliker

Dorothy Heller
Edward Hopper
John Hultberg
Tom Ingle
Mitchell Jamieson
Murray Jones
Matsumi Kanemitsu
Herbert Katzman
Nathaniel Kaz
Gyorgy Kepes
William Kienbusch
William King
Dong Kingman
Jonah Kinigstein
Jules Kirschenbaum
Franz Kline
Karl Knaths
Lee Krasner
Ibram Lassaw
John Laurent
Pietro Lazzari
Jack Levine
Jacques Lipchitz
Peter Lipman-Wulf
Seymour Lipton
Oronzio Maldarelli
Conrad Marca-Relli
Boris Margo
Ezio Martinelli
Henry Mattson
Douglas McClellan
James McGarrell
Hugh Mesibov
Richard Miller
Hans Moller
Randall Morgan
Carl Morris
Kyle Morris
Robert Motherwell
George Mueller
Walter Murch
Louise Nevelson
Juan Nickford
Isamu Noguchi
Kenzo Okada
Georgia O'Keeffe
Earle Olsen
Charles Oscar
Alfonso Ossorio
Stephen Pace
William Palmer

Robert Andrew Parker
Abbott Pattison
Philip Pearlstein
I. Rice Pereira
Gabor Peterdi
Richard Pousette-Dart
Gregorio Prestopino
Leo Quanchi
George Ratkai
Abraham Rattner
Ad Reinhardt
Jeanne Reynal
Larry Rivers
Hugo Robus
Ralph M. Rosenborg
Robert Rosenwald
Theodore Roszak
Kay Sage
Louis Schanker
Henry Schnakenberg
Jo Anne Schneider
Charles Schucker
Ethel Schwabacher
Manfred Schwartz
Charles Seliger
Kurt Seligmann
Ben Shahn
Charles Sheeler
Raphael Soyer
Theodoros Stamos
James Sterling
Harold Sterner
William Story
Peter Takal
Reuben Tam
Sabina Teichman
William Thon
Mark Tobey
George Tooker
Trajan
Jack Tworkov
Robert Vickrey
Ruth Vodicka
John Von Wicht
Vaclav Vytlacil
Jane Wasey
Hugo Weber
Nat Werner
Anita Weschler
John Wilde
Walter Williams

Andrew Wyeth
Karl Zerbe
William Zorach

1955

Paintings, Sculpture,
Watercolors, and Drawings

Artists
Samuel Adler
Josef Albers
Calvin Albert
Ivan Albright
John Altoon
David Aronson
Ruth Asawa
Peggy Bacon
Leonard Baskin
Helen Beling
Eugene Berman
Isabel Bishop
Peter Blume
Ilya Bolotowsky
Louis Bosa
Dorr Bothwell
Louis Bouché
Louise Bourgeois
Richard Bové
Byron Browne
Fritz Bultman
Louis Bunce
Charles Burchfield
Paul Burlin
Paul Cadmus
Doris Caesar
Alexander Calder

Mary Callery
Victor Candell
Gerald Coarding
Warrington Colescott
Robert Conover
Robert Cook
Edward Corbett
Joseph Cornell
Staats Cotsworth
Ralston Crawford
Robert Cronbach
Willard W. Cummings
Virginia Cuthbert
Lindsay Daen
Robert D'Arista
Stuart Davis
José De Creeft
Adolf Dehn
Koren Der Harootian
José De Rivera
Arthur Deshaies
Edwin Dickinson
Burgoyne Diller
Blanche Dombek
Enrico Donati
Seymour Drumlevitch
Lu Duble
Hazard Durfee
Elise
Philip Evergood
Lyonel Feininger
Lorser Feitelson
John Ferren
Perle Fine
James Fitzgerald
Seymour Fogel
Helen Frankenthaler
Jared French
Lee Gatch
Ruth Gikow
Fritz Glarner
Leon Golub
Xavier Gonzalez
Frank Goodnow
Byron Goto
Joseph Goto
Lorrie Goulet
John Graham
Morris Graves
Dorothea Greenbaum
Balcomb Greene

William Gropper
Chaim Gross
Richard Grossenbach
Louis Guglielmi
Philip Guston
Robert Gwathmey
Luke Gwilliam
Tom Hardy
Minna Harkavy
Grace Hartigan
Milton Hebald
Hans Hofmann
Donald W. Holst
Edward Hopper
Robert B. Howard
John Hultberg
Lewis Iselin
Ynez Johnston
Luise Kaish
Mariska Karasz
Nathaniel Kaz
León Kelly
William King
Dong Kingman
Jules Kirschenbaum
Karl Knaths
Edward Laning
Maurice Lapp
Joe Lasker
James Lechay
Leonid
Peter Lipman-Wulf
Loren MacIver
Oronzio Maldarelli
Peppino Mangravite
Conrad Marca-Relli
Boris Margo
Berta Margoulies
Helen Marshall
Knox Martin
Matta
Henry Mattson
Robert McChesney
Sigmund Menkes
Felicia Meyer
Walter Midener
Robert Moir
Hans Moller
Maud Morgan
Randall Morgan
Carl Morris

George L. K. Morris
George Mueller
Juan Nickford
Tino Nivola
Isamu Noguchi
Nuala (Elsa De Brun)
Kenzo Okada
Georgia O'Keeffe
Alfonso Ossorio
Arthur Osver
William Palmer
Robert Andrew Parker
James Penney
I. Rice Pereira
Walter Plate
Rudy Pozzatti
Gregorio Prestopino
Easton Pribble
Leo Quanchi
Walter Quirt
George Ratkai
Abraham Rattner
Anton Refregier
Siegfried Reinhardt
Jeanne Reynal
Larry Rivers
Hugo Robus
Theodore Roszak
Kay Sage
Charles Salerno
Concetta Scaravaglione
Henry Schnakenberg
Karl Schrag
Georges Schreiber
Charles Schucker
Manfred Schwartz
Charles Seliger
Kurt Seligmann
John Sennhauser
Ben Shahn
Charles Sheeler
Helena Simkhovitch
Sidney Simon
Simpson-Middleman
Mitchell Siporin
Esphyr Slobodkina
David Smith
Joseph Solman
Raphael Soyer
Leo Steppat
Walter Stuempfig

Sahl Swarz
Peter Takal
Reuben Tam
Yves Tanguy
John Taylor
William Thon
Mark Tobey
Stanley Twardowicz
Russell Twiggs
Jack Tworkov
Lucia Vernarelli
Ruth Vodicka
John Von Wicht
Charmion Von Wiegand
Vaclav Vytlacil
Charles Wadsworth
Sylvia Wald
Carl Walters
Jane Wasey
Nat Werner
Anita Weschler
Charles White
John Wilde
Walter Williams
Karl Zerbe
William Zorach

Painting

Artists
Samuel Adler
Josef Albers
Ivan Albright
Albert Alcalay
Takeshi Asada
William Baziotes
Romare Bearden

Rosemarie Beck
Tom Benrimo
Claude Bentley
Ernestine Betsberg
Janice Biala
Arnold Blanch
Arbit Blatas
Yuli Blumberg
Seymour Boardman
Ilya Bolotowsky
Elie Borgrave
Ernest Briggs
James Brooks
Carlyle Brown
Colleen Browning
Hans Burkhardt
Peter Busa
Lawrence Calcagno
Victor Candell
Norman Carton
William Chaiken
Elwyn Chamberlain
Herman Cherry
Carmen Cicero
Minna Citron
William Congdon
Robert F. Conover
Willard W. Cummings
Robert D'Arista
Adolf Dehn
Robert Deniro
Richard Diebenkorn
Harvey Dinnerstein
Jimmy Ernst
Philip Evergood
John Ferren
Ernest Fiene
Keith Finch
Jane Freilicher
Jared French
Shizuko Fujimoto
Lee Gatch
Fritz Glarner
Leon Golub
Byron Goto
Adolph Gottlieb
Morris Graves
Robert Greco
Balcomb Greene
Stephen Greene
John Gregoropoulos

William Gropper
Louis Guglielmi
Carl Hall
Lily Harmon
Grace Hartigan
Leon Hartl
John Heliker
Fannie Hillsmith
Joseph Hirsch
Margo Hoff
Hans Hofmann
John Hultberg
Herbert Katzman
León Kelly
Earl Kerkam
Robert Keyser
Jules Kirschenbaum
Franz Kline
Karl Knaths
Joe Lasker
James C. Leong
Leonid
Jack Levine
Israel Litwak
Eugene Ludins
Loren MacIver
Howard Mandel
Leo Manso
Conrad Marca-Relli
Boris Margo
Fletcher Martin
Keith Martin
Alice Trumbull Mason
Eugene Massin
Matta
James McGarrell
Sigmond Menkes
Felicia Meyer
Edward Millman
Joan Mitchell
Hans Moller
Randall Morgan
George Mueller
Walter Murch
Kenzo Okada
Georgia O'Keeffe
John Opper
Arthur Osver
William Palmer
Philip Pearlstein
I. Rice Pereira

Gabor Peterdi
George Picken
Alton Pickens
Walter Plate
Reginald Pollack
Richard Pousette-Dart
Gregorio Prestopino
Easton Pribble
Abraham Rattner
Rudolf Ray
Anton Refregier
Ad Reinhardt
Wallace Reiss
Louis Ribak
Larry Rivers
Franklin Robbins
Herman Rose
Kay Sage
Lucia Salemme
Herbert Saslow
David Sawin
Henry Schnakenberg
Charles Schucker
Ethel Schwabacher
Kurt Seligmann
Ben Shahn
Charles Sheeler
Sarai Sherman
Mitchell Siporin
Joseph Solman
Moses Soyer
Raphael Soyer
Theodoros Stamos
Walter Stein
Reuban Tam
Stanley D. Tasker
Frederic Taubes
John Taylor
Howard Thomas
Mark Tobey
Anthony Toney
George Tooker
Nahum Tschacbasov
Stanley Twardowicz
Jack Tworkov
Vasilieff
Estaban Vicente
Robert Vickrey
Martha Visser't Hooft
John Von Wicht
June Wayne

Max Weber
Walter Williams
Sol Wilson
Jean Xceron
Karl Zerbe

1954

*Sculpture, Watercolors,
and Drawings*

1954 Annual Exhibition

SCULPTURE
WATERCOLORS
DRAWINGS

MARCH 17
APRIL 18

Whitney Museum of American Art

Artists
Fritzie Abadi
Josef Albers
Calvin Albert
Charles H. Alston
Leo Amino
Roger Anliker
Charles Annan
Peggy Bacon
Saul Baizerman
Gertrude Barrer
William Baziotes
Robert B. Becker
Isabel Bishop
Bill Bomar
Grace Borgenicht
Louis Bosa
Louise Bourgeois
William Brice
Gandy Brodie
James Brooks
Carlyle Brown
Charles Burchfield
Paul Cadmus
Doris Caesar
Alexander Calder

Victor Candell
Rhys Caparn
Chi Chen
Edward Corbett
Lucille Corcos
Joseph Cornell
Rollin Crampton
Robert Cronbach
José De Creeft
Julio De Diego
Adolf Dehn
Willem de Kooning
Koren Der Harootian
José De Rivera
Lu Duble
Jimmy Ernst
Wharton Esherick
Lyonel Feininger
Herbert Ferber
Perle Fine
Antonio Frasconi
Paul Frazier
David Frendenthal
Jared French
Sue Fuller
Naum Gabo
William Getman
Joseph Glasco
Vincent Glinsky
Lloyd Goff
Xavier Gonzalez
Sidney Gordin
Joseph Goto
Adolph Gottlieb
Morris Graves
Stephen Greene
Peter Grippe
Chaim Gross
Isadore Grossman
William Halsey
Tom Hardy
David Hare
Milton Hebald
Albert Heckman
Charles Heidenreich
John Heliker
Hans Hofmann
Edward Hopper
Cecil Howard
Hazel Janicki
Ernesto Gonzalez Jerez

Alice Edith Johnson
Buffie Johnson
Ynez Johnston
Nathaniel Kaz
León Kelly
Adaline Kent
William Kienbusch
William King
Dong Kingman
Jonah Kinigstein
Jules Kirschenbaum
Robert Knipschild
Gabriel Kohn
Richard Koppe
Bruno Krauskopf
Louise Kruger
Edward Laning
Joe Lasker
Ibram Lassaw
Robert Laurent
Jacob Lawrence
James Lechay
Jacques Lipchitz
Peter Lipman-Wulf
Seymour Lipton
Ward Lockwood
Oronzio Maldarelli
Peppino Mangravite
Boris Margo
Marguerite
Reginald Marsh
Edward Millman
Robert Moir
Hans Moller
Robert Motherwell
Alfonso Ossorio
Stephen Pace
William Pachner
Betty Parsons
Abbott Pattison
I. Rice Pereira
Bernard Perlin
Simmons Persons
Gabor Peterdi
Blanche Phillips
Marianna Pineda
Ogden M. Pleissner
Jackson Pollock
Gregorio Prestopino
Robert G. Price
Sara Provan

Waldemar Raemisch
George Ratkai
Jeanne Reynal
Louis Ribak
Larry Rivers
Hugo Robus
James Rosati
Robert Rosenwald
Theodore Roszak
Andrée Ruellan
Alfred Russell
Anne Ryan
Hélène Sardeau
Concetta Scaravaglione
Karl Schrag
Georges Schreiber
Charles Schucker
Charles Seliger
Kurt Seligman
John Sennhauser
Ben Shahn
Sarai Sherman
David Smith
Edith M. Smith
Miron Sokole
Moses Soyer
Edwin E. Sponsler
Theodoros Stamos
Evelyn Statsinger
Saul Steinberg
Leo Steppat
Edward John Stevens
Jules Struppeck
Duncan Robert Stuart
Sahl Swarz
John H. Taylor
William Thon
Mark Tobey
Harold Tovish
Stanley Twardowicz
Polygnotos Vagis
George Vander Sluis
Robert Vickrey
Ruth Vodicka
John Von Wicht
Nat Werner
John Wilde
Nina Winkel
Clark Winter
Andrew Wyeth
William Zorach

1953

*Sculpture, Watercolors,
and Drawings*

1953 Annual Exhibition

SCULPTURE
WATERCOLORS
DRAWINGS

APRIL 9
MAY 29

Whitney Museum of American Art

Artists

Calvin Albert
Harold Ambellan
Leo Amino
Charles Annan
Alexander Archipenko
Saul Baizerman
Stanley Bate
Will Behler
Jane Berlandina
Eugene Berman
Isabel Bishop
Arbit Blatas
Louise Bourgeois
James Brooks
Carlyle Brown
Charles Burchfield
Paul Cadmus
Alexander Calder
Mary Callery
Rhys Caparn
Robert Cook
Edward Corbett
Lucille Corcos
Joseph Cornell
Konrad Cramer
Andrew Dasburg
José De Creeft
Julio De Diego
Dorothy Dehner
Willem de Kooning
Koren Der Harootian
Henry Di Spirito

Lu Duble
Frank Duncan
Leonard Edmondson
Elizabeth Engelhard
Jimmy Ernst
Wharton Esherick
Emlen Etting
Lyonel Feininger
Herbert Ferber
David Frendenthal
Sue Fuller
Joseph Glasco
Sidney Gordin
Adolph Gottlieb
Lorrie Goulet
Morris Graves
Dorothea Greenbaum
Balcomb Greene
John Grillo
Peter Grippe
Werner Groshans
Chaim Gross
Isidore Grossman
Lena Gurr
Philip Guston
Joseph Hahn
William Halsey
James Hansen
David Hare
Minna Harkavy
Milton Hebald
Albert Heckman
Diana Heiskell
Harry Hoehn
Hans Hoffman
John Hovannes
Robert B. Howard
Lewis Iselin
Ynez Johnston
Joe Jones
Florence Kawa
Nathaniel Kaz
León Kelly
Ellen Key-Oberg
William Kienbusch
Dong Kingman
Jonah Kinigstein
Franz Kline
Henry Koerner
Gabriel Kohn
Richard Koppe

Yasuo Kuniyoshi
Lawrence Kupferman
Irene Lagorio
Ibram Lassaw
Jacob Lawrence
James Lechay
Barbara Lekberg
Leonid
Simon Levine
Herschel Levit
Israel Levitan
Edmund Lewandowski
Peter Lipman-Wulf
Richard Lippold
Seymour Lipton
Oronzio Maldarelli
Peppino Mangravite
Boris Margo
Berta Margoulies
De Hirsh Margules
John Marin
Joseph Meert
Walter C. Midener
Edward Millman
Robert Moir
Hans Moller
George L. K. Morris
Mark Morrison
Robert Motherwell
Paul Nabb
Fred Nagler
Katharine Nash
Louise Nevelson
Juan Nickford
Charles Oscar
Alfonso Ossorio
Stephen Pace
William Pachner
Betty Parsons
Gabor Peterdi
Donald A. Peters
Marianna Pineda
Ogden M. Pleissner
Reginald Pollack
Jackson Pollock
Henry Varnum Poor
Gregorio Prestopino
Sara Provan
George Ratkai
Bernard Reder
Jeanne Reynal

George Rickey
Ivan Rigby
Hugo Robus
James Rosati
Bernard Rosenthal
Theodore Roszak
Alfred Russell
Anne Ryan
Atillio Salemme
Lucia Autorino Salemme
Charles Salerno
Louis Schanker
Xanti Schawinsky
Day Schnabel
Karl Schrag
Georges Schreiber
Jason Seley
Charles Shaw
Helena Simkhovitch
David Smith
Jacob Getlar Smith
Miron Sokole
Edwin E. Sponsler
Saul Steinberg
Harry Sternberg
Edward John Stevens
William Talbot
Dorothea Tanning
John Taylor
Marie Taylor
Donald Thrall
Mark Tobey
Harold Tovish
Jack Tworkov
Charles Umlauf
Bror Utter
Ruth Vodicka
Jane Wasey
Cady Wells
Nat Werner
Anita Weschler
Charles White
Gurdon Woods
Andrew Wyeth
Jack Zuckerman

Painting

Artists
Samuel Adler
Josef Albers
Bernard Arnest
David Aronson
Milton Avery
Will Barnet
William Baziotes
Isabel Bishop
Lucile Blanch
Al Blaustein
Peter Blume
Ilya Bolotowsky
Cameron Booth
Richard Bové
James Brooks
Carlyle Brown
Byron Browne
Colleen Browning
Louis Bunce
Peter Busa
Paul Cadmus
Victor Candell
William Chaiken
Edward Chavez
Carroll Cloar
William Congdon
Robert Conover
Ralston Crawford
Harry Crowley
Virginia Cuthbert
Stuart Davis
Worden Day
Willem de Kooning
Edwin Dickinson

Burgoyne Diller
Frank Duncan
Hazard Durfee
Ethel Edwards
Dean Ellis
Jimmy Ernst
Philip Evergood
Lyonel Feininger
Ernest Fiene
Seymour Fogel
Karl E. Fortess
Michael Frary
Guy Fraumeni
Jared French
Lee Gatch
Jan Gelb
Fritz Glarner
Joseph Glasco
Adolph Gottlieb
Robert Greco
Stephen Greene
Marion Greenstone
Louis Guglielmi
Philip Guston
Robert Gwathmey
John Hartell
John Heliker
Hans Hofmann
Edward Hopper
Jo N. Hopper
John Langley Howard
Gerome Kamrowski
Fredric Karoly
Herbert Katzman
Jonah Kinigstein
Jules Kirschenbaum
Franz Kline
Karl Knaths
Robert Knipschild
Joe Lasker
Leonid
Julian E. Levi
Jack Levine
Edmund Lewandowski
Howard Mandel
Leo Manso
Conrad Marca-Relli
Boris Margo
John Marin
Reginald Marsh
Fletcher Martin

Alice Trumbull Mason
Henry Mattson
George McNeil
Edward Melcarth
Paul Mommer
Randall Morgan
George L. K. Morris
George Morrison
Robert Motherwell
Walter Murch
Roy Newell
Georgia O'Keeffe
Arthur Osver
William Palmer
Charlotte Park
I. Rice Pereira
Bernard Perlin
Marjorie Phillips
Walter Plate
Jackson Pollock
Henry Varnum Poor
Richard Pousette-Dart
Gregorio Prestopino
Walter Quirt
Abraham Rattner
Anton Refregier
Ad Reinhardt
Siegfried Reinhardt
Herman Rose
Alfred Russell
Kay Sage
Attilio Salemme
Louis Schanker
Henry Schnakenberg
Charles Schucker
Manfred Schwartz
Kurt Seligmann
Ben Shahn
Charles Sheeler
Sidney Simon
Mitchell Siporin
Esphyr Slobodkina
Judson Smith
Raphael Soyer
Theodoros Stamos
Duncan R. Stuart
Walter Stuempfig
Reuben Tam
Yves Tanguy
Mark Tobey
Margaret Tomkins

Anthony Toney
George Tooker
Jack Tworkov
Esteban Vicente
Robert Vickrey
Martha Visser't Hooft
Vaclav Vytlacil
Howard Warshaw
Max Weber
Ralph L. Wickiser
John Wilde
Walter Williams
Joe Wolins
Hale Woodruff
Karl Zerbe

1952

Sculpture, Watercolors, and Drawings

Artists
Leo Amino
Charles Annan
Alexander Archipenko
John Atherton
Milton Avery
Saul Baizerman
Will Barnet
John R. Baxter
William Baziotes
Ben-Zion
Isabel Bishop
Peter Blanc
Arbit Blatas
William Brice
James Brooke

Byron Browne
Fritz Bultman
Charles Burchfield
Doris Caesar
Alexander Calder
Kenneth Callahan
Mary Callery
Malcom Edgar Case
Federico Castellón
George Cerny
George Constant
Robert Cook
Jon Corbino
Lily Cushing
José De Creeft
Willem de Kooning
Ara Derderian
Koren Der Harootian
José De Rivera
Sari Dienes
Blanche Dombek
Frank Duncan
Winslow B. Eaves
Leonard Edmondson
Jules Engel
Wharton Esherick
Clara Fasano
Lyonel Feininger
Herbert Ferber
Perle Fine
David Fredenthal
Joseph Glasco
Vincent Glinsky
Xavier Gonzalez
Sidney Gordin
Adolph Gottlieb
Morris Graves
Dorothea Greenbaum
Peter Grippe
Chaim Gross
Isidore Grossman
George Grosz
Philip Guston
Robert Gwathmey
Raoul Hague
Carl Hall
David Hare
Minna Harkavy
Milton Hebald
Albert W. Heckman
Hesketh

Hans Hofmann
Robert B. Howard
Mitchell Jamieson
Joe Jenks
Ynez Johnston
Joe Jones
Herbert Kallem
Karl Kasten
Nathaniel Kaz
William Kienbusch
William King
Dong Kingman
Franz Kline
Henry Koerner
Yasuo Kuniyoshi
Lawrence Kupferman
Ibram Lassaw
Jacob Lawrence
Rico Lebrun
James Lechey
Michael Lekakis
Leonid
Israel Levitan
Alfred Levitt
Edmund Lewandowski
Norman Lewis
Marjorie Liebman
Peter Lipman-Wulf
Richard Lippold
Seymour Lipton
Ward Lockwood
Agnes Potter Lowrie
Daniel Maloney
Boris Margo
Berta Margoulies
Marguerite
De Hirsh Margules
John Marin
Janet Marren
Reginald Marsh
Joseph Meierhans
Dina Melicov
Fred Meyer
Edward Millman
Robert Moir
Hans Moller
Robert Motherwell
Seong Moy
William Muir
Robert S. Neuman
Isamu Noguchi

B.J.O. Nordfeldt
Elizabeth Olds
John Opper
Charles Oscar
Charles Owens
William Pachner
William Palmer
Betty Parsons
I. Rice Pereira
Gabor Peterdi
Ogden M. Pleissner
Jackson Pollock
Anne Poor
Henry Varnum Poor
Gregorio Prestopino
Waldemar Raemisch
George Ratkai
Bernard Reder
Ad Reinhardt
Jeanne Reynal
George Rickey
Hugo Robus
James Rosati
Theodore Roszak
Alfred Russel
Attilio Salemme
Charles Salerno
Cencetta Scaravaglione
Armin Scheler
Day N. Schnabel
Henry Schnakenberg
Georges Schreiber
Jason Seley
Charles Seliger
John Sennhauser
Ben Shahn
David Smith
Saul Steinberg
Charles Stevens
Ary Stillman
F. Alston Swift
Rueban Tam
Frederic Taubes
John Taylor
Pavel Tchelitchew
William Thon
Arnold Thurm
Mark Tobey
George Tooker
Harold Tovish
Trajan

Polygnotos Vagis
Charles Virga
Ruth Vodicka
John Von Wicht
Vaclav Vytlacil
Carl Walters
Heinz Warneke
Jane Wasey
Roy Weber
Saul Weinstock
Nat Werner
Anita Weschler
Charles White
John Wilde
Andrew Wyeth
Karl Zerbe
William Zorach
Jack Zuckerman

Painting

Artists
Herb Aach
Samuel Adler
Ivan Albright
Charles H. Alston
John Anderson
Dorothy Andrews
Milton Avery
Virginia Banks
George Barber
William Baziotes
John Beauchamp
Tom Benrimo
Arnold Blanch
Julius Bloch
Ilya Bolotowsky

Bill Bomar
Louis Bosa
Louis Bouché
Clarence A. Brodeur
Fritz Bultman
Paul Burlin
Peter Busa
Kenneth Callahan
Victor Candell
William Chaiken
Carroll Cloar
Russell Cowles
Ralston Crawford
Francis Criss
Beatrice Cuming
Virginia Cuthbert
Kenneth Davies
Stuart Davis
Adolph Dehn
Burgoyne Diller
Maurice Douek
Guy Pène Du Bois
Hazard Durfee
Myrwyn Eaton
Ethel Edwards
Philip C. Elliott
Max Ernst
Philip Evergood
Kenneth Evett
Remo Farruggio
Ernest Fiene
Karl E. Fortess
C. Murray Foster
Jack Frankfurter
Seymour Franks
Lee Gatch
Helen Gerardia
Fritz Glarner
Charles L. Goeller
Stephen Greene
William Gropper
Werner Groshans
Joseph Gualtieri
Louis Guglielmi
Robert Gwathmey
Carl Hall
James V. Harvey
Hans Hofmann
Harlan H. Holladay
Peter Hopkins
Edward Hopper

Martin Jackson
Hazel Janicki
George J. Kachergis
Morris Kantor
Herbert Katzman
León Kelly
Franz Kline
Karl Knaths
Adolf Konrad
Yasuo Kuniyoshi
Edward Laning
Jack Levine
William H. Littlefeild
Charles Locke
Erle Loran
Ethel Magafan
John Marin
Reginald Marsh
Henry Mattson
James McCray
Walter Meigs
Edwards Melcarth
Sigmund Menkes
Maud Morgan
Randall Morgan
Kyle R. Morris
Robert Motherwell
Lee Mullican
Anna Neagoe
Arthur Osver
Amédée Ozenfant
William Palmer
Raymond Parker
Marjorie Phillips
George Picken
Rudy Pozzati
Raymond Prohaska
Richard T. Pyle
Leo Quanchi
Savo Radulovic
Anton Refregier
Sam Reichmann-Lewis
Ad Reinhardt
Siegfried Reinhardt
Ruth Rosekrans
Andrée Ruellan
Alfred Russell
Felix Ruvolo
Kay Sage
Attilio Salemme
Rolph Scarlett

Henry Schnakenberg
Charles Schucker
Ethel Schwabacher
Lester O. Schwartz
David Segel
William Seitz
Zoltan Sepeshy
Ben Shahn
Charles Sheeler
Charles Sibley
Sidney Simon
Salvatore Sirugo
Esphyr Slobodkina
Leon Polk Smith
Moses Soyer
Raphael Soyer
Theodoros Stamos
Duncan Robert Stuart
Reuben Tam
Mark Tobey
Margaret Tomkins
Bradley Tomlin
Anthony Toney
George Tooker
Joyce Treiman
Tromka
Nahum Tschacbasov
Dorothy Varian
Robert Vickrey
Martha Visser't Hooft
John Von Wicht
Vaclav Vytlacil
John Wilde
Sol Wilson
Julius Woeltz
Jean Xceron
Marguerite Zorach

1951

Sculpture, Watercolors,
and Drawings

Artists
Leo Amino
Roger Anliker
Saul Baizerman
Kit Barker
Gertrude Barrer
Oliver O'Connor Barrett
William Baziotes
Romare Bearden
Isabel Bishop
Peter Blume
Henry Botkin
Louise Bourgeois
William Brice
James Brooks
C. Ludwig Brumme
Charles Burchfield
Alexander Calder
Kenneth Callahan
Mary Callery
Albino Cavallito
Glenn Chamberlain
Lucille Corcos
Charles Culver
Emma Lou Davis
José De Creeft
Adolf Dehn
Dorothy Dehner
Willem de Kooning
Koren Der Harootian
José De Rivera
Frank Di Gioia
Henry Di Spirito

Lu Duble
Jules Engel
Jimmy Ernst
Philip Evergood
Lyonel Feininger
Herbert Ferber
Perle Fine
David Fredenthal
Sue Fuller
Naum Gabo
Oronzo Gasparo
Ruth Gikow
Joseph Glasco
Maurice Glickman
Vincent Glinsky
Maurice Golubov
Xavier Gonzalez
Aaron J. Goodelman
Adolph Gottlieb
Lorrie Goulet
Ellwood Graham
Morris Graves
Dorothea Greenbaum
Stephen Greene
Peter Grippe
Chaim Gross
George Grosz
Philip Guston
David Hare
Minna Harkavy
Rosella Hartman
Milton Hebald
Albert W. Heckman
John Edward Heliker
Fannie Hillsmith
Hans Hofmann
John Hovannes
John Langley Howard
Robert B. Howard
Lewis Iselin
Randolph Johnston
Ynez Johnston
Gerome Kamrowski
Nathaniel Kaz
León Kelly
William Kienbusch
Dong Kingman
Henry Koerner
Henry Kreis
Lawrence Kupferman
Edward Laning

Ibram Lassaw
Robert Laurent
Jacob Lawrence
Wesley Lea
Michael Lekakis
Leonard
Jacques Lipchitz
Richard Lippold
Seymour Lipton
Eleanore Lockspeiser
Erle Loran
Oronzio Maldarelli
Berta Margoulies
De Hirsh Margules
John Marin
Reginald Marsh
John W. McCoy
Walter Midener
Burr Miller
Robert Moir
Hans Moller
George Morrison
Robert Motherwell
Ernest Mundt
Walter Murch
Juan Nickford
Isamu Noguchi
Nuala (Elsa De Brun)
Richard O'Hanlon
William Pachner
Simmons Persons
Dimitri Petrov
George Picken
Ogden M. Pleissner
Jackson Pollock
Richard Pousette-Dart
Josef Presser
Sara Provan
Savo Radulovic
Waldemar Raemisch
Grace Raney
Bernard Reder
Anton Refregier
Ad Reinhardt
Jeanne Reynal
Hugo Robus
Theodore J. Roszak
Henry Rox
Andrée Ruellan
Alfred Russell
Robert Russin

Anne Ryan
Lucia Autorino Salemme
Concetta Scaravaglione
Louis Schanker
Karl Schrag
Charles Seliger
Kurt Seligmann
John Sennhauser
Ben Shahn
Mitchell Siporin
Hannah Small
David Smith
Sibley Smith
Theodoros Stamos
Edward John Stevens
Ary Stillman
Henry Strater
William Talbot
Reuben Tam
William Thon
Mark Tobey
Anthony Toney
Trajan
Jack Tworkov
Charles Umlauf
Martha Visser't Hooft
John Von Wicht
Abraham Walkowitz
Carl Walters
Jane Wasey
Sam Weinik
Cady Wells
Nat Werner
Anita Weschler
Andrew Wyeth
Karl Zerbe
William Zorach

Painting

Artists

Samuel Adler
Charles H. Alston
John Anderson
Roger Anliker
Ruth Armer
John Barber
Gertrude Barrer
William Baziotes
John Beauchamp
Emil Bisttram
Arnold Blanch
Peter Blume
Cameron Booth
Henry Botkin
Richard Bové
James Brooks
Carlyle Brown
Colleen Browning
Audrey Buller
Louis Bunce
Hans Burkhardt
Gretna Campbell
Victor Candell
Tom Cavanaugh
Edward Chavez
Serge Chermayeff
Herman Cherry
Minna Citron
William Congdon
Robert Conover
Howard Cook
John Rogers Cox
Rollin Crampton
Francis Criss

Kenneth Davies
Stuart Davis
Worden Day
Enrico Donati
Guy Pène Du Bois
Jimmy Ernst
Philip Evergood
Lyonel Feininger
T. Lux Feininger
John Ferren
Keith Finch
James Fitzgerald
Seymour Fogel
Gray Foy
Thomas Fransioli Jr.
A. E. Gallatin
Lee Gatch
Jan Gelb
Howard Gibbs
Fritz Glarner
Joseph Glasco
Maurice Golubov
Adolph Gottlieb
Harry Gottlieb
Louis Grebenak
Robert Greco
Balcomb Greene
Marion Greenwood
Carl Hall
J. M. Hanson
Charles Heaney
John Heliker
Hans Hofmann
Edward Hopper
Walter Houmère
John Langley Howard
Dorothy Hoyt
Miyoko Ito
Wendell Jones
Gerome Kamrowski
Bernard Karfiol
Frederic Karoly
Herbert Katzman
Karl Knaths
Richard Koppe
Irving Kriesberg
Yasuo Kuniyoshi
Joe Lasker
Charles Le Clair
Doris Lee
Jack Levine

Vincent John Longo
Eugene Ludins
Loren MacIver
Howard Mandel
Peppino Mangravite
Fletcher Martin
Alice Trumbull Mason
Walter Meigs
Felicia Meyer
Lily Michael
William Millarc
Kenneth Hayes Miller
Edward Millman
Raymond Mintz
Joan Mitchell
George L. K. Morris
Robert Motherwell
Walter Murch
Amédée Ozenfant
William Pachner
Alan Parker
Lloyd Parsons
I. Rice Pereira
Bernard Perlin
Gabor Peterdi
Bernard Pfriem
Joseph Pollet
Jackson Pollock
David Porter
Richard Pousette-Dart
Sara Provan
Steve Raffo
Abraham Rattner
Ad Reinhardt
Sigfried Gerhard Reinhardt
Wallace Reiss
Kay Sage
William Saltzman
Rolph Scarlett
Louis Schanker
Ethel Schwabacher
Manfred Schwartz
Kurt Seligmann
Ben Shahn
David Shapiro
Simpson-Middleman
Mitchell Siporin
Esphyr Slobodkina
T. Snyder
Frann Spencer
Theodoros Stamos

Carolyn Stoloff
Duncan Robert Stuart
Yves Tanguy
John Taylor
William Thon
Joyce Treiman
Margit Varga
Robert Vickrey
Martha Visser't Hooft
Max Weber
Hans Weingaertner
Raymond John Wendell
Andrew Wyeth
Marguerite Zorach

1950
*Sculpture, Watercolors,
and Drawings*

Artists

Humbert Albrizio
Leo Amino
Alexander Archipenko
Saul Baizerman
Oliver O'Connor Barrett
Clay Bartlett
William Baziotes
John Begg
Cecil C. Bell
Ben Benn
Ben-Zion
Johnfried G. Bergschneider
Eugene Berman
Virginia Berresford
Isabel Bishop
Aaron Bohrod

Raymond Breinin
William Brice
C. Ludwig Brumme
Charles Burchfield
Paul Cadmus
Doris Caesar
Alexander Calder
Kenneth Callahan
Mary Caller
Samuel Shawan
Federico Castellón
Howard Cook
John Corbino
Lucille Corcos
Martin Craig
Robert Cronbach
José De Creeft
Adolf Dehn
Dorothy Dehner
Eleanor De Laittre
Beauford Delany
Koren Der Harootian
José De Rivera
Nathaniel Dirk
Henry Di Spirito
Lu Duble
Jimmy Ernst
Alfeo Faggi
Fred Farr
Lyonel Feininger
Herbert Ferber
Ernest Fiene
Vera Frasier
David Fredenthal
Jared French
Arnold Geissbuhler
Ruth Gikow
Maurice Glickman
Xavier Gonzalez
Aaron J. Goodelman
Adolph Gottlieb
Lorrie Goulet
Morris Graves
Stephen Greene
Peter Grippe
Willim Gropper
Chaim Gross
George Grosz
John Groth
Philip Guston
Ernest Guteman

David Hare
Minna Harkavy
John Hartell
Bertram Hartman
Stanley William Hayter
Milton Hebald
John Edward Heliker
Fannie Hillsmith
Willard Hirsch
Hans Hofmann
John Hovannes
Robert B. Howard
Isabella Howland
Randolph W. Johnston
Nathaniel Kaz
León Kelly
Adaline Kent
William Kienbusch
William D. King
Dong Kingman
Dwight Kirsch
Guitou Knoop
Henry Koerner
Chaim Koppelman
Lawrence Kupferman
Frances Lamont
Chet La More
Edward Laning
Ibram Lassaw
Jacob Lawrence
Wesley Lea
Rico Lebrun
James Lechey
Irving Lehman
Michael Lekakis
Leonard
Leonid
Jack Levine
Edmund Lewandowski
Jacques Lipchitz
Jacob Lipkin
Peter Lipman-Wulf
Seymour Lipton
Ward Lockwood
Loren MacIver
Oronzio Maldarelly
Berta Margoulies
De Hirsh Margules
John Marin
Reginald Marsh
Austin Mecklem

Walter Midener
Burr Miller
Hans Moller
Mark Morrison
Simon Moselsio
Louise Nevelson
Juan Nickford
Isamu Noguchi
Elizabeth Nottingham
William Palmer
Augustus Peck
I. Rice Pereira
Harley Perkins
Bernard Perlin
Louise Pershing
Geri Pine
Ogden M. Pleissner
Josef Presser
Gregorio Prestopino
Edward Rager
Ad Reinhardt
Hugo Robus
Theodore J. Roszak
Benjamin Rowland
Henry Rox
Lucia Autorino Salemme
Charles Salerno
Louis Schanker
Day N. Schnabel
Georges Schreiber
John Sennhauser
Zoltan Sepeshy
Ben Shahn
Charles Sheeler
Millard Sheets
Mitchell Siporin
David Smith
Theodoros Stamos
Saul Steinberg
Edward John Stevens
Ary Stillman
Walter Stuempfig
William Talbot
Reuben Tam
Yves Tanguy
John Taylor
William Thon
George Tooker
Charles Umlauf
Polygnotos Vagis
John Von Wicht

Vaclav Vytlacil
Marion Walton
Heinz Warneke
Jane Wasey
Max Weber
Cady Wells
Nat Werner
Anita Weschler
Charles White
Alan Wood-Thomas
Karl Zerbe
William Zorach

Painting

1950 ANNUAL EXHIBITION OF
CONTEMPORARY
AMERICAN PAINTING

NOVEMBER 10 TO DECEMBER 31, 1950

WHITNEY MUSEUM OF AMERICAN ART
TEN WEST EIGHTH STREET · NEW YORK

Artists
Josef Albers
Ivan Le Lorraine Albright
Bernard Arnest
David Aronson
Virginia Banks
William Baziotes
Max Beckmann
Ben-Zion
Eugene Berman
Isabel Bishop
Arnold Blanch
Ilya Bolotowsky
Louis Bosa
Henry Botkin
Louis Bouché
Alexander Brook
James Brooks
Byron Browne
Fritz Bultman
Paul Burlin
Peter Busa

Paul Cadmus
Kenneth Callahan
Edward Chavez
William Congdon
Robert Conover
Fred Conway
Russell Cowles
Norman Daly
Julio De Diego
Willem de Kooning
Guy Pène Du Bois
Frank Duncan
Dean Ellis
Jimmy Ernst
Philip Evergood
Lyonel Feininger
Ernest Fiene
Louis Finkelstein
Frederick Franck
Gilbert A. Franklin
Seymour Franks
Sideo Fromboluti
N. Gabo
Lee Gatch
Fritz Glarner
Augustus Goertz
Adolph Gottlieb
Simon Greco
Barry Greenberg
Balcomb Greene
Gertrude Greene
Stephen Greene
George Grosz
Louis Guglielmi
Philip Guston
James Guy
Robert Gwathmey
J.M. Hanson
Stanley William Hayter
John Edward Heliker
Fannie Hillsmith
Joseph Hirsch
Hans Hofmann
Bernard Karfiol
Weldon Kees
León Kelly
Karl Knaths
Henry Koerner
Yasuo Kuniyoshi
Joe Lasker
Rico Lebrun

Leonid
William Lester
Jack Levine
Molly Luce
Eugene Ludins
Loren MacIver
Howard Mandel
Leo Manso
Boris Margo
John Marin
Reginald Marsh
Henry Mattson
Joseph Meert
Edward Melcarth
Kenneth Hayes Miller
Edward Millman
Randall Morgan
George L. K. Morris
Robert Motherwell
Seong Moy
Walter Murch
Kenneth Nack
Georgia O'Keeffe
Arthur Osver
Amedee J. Ozenfant
William Pachner
William Palmer
Raymond Parker
I. Rice Pereira
Alton Pickens
Jackson Pollock
Richard Pousette-Dart
Gregorio Prestopino
Leo Quanchi
Walter Quirt
George Ratkai
Abraham Rattner
Ad Reinhardt
Leatrice Rose
Mark Rothko
Alfred Russell
Kay Sage
Attilio Salemme
Henry Schnakenberg
Georges Schreiber
Sonia Sekula
Kurt Seligmann
John Sennhauser
Ben Shahn
Charles Sheeler
Sarai Sherman

Sidney Simon
Mitchell Siporin
John Sloan
Esphyr Slobodkina
William T. Snaith
Joseph Solman
Raphael Soyer
Niles Spencer
Everett Spruce
Theodoros Stamos
John Stephan
Hedda Sterne
Maurice Sterne
Walter Stuempfig
Rufino Tamayo
Yves Tanguy
Victor Thall
Bradley Tomlin
Anthony Toney
George Tooker
Joyce Treiman
Pat Trivigno
Esteban Vicente
John Von Wicht
Howard Warshaw
Max Weber
John Wilde
Emerson Woelffer
Joe Wolins
Jean Xceron
Karl Zerbe

1949

*Sculpture, Watercolors,
and Drawings*

Artists

George Aarons
Ivan Le Lorraine Albright
Humbert Albrizio
Leo Amino
Alexander Archipenko
Saul Baizerman
Oliver O'Connor Barrett
William Baziotes
C. Whitney Bender
Ward Bennett
Ben-Zion
Eugene Berman
Isabel Bishop
Raymond Breinin
William Brice
Douglas E. Brown
C. Ludwig Brumme
Charles Burchfield
Paul Cadmus
Doris Caesar
Alexander Calder
Kenneth Callahan
Vincent Campanella
George Cerny
Nicolai Cikovsky
George Constant
Jon Corbino
Lucille Corcos
Charles Culver
Charles Cutler
Giglio Dante
Alice Decker

José De Creeft
Adolf Dehn
Jean De Marco
Koren Der Harootian
José De Rivera
Nathaniel Dirk
Robert Drew
Lu Duble
Frank Duncan
Hazard Durfee
Winslow B. Eaves
Ethel Edwards
Jimmy Ernst
Philip Evergood
Alfeo Faggi
Clara Fasano
Lyonel Feininger
Herbert Ferber
Louis Ferstadt
Paul Fiene
Perle Fine
David Fredenthal
Jared French
Ruth Gikow
Maurice Glickman
Vincent Glinsky
Xavier Gonzalez
Aaron J. Goodelman
Adolph Gottlieb
Moris Graves
Dorothea Greenbaum
Stephen Greene
Oliver Grimley
Peter Grippe
Chaim Gross
George Grosz
David Hare
Minna Harkavy
Bertram Hartman
Rosella Hartman
Cleo Hartwig
Stanley William Hayter
Milton Hebald
Albert W. Heckman
John Edward Heliker
Fannie Hillsmith
Charles Hopkinson
Milton Horn
John Hovannes
Lee Jackson
Mitchell Jamieson

Randolph W. Johnston
Joe Jones
Nathaniel Kaz
William Kienbusch
Dong Kingman
Henry Koerner
Yasuo Kuniyoshi
Lawrence Kupferman
Frances Kent Lamont
Lily Landis
Edward Laning
Ibram Lassaw
Robert Laurent
Jacob Lawrence
Wesley Lea
Irving Lehman
Michael Lekakis
Jack Levine
Alfred Levitt
Jacques Lipchitz
Jacob Lipkin
Seymour Lipton
Ward Lockwood
Joseph Lonzar
Loren MacIver
Oronzio Maldarelli
Howard Mandel
Boris Margo
Berta Margoulies
De Hirsh Margules
John Marin
Reginald Marsh
Julian Martin
Matta
Miriam McKinnie
Burr Miller
Bruce Mitchell
Hans Moller
Robert Motherwell
Reuben Nakian
Isamu Noguchi
Nuala (Elsa De Brun)
William Pachner
I. Rice Pereira
Harley Perkins
Simmons Persons
Gabor Peterdi
Alton Pickens
Ogden M. Pleissner
Richard Pousette-Dart
Raymond Puccinelli

Andre Racz
Edna Reindel
Hugo Robus
Theodore J. Roszak
Mark Rothko
Benjamin Rowland Jr.
Henry Rox
Robert I. Russin
Lucia Autorino Salemme
Charles Salerno
Hélène Sardeau
Henry Schnakenberg
William N. Schneider
Henry Schonbauer
Georges Schreiber
William Seitz
Ben Shahn
Millard Sheets
Mitchell Siporin
John Sloan
Louis Slobodkin
Hannah Small
David Smith
Sibley Smith
Mitzi Solomon
Eugene Speicher
Theodoros Stamos
Saul Steinberg
Edward John Stevens
Ary Stillman
Beatrice Stone
John Taylor
William Thon
Mark Tobey
Trajan
Charles Umlauf
Polygnotos Vagis
Rudolf Von Huhn
Vaclav Vytlacil
Abraham Walkowitz
Carl Walters
Heinz Warneke
Howard Warshaw
Jane Wasey
Cady Wells
Nat Werner
Anita Weschler
Wilson
Arline Wingate
Nina Winkel
Andrew Wyeth

Karl Zerbe
William Zorach

Painting

1949 ANNUAL EXHIBITION OF
CONTEMPORARY
AMERICAN PAINTING

DECEMBER 16, 1949 TO FEBRUARY 5, 1950

WHITNEY MUSEUM OF AMERICAN ART
TEN WEST EIGHTH STREET · NEW YORK

Artists

Edmund Archer
Bernard Arnest
David Aronson
R. Maxil Ballinger
Virginia Banks
William Baziotes
Max Beckmann
Whitney Bender
Eugene Berman
Louis Bosa
Dorr Bothwell
William Brice
Alexander Brook
Byron Browne
Vincent Campanella
Federico Castellón
William Chaiken
Edward Chavez
Francis Colburn
Fred Conway
Marty Lewis Cornelius
Virginia Cuthbert
Willem de Kooning
Eleanor De Laittre
Maurice Douek
Guy Pène Du Bois
Frank Duncan
Hazard Durfee
Harry Engel
Jimmy Ernst
Max Ernst

Philip Evergood
Sally Fairchild
Remo Farruggio
Lyonel Feininger
Ernest Fiene
Perle Fine
Seymour Fogel
Frederick Franck
Thomas Fransioli Jr.
Jared French
A. E. Gallatin
Lee Gatch
Panos Ghikas
Kahlil Gibran
Augustus Goertz
Adolph Gottlieb
Cleve Gray
Balcomb Greene
Werner Groshans
George Grosz
James Grunbaum
Louis Guglielmi
Robert Gwathmey
Leon Hartl
Theodore G. Haupt
Stanley William Hayter
William E. Hentschel
Fannie Hillsmith
Hans Hofmann
Mervin Honig
Walter Houmère
Lee Jackson
Mitchell Jamieson
Mervin Jules
Morris Kantor
Weldon Kees
Earl Kerkam
Karl Knaths
Henry Koerner
Arthur Kraft
Yasuo Kuniyoshi
Joseph Lasker
Leonid
Julian E. Levi
Jack Levine
Michael Loew
Nan Lurie
Dan Lutz
Loren MacIver
Howard Mandel
Leo Manso

Boris Margo
John Marin
William C. McNulty
Joseph Meert
Edward Melcarth
Knud Merrild
Kenneth Hayes Miller
Edward Millman
Paul Mommer
Randall Morgan
Carl Morris
George L. K. Morris
Robert Motherwell
Walter Murch
Kenneth Nack
B. J. O. Nordfeldt
Georgia O'Keeffe
Arthur Osver
I. Rice Pereira
Alton Pickens
Jackson Pollock
Henry Varnum Poor
Gregorio Prestopino
Easton Pribble
Leo Quanchi
Walter Quirt
Steve Raffo
Charles W. Rain
George Ratkai
Abraham Rattner
Anton Refregier
Louis Ribak
Kurt Roesch
Herman Rose
Mark Rothko
Andrée Ruellan
Alfred Russell
Kay Sage
Attilio Salemme
Henry Schnakenberg
Ethel Schwabacher
Manfred Schwartz
Charles Seliger
Kurt Seligmann
John Sennhauser
Ben Shahn
Charles Sheeler
Sarai Sherman
Mitchell Siporin
John Sloan
Charles Augustus Smith

Judson Smith
William T. Snaith
Raphael Soyer
Eugene Speicher
Niles Spencer
Everett Spruce
Theodoros Stamos
Harry Sternberg
Hedda Sterne
Muriel Streeter
Walter Stuempfig
Reuben Tam
Yves Tanguy
Frederic Taubes
Victor Thall
Mark Tobey
Walker Tomlin
Anthony Toney
George Tooker
Nahum Tschacbasov
Vaclav Vytlacil
Howard Warshaw
Franklin Watkins
Erika Weihs
Steve Wheeler
Sol Wilson
Emerson Woelffer
Joe Wolins

1948
*Sculpture, Watercolors,
and Drawings*

Artists
Humbert Albrizio
Leo Amino

Oliver O'Connor Barrett
Richmond Barthé
William Baziotes
Romare Bearden
Lu Belmont
C. Whitney Bender
Rainey Bennett
Eugene Berman
Isabel Bishop
Peter Blume
Aaron Bohrod
Ross Braught
Douglas Brown
Byron Browne
C. Ludwig Brumme
Charles Burchfield
Paul Cadmus
Doris Caesar
Kenneth Callahan
Federico Castellón
George Cerny
Herman Cherry
George Constant
Robert Cronbach
Stefano Cusumano
Lewis Daniel
Stuart Davis
Horace Day
José De Creeft
Adolf Dehn
Koren Der Harootian
José De Rivera
Nathaniel Dirk
Blanche Dombek
Ralph Dubin
Lu Dublee
W. Doug Duncalfee
Frank Duncan
Hazard Durfee
Winslow Bryan Eaves
Phoebe Erickson
Philip Evergood
Lyonel Feininger
Herbert Ferber
William Fett
Paul Fiene
David Fredenthal
Jared French
Ruth Gikow
Maurice Glickman
Aaron J. Goodelman

Arshile Gorky
Morris Graves
Simon Greco
Dorothea Greenbaum
Marion Greenwood
Peter Grippe
Chaim Gross
George Grosz
Ernest Guteman
Raoul Hague
Carl Hall
David Hare
Minna Harkavy
Rosella Hartman
Cleo Hartwig
Milton Hebald
Albert W. Heckman
Diana Heiskell
John Edward Heliker
Edward Hopper
John Hovannes
Robert B. Howard
Paul Hyun
Gerome Kamrowski
Nathaniel Kaz
León Kelly
Adaline Kent
William Kienbusch
Dong Kingman
Henry Koerner
Joseph Konzal
Chaim Koppelman
Henry Kreis
Yasuo Kuniyoshi
Lawrence Kupferman
Frances Kent Lamont
Edward Laning
Ibram Lassaw
Robert Laurent
Jacob Lawrence
Wesley Lea
Rico Lebrun
Michael Lekakis
Jack Levine
Jacques Lipchitz
Jacob Lipkin
Seymour Lipton
Charles Locke
Joseph Lonzar
Erle Loran
Gwen Lux

Oronzio Maldarelli
Boris Margo
Berta Margoulies
De Hirsh Margules
John Marin
Reginald Marsh
Ezio Martinelli
Matta
Burr Miller
Bruce Mitchell
Hans Moller
George L. K. Morris
Robert Motherwell
Isaac Lane Muse
Fred Nagler
Isamu Noguchi
Bernard Olshan
William Palmer
Edwin A. Park
Augustus Peck
Bernard Perlin
Helen Phillips
Ogden M. Pleissner
Carl O. Podszus
Jackson Pollock
Charles Prendergast
Raymond Puccinelli
Ad Reinhardt
Hugo Robus
Wallace Rosenbauer
Theodore J. Roszak
Mark Rothko
Henry Rox
Charles Salerno
Hélène Sardeau
Louis Schanker
Elsa Schmid
Day N. Schnabel
Henry Schnakenberg
Henry Schonbauer
Georges Schreiber
John Sennhauser
Ben Shahn
Charles Sheeler
Mitchell Siporin
Hannah Small
David Smith
Mitzi Solomon
Max Spivak
Theodoros Stamos
Harry Sternberg

Edward John Stevens
Ary Stillman
Sahl Swarz
Yves Tanguy
Richard Taylor
Pavel Tchelitchew
Charles Umlauf
John Von Wicht
Vaclav Vytlacil
Carl Walters
Marion Walton
Heinz Warneke
Howard Warshaw
Jane Wasey
Cady Wells
Nat Werner
Anita Weschler
Nina Winkel
Charles Clifford Wright
Andrew Wyeth
Vladimir Yoffe
Karl Zerbe
William Zorach

Painting

1948 ANNUAL EXHIBITION OF
CONTEMPORARY
AMERICAN PAINTING

NOVEMBER 13, 1948 TO JANUARY 2, 1949

WHITNEY MUSEUM OF AMERICAN ART
TEN WEST EIGHTH STREET • NEW YORK

Artists
Ivan Le Lorraine Albright
Lester J. Ambrose
Bernard Arnest
Carl Ashby
John Atherton
Maxil Ballinger
William Baziotes
Max Beckmann
Thomas H. Benton
Ben-Zion

Eugene Berman
Isabel Bishop
Hyman Bloom
Louis Bosa
Henry Botkin
Louis Bouché
Louise Bourgeois
William Brice
Alexander Brook
Paul Burlin
Peter Busa
Paul Cadmus
Edward Chavez
Francis Colburn
Fred Conway
Aleta Cornelius
Russell Cowles
John Rogers Cox
Ralston Crawford
Stefano Cusumano
Virginia Cuthbert
Norman Daly
Worden Day
Willem de Kooning
Lamar Dodd
Seymour Drumlevitch
Guy Pène Du Bois
Harry Engel
Max Ernst
Philip Evergood
Claire Falkenstein
Remo Farruggio
Lyonel Feininger
Seymour Franks
Thomas Fransioli Jr.
Jared French
Martin Friedman
Carl Gaertner
Elizabeth Bart Gerald
Kahlil Gibran
Maxwell Gordon
Adolph Gottlieb
Cleve Gray
Balcomb Greene
Stephen Greene
Werner Groshans
Sidney Gross
George Grosz
Jean Guerin
Louis Guglielmi
Philip Guston

James Guy
Robert Gwathmey
Carl Hall
John Edward Heliker
Arnold Herstand
Joseph Hirsch
Hans Hofmann
Edward Hopper
Walter Houmère
Lee Jackson
Marion Junkin
Bernard Karfiol
Karl Knaths
Henry Koerner
Walt Kuhn
Yasuo Kuniyoshi
Lawrence Kupferman
Chet La More
Edward Laning
Joe Lasker
Rico Lebrun
Julian E. Levi
Jack Levine
Charles Locke
Eugene Ludins
Loren MacIver
Howard Mandel
Leo Manso
Irving Marantz
Boris Margo
John Marin
Reginald Marsh
Fletcher Martin
Martyl
John Masteller
Matta
Henry E. Mattson
Felicia Meyer
Kenneth Hayes Miller
Hans Moller
George L. K. Morris
George Morrison
Walter Murch
Georgia O'Keeffe
Arthur Osver
William Palmer
I. Rice Pereira
Alton Pickens
Joseph Pollet
Henry Varnum Poor
Gregorio Prestopino

Walter Quirt
Steve Raffo
Abraham Rattner
Ruth Ray
Edward A. Reep
Anton Refregier
Philip Reisman
Esther G. Rolick
Samuel Rosenberg
Santina M. Rossetto
Kay Sage
Attilio Salemme
Louis Schanker
Harry W. Scheuch
Katharine Schmidt
Henry Schankenberg
Georges Schreiber
Charles Seliger
Kurt Seligmann
Zoltan Sepeshy
Ben Shahn
Charles Sheeler
Mitchell Siporin
John Sloan
Charles A. Smith
Isaac Soyer
Raphael Soyer
Niles Spencer
Everett Spruce
Theodoros Stamos
Harold Sterner
Walter Stuempfig
Reuben Tam
Rufino Tamayo
Yves Tanguy
Dorothea Tanning
Pavel Tchelitchew
Margaret Tomkins
Bradley Walker Tomlin
Anthony Toney
George Tooker
James Turnbull
Dorothy Varian
Frede Vidar
Sylvia Wald
Erika Weihs
Denny Winters
Zsissly

1947

Sculpture, Watercolors,
and Drawings

Artists
George Aarons
Humbert Albrizio
Leo Amino
Alexander Archipenko
Darrel Austin
Milton Avery
Peggy Bacon
Richmond Barthé
William Baziotes
Rainey Bennett
Isabel Bishop
Peter Blume
Aaron Bohrod
Douglas Brown
Byron Browne
C. Ludwig Brumme
Charles Burchfield
Paul Cadmus
Doris Caesar
Corrado Cagli
Kenneth Callahan
Mary Callery
Federico Castellón
George Cerny
Lucille Corcos
Robert Cronbach
Charles Gordon Cutler
Salvador Dalí
Stuart Davis
José De Creeft
Adolf Dehn
Walt Dehner

Marina Nuñez Del Prado
Jean De Marco
Koren Der Harootian
José De Rivera
Nathaniel Dirk
Peggy Dodds
Blanche Dombek
Lu Duble
Alfeo Faggi
Clara Fasano
William Dean Fausett
Lyonel Feininger
Herbert Ferber
Paul Fiene
Perle Fine
Harvey Fite
Esteban Francis
David Fredenthal
Jared French
Oronzo Gasparo
Ruth Gikow
Maurice Glickman
Vincent Glinsky
Aaron J. Goodelman
Arshile Gorky
Adolph Gottlieb
Harry Gottlieb
Dorothea Greenbaum
Stephen Greene
Peter Grippe
William Gropper
Chaim Gross
George Grosz
James Guy
Raoul Hague
Stuart Halden
David Hare
Minna Harkavy
Bertram Hartman
Rosella Hartman
Arthur K. D. Healy
Milton Hebald
Albert W. Heckman
John Edward Heliker
Edward Hopper
John Hovannes
Gerome Kamrowski
Nathaniel Kaz
Dong Kingman
Henry Kreis
Yasuo Kuniyoshi

235

Frances Kent Lamont
Chet La More
Lillian Landis
Ibram Lassaw
Robert Laurent
Jacob Lawrence
Wesley Lea
Rico Lebrun
Jack Levine
Jacques Lipchitz
Richard Lippold
Seymour Lipton
Charles Locke
Gwen Lux
Ian Maciver
Oronzio Maldarelli
Boris Margo
Berta Margoulies
De Hirsh Margules
Reginald Marsh
Ezio Martinelli
Matta
Bruce Mitchell
Hans Moller
Simon Moselsio
Robert Motherwell
Isaac Lane Muse
Louise Nevelson
Isamu Noguchi
Richard O'Hanlon
Elizabeth Olds
Charles Owens
William C. Palmer
I. Rice Pereira
Bernard Perlin
George Picken
Ogden M. Pleissner
Gregorio Prestopino
Abraham Rattner
Anton Refregier
Ad Reinhardt
Hugo Robus
Wallace Rosenbauer
Theodore J. Roszak
Mark Rothko
Henry Rox
Lucia Autorino Salemme
Charles Salerno
Hélène Sardeau
Concetta Scaravaglione
Louis Schanker

Day N. Schnabel
Georges Schreiber
Ethel Schwabacher
Kurt Seligmann
Zoltan Sepeshy
Ben Shahn
Charles Sheeler
Mitchell Siporin
Hannah Small
David Smith
Mitzi Solomon
Eugene Speicher
Max Spivak
Saul Steinberg
Edward John Stevens
Prentiss Taylor
Richard Taylor
Pavel Tchelitchew
Elizabeth Terrell
Trajan
Charles Umlauf
Elis Velikovsky
Paul C. Virdone
John Von Wicht
Abraham Walkowitz
Marion Walton
Heinz Warneke
Howard Warshaw
Jane Wasey
Max Weber
Cady Wells
Nat Werner
Anita Weschler
Warren Wheelock
Arline Wingate
Andrew Wyeth
Vladimir Yoffe
Karl Zerbe
William Zorach

Painting

1947 ANNUAL EXHIBITION OF
CONTEMPORARY
AMERICAN PAINTING

DECEMBER 6, 1947 TO JANUARY 25, 1948

WHITNEY MUSEUM OF AMERICAN ART
TEN WEST EIGHTH STREET • NEW YORK

Artists

Ivan Le Lorraine Albright
Bernard Arnest
David Aronson
Carl Ashby
William Baziotes
Romare Bearden
Eugene Berman
Isabel Bishop
Arnold Blanch
Aaron Bohrod
Louis Bosa
Louis Bouché
Louise Bourgeois
Raymond Breinn
Alexander Brook
Carlyle Brown
Byron Browne
Audrey Buller
Paul Burlin
Kenneth Callahan
Federico Castellón
Marc Chagall
Edward Chavez
Francis Colburn
Fred Conway
Aleta Cornelius
Ralston Crawford
Virginia Cuthbert
Norman Daly
Stuart Davis
Julio De Diego
Daniel Dickerson
Werner Drewes
Guy Pène Du Bois

Harry Engel
Philip Evergood
Kenneth Evett
Ernest Fiene
Perle Fine
James H. Fitzgerald
Joseph Floch
Karl E. Fortess
Esteban Frances
Seymour Franks
Thomas Fransioli Jr.
Jared French
Martin Friedman
Elizabeth Bart Gerald
Charles Gilbert
Arshile Gorky
Adolph Gottlieb
Balcomb Greene
Stephen Greene
William Gropper
Sidney Gross
O. Louis Guglielmi
Philip Guston
Robert Gwathmey
Carl Hall
Leah R. Hamilton
Hananiah Harari
Stanley William Hayter
Charles Heaney
John Edward Heliker
Hopkins Hensel
Joseph Hirsch
Hans Hofmann
Carl Holty
Walter Houmère
John Langley Howard
Lee Jackson
Martin Jackson
Edward Powis Jones
Wendell Jones
Mervin Jules
Gerome Kamrowski
Morris Kantor
Bernard Karfiol
Arthur Kaufmann
Henry Koerner
Karl Knaths
Walt Kuhn
Edward Laning
Joe Lasker
Doris Lee

Jack Levine
Molly Luce
Eugene Ludins
Loren MacIver
Peppino Mangravite
Boris Margo
John Marin
Reginald Marsh
Fletcher Martin
Matta
Henry Mattson
Edward Melcarth
Sigmund Menkes
Kenneth Hayes Miller
Edward Millman
Hans Moller
Johannes Molzahn
Paul Mommer
Carl Morris
George Morrison
Robert Motherwell
Ralph Nelson
Arthur Osver
Amédée Ozenfant
Lloyd Parsons
John C. Pellew
Albert Pels
I. Rice Pereira
Bernard Perlin
George Picken
Joseph Pollet
Jackson Pollock
Gregorio Prestopino
Steve Raffo
Abraham Rattner
Edward A. Reep
Ad Reinhardt
Philip Reisman
Boardman Robinson
Herman Rose
Mark Rothko
Kay Sage
Attilio Salemme
Harry W. Scheuch
Henry Schnakenberg
Max Schnitzler
Georges Schreiber
Manfred Schwartz
Kurt Seligmann
Zoltan Sepeshy
Ben Shahn

Charles G. Shaw
Charles Sheeler
Mitchell Siporin
John Sloan
Charles A. Smith
Moses Soyer
Raphael Soyer
Eugene Speicher
Niles Spencer
Everett Spruce
Theodoros Stamos
Philip Stapp
Rosalyn Stern
Walter Stuempfig
Rufino Tamayo
Yves Tanguy
William Thon
Mark Tobey
Bradley Walker Tomlin
George Tooker
Dorothy Varian
Max Weber
Steve Wheeler
Sol Wilson
Andrew Wyeth
Leon Zouté

1946

Sculpture, Watercolors, and Drawings

Artists
Ivan Le Lorraine Albright
Marianne Appel
Bernard Arnest
Peggy Bacon

William Baziotes
Romare Bearden
Maurice Becker
Cecil C. Bell
Rainey Bennett
Ben-Zion
Richard Bergere
Eugene Berman
Janice Biala
Isabel Bishop
Louis Bosa
Louise Bourgeois
Alexander Brook
Byron Browne
Charles Burchfield
Paul Burlin
David Burliuk
Paul Cadmus
Corrado Cagli
Alexander Calder
Clarence H. Carter
Albino Cavallito
Francis Chapin
Minna Citron
George Constant
Howard Cook
Jon Corbino
Martin Craig
Alfred D. Crimi
Salvador Dalí
Stuart Davis
José De Creeft
Julio De Diego
Adolf Dehn
Walt Dehner
Jean De Marco
Koren Der Harootian
Olin Dows
Lu Duble
Stuart Edie
Wharton Esherick
Philip Evergood
Charles Farr
Clara Fasano
Lyonel Fieninger
Herbert Ferber
Louis Ferstadt
Ernest Fiene
Paul Fiene
Perle Fine
Harvey Fite

Josef Foshko
David Fredenthal
Oronzo Gasparo
André Girard
Marshall Glasier
Maurice Glickman
Aaron J. Goodelman
Gertrude Goodrich
Maurice Gordon
Arshile Gorky
Adolph Gottlieb
Morris Graves
Dorothea Greenbaum
Stephen Greene
Peter Grippe
William Gropper
Chaim Gross
George Grosz
Philip Guston
Raoul Hague
Minna Harkavy
Bertram Hartman
Rosella Hartman
John Hovannes
Lee Jackson
Joe Jones
Mervin Jules
Gerome Kamrowski
Morris Kantor
Hilde Kayn
Nathaniel Kaz
Henry G. Keller
León Kelly
Dong Kingman
Bernard Klonis
Benjamin Kopman
Henry Kreis
Yasuo Kuniyoshi
Lawrence Kupferman
Frances Kent Lamont
Chet La More
Edward Laning
Ibram Lassaw
Robert Laurent
Jacob Lawrence
Rico Lebrun
James Lechay
Fernand Léger
Hayley Lever
Edmund Lewandowski
Jacques Lipchitz

Seymour Lipton
Ward Lockwood
Thomas G. Lo Medico
Guy Maccoy
Claire Mahl
Oronzio Maldarelli
Dwight Marfield
Boris Margo
Berta Margoulies
De Hirsh Margules
John Marin
Reginald March
Martyl
Austin Mecklem
Barse Miller
Bruce Mitchell
Hans Moller
Simon Moselsio
Robert Motherwell
Fred Nagler
Louise Nevelson
Isamu Noguchi
Elizabeth Olds
Charles Owens
William Palmer
Phil Paradise
Waldo Peirce
Simmons Persons
George Picken
Hobson Pittman
Ogden M. Pleissner
Anne Poor
Henry Varnum Poor
Anton Refregier
Philip Reisman
Hugo Robus
Umberto Romano
Ralph Rosenborg
Doris Rosenthal
Theodore J. Roszak
Mark Rothko
Charles Rudy
Andrée Ruellan
Charles Salerno
Concetta Scaravaglione
Louis Schanker
Josef Scharl
Day N. Schnabel
Henry Schnakenberg
Zoltan Sepeshy
Ben Shahn

Mitchell Siporin
Hannah Small
David Smith
Jacob Getlar Smith
Leon P. Smith
Miron Sokole
Mitzi Solomon
Elizabeth Sparhawk-Jones
Eugene Speicher
William Steig
Joseph Stella
Edward John Stevens Jr.
Richard Taylor
Mark Tobey
Trajan
James Turnbull
Allen Ullman
Charles Umlauf
Albert Urban
Elis Velikovsky
John Von Wicht
Carl Walters
Marion Walton
Heinz Warneke
Jane Wasey
Max Weber
John A. Wedda
Nat Werner
Warren Wheelock
Vera White
Andrew Wyeth
Ossip Zadkine
Karl Zerbe
William Zorach

Painting

Artists
Edmund Archer
David Aronson
John Atherton
Darrel Austin
Harold Baumbach
William Baziotes
Romare Bearden
Jane Berlandina
Eugene Berman
Harry Bertoia
Isabel Bishop
Arnold Blanch
Hyman Bloom
Louis Bosa
Raymond Breinin
Alexander Brook
Byron Browne
Audrey Buller
Paul Burlin
David Burliuk
Peter Busa
Paul Cadmus
Kenneth Callahan
John Carroll
Federico Castellón
Marc Chagall
Francis Colburn
Russell Cowles
Ralston Crawford
Virginia Cuthbert
Salvador Dalí
Stuart Davis
Julio De Diego
Eleanor De Laittre

Joseph De Martini
Harry Dix
Arthur G. Dove
Werner Drewes
Guy Pène Du Bois
Terence R. Duren
Max Ernst
Philip Evergood
Sylvia Fein
Tully Filmus
Perle Fine
James H. Fitzgerald
Vaughn Flannery
Richard Florsheim
Karl E. Fortess
Seymour Franks
Suzy Frelinghuysen
Jared French
Norma S. Fried
Martin Friedman
E. Bart Gerald
Arshile Gorky
Adolph Gottlieb
Cleve Gray
Balcomb Greene
Stephen Greene
William Gropper
Sidney Gross
George Grosz
Jean Guerin
O. Louis Guglielmi
Philip Guston
Robert Gwathmey
Carl Hall
Hananiah Harari
Lily Harmon
Stanley William Hayter
John Edward Heliker
William E. Hentschel
Joseph Hirsch
Stefan Hirsch
Carl Holty
Edward Hopper
Walter Houmère
Charles Howard
John Langley Howard
Lee Jackson
Edward P. Jones
Joe Jones
Wendell Jones
Mervin Jules

Morris Kantor
Bernard Karfiol
Karl Knaths
Walt Kuhn
Yasuo Kuniyoshi
Doris Lee
Julian E. Levi
Charles Locke
Eugene Ludins
Loren MacIver
Boris Margo
John Marin
Reginald Marsh
Matta
Henry Mattson
Henrik Martin Mayer
Austin Mecklem
Edward Melcarth
Knud Merrild
Kenneth Hayes Miller
L. Moholy-Nagy
Hans Moller
Johannes Molzahn
Carl Morris
George L. K. Morris
Robert Motherwell
B. J. O. Nordfeldt
Georgia O'Keeffe
Arthur Osver
Amédée Ozenfant
Lloyd Parsons
Waldo Peirce
I. Rice Pereira
Alton Pickens
Joseph Pollet
Jackson Pollock
Gregorio Prestopino
Robert O. Preusser
Philip Reisman
Constance Richardson
Kurt Roesch
Mark Rothko
Andrée Ruellan
Felix Ruvolo
Kay Sage
Attilio Salemme
Louis Schanker
Josef Scharl
Henry Schnakenberg
Manfred Schwartz
Zoltan Sepeshy

Ben Shahn
Charles Sheeler
Mitchell Siporin
John Sloan
Miron Sokole
Raphael Soyer
Vincent Spagna
Eugene Speicher
Everett Spruce
Theodoros Stamos
Harry Sternberg
Harold Sterner
Walter Stuempfig
Rufino Tamayo
Yves Tanguy
John Taylor
Pavel Tchelitchew
Mark Tobey
Margaret Tomkins
Bradley Walker Tomlin
Nahum Tschacbasov
Dorothy Varian
Frede Vidar
John Von Wicht
Joseph P. Vorst
Max Weber
Steve Wheeler
Esther Williams
Reginald Wilson
Jean Xceron
Karl Zerbe

1945

Sculpture, Watercolors,
and Drawings

Artists
Mary Hoover Aiken
Ivan Le Lorraine Albright
Edmund Archer
Alexander Archipenko
Darrel Austin
Milton Avery
Peggy Bacon
Saul Baizerman
Richmond Barthé
Gifford Beal
John Begg
Cecil C. Bell
Rainey Bennett
Ahron Ben-Shmuel
Thomas Benton
Eugene Berman
Isabel Bishop
Aaron Bohrod
Otto Botto
Louis Bouché
Raymond Breinin
Alexander Brook
Charles Burchfield
Copeland C. Burg
David Burliuk
Betty Burroughs
Paul Cadmus
Alexander Calder
Clarence H. Carter
Francis Chapin
Minna Citron
Jon Corbino

Lucille Corcos
John Steuart Curry
Gutaf Dalstrom
Lewis Daniel
Jo Davidson
Robert Davidson
Stuart Davis
Horace Day
José De Creeft
Julio De Diego
Adolf Dehn
Walt Dehner
Frank Di Gioia
Harry Dix
Thomas Donnelly
Hazard Durfee
Stuart Edie
Emlen Etting
Philip Evergood
Alfeo Faggi
William Dean Fausett
Sylvia Fein
Lyonel Feininger
Herbert Ferber
William H. Ferguson
William Fett
Paul Fiene
Harvey Fite
Josef Foshko
David Fredenthal
Jared French
Oronzo Gasparo
Maurice Glickman
Vincent Glinsky
Aaron J. Goodelman
Bertam Goodman
Morris Graves
Dorothea Greenbaum
Peter Grippe
Chaim Gross
George Grosz
James Guy
Raoul Hague
Minna Harkavy
Lily Harmon
Rosella Hartman
Milton Hebald
Vanessa Helder
John Edward Heliker
Gerrit Hondius
Edward Hopper

Winfeild Hoskins
John Hovannes
Mervin Jules
Margaret Brassler Kane
Bernard Karfiol
Nathaniel Kaz
Henry G. Keller
León Kelly
Walt Killam
Dong Kingman
Robert Kittredge
Bernard Klonis
Benjamin Kopman
Emil J. Kosa Jr.
Eve Kottgen
Henry Kreis
Yasuo Kuniyoshi
Lawrence Kupferman
Frances Kent Lamont
Jacob Lawrence
Robert Laurent
Julian E. Levi
Jack Levine
L. Jean Liberté
Thomas G. Lo Medico
Guy Maccoy
Oronzio Maldarelli
Berta Margoulies
De Hirsh Margules
John Marin
Reginald Marsh
Fletcher Martin
Martyl
Karl Mattern
William C. McNulty
Edward Melcarth
G. Macculloch Miller
Kenneth Hayes Miller
Bruce Mitchell
Simon Moseelsio
Don Mundt
Isamu Noguchi
Elisabeth Olds
William C. Palmer
Phil Paradise
John C. Pellew
Simmons Persons
George Picken
Hobson Pittman
John Franklin Platt
Ogden M. Pleissner

Daniel Rasmusson
Hugo Robus
Charles Rosen
Theodore J. Roszak
Andrée Ruellan
Lilian Swann Saarinen
Hélène Sardeau
Concetta Scaravaglione
Louis Schanker
Saul Schary
Katherine Schmidt
Carl L. Schmitz
Henry E. Schnakenberg
Henry Schonbauer
Georges Schreiber
Zoltan Sepeshy
Ben Shahn
Charles Sheeler
John Sloan
Louis Slobodkin
Hannah Small
David Smith
Miron Sokole
Mitzi Solomon
Elizabeth Sparhawk-Jones
Eugene Speicher
Benton Spruance
William Steig
Edward John Stevens
Katharine Sturgis
Prentiss Taylor
Richard Taylor
Elizabeth Terrell
James Turnbull
Albert Urban
Polygnotos Vagis
Joseph Vavak
Abraham Walkowitz
Carl Walters
Marion Walton
Jane Wasey
Max Weber
John A. Wedda
Albert Wein
Cady Wells
Nat Werner
Anita Weschler
Warren Wheelock
Vera White
John Whorf
Harry Wickey

Arline Wingate
Andrew Wyeth
William Zorach
Zsissly

Painting

Artists

Conrad Albrizio
Revington Arthur
John Atherton
Darrel Austin
Lucia Autorino
Herbert Barnet
William Baziotes
Romare Bearden
Maurice Becker
Ben-Zion
Eugene Berman
Henry Billings
Isabel Bishop
Arnold Blanch
Arbit Blatas
Aaron Bohrod
Louise Bourgeois
Raymond Breinin
Byron Browne
Emerson C. Burkhart
Paul Burlin
David Burliuk
Paul Cadmus
Kenneth Callahan
Nicolai Cikovsky
Francis Colburn
Howard Cook
Russell Cowles
Ralston Crawford

John Steuart Curry
Virginia Cuthbert
Lewis Daniel
Julio De Diego
Joseph De Martini
Edwin Dickenson
Arthur G. Dove
Otis Dozier
Guy Pène Du Bois
Max Ernst
Philip Evergood
William Dean Fausett
Lyonel Feininger
William Fett
Ernest Fiene
Tully Filmus
Joseph Floch
Seymour Fogel
Maurice Freedman
Suzy Frelinghuysen
Bart Gerald
Arshile Gorky
Douglas Gorsline
Adolph Gottlieb
Harry Gottlieb
Balcomb Green
Marion Greenwood
William Gropper
Sidney Gross
Philip Guston
Robert Gwathmey
Lily Harmon
John Hartell
Leon Hartl
Stanley William Hayter
John Edward Heliker
Jean Helion
Joseph Hirsch
Hans Hofmann
Carl Holty
Edward Hopper
Walter Houmère
Charles Howard
Lee Jackson
Joe Jones
Wendell Jones
Mervin Jules
Bernard Karfiol
León Kelly
Yeffe Kimball
Frank Kleinholz

Karl Knaths
Benjamin Kopman
Walt Kuhn
Yasuo Kuniyoshi
Edward Laning
Doris Lee
Fernand Léger
Julian E. Levi
Jack Levine
L. Jean Liberté
Charles Locke
Carlos Lopez
Molly Luce
Loren MacIver
Wray Manning
John Marin
Reginald Marsh
Fletcher Martin
Martyl
Matta
Henry Mattson
Henry Lee McFee
Edward Melcarth
Sigmund Menkes
Kenneth Hayes Miller
Peter Miller
Johannes Molzahn
George L. K. Morris
Robert Motherwell
B. J. O. Norfeldt
Georgia O'Keeffe
Arthur Osver
Amédée Ozenfant
William Palmer
I. Rice Pereira
George Picken
Horace Pippin
Joseph Pollet
Gregorio Prestopino
Karl Priebe
Walter Quirt
Abraham Rattner
Anton Refregier
Constance C. Richardson
Kurt Roesch
Charles Rosen
Mark Rothko
Andrée Ruellan
Attilio Salemme
Louis Schanker
Josef Scharl

Henry Schnakenberg
Georges Schreiber
Kurt Seligmann
Zoltan Sepeshy
Ben Shahn
Charles G. Shaw
Everett Shinn
John Sloan
Lawrence Beal Smith
Miron Sokole
Raphael Soyer
Everett Spruce
Theodoros Stamos
Margaret Stark
Harry Sternberg
Harold Sterner
Walter Stuempfig
Dorothea Tanning
Prentiss Taylor
Richard Taylor
Pavel Tchelitchew
William Thon
Mark Tobey
Bradley Walker Tomlin
Abram Tromka
Nahum Tschacbasov
Dorothy Varian
Frede Vidar
Joseph P. Vorst
Howard Warshaw
Max Weber
Steve Wheeler
Sol Wilson
Karl Zerbe

1944
Painting

1944 ANNUAL EXHIBITION OF
CONTEMPORARY
AMERICAN PAINTING

NOVEMBER 14 TO DECEMBER 12, 1944

WHITNEY MUSEUM OF AMERICAN ART
TEN WEST EIGHTH STREET • NEW YORK

Artists
Ivan Le Lorraine Albright
Conrad A. Albrizio
John Atherton
Milton Avery
Eugene Berman
George Biddle
Isabel Bishop
Harold Black
Arnold Blanch
Arbit Blatas
Julius Bloch
Raymond Breinin
Alexander Brook
Audrey Buller
Paul Burlin
David Burliuk
Paul Cadmus
John Carroll
James Chapin
Nicolai Cikovsky
Russell Cowles
Ralston Crawford
Lewis Daniel
A. Mark Datz
Julio De Diego
Joseph De Martini
Thomas H. Donnelly
Arthur G. Dove
Guy Pène Du Bois
Yvonne Du Bois
Emlen Etting
Philip Evergood
Sylvia Fein

Ernest Fiene
Tully Filmus
Suzy Frelinghuysen
Jared French
Carl Gaertner
Douglas W. Gorsline
Adolph Gottlieb
Harry Gottlieb
Balcomb Greene
Marion Greenwood
William Gropper
George Grosz
O. Louis Guglielmi
Philip Guston
Robert Gwathmey
Carl A. Hall
Hananiah Harari
Abraham Harriton
Bertram Hartman
Rosella Hartman
Albert W. Heckman
Norbert Heermann
John Edward Heliker
Stefan Hirsch
Alexandre Hogue
Carl Holty
Walter Houmère
Charles Howard
Peter Hurd
Eric Isenburger
Lee Jackson
Joe Jones
Mervin Jules
Morris Kantor
Bernard Karfiol
Hilde Kayn
León Kelly
Georgina Klitgaard
Karl Knaths
John Koch
Leon Kroll
Walt Kuhn
Yasuo Kuniyoshi
Lawrence Lebduska
Rico Le Brun
James Lechay
Doris Lee
Mac Le Sueur
Julian E. Levi
Jack Levine
Charles Locke

Erle Loran
Molly Luce
Eugene Ludins
Dan Lutz
Theodore Lux
Loren MacIver
Peppino Mangravite
John Marin
Fletcher Martin
Martyl
Henry Mattson
Jan Matulka
Henry Lee McFee
Austin Mecklam
Joseph Meert
Edward Melcarth
Felecia Meyer
Herbert Meyer
Kenneth Hayes Miller
George L. K. Morris
Georgia O'Keeffe
Arthur Osver
Walter Pach
Lloyd Parsons
James Patrick
Waldo Peirce
Albert Pels
I. Rice Pereira
George Picken
Horace Pippin
Joseph Pollet
Henry Varnum Poor
Gregorio Prestopino
Karl Priebe
Walter Quirt
Abraham Rattner
Anton Refregier
Constance C. Richardson
Samuel Rosenberg
Doris Rosenthal
Andrée Ruellan
Felix Ruvolo
Paul Sample
Patsy Santo
Louis Schanker
Saul Schary
Henry Schnakenberg
Max Schnitzler
Antoinette Schulte
William Schwartz
Ben Shahn

Charles Sheeler
Cordray Simmons
Judson Smith
Isaac Soyer
Moses Soyer
Raphael Soyer
Eugene Speicher
Niles Spencer
Margaret Stark
Algot Stenbery
Harry Sternberg
Harold Sterner
Walter Stuempfig
William Thoeny
William Thon
Bradley Walker Tomlin
James Turnbull
Paul Ullman
Dorothy Varian
Max Weber
Steve Wheeler
Esther Williams
Stark Young
Karl Zerbe

1943
*Sculpture, Paintings,
Watercolors, and Drawings*

Artists
Ivan Le Lorraine Albright
John Atherton
Darrel Austin
Milton Avery
Peggy Bacon
Cecil C. Bell

Rainey Bennett
Ahron Ben-Shmuel
Thomas Benton
Eugene Berman
Isabel Bishop
Arnold Blanch
Lucile Blanch
Arbit Blatas
Aaron Bohrod
Louis Bouché
Raymond Breinin
Alexander Brook
Charles Burchfield
Paul Burlin
Paul Cadmus
Alexander Calder
Clarence Holbrook Carter
Federico Castellón
Albino Cavallito
Francis Chapin
Howard Cook
Jon Corbino
Lucille Corcos
Russell Cowles
John Rogers Cox
Thomas Craig
Francis Criss
Robert Cronbach
John Steuart Curry
Jo Davidson
Stuart Davis
José De Creeft
Julio De Diego
Adolf Dehn
Jospeh De Martini
Guy Pène Du Bois
Stuart Edie
Philip Evergood
Alfeo Faggi
William Dean Fausett
Lyonel Feininger
Ernest Fiene
Paul Fiene
Tully Filmus
Jared French
Carl Gaertner
Maurice Glickman
Aaron J. Goodelman
Arshile Gorky
Harry Gottlieb
Morris Graves

Dorothea S. Greenbaum
Balcomb Greene
Waylande Gregory
William Gropper
Chaim Gross
George Grosz
O. Louis Guglielmi
Philip Guston
Robert Gwathmey
Carl A. Hall
Hananiah Harari
Minna Harkavy
Bertram Hartman
Rosella Hartman
Milton Hebald
Albert W. Heckman
John Edward Heliker
Charles Trumbo Henry
Alexandre Hogue
Edward Hopper
Walter Houmère
Cecil Howard
Charles Howard
Isabella Howland
Peter Hurd
Lee Jackson
Joe Jones
Mervin Jules
Morris Kantor
Bernard Karfiol
Henry G. Keller
Dong Kingman
Frank Kleinholz
John Koch
Henry Kreis
Walt Kuhn
Yasuo Kuniyoshi
Edward Laning
Robert Laurent
Jacob Lawrence
Rico Lebrun
Doris Lee
Julian E. Levi
Saul Levine
Charles Locke
Ward Lockwood
Molly Luce
Eugene Ludins
Oronzio Maldarelli
Berta Margoulies
De Hirsh Margules

John Marin
Reginald Marsh
Fletcher Martin
Martyl
Henry Mattson
Austin Mecklem
Kenneth Hayes Miller
Bruce Mitchell
George L. K. Morris
Simon Moselsio
Georgia O'Keeffe
William Palmer
Phil Paradise
Waldo Peirce
George Picken
Geri Pine
Horace Pippin
Gregorio Prestopino
Walter Quirt
Abraham Rattner
Anton Refregier
Louis Ribak
Boardman Robinson
Hugo Robus
Doris Rosenthal
Theodore J. Roszak
Andrée Ruellan
Concetta Scaravaglione
Saul Schary
Katherine Schmidt
Henry Schnakenberg
Georges Schreiber
Antoinette Schulte
Manfred Schwartz
Zoltan Sepeshy
Ben Shahn
Charles Sheeler
Mitchell Siporin
John Sloan
Louis Slobodkin
Hannah Small
David Smith
Lawrence Beall Smith
Raphael Soyer
Eugene Speicher
Harry Sternberg
Harold Sterner
Walter Stuempfig
Miklos Suba
John W. Taylor
Richard Taylor

Elizabeth Terrell
Bradley Walker Tomlin
Van Day Truex
James Turnbull
Dorothy Varian
Carlos Walters
Marion Walton
Jane Wasey
Max Weber
John A. Wedda
Nat Werner
Anita Weschler
Warren Wheelock
Harry Wickey
Esther Williams
Karl Zerbe
William Zorach

1942

*Sculpture, Paintings,
Watercolors, Drawings,
and Prints*

Artists
Alexander Archipenko
John Taylor Arms
John Atherton
Darrel Austin
Peggy Bacon
Richmond Barthé
Cecil C. Bell
Thomas Benton
Jane Berlandina
Julien Binford
Isabel Bishop
Arnold Blanch

Lucile Blanch
Julius Bloch
Louis Bouché
Fiske Boyd
Theodore Brenson
Ann Brockman
Alexander Brook
Charles Burchfield
David Burliuk
Paul Cadmus
Doris Caesar
Alexander Calder
John Carroll
Clarence Holbrook Carter
Federico Castellón
Minna Citron
Howard Cook
Lucille Corcos
Thomas Craig
Lewis C. Daniel
Andrew Dasburg
Jo Davidson
Gladys Rockmore Davis
Stuart Davis
José De Creeft
Adolf Dehn
Walt Dehner
John De Martelly
Joseph De Martini
Guy Pène Du Bois
Caroline Durieux
Stephen Etnier
Emlen Etting
Philip Evergood
Alfeo Faggi
William Dean Fausett
Lyonel Feininger
Herbert Ferber
Ernest Fiene
Paul Fiene
Tully Filmus
Karl E. Fortess
David Fredenthal
Don Freeman
Oronzo Gasparo
Marshall Glasier
Maurice Glickman
Lloyd Goff
Aaron J. Goodelman
Bertram Goodman
Harry Gottlieb

Morris Graves
Balcomb Greene
Marion Greenwood
William Gropper
Chaim Gross
George Grosz
O. Louis Guglielmi
Philip Guston
James Guy
Robert Gwathmey
Hananiah Harari
Marsden Hartley
Bertram Hartman
Rosella Hartman
Milton Hebald
Albert W. Heckman
John Edward Heliker
Joseph Hirsch
Alexandre Hogue
Edward Hopper
Cecil Howard
Joe Jones
Wendell Jones
Mervin Jules
Bernard Karfiol
Nathaniel Kaz
Henry G. Keller
Georgina Klitgaard
Gene Kloss
Karl Knaths
Benjamin Kopman
Leon Kroll
Walt Kuhn
Yasuo Kuniyoshi
Lawrence Kupferman
Chet La More
Armin Landeck
Edward Laning
Robert Laurent
Lawrence Lebduska
Rico Lebrun
James Lechay
Doris Lee
Julian E. Levi
Jack Levine
Edmund Lewandowski
Martin Lewis
Charles Locke
Thomas G. Lo Medico
Louis Lozowick
Eugene Ludins

243

Guy Maccoy
Oronzio Maldarelli
Peppino Mangravite
De Hirsh Margules
Herman Maril
John Marin
Reginald Marsh
Fletcher Martin
Henry Mattson
Henry Lee McFee
Barse Miller
Kenneth Hayes Miller
Bruce Mitchell
Maud Morgan
George L. K. Morris
Thomas W. Nason
Jackson Lee Nesbitt
Georgia O'Keeffe
Elizabeth Olds
William Palmer
Phil Paradise
Augustus Peck
Waldo Peirce
George Picken
Hobson Pittman
Henry Varnum Poor
Leonard Pytlak
Luis Quintanilla
Walter Quirt
Anton Refregier
Robert Riggs
Boardman Robinson
Hugo Robus
Fermin Rocker
Caroline Speare Rohland
Paul Rohland
Charles Rosen
Doris Rosenthal
Harry Rosin
Theodore J. Roszak
Andrée Ruellan
Robert Russin
Sally Ryan
Saul Schary
Katherine Schmidt
Carl L. Schmitz
Henry Schnakenberg
Karl Schrag
Georges Schreiber
Manfred Schwartz
Zoltan Sepeshy

Ben Shahn
Charles Sheeler
Millard Sheets
John Sloan
Louis Slobodkin
Hannah Small
David Smith
Lawrence Beall Smith
Miron Sokole
Raphael Soyer
Eugene Speicher
Niles Spencer
Benton Spruance
Everett Spruce
Bernard Steffen
Harry Sternberg
Frederick Taubes
Bradley Walker Tomlin
Eugene Trentham
James Turnbull
Frank Utpatel
Mariquita Villard
Joseph Vorst
Sylvia Wald
Carl Walters
Hyman Warsager
Jane Wasey
Franklin Watkins
Colton Waugh
Max Weber
Stow Wengenroth
Nat Werner
Harry Wickey
Esther Williams
Reginald Wilson
Arline Wingate
Adolf Wolff
Karl Zerbe
William Zorach

1941

*Sculpture, Watercolors,
Drawings, and Prints*

Artists

Mary Hoover Aiken
H. Oliver Albright
Ivan Le Lorraine Albright
Carlos Andreson
Vera Andrus
Marianne Appel
Edmund Archer
Alexander Archipenko
John Taylor Arms
John Atherton
Peggy Bacon
Saul L. Baizerman
Will Barnet
Cecil C. Bell
Rainey Bennett
Thomas Benton
Henry Billings
S. F. Bilotti
Isabel Bishop
Lucile Blanch
Julius Bloch
Aaron Bohrod
Otto Botto
Fiske Boyd
Raymond Breinin
Ann Brockman
Charles Burchfield
Betty Burroughs
Nathaniel Burwash
Andrew Butler
Paul Cadmus
Harry Poole Camden

Charles Campbell
Rhys Caparn
Page Cary
Federico Castellón
Albino Cavallito
Cornelia Van A. Chapin
Minna Citron
Howard Cook
Lydia Cooley
Lucille Corcos
John Costigan
Lee Brown Coye
Konrad Cramer
Philbrick Crouch
John Steuart Curry
Lewis Daniel
Andrew Dasburg
Mark A. Datz
Jo Davidson
Hubert Davis
Stuart Davis
Horace Day
José De Creeft
Adolf Dehn
John De Martelly
José Ruiz De Rivera
Nathaniel Dirk
Harry Dix
Thomas Donnelly
Mabel Dwight
Stuart Edie
Philip Evergood
William Dean Fausett
Lyonel Feininger
Herbert Ferber
Ernest Fiene
Paul Fiene
John B. Flannagan
Seymour Fogel
David Fredenthal
Don Freeman
Jared French
Erwin F. Frey
Wanda Gag
Emil Ganso
Oronzo Gasparo
Todros Geller
Eugenie Gershoy
Marshall Glasier
Harry Glassgold
Maurice Glickman

Gertrude Goodrich
Harry Gottlieb
Hardie Gramatky
Dorothea S. Greenbaum
Waylande Gregory
William Gropper
Chaim Gross
Maurice Grosser
George Grosz
John Groth
Adlai S. Hardin
Minna Harkavy
Perkins Harnly
Abraham Harriton
Bertram Hartman
Rosella Hartman
Albert W. Heckman
John Edward Heliker
Irwin Hoffman
Edward Hopper
John Hovannes
Victoria Huntley
Joe Jones
Wendell Jones
Mervin Jules
Bernard Karfiol
Henry Keller
Walt Killam
Gina Knee
Henry Kreis
Max Kuehne
Yasuo Kuniyoshi
Lawrence Kupferman
Armin Landeck
Edward Laning
J.J. Lankes
Barbara Latham
Robert Laurent
Arthur Lee
Joseph Lenhard
L. Jean Liberté
Russell Limbach
Charles Locke
Thomas Lo Medico
John Lonergan
Louis Lozowick
Oronzio Maldarelli
De Hirsh Margules
Kyra Markham
Jack Markow
Reginald Marsh

Karl Mattern
William McNulty
Austin Mecklem
McCullough Miller
Edward Millman
Bruce Mitchell
Frances Mallory Morgan
Eugene Morley
Simon Moselsio
Kornig Nalbandian
Thomas Nason
William C. Palmer
Simmons Persons
George Picken
Ogden M. Pleissner
Leslie Powell
Mac Raboy
Hugo Robus
Caroline Speare Rohland
Sanford Ross
Theodore Roszak
Lewis Rubenstein
Charles Rudy
Antonio Salemme
Paul Sample
Isaac J. Sanger
Concetta Scaravaglione
Louis Schanker
Katherine Schmidt
Henry Schnakenberg
Georges Schreiber
Ben Shahn
Millard Sheets
Eugenie Shonnard
Mitchell Siporin
John Sloan
Louis Slobodkin
David Smith
Jacob Getlar Smith
Lawrence Beall Smith
Raphael Soyer
Eugene Speicher
Benton Spruance
Harwood Steiger
Harry Sternberg
Alexander Stoller
Prentiss Taylor
Byron Thomas
Laurence Tompkins
James B. Turnbull
Joseph Vogel

John Von Wicht
Vaclav Vytlacil
Ernest Walker
Abraham Walkowitz
Carl Walters
Marion Walton
Heinz Warneke
Hyman Warsager
Jane Wasey
Max Weber
Cady Wells
Stow Wengenroth
Nat Werner
Anita Weschler
Warren Wheelock
Gertrude V. Whitney
John Whorf
Harry Wickey
Vally Wieselthier
Arline Wingate
Meyer Wolfe
Grant Wood
Andrew Wyeth
Art Young
Mahonri M. Young
William Zorach

Painting

Artists
Laurence Adams
Marianne Appel
Edmund Archer
Darrel Austin
Isabel Bate
Cecil C. Bell
Julien Binford

Isabel Bishop
Harold Black
Peter Blume
Aaron Bohrod
Raymond Breinin
Audrey Buller
Paul Cadmus
Clarence Holbrook Carter
Federico Castellón
Daniel R. Celentano
Paul Lewis Clemens
Lucille Corcos
Gladys Rockmore Davis
Lew Davis
Horace Day
John De Martelly
Angelo Di Benedetto
Harry Dix
Yvonne Du Bois
Stuart Edie
Emlen Etting
Philip Evergood
William Dean Fausett
Tully Filmus
Karl E. Fortess
David Fredenthal
Don Freeman
Jared French
Oronzo Gasparo
Lloyd Goff
Arshile Gorky
Douglas W. Gorsline
Adolph Gottlieb
Balcomb Greene
Marion Greenwood
O. Louis Guglielmi
James Guy
Robert Gwathmey
Frederick Haucke
John Edward Heliker
Joseph Hirsch
Peter Hurd
Lee Jackson
Joe Jones
Mervin Jules
Walt Killam
John Koch
Edward Laning
Doris Lee
Jack Levine
Erle Loran

Luigi Lucioni
George Marinko
Fletcher Martin
John McCrady
Felicia Meyer
Edward Millman
George L. K. Morris
William C. Palmer
Phil Paradise
Alzira Peirce
Gregorio Prestopino
Walter Quirt
Charles W. Rain
Anton Refregier
Louis Ribak
Andrée Ruellan
Louis Schanker
Saul Schary
Max Schnitzler
Georges Schreiber
Symeon Shimin
Mitchell Siporin
Lawrence Beall Smith
Isaac Soyer
Everett Spruce
Harry Sternberg
Reuben Tam
James B. Turnbull
Paul Ullman
Margit Varga
Esther Williams
Reginald Wilson
Andrew Wyeth
Edmund Yaghjian
Karl Zerbe

1940

*Sculpture, Paintings,
Watercolors, Drawings,
and Prints*

1940 ANNUAL EXHIBITION OF
CONTEMPORARY
AMERICAN ART
SCULPTURE
PAINTINGS
WATERCOLORS
DRAWINGS
PRINTS

WHITNEY MUSEUM OF AMERICAN ART
TEN WEST EIGHTH STREET · NEW YORK

Artists

Ivan Le Lorraine Albright
John Taylor Arms
Peggy Bacon
Saul Baizerman
Richmond Barthé
Michael Baxte
A. S. Baylinson
Gifford Beal
Cecil C. Bell
Thomas Benton
Saul Berman
Virginia Berresford
Frank Besedick
George Biddle
Henry Billings
S. F. Bilotti
Isabel Bishop
Arnold Blanch
Lucile Blanch
Julius Bloch
Peter Blume
Aaron Bohrod
Louis Bouché
Fiske Boyd
Alexander Brook
Byron Browne
Edward Bruce
Audrey Buller
Charles Burchfield
Jacob Burck
Paul Burlin

David Burliuk
Betty Burroughs
Paul Cadmus
John Carroll
Clarence H. Carter
Federico Castellón
Albino Cavallito
Nicolai Cikovsky
Minna Citron
Jon Corbino
John E. Costigan
Lee Brown Coye
Thomas Craig
Francis Criss
John Steuart Curry
Lewis C. Daniel
Jo Davidson
Gladys Rockmore Davis
Hubert Davis
Stuart Davis
Horace Day
José De Creeft
Adolf Dehn
John S. De Martelly
José Ruiz De Rivera
Frederick K. Detwiller
Adolphe Dioda
Nathaniel Dirk
Stevan Dohanos
Thomas Donnelly
Arthur G. Dove
Guy Pène Du Bois
Mabel Dwight
Stuart Edie
Franc Epping
Emlen Etting
Philip Evergood
Lorser Feitelson
Herbert Ferber
Duncan Ferguson
Louis Ferstadt
Mitchell Fields
Ernest Fiene
Paul Fiene
Eugene C. Fitsch
John B. Flannagan
Walter K. Frame
Don Freeman
Jared French
Wanda Gag
Emil Ganso

Karl E. Fortess
Oronzo Gasparo
Eugenie Gershoy
C. K. Gleeson
Maurice Glickman
Lloyd Goff
Aaron J. Goodelman
Sonia Gordon-Brown
Arshile Gorky
Douglas W. Gorsline
Harry Gottlieb
Dorothea S. Greenbaum
William Gropper
Chaim Gross
George Grosz
John Groth
O. Louis Guglielmi
Phillip Guston
James M. Guy
Robert Gwathmey
Minna Harkavy
Abraham Harriton
Leon Hartl
Marsden Hartley
Bertram Hartman
Rosella Hartman
Milton Hebald
Albert W. Heckman
Eugene Higgins
Joseph Hirsch
Alexandre Hogue
Edward Hopper
Earle Horter
John Hovannes
Victoria Hutson Huntley
Paul Hyun
Joe Jones
Mervin Jules
Margaret Brassler Kane
Morris Kantor
Bernard Karfiol
Henry G. Keller
León Kelly
Georgina Klitgaard
Frederic Knight
John Koch
Benjamin Kopman
Romuald Kraus
Henry Kreis
Leon Kroll
Max Kuehne

Walt Kuhn
Yasuo Kuniyoshi
Lawrence Kupferman
Armin Landeck
Edward Laning
J.J. Lankes
Barbara Latham
Robert Laurent
Rico Lebrun
Arthur Lee
Doris Lee
Julian E. Levi
Jack Levine
Martin Lewis
Russell T. Limbach
Charles Locke
Frank London
Louis Lozowick
Molly Luce
Luigi Lucioni
Oronzio Maldarelli
Peppino Mangravite
Berta Margoulies
George Marinko
Kyra Markham
Jack Markow
Reginald Marsh
Antonio P. Martino
Henry Mattson
John Ward McClellan
Henry Lee McFee
Fletcher Martin
William C. McNulty
Frank Mechau
Felicia Meyer
G. Macculloch Miller
Helen Miller
Kenneth Hayes Miller
Eugene Morley
Herta Moselsio
Simon Moselsio
Thomas Nason
Edith W. Newton
Isamu Noguchi
William C. Palmer
Waldo Peirce
Marjorie Phillips
George Picken
Hobson Pittman
Henry Varnum Poor
Gregorio Prestopino

Mac Raboy
Daniel Rasmusson
Louis Ribak
Walter Du Bois Richards
Hugo Robus
Caroline Speare Rohland
Paul Rohland
Umberto Romano
Charles Rosen
Sanford Ross
Lincoln Rothschild
Charles Rudy
Andrée Ruellan
Allen Saalburg
Hélène Sardeau
Concetta Scaravaglione
Katherine Schmidt
Henry Schnakenberg
Henry Schonbauer
Georges Schreiber
Charles E. Shannon
William Sharp
Millard Sheets
Charles Sheeler
Symeon Shimin
John Sloan
Louis Slobodkin
Judson Smith
Lawrence Beall Smith
Raphael Soyer
Eugene Speicher
Francis Speight
Niles Spencer
Benton Spruance
Everett Spruce
Joseph Stella
Harry Sternberg
Dudley V. Talcott
Prentiss Taylor
Byron Thomas
Jennings Tofel
Manuel J. Tolegian
Bradley Walker Tomlin
Dorothy Varian
Carl Walters
Marion Walton
Heinz Warneke
Hyman Warsager
Jane Wasey
Franklin C. Watkins
Nan Watson

Max Weber
Stow Wengenroth
Nat Werner
Warren Wheelock
Gertrude V. Whitney
Harry Wickey
Grant Wood
Marguerite Zorach
William Zorach

Painting

Artists
Edmund Archer
John Atherton
A. S. Baylinson
Gifford Beal
Cecil C. Bell
Thomas Benton
Saul Berman
George Biddle
Henry Billings
Isabel Bishop
Harold Black
Arnold Blanch
Lucile Blanch
Aaron Bohrod
Louis Bouché
Manuel Bromberg
Alexander Brook
Edith Bry
Audrey Buller
Charles Burchfield
Paul Burlin
David Burliuk
Andrew Butler
Paul Cadmus

John Carroll
Clarence Holbrook Carter
Federico Castellón
Daniel R. Celentano
Francis Chapin
Nicolai Cikovsky
Paul Lewis Clemens
Jon Corbino
Russell Cowles
Ralston Crawford
Francis Criss
John Steuart Curry
Lewis C. Daniel
Randall Davey
Stuart Davis
Horace Day
Julio De Diego
John De Martelly
Lamar Dodd
Olin Dows
Otis Dozier
Werner Drewes
Guy Pène Du Bois
Yvonne Du Bois
Emlen Etting
Philip Evergood
William Dean Fausett
Lyonel Feininger
Vaughn Flannery
David Fredenthal
Karl Free
Ernest Fiene
Mary Fife
Tully Filmus
Don Freeman
Jared French
Emil Ganso
Oronzo Gasparo
E. Bart Gerald
Marshall Glasier
Lloyd Goff
Arshile Gorky
Adolph Gottlieb
William Gropper
George Grosz
Louis Guglielmi
Robert Gwathmey
Marsden Hartley
Bertram Hartman
Harry Hering
Stefan Hirsch

Edward Hopper
Peter Hurd
Joe Jones
Mervin Jules
Morris Kantor
Bernard Karfiol
Paul Kelpe
Rockwell Kent
Elenora Kissel
Michael Klein
John Koch
Walt Kuhn
Yasuo Kuniyoshi
Richard Lahey
Edward Laning
Lawrence Lebduska
Doris Lee
Julian E. Levi
Jack Levine
Charles Locke
Ward Lockwood
Frank London
Molly Luce
Luigi Lucioni
Peppino Mangravite
George Marinko
Reginald Marsh
Fletcher Martin
Henry Mattson
Jan Matulka
William Ashby McCloy
Henry Lee McFee
Austin Mecklem
Felicia Meyer
Herbert Meyer
Harriette G. Miller
Kenneth Hayes Miller
Patrick Morgan
Jerome Myers
Frank Osborn
William C. Palmer
Joseph Pandolfini
Fred Papsdorf
Lloyd Parsons
Waldo Pierce
Jospeh Pollet
Henry Varnum Poor
Gregorio Prestopino
Walter Quirt
Harold Rabinovitz
Anton Refregier

Edna Reindel
Louis Ribak
Boardman Robinson
Paul Rohland
Paul Sample
Patsy Santo
Louis Schanker
Saul Schary
Katherine Schmidt
Henry Schnakenberg
Georges Schreiber
Zoltan Sepeshy
Daniel Serra
Ben Shahn
Frederick Shane
Charles Sheeler
Henrietta Shore
Clyde Singer
Mitchell Siporin
John Sloan
Lawrence Beall Smith
Moses Soyer
Raphael Soyer
Niles Spencer
Bernard Steffen
Harry Sternberg
Maurice Sterne
Chuzo Tamotzu
Manuel Tolegian
Bradley Walker Tomlin
Dorothy Varian
Joseph P. Vorst
Franklin C. Watkins
Nan Watson
Max Weber
Harold Weston
Esther Williams
Zsissly

1939
Sculpture, Drawings, and Prints

1939 ANNUAL EXHIBITION OF
CONTEMPORARY
AMERICAN SCULPTURE
DRAWINGS AND PRINTS
JANUARY 24 TO FEBRUARY 1

WHITNEY MUSEUM OF AMERICAN ART
TEN WEST EIGHTH STREET · NEW YORK

Artists
Ivan Le Lorraine Albright
Alexander Archipenko
Peggy Bacon
Saul Baizerman
Ahron Ben-Shmuel
Eugene Berman
S. F. Bilotti
Isabel Bishop
Peter Blume
Betty Burroughs
Andrew Butler
Paul Cadmus
A. Stirling Calder
Federico Castellón
Albino Cavallito
Nicolai Cikovsky
Minna Citron
J. E. Costigan
J. Claude Crow
Lewis C. Daniel
Jo Davidson
Hubert Davis
Richard Davis
José De Creeft
Adolf Dehn
John S. De Martelly
José Ruiz De Rivera
Mabel Dwight
Franc Epping
Roberta Everett
Philip Evergood
Mitchell Fields
Eugene C. Fitsch

John B. Flannagan
Karl Free
Don Freeman
Jared French
Wanda Gag
Emil Ganso
Eugenie Gershoy
Maurice Glickman
Aaron J. Goodelman
Boris Gorelick
Dorothea S. Greenbaum
Waylande Gregory
William Gropper
Chaim Gross
George Grosz
John Groth
Minna R. Harkavy
Rosella Hartman
Alonzo Hauser
Milton Hebald
Albert W. Heckman
Irwin D. Hoffman
Earle Horter
John Hovannes
Victoria Hutson Huntley
Paul Hyun
Sylvia Shaw Judson
Margaret Brassler Kane
Henry Kreis
Yasuo Kuniyoshi
Armin Landeck
Edward Laning
Robert Laurent
Tom Lea
Rico Lebrun
Arthur Lee
Doris Lee
Martin Lewis
Russell T. Limbach
Charles Locke
Thomas G. Lo Medico
Louis Lozowick
Kyra Markham
Reginald Marsh
William C. McNulty
Helen Miller
Eugene Morley
Dudley Morris
Simon Moselsio
Thomas Nason
Isamu Noguchi

William C. Palmer
Walter Du Bois Richards
Robert Riggs
Hugo Robus
Umberto Romano
Charles Rudy
Sally Ryan
Antonio Salemme
Concetta Scaravaglione
Louis Schanker
Carl L. Schmitz
Henry Schonbauer
Freeman L. Schoolcraft
Georges Schreiber
John Sloan
Louis Slobodkin
Raphael Soyer
Benton Spruance
Harry Sternberg
Dudley V. Talcott
Prentiss Taylor
Byron Thomas
Carl Walters
Marion Walton
Heinz Warneke
Jane Wasey
Stow Wengenroth
Nat Werner
Anita Weschler
Warren Wheelock
Gertrude V. Whitney
Harry Wickey
William Zorach

Watercolors

1939 ANNUAL EXHIBITION OF
CONTEMPORARY
AMERICAN
WATERCOLORS
FEBRUARY 22 TO MARCH 15

WHITNEY MUSEUM OF AMERICAN ART
TEN WEST EIGHTH STREET · NEW YORK

Artists

Carlos Andreson
Marianne Appel
Peggy Bacon
John J. Barsotti
Cecil C. Bell
Rainey Bennett
Theresa F. Bernstein
Virginia Berresford
Lucile Blanch
Aaron Bohrod
Otto Botto
Charles Burchfield
Kenneth Callahan
Charles Campbell
Clarence Holbrook Carter
Federico Castellón
Howard Cook
Lucille Corcos
Russell Cowes
Lee Brown Coye
Thomas Craig
Lewis C. Daniel
Hubert Davis
Horace Day
Adolf Dehn
Frank Di Gioia
Nathaniel Dirk
Steven Dohanos
Olin Dows
Stuart Edie
Louis Ferstadt
Susan Frazier
David Fredenthal
Emil Ganso

Bertram Goodman
Harry Gottlieb
Hardie Gramatky
Perkins Harnley
Abraham Harriton
Edward Hopper
Earle Horter
Henry G. Keller
Aline Kilham
Josef Lenhard
L. Jean Liberté
Ward Lockwood
John Lonergan
George Macrum
Reginald Marsh
Giovanni Martino
Austin Mecklem
Bruce Mitchell
Simmons Persons
Caroline Speare Rohland
Paul Rohland
Allen Saalburg
Paul Sample
Saul Schary
Georges Schreiber
Zoltan Sepeshy
Millard Sheets
Jean Paul Slusser
Jacob Getlar Smith
Harwood Steiger
John W. Taylor
Prentiss Taylor
James B. Turnbull
Ernest Walker
Max Weber
John Whorf
William Zorach

1938
Painting

1938 ANNUAL EXHIBITION OF
CONTEMPORARY
AMERICAN
PAINTING
NOVEMBER 2 TO DECEMBER 11

WHITNEY MUSEUM OF AMERICAN ART
TEN WEST EIGHTH STREET · NEW YORK

Artists

A. S. Baylinson
Gifford Beal
Saul Berman
Henry Billings
Isabel Bishop
Arnold Blanch
Lucile Blanch
Julius Bloch
Aaron Bohrod
Ilya Bolotowsky
Alexander Brook
Charles Burchfield
George Byron-Browne
Paul Cadmus
Charles Campbell
Jo Cantine
John Carroll
Daniel R. Celentano
Nicolai Cikovsky
Paul Lewis Clemens
Jon Corbino
Francis Criss
Gladys Rockmore Davis
Stuart Davis
Thomas Donnelly
Guy Pène Du Bois
Stephen Etnier
Philip Evergood
Ernest Fiene
Karl E. Fortess
Jared French
Emil Ganso
Charles L. Goeller

Lloyd Goff
Anne Goldthwaite
Douglas W. Gorsline
Balcomb Greene
William Gropper
George Grosz
O. Louis Guglielmi
Phillip Guston
Leon Hartl
Marsden Hartley
Bertram Hartman
Theodore G. Haupt
Eugene Higgins
Peter Hurd
Joe Jones
Mervin Jules
Morris Kantor
Bernard Karfiol
León Kelly
Georgina Klitgaard
John Koch
Benjamin Kopman
Leon Kroll
Yasuo Kuniyoshi
Richard Lahey
Edward Laning
Lawrence H. Lebduska
Doris Lee
Julian E. Levi
Jack Levine
Charles Locke
Molly Luce
Luigi Lucioni
Peppino Mangravite
George Marinko
Kyra Markham
Reginald Marsh
Alice T. Mason
Henry Lee McFee
Paul Mommer
Eugene Morley
C. G. Nelson
Elliot Orr
Waldo Peirce
Albert Pels
George Picken
Henry Varnum Poor
Gregorio Prestopino
Walter Quirt
Louis Ribak
Samuel Rosenberg

Theodore J. Roszak
H. D. Rothschild
Katherine Schmidt
Ben Shahn
Raymond Skolfield
John Sloan
Judson Smith
Isaac Soyer
Harry Sternberg
Maurice Sterne
Frederic Taubes
Manuel J. Tolegian
Nahum Tschacbasov
Allen Tucker
James B. Turnbull
Franklin C. Watkins
Max Weber
Bob White
Esther Williams
N. Ziroli
Zsissly

Sculpture, Watercolors,
Drawings, and Prints

Artists
Ida Abelman
Howard J. Ahrens
Carlos Andreson
Vera Andrus
John Taylor Arms
Peggy Bacon
Gifford Beal
Fred Becker
Cecil C. Bell
Ahron Ben-Shmuel
S. F. Bilotti

Isabel Bishop
Lucile Blanch
Julius Bloch
Peter Blume
Aaron Bohrod
Fiske Boyd
Ann Brockman
Charles Burchfield
Jacob Burck
Betty Burroughs
Andrew Butler
Paul Cadmus
Clarence H. Carter
Federico Castellón
Albino Cavallito
Minna Citron
Lydia Cooley
Lucille Corcos
John E. Costigan
Alfred D. Crimi
Beatrice Cuming
Lewis C. Daniel
A. Mark Datz
Hubert Davis
Horace Day
Alice Decker
Adolf Dehn
José Ruiz De Rivera
Frederick K. Detwiller
Stevan Dohanos
Thomas Donnelly
Mabel Dwight
Stuart Edie
Sybil Emerson
William Dean Fausett
Herbert Ferber
Duncan Ferguson
Louis Ferstadt
Mitchell Fields
Ernest Fiene
Paul Fiene
Eugene C. Fitsch
John Flanagan
John B. Flannagan
George Franklin
Susan Frazier
Karl Free
Don Freeman
Jared French
Ada V. Gabriel
Wanda Gag

Emil Ganso
Albert W. Heckman
Stefan Hirsch
Irwin D. Hoffman
William R. Hollingsworth Jr.
Oronzo Gasparo
Euginie Gershoy
Maurice Glickman
Vincent Glinsky
Esther B. Goetz
Lloyd Goff
Boris Gorelick
Hardie Gramatky
Dorothea S. Greenbaum
William Gropper
Chaim Gross
Thomas Handforth
Minna Harkavy
Bertram Hartman
Rosella Hartman
Milton Hebald
Louis Hechenbleikner
Emil Holzhauer
Charles Hopkinson
Edward Hopper
Earle Horter
Loretta Howard
Isabella Howland
Victoria Hutson Huntley
Paul Hyun
Wendell Jones
Marion M. Junkin
Margaret Brassler Kane
Bernard Karfiol
Nathaniel Kaz
J. Wallace Kelly
Henry Kreis
Yasuo Kuniyoshi
Laurence E. Kupferman
Richard Lahey
Edward Laning
J. J. Lankes
Robert Laurent
Joseph Leboit
Rico Lebrun
Arthur Lee
A. F. Levinson
Edgar Levy
Russell T. Limbach
Charles Locke
John Lonergan

Louis Lozowick
Luigi Lucioni
Nan Lurie
Oronzio Maldarelli
Paul Manship
De Hirsh Margules
Kyra Markham
Reginald Marsh
William C. McNulty
Bruce Mitchell
Eugene Morley
Jerome Myers
J. Ruth Nickerson
Arnold Rönnebeck
Harry Rosin
Lincoln Rothschild
Charles Rudy
Andrée Ruellan
Sally Ryan
Margery Ryerson
Antonio Salemme
Ann Nooney
Elizabeth Nottingham
Karl Oberteuffer
Moses Oley
Peterpaul Ott
Walter Pach
Orville H. Peets
Simmons Persons
George Picken
Ogden M. Pleissner
Mac Raboy
Daniel Rasmusson
Grant Reynard
Walter Du Bois Richards
Robert Riggs
Hugo Robus
Caroline Speare Rohland
Paul Sample
I.J. Sanger
Hélène Sardeau
Concetta Scaravaglione
Saul Schary
Katherine Schmidt
Carl L. Schmitz
Henry Schonbauer
Georges Schreiber
Ben Shahn
Charles Sheeler
Millard Sheets
Raymond Skolfield

John Sloan
Louis Slobodkin
Charles W. Smith
Raphael Soyer
Carl Sprinchorn
Benton Spruance
Joseph Steig
Harry Sternberg
Alexander Stoller
Dudley Talcott
Harry LeRoy Taskey
John W. Taylor
Prentiss Taylor
Elizabeth Terrell
Tromka
James B. Turnbull
Joseph Vogel
Vaclav Vytlacil
Abraham Walkowitz
Carl Walters
Marion Walton
Nan Watson
Heinz Warneke
Stow Wengenroth
Nat Werner
Gertrude V. Whitney
John Whorf
Harry Wickey
Maria Wickey
Reginald Wilson
Grant Wood
Denys Wortman
Andrew Wyeth
Art Young
Mahonri M. Young
William Zorach

1937

Painting

Artists

Ivan Le Lorraine Albright
Conrad A. Albrizio
Eugene Berman
Edward Biberman
Henry Billings
Ilse Bischoff
Isabel Bishop
Arnold Blanch
Lucile Blanch
Aaron Bohrod
Henry A. Botkin
Louis Bouché
Edgar Britton
Alexander Brook
Audrey Buller
Paul Burlin
Andrew Butler
George Byron-Browne
Paul Cadmus
Clarence H. Carter
Daniel R. Celentano
Robert O. Chadeayne
Francis Chapin
Jon Corbino
Ralston Crawford
Francis Criss
John Steuart Curry
Gladys Rockmore Davis
Lew E. Davis
Stuart Davis
Nathaniel Dirk
Lamar Dodd
Guy Pène Du Bois

Emlen Etting
Philip Evergood
William Dean Fausett
Lorser Feitelson
Ernest Fiene
Mary Fife
John Flolinsbee
Karl E. Fortess
Don Freeman
Jared French
Lee Gatch
William J. Glackens
Arshile Gorky
Harry Gottlieb
William Gropper
George Grosz
Abraham Harrington
Marsden Hartley
Theodore G. Haupt
Charles Trumbo Henry
Alexandre Hogue
Edward Hopper
Earle Horter
Nora Houston
Peter Hurd
Joe Jones
Bernard Karfiol
Waldo Kaufer
Frederic Knight
Max Kuehne
Walt Kuhn
Yasuo Kuniyoshi
Edward Laning
Ernest Lawson
H. Lawrence Lebduska
Julian E. Levi
Jack Levine
Charles Locke
Erle Loran
Molly Luce
Reginald Marsh
Antonio P. Martino
Henry Mattson
Virginia Armitage McCall
David McCosh
Austin Mecklem
Paul Meltsner
Kenneth Hayes Miller
Dudley Morris
Elliot Orr
William C. Palmer

Lloyd Parsons
John C. Pellew
Robert Philipp
Biagio Pinto
Hobson Pittman
Joseph Pollet
Edna Reindel
Louis Ribak
Paul Rohland
Charles Rosen
Theodore J. Roszak
Andrée Ruellan
Katherine Schmidt
Henry Schnakenberg
Charles Sheeler
John Sloan
Isaac Soyer
Moses Soyer
Raphael Soyer
Elizabeth Sparhawk-Jones
Eugene Speicher
Francis Speight
Niles Spencer
Benton Spruance
Everett Spruce
Manuel J. Tolegian
Nahum Tschacbasov
Allen Tucker
Stuyvesant Van Veen
Dorothy Varian
Max Weber

1936
Sculpture, Drawings, and Prints

SECOND BIENNIAL EXHIBITION
PART ONE—SCULPTURE
DRAWINGS AND PRINTS
JANUARY 14 TO FEBRUARY 13, 1936

WHITNEY MUSEUM
OF AMERICAN ART
TEN WEST EIGHTH STREET · NEW YORK

Artists
Humber Albrizio
Frank Hartley Anderson
John Taylor Arms
Peggy Bacon
Weldon Bailey
Richmond Barthé
Gifford Beal
Ahron Ben-Shmuel
Thomas H. Benton
Virginia Berresford
N. Bervinchak
S. F. Bilotti
Isabel Bishop
Peter Blume
James Brooks
Andrew Butler
Paul Cadmus
John Carroll
Harold Cash
Albino Cavallito
Howard Cook
Jon Corbino
John E. Costigan
Martin Craig
Konrad Cramer
John Steuart Curry
Lewis C. Daniel
A. Mark Datz
Jo Davidson
G. R. Davis Jr.
Hubert Davis
Alice Decker
Adolph Dehn

Hunt Diederich
Caroline Durieux
Mabel Dwight
Wharton Esherick
Duncan Ferguson
Paul Fiene
Eugene C. Fitsch
John B. Flannagan
Gerald Foster
Hans Foy
Allan Freelon
Don Freeman
Jared French
Wanda Gag
Eugenie Gershoy
Vincent Glinsky
Aaron J. Goodelman
Waylande Gregory
William Gropper
Chaim Gross
Walker Hancock
Thomas Handforth
Minna R. Harkavy
Rosella Hartman
Herbert Haseltine
Alonzo Hauser
Albert W. Heckman
Stefan Hirsch
Malvina Hoffman
James House Jr.
Anna Hyatt Huntington
Victoria Hutson
Sylvia Shaw Judson
Morris Kantor
Bernard Karfiol
J. Wallace Kelly
León Kelly
Leon Kroll
A. Z. Kruse
Max Kuehne
Walt Kuhn
Yasuo Kuniyoshi
Gaston Lachaise
Richard Lahey
Edward Laning
Ibram Lassaw
Robert Laurent
Arthur Lee
Julian E. Levi
Josephine Levy
E. Barnard Lintott

Charles Locke
Louis Lozowick
Luigi Lucioni
Gwen Lux
Oronzio Maldarelli
Berta Margoulies
Jack Markow
Dina Melicov
Kenneth Hayes Miller
Dudley Morris
Simon Moselsio
Roland Mousseau
Reuben Nakian
Edith Newton
Joseph Nicolosi
William B. O'Brian
William C. Palmer
Orville H. Peets
Tomas Penning
Carlotta Petrina
Carl Pickhardt Jr.
Angelo Pinto
Salvatore Pinto
C. Pollock
Lionel S. Reiss
Robert Riggs
Boardman Robinson
Hugo Robus
Jane Rogers
Jo Rollo
Wallace Rosenbauer
Lincoln Rothschild
Charles Rudy
Andrée Ruellan
Jose A. Ruiz
Alexander Sambugnac
Hélène Sardeau
Concetta Scaravaglione
Henry Schonbauer
Shelby Shakelford
Charles Sheeler
Raymond Skolfield
John Sloan
Charles W. Smith
Raphael Soyer
Eugene Speicher
Benton Spruance
Harry Sternberg
Alexander Stoller
Jack W. Taylor
Prentiss Taylor

Lenore Thomas
Polygnotos Vagis
Carl Walters
Marion Walton
Heinz Warneke
Jane Wasey
Stow Wengenroth
Nat Werner
Anita Weschler
Warren Wheelock
Gertrude V. Whitney
Harry Wickey
Esther Williams
Grant Wood
Denys Wortman
Mahanri Young
William Zorach

Watercolors and Pastels

Artists

Boris Aronson
Milton Avery
Jozef G. Bakos
Charles Baskerville
Reynolds Beal
Cecil C. Bell
George Biddle
Lucile Blanch
Julius Bloch
Edgar Bohlman
Aaron Bohrod
Arthur Bowes
Fiske Boyd
Edgar Britton
Charles E. Burchfield
Henri Burkhard

Nathaniel C. Burwash
Clarence H. Carter
Francis Chapin
Lydia Cooley
Lucille Corcos
Gustaf Dalstrom
Andrew Dasburg
Randall Davey
Stuart Davis
Horace Day
Walt Dehner
Nathaniel Dirk
Peggy Dodds
Stevan Dohanos
Thomas Donnelly
Raymond Baxter Dowden
Elsie Driggs
Stuart Edie
Louis M. Eilshemius
Louis G. Ferstadt
Ernest Fiene
George Franklin
Susan Frazier
Karl Free
Emil Ganso
Harry Gottlieb
Jack J. Greitzer
George Grosz
Perkins Harnly
Abraham Harriton
Marsden Hartley
Bertram Hartman
Harry Hering
Eugene Higgins
Emil Holzhauer
Edward Hopper
Earl Horter
Loretta Howard
Neil McDowell Ives
Charles Kaeselau
Henry G. Keller
Paul Kelpe
Georgina Klitgaard
Stewart Klonis
Karl Knaths
Hayley Lever
L. Jean Liberté
Ward Lockwood
John Lonergan
S. L. Margolies
John Marin

Reginald Marsh
Jan Matulka
Helen McAuslan
David McCosh
Austin Mecklem
William Meyerowitz
Bruce Mitchell
Elliot Orr
Harley Perkins
George Picken
Hobson Pittman
Philip Reisman
Louis Ribak
Caroline Speare Rohland
Paul Rohland
Sanford Ross
Paul S. Sample
Saul Schary
Henry Schnakenberg
Georges Schreiber
Millard Sheets
Martha Simpson
Alice R. Huger Smith
Jacob Getlar Smith
Miron Sokole
Moses Soyer
Carl Sprinchorn
Harwood Steiger
Joseph Stella
Anne Ophelia Todd
Herman Trunk Jr.
Allen Tucker
Stuyvesant Van Veen
Abraham Walkowitz
Max Weber
Isabel L. Whitney
John Whorf
William Zorach

Painting

Artists

Gifford Beal
Maurice Becker
Saul Berman
Virginia Berresford
Edward Biberman
Henry Billings
Isabel Bishop
Arnold Blanch
Lucille Blanch
Julius Bloch
Aaron Bohrod
Louis Bouché
Fiske Boyd
Alexander Brook
Edward Bruce
Audrey Buller
Paul Burlin
Paul Cadmus
John Carroll
Nicolai Cikovsky
Jon Corbino
Francis Criss
John Steuart Curry
Stuart Davis
Nathaniel Dirk
Thomas Donnelly
Arthur G. Dove
Stephen Etnier
Emlen Etting
Philip Evergood
Ernest Fiene
Mary Fife
Don Freeman
Jared French

Arnold Friedman
Emil Ganso
Walter Gardner
William Glackens
Arshile Gorky
Harry Gottlieb
John D. Graham
William Gropper
Louis Guglielmi
Bertram Hartman
Zoltan Hecht
Eugene Higgins
Stefan Hirsch
Alexandre Hogue
Mary Hoover
Edward Hopper
Joe Jones
Morris Kantor
Bernard Karfiol
H. E. Kleinert
Georgina Klitgaard
Benjamin Kopman
Alexander J. Kostellow
Leon Kroll
Max Kuehne
Walt Kuhn
Yasuo Kuniyoshi
Richard Lahey
Edward Laning
Ernest Lawson
Doris Lee
Ward Lockwood
Frank London
Molly Luce
Luigi Lucioni
Eugene Ludins
Peppino Mangravite
John Marin
Reginald Marsh
Henry Mattson
Jan Matulka
Henry Lee McFee
Frank Mechau Jr.
Austin Mecklem
Herbert Meyer
Kenneth Hayes Miller
Paul Mommer
Jerome Myers
C. G. Nelson
William C. Palmer
Waldo Peirce

Harley Perkins
George Picken
Joseph Pollet
Henry Varnum Poor
Constantine Pougialis
Charles Prendergast
Walter Quirt
Edna Reindel
Louis Ribak
Paul Rohland
Charles Rosen
Samuel Rosenberg
Theodore J. Roszak
H. D. Rothschild
Louis Schanker
Saul Schary
Henry Schnakenberg
Charles Sheeler
Clyde Singer
John Sloan
Judson Smith
Moses Soyer
Raphael Soyer
Eugene Speicher
Niles Spencer
Everett Spruce
Joseph Stella
Byron Thomas
Nahum Tschacbasov
Allen Tucker
Dorothy Varian
Franklin C. Watkins
Nan Watson
Max Weber
Esther Williams
Arnold Wiltz
Edmund Yaghjian
Zsissly

1934
Painting

Artists
M. Azzi Aldrich
Edmund Archer
Horus Armistead
George C. Ault
Jozef G. Bakos
A. S. Baylinson
Ben Benn
Thomas H. Benton
Saul Berman
Edward Biberman
George Biddle
Joseph Biel
Henry H. Billings
Isabel Bishop
Arnold Blanch
Lucile Blanch
Julius Bloch
Aaron Bohrod
Louis Bouché
Byron B. Boyd
Fiske Boyd
Alexander Brook
Edward Bruce
David Burliuk
Bryson Burroughs
Paul Cadmus
Harry Carnohan
John Carroll
Clarence Holbrook Carter
Nicolai Cikovsky
Rose Clark
Konrad Cramer
Francis Criss

John Cunning
John Steuart Curry
Andrew Dasburg
Stuart Davis
Joseph De Martini
Charles Demuth
Nathaniel Dirk
Thomas Donnelly
Arthur G. Dove
Guy Pène Du Bois
Stuart Edie
Louis Michel Eilshemius
Philip Evergood
Ernest Fiene
Karl Free
Emil Ganso
Elizabeth Bart Gerald
Isolde Therese Gilbert
William J. Glackens
Anne Goldthwaite
Bertram Goodman
Harry Gottlieb
Bernar Gussow
Marsden Hartley
Bertram Hartman
Lee Hersch
Eugene Higgins
Roy Hilton
Stefan Hirsch
Irwin D. Hoffman
Gerrit Hondius
Edward Hopper
Isabella Howland
Joe Jones
John Kane
Morris Kantor
Bernard Karfiol
Georgina Klitgaard
Karl Knaths
Alexander J. Kostellow
Leon Kroll
Max Kuehne
Walt Kuhn
Yasuo Kuniyoshi
Richard Lahey
Edward Laning
Ernest Lawson
Doris Lee
Hayley Lever
L. Jean Liberté
Ward Lockwood

Charles Logasa
Molley Luce
Luigi Lucioni
Eugene Ludins
Gus Mager
Peppino Mangravite
Herman Maril
Reginald Marsh
Henry Mattson
Jan Matulka
Henry Lee McFee
Frank Mechau Jr.
Austin Mecklem
Kenneth Hayes Miller
Paul Mommer
Hermon More
David Morrison
Jerome Myers
Willard Nash
C. G. Nelson
Hieo Noda
S. Walter Norris
Georgia O'Keeffe
Elliot Orr
Walter Pach
William C. Palmer
Lloyd Parsons
Waldo Peirce
I. Rice Pereira
Marjorie Phillips
George Picken
Angelo Pinto
Joseph Pollet
Henry Varnum Poor
Charles E. Prindiville
Edna Reindel
Louis Ribak
Paul Rohland
Charles Rosen
Samuel Rosenberg
Doris Rosenthal
Theodore J. Roszak
Sarkis Sarkisian
Katherine Schmidt
Henry Schnakenberg
Ben Shahn
Charles Sheeler
Millard Sheets
John Sloan
Jacob Getlar Smith
Judson Smith

Raphael Soyer
Eugene Speicher
Niles Spencer
Maurice Sterne
Byron Thomas
Herman Trunk Jr.
Allen Tucker
Carroll Tyson
Dorothy Varian
A. Walkowitz
Franklin C. Watkins
Nan Watson
Max Weber
Harold Weston
Arnold Wiltz
Grant Wood
Jacques Zucker

1933

Sculpture, Watercolors, and Prints

FIRST BIENNIAL
EXHIBITION OF
CONTEMPORARY
AMERICAN SCULPTURE
WATERCOLORS
··AND PRINTS··
DECEMBER 5TH, 1933 TO JANUARY 11TH, 1934

WHITNEY MUSEUM
OF AMERICAN ART
TEN WEST EIGHTH STREET · NEW YORK

Artists
Rifka Angel
John Taylor Arms
Boris Aronson
Milton Avery
Peggy Bacon
Saul L. Baizerman
Josef G. Bakos
Richmond Barthé
Gifford Beal
Maurice Becker
Ahron Ben-Shmuel
Theresa F. Bernstein
Virginia Berresford

George Biddle
S. F. Bilotti
Isabel Bishop
Arnold Blanch
Lucile Blanch
Lawrence Blazey
Julius Bloch
Peter Blume
Aaron Bohrod
Fiske Boyd
Simeon Braguin
Edgar Britton
James D. Brooks
Sonia Gordon Brown
Charles Burchfield
Jacob Burck
Henri Burkhard
Betty Burroughs
Andrew Butler
Kenneth Callahan
Charles Campbell
John Carroll
Clarence Holbrook Carter
Albino Cavallito
Francis Chapin
Howard Cook
Willard R. Cox
Florence Ballin Cramer
Konrad Cramer
Francis Criss
John Steuart Curry
Carl G. Cutler
Gustaf Dalstrom
Lewis C. Daniel
Andrew Dasburg
Mark Datz
Randall Davey
Jo Davidson
Morris Davidson
Hubert Davis
Stuart Davis
Alice Decker
Adolf Dehn
Charles Demuth
Frederick K. Detwiller
Nathaniel Dirk
Stevan Dohanos
Anne Goldthwaite
Aaron J. Goodelman
Harry Gottlieb
Dorothea S. Greenbaum

Jack J. Greitzer
William Gropper
Chaim Gross
Thomas Donnelly
Elsie Driggs
Mabel Dwight
Stuart Edie
George William Eggers
Wharton Esherick
Rudolph Evans
Alfeo Faggi
Duncan Ferguson
Louis G. Ferstadt
Ernest Fiene
Paul Fiene
John B. Flannagan
Gerald Foster
Hans Foy
Susan Frazier
Karl Free
Don Freeman
Wanda Gag
Emil Ganso
Eugenie Gershoy
William Glackens
Anna Glenny
H. Glintenkamp
Thomas Handforth
Bertram Hartman
Rosella Hartman
Childe Hassam
Albert W. Heckman
Eugene Higgins
Stefan Hirsch
Emil Holzhauer
Edward Hopper
Earl Horter
James House Jr.
Cecil Howard
Victoria Hutson
Jo Jenkins
S. B. Kahan
Morris Kantor
Bernard Karfiol
Henry G. Keller
J. Wallace Kelly
León Kelly
Rockwell Kent
Georgina Klitgaard
Karl Knaths
A. Z. Kruse

Max Kuehne
Walt Kuhn
Yasuo Kuniyoshi
Gaston Lachaise
Richard Lahey
J.J. Lankes
Robert Laurent
Arthur Lee
Hayley Lever
L. Jean Liberté
Charles Locke
Ward Lockwood
John Lonegan
Louis Lozowick
Luigi Lucioni
Oronzio Maldarelli
John Marin
Reginald Marsh
Jan Matulka
Helen McAuslan
David McCosh
Henry Lee McFee
Austin Mecklem
Hannah Mecklem
Jo Mielziner
Harriette G. Miller
Kenneth Hayes Miller
Bruce Mitchell
Jerome Myers
Reuben Nakian
Walter Pach
William C. Palmer
Charles Hovey Pepper
Carlotta Petrina
George Picken
Hobson Pittman
Henry Varnum Poor
John Ramsey
Philip Reisman
Louis Ribak
Robert Riggs
Boardman Robinson
Hugo Robus
Caroline Speare Rohland
Paul Rohland
Jo Rollo
Umberto Romano
Arnold Rönnebeck
Lincoln Rothschild
Andrée Ruellan
Hélène Sardeau

Concetta Scaravaglione
Henry Schnakenberg
Ben Shahn
Charles Sheeler
John Sloan
Jean Paul Slusser
Jacob Getlar Smith
William Sommer
Moses Soyer
Eugene Speicher
Benton Spruance
Harry Sternberg
Maurice Sterne
John Storrs
Bunji Tagawa
J.W. Taylor
M.A. Tricca
Herman Trunk Jr.
Allen Tucker
Carl Walters
Marion Walton
Max Weber
Stow Wengenroth
Warren Wheelock
Gertrude V. Whitney
John Whorf
Harry Wickey
Esther Williams
Arnold Wiltz
Louis Wolchonok
William Wolfson
Grant Wood
Mahonri M. Young
William Zorach

Painting

FIRST BIENNIAL EXHIBITION
OF CONTEMPORARY
AMERICAN PAINTING
NOVEMBER 22ND, 1932, TO JANUARY 5TH, 1933

WHITNEY MUSEUM
OF AMERICAN ART
TEN WEST EIGHTH STREET, NEW YORK

Artists

Jean Crawford Adams
Dewey Albinson
Ivan Le Lorraine Albright
Edmund Archer
Emil Armin
George C. Ault
Jozef G. Bakos
Paul Bartlett
A.S. Baylinson
Gifford Beal
Ben Benn
George Biddle
Isabel Bishop
Arnold Blanch
Lucile Blanch
Julius Bloch
Oscar Bluemner
Peter Blume
Adolphe Borie
Louis Bouché
Fiske Boyd
Alexander Brook
Edward Bruce
Henri Burkhard
David Burliuk
Bryson Burroughs
Jo Cain
Blendon Campbell
Vincent Canadé
John Carroll
Nicolay Cikovsky
Florence Ballin Cramer
Konrad Cramer

Francis Criss
John Cunning
John Steuart Curry
Andrew Dasburg
Stuart Davis
Charles Demuth
Nathaniel Dirk
Thomas Donnelly
Arthur G. Dove
Elsie Driggs
Guy Pène Du Bois
Charles Stafford Duncan
Stuart Edie
Louis Michel Eilshemius
Stephen Etnier
Ernest Fiene
Frances Foy
Kenneth Frasier
Karl Free
Arnold Friedman
Emil Ganso
WM. J. Glackens
Anne Goldthwaite
Harry Gottlieb
John D. Graham
Davenport Griffen
Bernar Gussow
Marsden Hartley
Bertram Hartman
Childe Hassam
Harry Hering
Eugene Higgens
Stefan Hirsch
Gerrit Hondius
Charles Hopkinson
Edward Hopper
Earl Horter
Isabella Howland
John Kane
Morris Kantor
Bernard Karfiol
Henry G. Keller
Georgina Klitgaard
Karl Knaths
Frederic Knight
Benjamin Kopman
Leon Kroll
Max Kuehne
Walt Kuhn
Yasuo Kuniyoshi
Richard Lahey

Edward Laning
Sidney Laufman
Ernest Lawson
Doris Lee
Hayley Lever
A. F. Levinson
Jonas Lie
William H. Littlefield
Ward Lockwood
Charles Logasa
Luigi Lucioni
Eugene Ludins
George Luks
Gus Mager
Peppino Mangravite
Reginald Marsh
Henry Mattson
Jan Matulka
Henry Lee McFee
Austin Mecklem
Gari Melchers
Kenneth Hayes Miller
Ross Moffett
David Morrison
Jerome Myers
Willard Nash
Georgia O'Keeffe
Otis Oldfield
Sam Ostrowsky
Walter Pach
Marjorie Phillips
George Picken
Salvatore Pinto
Theresa Pollak
Joseph Pollet
Henry Varnum Poor
Edward W. Redfield
Paul Rohland
Umberto Romano
Charles Rosen
Theodore J. Roszak
W. Vladimir Rousseff
Saul Schary
Katherine Schmidt
Henry Schnakenberg
Ben Shahn
Charles Sheeler
Anatol Shulkin
John Sloan
Judson Smith
Raphael Soyer

Eugene Speicher
Francis Speight
Niles Spencer
Joseph Stella
Maurice Sterne
Florine Stettheimer
Chuzo Tamotzu
Bradley Walker Tomlin
Herman Trunk Jr.
Allen Tucker
Carroll Tyson
Laura Van Pappelendam
Dorothy Varian
Abraham Walkowitz
Nan Watson
Max Weber
Harold Weston
Warren Wheelock
Arnold Wiltz
Grant Wood
Stanley Wood
Marguerite Zorach

Board of Trustees

Staff

Jay Abu-Hamda
Stephanie Adams
Rebecca Adib
Adrienne Alston
Ronnie Altilo
Martha Alvarez-LaRose
Callie Angell
Marilou Aquino
Rachel Arteaga
I. D. Arude
Bernadette Baker
John Balestrieri
Wendy Barbee-Lowell
Justine Benith
Harry Benjamin
Jeffrey Bergstrom
Caitlin Bermingham
Ivy Blackman
Hillary Blass
Richard Bloes
Leigh Brawer
Rebekah Burgess
Douglas Burnham
Ron Burrell
Garfield Burton
Johanna Burton
Pablo Caines
Margaret Cannie
Irving Carabello
Gary Carrion-Murayari
Brooke Cheney
Ramon Cintron
Casey Claps
Ron Clark
Melissa Cohen
John Collins
Arthur Conway
Jessica Copperman
Matthew Corey
Nicole Cosgrove
Heather Cox
Kenneth Cronan
Ashleigh Crowther
Sakura Cusie
Donna De Salvo

Robert Deeds
Anthony DeMercurio
Kristin Denner
Eduardo Diaz
Lauren DiLoreto
Erin Dooley
Lisa Dowd
Delano Dunn
Anita Duquette
Alvin Eubanks
Altamont Fairclough
Eileen Farrell
Jeanette Fischer
Rich Flood
Seth Fogelman
Carter Foster
Samuel Franks
Murlin Frederick
Annie French
Donald Garlington
Larissa Gentile
Liz Gillroy
Rebecca Gimenez
Francesca Grassi
Meghan Greene
Chrystie Greges
Molly Gross
Peter Guss
Kate Hahm
Kiowa Hammons
Barbara Haskell
Matthew Heffernan
Maura Heffner
Dina Helal
Claire Henry
Brad Henslee
Carmen Hermo
Carlos Hernandez
Jennifer Heslin
Ann Holcomb
Nicholas S. Holmes
Tracy Hook
Abigail Hoover
Brooke Horne
Sarah Hromack

Karen Huang
Wycliffe Husbands
Beth A. Huseman
Chrissie Iles
Carlos Jacobo
Bernard Johnson
Kate Johnson
Diana Kamin
Chris Ketchie
David Kiehl
Anna Knoell
Tom Kraft
Emily Krell
Tina Kukielski
Diana Lada
Diana Lee
Sang Soo Lee
Kristen Leipert
Monica Leon
Jeffrey Levine
Danielle Linzer
Kelley Loftus
Stephanie Lussier
Doug Madill
Carol Mancusi-Ungaro
Louis Manners
Joseph Mannino
Heather Maxson
Jessica McCarthy
Sandra Meadows
Bridget Mendoza
Graham Miles
Sarah Milestone
Dana Miller
David Miller
Christa Molinaro
Matt Moon
Josue' Morales
Victor Moscoso
Sasha Nicholas
Carlos Noboa
Kisha Noel
Margot Norton
Thomas Nunes
Brianna O'Brien

Rose O'Neill-Suspitsyna
Nelson Ortiz
Nicholas Parish
Christiane Paul
Laura Phipps
Angelo Pikoulas
Kathryn Potts
Linda Priest
Vincent Punch
Stina Puotinen
Christy Putnam
Catie Rachel
Jessica Ragusa
Benji Reid
Maggie Ress
Emanuel Riley
Ariel Rivera
Felix Rivera
Jeffrey Robinson
Georgianna Rodriguez
Gina Rogak
Clara Rojas-Sebesta
Justin Romeo
Joshua Rosenblatt
Amy Roth
Scott Rothkopf
Carol Rusk
Doris Sabater
Angelina Salerno
Leo Sanchez
Rafael Santiago
Paula Santos
Galina Sapozhnikova
Kristin Sarli
Lynn Schatz
Brittanie Schmieder
Gretchen Scott
David Selimoski
Jason Senquiz
Ai Wee Seow
Elisabeth Sherman
Kasey Sherrick
Matt Skopek
Joel Snyder
Michele Snyder

Stephen Soba
Julia Sobol
Barbi Spieler
Carrie Springer
John S. Stanley
Mark Steigelman
Minerva Stella
Hillary Strong
Emilie Sullivan
Elisabeth Sussman
Mary Anne Talotta
Julie Thomson
Kean Tan
Ellen Tepfer
Phyllis Thorpe
James Tomasello
Limor Tomer
Ana Torres
Alexis Tragos
Jordan Troeller
Beth Turk
Miranda Varela
Ray Vega
Rafael Vera
Snigdha Verma
Eric Vermilion
Jessica Vodofsky
Esme Watanabe
Cecil Weekes
Adam D. Weinberg
Margie Weinstein
Alexandra Wheeler
Michelle Wilder
John Williams
Natalee Williams
Rachel de W. Wixom
Sarah Zilinski

As of December 1, 2009